Modernism's Other Work

Modernism's Other Work

The Art Object's Political Life

Lisa Siraganian

OXFORD
UNIVERSITY PRESS

OXFORD
UNIVERSITY PRESS

Oxford University Press, Inc., publishes works that further
Oxford University's objective of excellence
in research, scholarship, and education.

Oxford New York
Auckland Cape Town Dar es Salaam Hong Kong Karachi
Kuala Lumpur Madrid Melbourne Mexico City Nairobi
New Delhi Shanghai Taipei Toronto

With offices in
Argentina Austria Brazil Chile Czech Republic France Greece
Guatemala Hungary Italy Japan Poland Portugal Singapore
South Korea Switzerland Thailand Turkey Ukraine Vietnam

Published by Oxford University Press, Inc.
198 Madison Avenue, New York, NY 10016

www.oup.com

Oxford is a registered trademark of Oxford University Press

Library of Congress Cataloging-in-Publication Data
Siraganian, Lisa.
Modernism's other work : the art object's political life / Lisa Siraganian.
p. cm.
Includes bibliographical references and index.
ISBN 978-0-19-979655-7 (hardcover : alk. paper) 1. American literature—20th century—
History and criticism. 2. Modernism (Literature)—United States. 3. Art in literature.
4. Art objects in literature. 5. Art and literature—United States—History—20th century.
6. Art—Political aspects—United States—History—20th century. I. Title.
PS228.M63S57 2011
700'.4112—dc22 2011012545

1 3 5 7 9 8 6 4 2

Printed in the United States of America
on acid-free paper

CONTENTS

ACKNOWLEDGMENTS

My fascination with modernism and its complicated commitments began as an undergraduate at Williams College. There I began to rack up debts to teachers that I cannot hope to repay fully. I especially want to thank Christopher Pye, Shawn Rosenheim, Stephen Tifft, and the late Larry Graver, who encouraged me as a first-year student in "Modern Drama" and let me go on and on about Samuel Beckett as a senior. At Oxford University, Jeri Johnson and Marilyn Butler made Exeter *the* place at Oxford to study for a second B.A. in English, and at Johns Hopkins University (JHU), Amanda Anderson, Sharon Cameron, Jerome Christensen, Brigid Doherty, Frances Ferguson, Neil Hertz, Steven Knapp, and Ruth Leys brilliantly showed me how it was done. Michael Fried has been a constant inspiration; his influence will be obvious. My biggest debt is to Walter Benn Michaels who demanded that I become a better thinker and writer than I thought I could be—a more astute, committed reader one could never have.

If this book was a hazy glimmer at Williams and Oxford, it really began to grow from a third-year paper presented in the prerenovated Gilman Hall 148 at JHU. Rachel Ablow, Dirk Bonker, Abigail Cheever, Michael Clune, Theo Davis, Anne Frey, Daniel Gil, Susie Herrmann, Amanda Hockensmith, Julia Kent, Jane Lesnick, Chris Lukasik, Larissa MacFarquhar, Tim Mackin, Hina Nazar, Deak Nabers, Davide Panagia, Shilpa Prasad, Julie Reiser, John D. Rockefeller V, James Schafer, and Maura Tumulty witnessed this project's birth cries and helped it—and me—along in ways that I cannot begin to repay. In particular, I feel incredibly honored for the friendship, intelligence, humor, and generosity of Mary Esteve, Jason Gladstone, Vicki Hsueh, and Ruth Mack.

Dartmouth College, and the English Department and Humanities Center in particular, proved to be a most felicitous spot to spend a couple of invigorating postdoctoral years, and I am grateful to both the Andrew W. Mellon Foundation and Dartmouth College for generously supporting my work. In particular, I appreciate the camaraderie and keen scholarship of Colleen Boggs, Laura Braunstein, Jonathan Crewe, George Edmondson, Ora Gelley, Alexandra Halasz, Andrew King, Thomas Luxon, Klaus Mladek, Kristin O'Rourke, Donald Pease, Louis Renza, Emanuel Rota, Ivy Schweitzer, Eleonora Stoppino, Peter Travis, and Melissa Zeiger.

I could not have been luckier than to have landed among such wonderful, encouraging colleagues at Southern Methodist University (SMU), especially in the English Department and Dedman College of Arts and Sciences. I am grateful to Angela Ards, Jessica Boon, Suzanne Bost, Rick Bozorth, Darryl Dickson-Carr, Irina Dumitrescu, Ezra Greenspan, Michael Householder, Bruce Levy, Alexis McCrossen, Dan Moss, Beth Newman, Tim Rosendale, Libby Russ, Jayson Gonzales Sae-Saue, Rajani Sudan, and Jim Zeigler, for their friendship and support. Dennis Foster, Nina Schwartz, Willard Spiegelman, and Steve Weisenburger willingly read and astutely commented on far more than their fair share of this book; their generosity and keen intelligence never cease to be inspiring. Shari Goldberg, Charles Hatfield, and the entire, motivating DFW Writing Group crew helped me whip chapters into shape, while the history guys' epic tennis matches kept me whipping backhands. My students—at JHU, Dartmouth, and SMU—urged me to clarify my ideas and provided brilliant alternative readings of their own that I wished were mine.

Over the past few years, I have presented sections of this book to various audiences, and I am exceedingly grateful for the comments, suggestions, and criticism I received from the following scholars: Charles Altieri, Jennifer Ashton, Sara Blair, Nicholas Brown, Jessica Burstein, Jonathan Freedman, Eric Hayot, Cathy Jurca, James Longenbach, Mark Maslan, John Michael, Robert von Hallberg, Erin Smith, Joe Tabbi, and Sharon Willis. The Post45 collective has been a stimulating source of new ideas; I especially thank J. D. Connor, Florence Dore, Amy Hungerford, Franny Nudelman, and Michael Szalay. Anthony Bale, Tracy Dyke Redmond, Sylvia Gross, Leta Ming, Anita Padmanabhan, Jane Strachan, Khachig Tölölyan, Ananya Vajpeyi, and Tara Watson have been far-flung friends and colleagues in body but close-knit in spirit.

For their willingness to give of their personal and professional help, I thank Michael Basinski and James Maynard at Special Collections, State University of New York at Buffalo, Tim Dean and the Humanities Center also at the State University of New York for a generous Charles D. Abbott grant to research the Wyndham Lewis archives, Paul Edwards and Helen D'Monte at the Wyndham Lewis Trust, and Melissa Watterworth at The Archives & Special Collections at the Thomas J. Dodd Research Center, University of Connecticut Libraries. I am grateful for the research support provided by the Andrew W. Mellon Foundation, Dartmouth College, and the JHU Arts and Sciences Dean's Office and English Department. In addition, the SMU Undergraduate Research Council, the SMU English Department, and the Dedman College Dean's Office graciously supported my research and writing during a sabbatical, and the General Board of Higher Education and Ministry of the United Methodist Church and the SMU Undergraduate Research Council provided additional funding to support the inclusion of images in this book.

Special thanks go to the expert editorial staff at Oxford University Press, especially Brendan O'Neill, for smoothly and swiftly guiding me through the

publishing process and masterfully creating a beautifully illustrated book, and Laura Poole, for her comprehensive work on the manuscript. Thanks to Katharine Boswell for lending her keen eyes at a crucial moment. I am also grateful to the three anonymous reviewers whose thoughtful comments and suggestions undoubtedly made this book better, even when I failed to follow their advice.

With great pleasure I dedicate this book to my large and extended family—especially my parents, Reuben Siraganian and Patricia Siraganian, and my sister, Jen Siraganian, each of whom has supported me and my work in countless ways. My daughter Isabel's zest and creativity are an inspiration and delight. While I was writing these acknowledgments she asked me if paintings die, reminding me not only of Wyndham Lewis's discussion of similar questions in *Tarr* but that modernist aesthetic queries can start young and, hopefully, stick around a while. Brian Hewitt has lived with this book nearly as long as I have, with far more grace, humor, and astuteness. I could have never done it without his love, patience, and faith in me. I only hope to repay the favor one day.

For permission to quote unpublished manuscripts from Wyndham Lewis: © by permission, The Wyndham Lewis Memorial Trust (a registered charity). Previously unpublished works by Charles Olson are copyright © University of Connecticut Libraries. Used with permission. Sections of earlier versions of chapter 1 (on Stein) and chapter 2 (on Wyndham Lewis) were published in "Out of Air: Theorizing the Art Object in Gertrude Stein and Wyndham Lewis," *Modernism/Modernity* 10, no. 4 (2003), 657–76. Material in chapter 3 appeared in "Modern Glass: How Williams Reframed Duchamp's Window," *William Carlos Williams Review* 28, no. 1–2 (2008), 117–39, and material in chapter 4 also appeared in "'A Disciplined Nostalgia': William Gaddis and the Modern Art Object," in *William Gaddis, "The Last of Something,"* ed. Crystal Alberts, Christopher Leise, and Birger Vanwesenbeeck (Jefferson, N.C.: McFarland, 2010), 101–14.

ABBREVIATIONS

AO Michael Fried, *Art and Objecthood: Essays and Reviews* (Chicago: University of Chicago Press, 1998).

BP Amiri Baraka [LeRoi Jones], *Blues People: Negro Music in White America* (New York: William Morrow, 1963).

Ch Wyndham Lewis, *The Childermass* (London: Methuen, 1956).

CP Elizabeth Bishop, *The Complete Poems, 1927–1979* (New York: Farrar, Straus, Giroux, 1983).

CP1 William Carlos Williams, *The Collected Poems of William Carlos Williams*, Volume 1, 1909–1939, ed. A. Walton Litz and Christopher MacGowan (New York: New Directions, 1986).

CP2 William Carlos Williams, *The Collected Poems of William Carlos Williams*, Volume 2, 1939–1962, ed. Christopher MacGowan (New York: New Directions, 1988).

GS1 Gertrude Stein, *Writings 1903–1932*, Volume 1, ed. Catherine R. Stimpson and Harriet Chessman (New York: Library of America, 1998).

GS2 Gertrude Stein, *Writings 1932–1946*, Volume 2, ed. Catherine R. Stimpson and Harriet Chessman (New York: Library of America, 1998).

I William Carlos Williams, *Imaginations*, ed. Webster Shott (New York: New Directions, 1970).

M Charles Olson, *The Maximus Poems*, ed. George F. Butterick (Berkeley: University of California Press, 1983).

OPo Charles Olson, *The Collected Poems of Charles Olson*, ed. George F. Butterick (Berkeley: University of California Press, 1987).

OPr Charles Olson, *Collected Prose/Charles Olson*, ed. Donald Allen and Benjamin Friedlander (Berkeley: University of California Press, 1997).

R William Gaddis, *The Recognitions* (1955; New York: Penguin, 1985).

RL Wyndham Lewis, *The Revenge for Love*, ed. Reed Way Dasenbrock (Santa Rosa: Black Sparrow Press, 1991).

TWM Wyndham Lewis, *Time and Western Man*, ed. Paul Edwards (Santa Rosa: Black Sparrow Press, 1993).

Modernism's Other Work

Introduction

cʌɔ

Meaning's Work

This book challenges deeply held critical beliefs about the meaning—in particular the political meaning—of modernism's commitment to the work of art as an object detached from the world. Ranging over works of poetry, fiction, painting, sculpture, and film, I argue that modernism's core aesthetic problem—the artwork's status as an object and a subject's relation to it—poses fundamental questions of agency, freedom, and politics. I hold that these political questions have always been modernism's critical work, even when—indeed, especially when—writers such as Gertrude Stein, Wyndham Lewis, and William Gaddis boldly assert the art object's immunity from the world's interpretations. In the process, the book sets out to upend our understanding of relationships between aesthetic autonomy and politics, relationships that long have been misunderstood in critical studies of modernism. Theodor Adorno's theorizing notwithstanding, modernist aesthetic independence is too often derided for its political obfuscation and elitism. *Modernism's Other Work* disputes this narrative, expanding the political framework for modernist studies in an altogether different direction than Frankfurt School theorists envisioned. I examine what a range of writers truly meant by autonomy and how its operation was conceived simultaneously and deliberately as an aesthetic and political act. The paradox of their accounts of autonomy is at the heart of this work.

We can begin to see this conception in Wallace Stevens's response to questions asked in 1934 by the editors of the left-wing journal *New Verse*: "Do you intend your poetry to be useful to yourself or others?" He initially affirms the most conventional account of aesthetic autonomy: "Not consciously. Perhaps I don't like the word *useful*."[1] Yet in responding to the very next question, "Do you think there can now be a use for narrative poetry?" he reverses himself, admitting poetic use with the caveat that the heroic poet leads the way: "There

can now be a use for poetry of any sort. It depends on the poet."[2] These contradictory statements suggest one reason that Stevens serves as a cipher for both formalists (Helen Vendler) and Marxist critics (Alan Filreis). Stevens's writing alternately purports a notion of the autonomous art object and then questions the very premise of that autonomy by declaring poetry's use in the world. The ambivalence long observed in Stevens's "Anecdote of the Jar" (1916) might be framed similarly.[3] On the one hand, the speaker depicts his placement of a manmade artifact utterly removed from the laws of nature ("It did not give of bird or bush"), "round" and self-contained like the quintessential organically unified art object. On the other hand, the jar is open enough to the atmosphere of that world ("of a port in air") such that its mere presence transforms nature into slovenliness. "Gray and bare" instead of lushly abundant, the jar is seemingly immune from nature's order while it is accessible enough to the "air" to order nature in a different, cultural sense.

Such paradoxes about art's independence and agency do not signal radical uncertainty but instead a refashioning—by Stevens and others—of what autonomy and poetic use can and should mean. Autonomy from the world was never, for the modernists, a failure of relation to it. Throughout this book, we shall see how an art object's autonomy means not liberation from the whole world but freedom from others ascribing meanings to art objects. I explore how modernists characterize and put into practice their aesthetic commitments in a variety of linguistic forms enabling and supporting a range of worldly commitments. In particular, the reader's or viewer's relation to the art object became a way to envision the political subject's ideal relation to a changing, rejuvenated, but essentially *liberal* state at a time when the discourse of threatened autonomy pervaded both high and mass culture.[4] The freedom of the art object not from the world generally but from the reader's meaning specifically presents a way to imagine an individual's complicated liberty within yet enduring connection to the state. Autonomy and threats to autonomy, particularity and universality, detachment and incorporation are all treated in light of liberalism's perceived promises or failures.

By connecting literary undertakings to conversations about aesthetics, visual arts, and politics, a new way of thinking about modernism's commitment to its spectators and readers, political issues, and technological innovations becomes available. In reexamining poetry's particular attention to collage, breath, and air as an ontological problem about beholding, the book theoretically and polemically rethinks the major twentieth-century debate on aesthetic autonomy—the notion that art is fundamentally removed from and even at odds with the world. It does so by selecting from major texts of the long modernist era (1914–75), including literature, archival documents, and visual materials, thus providing a new literary critical and historical account of the text's imagined frame.[5] In the process, we see changes to our conventional accounts of twentieth-century literature's periodization. Not pre-1945

versus post-1945, not modernism versus postmodernism. Instead, post-modern debates pitting textual experience against textual representation emerge from unexpected modernist antecedents. Simultaneously, writing habitually labeled postmodern *avant la lettre* (that of Stein, Lewis, and later, Elizabeth Bishop and Gaddis) will be seen to work as a different version of high or aesthetic modernism, one at odds with stereotypical accounts of the modern art object's independence.

I start with poetry's relation to the art object—and collage in particular—because American poets articulate their relation to the art object through sophisticated responses to modern painting. As Stevens claims, "Poets must often turn to the literature of painting for a discussion of their own problems."[6] When twentieth-century writers discuss the "problems" of the art object, they often disregard distinctions between genres or media, between readers and spectators and, frequently, between different kinds of readers or different forms of spectatorship. In making this point, I want to be clear that I am not seeking to duplicate their method by ignoring the fundamental interpretive differences between different media and genres, between the work a reader does (often in a quiet, private, or domestic space) and the work a film viewer or painting spectator does (often in a louder, public, institutional, or commercial space).[7] Elizabeth Bergmann Loizeaux discusses how ekphrastic poetry negotiates between these various communities by focusing on the different relations between poet, spectator, and reader in poems that address a work of art, thus establishing the importance of the audience/spectator's role to modernism and postmodernism.[8] My study, in contrast, does not focus primarily on ekphrastic texts precisely because many writers abstracted aesthetic problems so they could more carefully translate them into the specific requirements of their medium. The writers I discuss blur and borrow between genres and media to forge a clear ideological goal: to illuminate an abstract debate about the relevance of the material world—in all its historical complexity and specificity—to art objects. Through a series of forays into the problem of modernism's commitment to the detached art object, I map an evolving and expanding debate about the spectator's or reader's role that eventually extends beyond any single genre, medium, or nation, becoming more fully globalized by the twentieth century's close.

To produce such a map, the book tracks two distinct understandings of the spectator's relation to the art object to reveal debates about the politics of detachment or incorporation. The first posits the irrelevance of the spectator to the meaning of the artwork, and the second posits the necessary involvement of the spectator in the production of the art object's meaning. Thus, the book begins by exploring the idea that a work's meaning can be separated from the reader's job in the productions of Stein and Lewis. As Stein puts it, "An Audience is pleasant if you have it, it is flattering and flattering is agreeable always, but if you have an audience the being an audience is their business,

they are the audience you are the writer, let each attend to their own business."[9] I discuss various articulations of this idea—that is, the notion of "meaning's autonomy," a phrase I use to distinguish my account from "aesthetic autonomy," the conventional depiction of art's removal from society. Because the focus on meaning's ontological status as opposed to its semiotic operations can seem counterintuitive, I explain this argument in detail, exploring the ramifications of the audience's imagined irrelevance. Gradually, the second account of spectatorship overtakes the first, as we explore the diametrically opposed, postmodern notion of "meaning's incorporation"—the idea that an art object's meaning inextricably relates to the reader's breath and thus her body—in the work of an artist such as VALIE EXPORT, and poets ranging from Charles Olson to contemporary writers Amiri Baraka, Juliana Spahr, and Leslie Marmon Silko. In discussions of the work of Mina Loy, Marcel Duchamp, William Carlos Williams, Vincente Minnelli, Gaddis, and Bishop, I illustrate the range of attempts to negotiate between the major opposing positions of spectatorship: the art object's immunity from the audience's interpretations, on the one hand, and the audience's relevance to the art object, on the other.

Modernism's Other Work, then, has three overlapping goals. First, by recovering an aesthetic dispute about the role of spectators or readers to a work's meaning, one long obscured by New Critical and poststructuralist orthodoxies, the book contends that the supposed antagonism between aesthetic autonomy and politics misrepresents the modernist ontology of the art object, albeit in a manner diverging from Adorno's account. In 1984, Peter Bürger reiterated the received wisdom when he defined aesthetic autonomy as "art's apartness from society," following the model of late-nineteenth-century Aestheticism.[10] But six decades earlier, modernists like Stein and Lewis defined the autonomy of art as the independence of art's *meaning* from a spectator's interpretations. This distinction creates the possibility for a discussion of politics out of a theory of beholding or reading, as autonomous art objects are imagined not as distinct from the world generally but distinct from spectators or readers particularly. All of the writers I consider in the book—both those arguing that meaning must be incorporated into art through breath and bodies and those rejecting this idea—conceive of art objects in simultaneously formal and political terms and insist on the trope of breath and bodies to do so. Second, the book explores how modernism anticipates in sophisticated and unexpected ways a post-1945 debate about art objects' relation to the world. Although my aims are not primarily theoretical, understanding the earlier dispute complicates later discussions about site-specific art and post–September 11, 2001, political poetry, as well as the post–World War II literary theories (reader response, poststructuralism, cultural studies) that aim to certify the role readers play in a text's meaning. Finally, *Modernism's Other Work* fundamentally realigns our conceptual map of modernism, shifting away

from modernism as a self-referential critique of realism—where art "becomes its own subject," as Arthur Danto puts it—to modernism as a debate about the relevance of spectators or readers to a text's meaning.[11] Instead of understanding modernism as a problematic relation between an object and its representation, modernism stands revealed as a conflicted, repeatedly renegotiated relation between the art object and its beholder that continues into the twenty-first century.

BREATHING COLLAGE

"[Meaning] all depends on inter-play" writes Stevens in a draft stanza of *The Man with the Blue Guitar* (1937), as he attempts to foresee—if not control—the "final atmosphere" for his poetry by rethinking his role as a poet in the world and reframing the ontology of poetry in relation to economic and political factors.[12] He suggests that the art object's independence is a complicated, contingent quality with limitations and worldly repercussions. By describing literary interpretation as "the final atmosphere," Stevens invokes a surprisingly common trope within modernism—invisible air—to discuss questions of beholding and meaning. We see this trope in Marcel Duchamp's allegedly final readymade, *50cc of Parisian Air* (1919), which also takes air as its subject matter, challenging our sense of how little an art object can be or mean (figure I.1). Duchamp's work consists of a glass ampule that he instructs a Parisian chemist to hermetically seal, in the process trapping 50cc of air—a tiny "breath" of Paris under glass. Alluding to Paris's formative role in the development of Impressionist, en plein air painting, he implies that Parisian air is qualitatively distinct and more valuable than air elsewhere. By measuring out a small, scientific quantity of a substance seemingly and hopefully in endless supply, he transforms an overlooked resource into a rare and precious element, particularly evocative for an artist displaced from his homeland by war and political instability.[13] But we can expand on his point. Privileging a volume of air, or any particular substance captured and named by the artist—a piece of newspaper or a scrap of wallpaper in a collage, a breeze wafting through an empty jar in Tennessee—transforms the way we think of that "object," whether as a work of art or as a thing in our physical world.

The lively modernist debate over the spectator's irrelevance to the art object's meaning often emerges here, around this unlikely topic of air, and, more specifically for poets, inhaled air. We can glimpse the outlines of the debate by comparing Stein's and Olson's respective attitudes toward the spectator's or reader's breath. In works as early as *Tender Buttons* (1914) and as late as *Lectures in America* (1935), Stein notoriously refuses the use of punctuation, insisting that commas are unnecessary because they let "you stop and take a breath but if you want to take a breath you ought to know yourself that you want to take a breath"

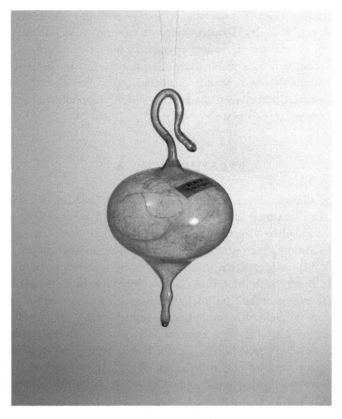

Figure I.1 Marcel Duchamp, *50cc of Parisian Air* (1919). © 2010 Artists Rights Society (ARS), New York /ADAGP, Paris/Succession Marcel Duchamp. © The Philadelphia Museum of Art/Art Resource, New York.

(*GS2* 320–21). She is claiming that commas are extraneous—possibly even detrimental—because they impinge on the reader's freedom to breathe on her own and not where the author declares that you must inhale while reading a text. Her texts, she suggests, are free of such physical prompts. Decades later, in his seminal essay, "Projective Verse" (1950), Olson argues that "verse will only do in which a poet manages to register both the acquisitions of his ear *and* the pressures of his breath" (*OPr* 241). Poets should mark down their breathing pattern so the reader can replicate it while reading the poem. Olson expands this idea into a political program: he regards bringing in immigrants' breath (with himself as the triangulating administrator), as honoring their personhood and providing the groundwork for political representation. Stein insists that the reader's breath is a matter of self-determination and should be kept out of the text, whereas Olson insists that the writer's breath is part of the poem and must be brought into the text for completeness. Nonetheless, both Stein and Olson understand

their divergent positions on the presence or absence of breath in their texts to have political consequences out in the world.

We might wonder why Stein and Olson concentrate on the nexus of breath, readers, and—of all things—political rights. When Stein claims that breathing relates to the reader's free will, and Olson connects breathing to the fundamentals of poetic meaning as a new force in democracy, neither exactly argues about the intricacies of performative stylistics or effective declamation. Nor are they discussing the thorny issues of personal voice and historical subjectivity, familiar from Eliot's claim that poets must extinguish their personality from a poem. Instead, both Stein and Olson use breath and air to express an essential relation between the literary text and its reader, while explicitly echoing the fundamental issue of determining freedom within liberalism. They do so during a historical period when aesthetic and political autonomy seemed threatened by a variety of forces (i.e., the rise of the bureaucratic state, fascist and imperialist dynamism abroad, corporate culture). For each writer, breath and air immediately invoke a set of relations between objects and subjects that dramatizes political life under these transforming conditions, even though they fundamentally disagree on how this relation works and how politics emerges from it. More specifically, the issue of breathing while reading emphasizes the physicality of a person's body in the world in relation to textual objects with meaning, enabling Stein and Olson to discuss materiality, literality, and particularity in relation to their writing, to meaning, and to the reader's role in the world.[14] From these local discussions of poetics, an account of micropolitics emerges: bodily liberty for Stein, minority representation for Olson. She imagines her breathless poetry emancipating readers; he imagines his breath-filled poetry giving readers of divergent backgrounds a representative voice they might not have possessed otherwise.

Focusing on breath or air undoubtedly feels like an odd way to conceptualize a relation between objects, readers, and liberty or equality. Although the air you breathe right now cannot be in anyone else's lungs simultaneously, it is difficult to conceive of an invisible substance as a literal thing in the world; one point of Duchamp's *50cc of Parisian Air* is to manifest that unusual experience for us. It is also hard to imagine how something as ever present as air could easily signify particularity, as does an individual's breath for Olson when he attempts to capture it in a projective poem. But the idea of taking samples of common worldly substances and having them signify differently within a text makes more sense when we relate it to another discussion, occurring nearly simultaneously, in the medium of painting. With the development of collage in the early part of the twentieth century, painters pasted ordinary, often mass-produced real-world objects next to paint on a canvas, prompting the question of how exactly a thick rope or a piece of oilcloth printed with trompe l'oeil chair-caning belongs in and relates to a complete work of art such as Pablo Picasso's *Still Life with Chair-Caning* (1912) (figure I.2). In addition to traditional

oil paint, this oval canvas supports a piece of oilcloth printed with trompe l'oeil chair-caning, paper, and—around the canvas's edge—a thick rope.[15] Taking a breath into a poem is like the taking of an object into a painting because, in both instances, including a literal "thing" in the world—air, newspaper, and so on—is intended as an act of signification altering the work as a whole. What the act or the thing signifies is another matter.

In the case of collage, critics have long debated whether these literal elements are scraps of the real, satirical symbols of mass production as cultural degradation, parodies of illusionism, strategies aimed to solve a formal puzzle about the picture plane's flatness, or attempts to destabilize the basic doctrines of painting. The debate has evolved with the last two possibilities squaring off, with collage either subjecting the heteronymous news of the day to the formal coherence of the work of art or presenting a radical alternative to the modernist tradition, one that critiques representational unity as well as art history's apotheosis of the decontextualized art object.[16] The rope in *Still Life with Chair-Caning* dramatizes this interpretive dilemma: either it signifies as part of an integrated representation of an ordinary domestic object (a tablecloth) that happens to be mounted on the wall, or it is intended as a parody of a painting frame, mocking the act of tying up or binding the work together

Figure I.2 Pablo Picasso, *Still Life with Chair-Caning* (1912). © 2010 Estate of Pablo Picasso/ Artists Rights Society (ARS), New York. © Reunion des Musees Nationaux/Art Resource, New York.

as a unified whole.[17] These conflicting options have been seen to exemplify an unstable binary of two contradictory models of spectatorship, neither of which supersedes the other.[18] Resembling Jacques Derrida's insights about the operations of framing in *Truth in Painting*, the rope demonstrates (in Christine Poggi's words) "the failure of the ground to hold, of the frame to enclose, and of the forms to signify a unified reality."[19] For like-minded critics, the presence of the rope and its two potential meanings signifies that the painting's frame no longer convincingly separates art from the world, undermining any hope for aesthetic autonomy. Once the frame fails to distinguish text from context, the work's self-sufficiency—its ability to hold the world at bay on the other side of the rope—would be irrevocably lost.

This deconstructive interpretation of collage as the collapse of the frame's conceptual integrity and thus a failure of aesthetic autonomy proved irresistible. By the 1990s, art historians interpreted Picasso's collage works as representing the postmodernist tradition in its early phrase, and literary critics quickly followed, taking up poststructuralist interpretations of collage in relation to the unsteadiness of the sign within literary modernism.[20] From their perspective, modernist poets influenced by Cubism were particularly attuned to an early form of postmodernism.[21] By incorporating a theory of collage into their own poetry, modernist writers seemingly spurred the transformation of modernism into postmodernism and of aesthetic autonomy (art versus the world) into heteronomy (art and the world).[22] Although this prevailing view of the relationship between modern literature and collage still dominates modernist studies today, it fails to explain the strange nexus of breath, autonomy, collage, and politics we have begun to trace. Throughout the book I make the claim that collage, as interpreted by a wide range of modernist writers and artists often through the unexpected trope of breath and air, looks surprisingly different from the received account just outlined.[23] In each instance, the difference between my account of this episode in modern art and the standard one is crucial to the untold history of meaning's autonomy.

Writers such as Stein and Williams, for example, argue that collage presents a hopeful promise of a frame that can transcend its various challenges, instead of seeing the problem of collage as instantiating an unstable binarism, throwing into disarray the logic of the frame or center and making aesthetic autonomy impossible. Describing the possibilities of modern art, Stein wonders, "Does an oil painting tend to go back into its frame because after all an oil painting belongs in its frame. Or does it not. It does and does not" (*GS2* 240–41). Frames, she suggests, can be simultaneously conceptual (like the rope that represents the edge of the painting) and literal (like the rope that represents the edge of the table). Paintings extend beyond their physical frames when literal objects are attached to them, and paintings "belong" in their frames as autonomous works of art because the entire collage, despite the varied origins of its component parts, represents an artist's unique

intention. This dualism does not deconstruct the frame—that would be Derrida's argument, which she both anticipates and rejects—but points to the need to eliminate the literal frame in modern art.[24] She repeatedly performs this move in her poetry by eliminating the punctuation marks (which she interprets as a kind of literal frame around a word) that might impinge on the reader's bodily freedom while reading.

This variant of modernist aesthetic autonomy appears most clearly outside the confines of literary studies, decades after many of these writers have begun their theorizing. Indeed, the question of the relationship between art objects and beholders finds its sharpest articulation in the 1960s art world, and Michael Fried's theorization of spectatorship at this moment is central both to these discussions and to my arguments.[25] In his seminal essay "Art and Objecthood" (1967), Fried foregrounds the relationship between the art object and its beholder through the notion of "objecthood," the overwhelming physical and literal presence of the work of art. Noting the escalating dominance of the physical object in contemporary art, Fried argues that the central struggle in modernist painting through Jackson Pollock was to "undo or neutralize objecthood" (*AO* 41). In contrast, the 1960s Minimalist art of Tony Smith, Robert Morris, and Donald Judd provides spectators the experience of objecthood: a heightened experience of the object in its installation space (*AO* 40). Instead of defeating objecthood, Minimalist art relishes its literality by establishing the spectator's experience as the essential part of a work's meaning (*AO* 153). "Art and Objecthood" sensed the beginnings of what is now a virtual orthodoxy: the spectators' increasingly significant role in post-1960s art.[26]

To take just one recent example: the walk-in kaleidoscopes and climate rooms of Olafur Eliasson's "Take Your Time" retrospective at the San Francisco Museum of Modern Art (2007) created situations demanding physiological responses from the viewer and relied on those responses to make their meaning. One installation, *Beauty*, consisted of luminous and colorful undulations of sprayed mist that the viewer not only observed but also felt against her face and inhaled in her lungs in a dark room lit only by one faint spotlight (figure I.3). The often involuntary nature of your response to such a work, which depends on physiological and optical games that require the experience of your reflexive, breathing body (hence, "tak[ing] your time" from you), makes clear that altering the spectators' sensorium is one of Eliasson's primary aims. "I see potential in the spectator," he writes, "in the receiver, the reader, the participator, the viewer, the user."[27] Where Fried sees confirmation of objecthood, Eliasson inhales *Beauty* into his body. Moreover, artists, poets, and critics who promote art as the full experience of the sensorium tend to supplement their view with an account of high modernism as arid and suffocating, void of sensory delights. As contemporary poet Brenda Hillman pithily writes, poking literal gaps into her sentences that might be filled with the

Figure I.3 Olafur Eliasson, *Beauty* (1993). Installation at *Minding the world*, ARoS Århus Kunstmuseum, Denmark, 2004. Photo: Poul Pedersen 2004. Courtesy the artist; neugerriemschneider, Berlin; and Tanya Bonakdar Gallery, New York. © Olafur Eliasson.

discerning sniffs of a reader, "Past modernisms, a library smells spicy."[28] Because modernism supposedly refused the full experience of air—the full visual, olfactory, sensory experience of Eliasson's *Beauty*—these artists and writers aim to reach back to what "modernism smell[ed] like" (in the words of art historian Caroline Jones) to detect the air-filled sensory experiences modernism supposedly rejected or denied.[29]

Quickly we shall see the problems with this account. Modernism, I am arguing, evoked breath and air to talk precisely about autonomy and invoke a person's varied freedoms, not to deny the body and its sensory experiences. If the question of the beholder's direct, physical function with respect to the meaning of an art object—whether that beholder is a receiver, reader, participator, viewer, or user—arises most clearly and dramatically in the 1960s and after, the following chapters show that these questions do not emerge sui generis in the postwar art world.[30] The same concerns about objecthood, beholders, and the role of experience to the artwork emerge in sophisticated ways during the heyday of literary modernism in the first half of the twentieth century.[31] Duchamp's *50cc of Parisian Air* is not a collage in any technical sense, but we might return to this work by thinking of it as collage's conceptual endgame, the bare minimum of painting (just as a urinal restaged as *Fountain* was the bare minimum of sculpture). He instructs a pharmacist to craft it instead of making it by hand, using air as the "collaged" element and the round glass ampule as the equivalent of a "support." This pared-down, largely conceptual object, more than any other, captures what collage means to the writers treated in this book. The discourse of air and breath enable them to transmute the physical world collage exemplifies into the language and realm of literature. Just as *50cc of Parisian Air*—and collage more generally—challenges us to reconsider our relationship to the represented air or atmosphere of a painting, so writing that either refuses to incorporate air and breath (Stein's) or actively attempts such incorporation (Olson's) signifies another way to think about the relation between our bodies, our texts, and the world.

Although Fried's "Art and Objecthood" does not explicitly explore the political ramifications of the spectator's involvement in, or removal from, art, one of my book's contentions is to show how extensive these issues of spectatorship and politics were throughout the entirety of the twentieth century and beyond, although rarely in ways critics, focusing on modernist distraction and new technology, have described. Modernist writers explore these political consequences passionately, carefully, and often quite variously. I attempt to untangle—and reconnect in new ways—their various accounts. Despite their radically different positions, all of the writers I discuss suggest that their positions on the role of spectatorship have political ramifications for some form of liberalism (whether progressivism, cosmopolitanism, or what would now be considered libertarianism). I explore exactly what it might mean to think of a

commitment to meaning's autonomy—the beholder's irrelevance to an object's meaning—to challenge usual binaries as signposts to modernism. Perhaps the old, vilified account of aesthetic autonomy (the art object's removal from life praxis) is too quickly accepted as a master construct, and the alternative of meaning's autonomy (the art object's immunity from the reader) is overlooked precisely because it troubles many conventionally opposed terms familiar to modernist discourse—political engagement versus aesthetic autonomy, mass culture versus high art, liberalism versus libertarian conservatism.

THE MISUNDERSTOOD POETICS OF AUTONOMY

We have seen how writers began adapting the discourse of modern collage to think about aesthetic autonomy in a different way, one unrecognized in critical accounts. The claim that aesthetic autonomy has been misunderstood is an argument as old as modernism itself. Here, I want to suggest why, in presenting a version of this idea, this book makes a new and different claim. The most compelling alternative histories of modernism—proposed first by Adorno and fueling the turn to the cultural and political within modernist studies—challenge the opposition of art and politics to unveil the hidden ideological commitments or, sometimes, the subversive possibilities of modernist aesthetics.[32] The recent turn to cultural objects within the new modernist studies relies on these insights to challenge the "great divide" between mass and high culture in modernity, often to suggest that autonomy was not as crucial or universal to modernism as was formerly understood.[33] However, while decrying the elitism and conservatism of modernist ideology, an aversion to all things New Critical has left certain orthodoxies, such as the actual workings of aesthetic autonomy, less examined.[34] Paradoxically, theorists of modernism tend to maintain New Critical definitions as accurately portraying modernists' own conception of autonomy, effectively reproducing the misrepresentation of the modernist aesthetic object.[35] In the process, what I call meaning's autonomy—the notion of the art object's immunity from the audience's response—has been historically and critically misrepresented, first by the New Critics and then by successive generations of literary critics who failed to distinguish between radically different notions of aesthetic independence.

Interpretations of T. S. Eliot's account of poetic autonomy are a case in point. The New Critics' particular version of aesthetic autonomy employed Eliot's assertion of poetry's unique identity and "integrity" with his claims that poetry does not contain moral-political commands.[36] But the notion of an aesthetically autonomous art entirely removed from politics is not exactly Eliot's position in the 1928 preface of *Sacred Wood*, in which he admits that "poetry as certainly has something to do with morals, and with religion,

and even with politics perhaps, though we cannot say what."[37] Unlike William Wimsatt and Cleanth Brooks's textbook definition of aesthetic autonomy as poetry "draw[ing] off by itself" and setting up "its own kind of intrinsic worth . . . apart from, and perhaps even in defiance of, the rival norms of ethics and politics," Eliot declares the relationship between poetic form and extrapoetic concerns as existent but essentially unknowable and inaccessible, free from demonstrable interpretations.[38] He later varies this idea, presenting it more psychologically and religiously as "literature which should be *un*consciously, rather than deliberately and defiantly, Christian" (emphasis in original).[39] *Modernism's Other Work* explores the gap charted by Eliot's italicized "*un.*" Therein lies the small but critical distinction between the New Critics' notion of aesthetic autonomy as promulgated in the 1950s and Eliot's notion of meaning's independence from inquisitive interpretation, between "in defiance of" the moral and political world on the one hand, and being separate from but still "hav[ing] something to do with" that world on the other.[40]

Adorno, responsible for the other dominant account of modernist aesthetic autonomy, takes a similar attitude to the distinctiveness of the art object from society but finds in this very difference an unexpected connectedness to the world, thereby undermining its own separation. Thus, in "On Lyric Poetry and Society" (1957), Adorno imagines the demand for the lyrical poem's autonomy in the postauratic world as itself a social need, one that "implies a protest against a social situation that every individual experiences as hostile, alien, cold, oppressive, and this situation is imprinted in reverse on the poetic work."[41] The more the work refuses to mention society, the more it depicts the unspoken world as a resistance to society. In its refusal to submit to the world's heteronomy, the work becomes politically relevant. But in this manner, the poem speaks out of both sides of its mouth simultaneously: as an individual, autonomous (organic) art object that is also critiquing the world for its false consciousness. Later in the essay, Adorno explains that this paradox stems from the inherent doubleness of language as a medium, which both "assimilates itself completely into subjective impulses" while remaining "that which establishes an inescapable relationship to the universal and to society."[42] Robert Kauffman provides insight on the problem when he explains that attention to form "is extended into the social and back again," whereas the art work is considered, after Benjamin, "as part of a constellation or force field [Kraftfeld] that obtains through a series of complex relationships between the work and the social" instead of a wholly independent object.[43] But whether Adorno invokes language's doubleness or Benjamin's force field, a strict account of autonomy fails once it is split apart by language or reattached to the social as part of a constellation (a form competing with the aesthetic).

Adorno's argument is instructive because it illuminates precisely how Stein's and Lewis's version of meaning's autonomy avoids both his and the

New Critics' dilemmas.[44] For Adorno, as for the New Critics with the affective fallacy, autonomy does not mean immunity or irrelevance to the social world but resistance to the social world—to either bourgeois culture (in Adorno's account) or emotive, untrained readers (in Wimsatt and Bearsdley's). If the work is actively rejecting, holding off, or refusing the heteronomous world—instead of simply declaring that world irrelevant to its meaning—then autonomy has already failed. In the act of making a judgment on the social world of the bourgeoisie or the flawed reader, the art object repositions itself in and of that world.[45] As Adorno puts it, "the lyric reveals itself to be most deeply grounded in society when it does not chime in with society."[46] But the modernists I discuss have a very different account of how autonomy works because they are rarely committed to the art object's resistance to or rejection of society; instead, they believe that the art object remains immune from society's *meaning*.[47] The difference is crucial. For these writers, autonomy, defined as the spectator's or reader's irrelevance to the meaning of the art object, produces something closer to a parallel political world, an account of the art object's freedom from readers that reflects a relation to the liberal political world in a fully allegorical, symbolic way, without the worry of mimetic accuracy and without the ideological critique Adorno demands from artistic greatness.

To reiterate, if the art object according to Adorno has no choice but to speak from within the structure of its aura-bereft, commodity status (and from this and only this position might it be able to resist capitalist culture), the version of aesthetic autonomy I depict exemplifies something quite different: a detached relationship not to the art object but to the art object's meaning. In certain ways, this distance resembles a Kantian account of political autonomy, where you may act freely following self-imposed laws but you still are tied to the world's varied, inescapable forces. The same paradoxical language of imperviousness and entanglement permeates discussions of meaning's autonomy within modernism, whether those discussions are framed as a poetics of beholding or as a micropolitics. The commitment to an art object as having a distinct meaning irrespective of any particular reader's correct or incorrect interpretation of that meaning is understood by Stein and Lewis to parallel a commitment to the classical liberal subject, whereas the critique of meaning's autonomy I discuss in the last section of the book maps onto the communitarian critique of the liberal subject in the work of Charles Taylor, Michael Sandel, and Judith Butler.[48] For these theorists, because classical liberal autonomy cannot account for commitments we did not choose, and because there are already far too many heteronomous actors involved, autonomy is ultimately an impossible goal. The poetics of meaning's incorporation in the work of Olson, Baraka, and Spahr follows a similar set of claims. In their poetics of communitarianism, meaning must heteronomously include readers—and readers' bodies—making meaning.

To locate this transition in meaning from the poetics and politics of detachment to that of incorporation, consider William Carlos Williams's lecture supporting economist C. H. Douglas's social credit theory, in which he argues that social credit would undermine the credit monopoly of big business while avoiding Marxist dogma and protecting civil liberties, becoming liberalism's golden middle way.[49] Although Williams is hardly well known for his economic theories (that was Pound's territory), his precise formulations in this text display an often-overlooked understanding of the relation between art and a political philosophy, as he suggests that poetry is a kind of aesthetic work that is simultaneously historical-political:

> [The artist] must admit all classes of subject to his attention, even though he hang for it. This is his work. Nothing poetic in the feudal, aristocratic sense but a breaking down, rather, of those imposed tyrannies over his verse forms. Technical matters, certainly, but most important to an understanding of the poet as a social regenerator. The facts are enclosed in his verses like a fly in amber.[50]

In this intricate and even contradictory description of his poetics, what looks like a political declaration of his right to incorporate controversial or forbidden material "even though he hang for it," morphs into a declaration of the artist's right to innovate formally. His "work"—a capacious term—breaks down "imposed tyrannies over his verse forms." The use of "tyrannies" is also complicated: although seemingly alluding to political coercion, the next phrase, "over his verse forms," refers to oppressive literary conventions. Disputes over literary form—between convention on the one hand and innovation on the other—are "technical matters" that illuminate a far more vital power in the poet, revealing him as a "social regenerator" who operates simultaneously as a force of destruction and as the protective illuminator of society's future evolution. Most strangely, by identifying and representing valuable details, Williams catches the "facts" of the world in the "amber" of poetry, a glowing, translucent ooze hardening over time. A physical barrier separates the reality of the trapped "fly" from the world of poetry readers and spectators who inspect it. The fly is both a palpable reality from our world— like one's breath—and, once trapped in the poem's impregnable amber, a truth protected from the world's spectators—a real toad in an imaginary garden.[51] Despite the peculiarity of this analogy, the same connections between political rights and artistic freedom, and between factual reality and poetic form, regularly appear in statements of Williams's poetics.[52]

Exploring these paradoxes throughout the lecture, Williams suggests that social credit theory permits the artist to do "technical" or formal work creating poetic forms that have nothing to do with government, society, or accumulating wealth, while simultaneously those independent forms allow his innovative poems to enclose "facts" that will regenerate society: "Not seeking to compete

with the great formulators of ideas, (the Cushing journals, the voluminous Veblen's and others) of his day he, the poet, at his best will see and enclose in the hard nut of the fruit, in the invention of his forms, the whole contemporary history."[53] Unlike Adorno, whom Williams at this moment might seem to anticipate, he is not implying that the aesthetic object is "wholly individual" from society, since it deliberately incorporates history in its nuts, the world's flies in its poetic amber.[54] Nor is he suggesting that the art object can undermine the status quo of liberal society through avant-garde ideological critique. Williams's notion of poetry is too invested in making contact with the everyday world, whereas his aesthetic position implies the potential for political change in an improved but not radically altered society. Yet his understanding of the art object stands squarely in the middle of an aesthetic and political debate of the period: the art object is paradoxically part of but in other ways shielded from the world (like a nut protected in a hard shell), while that same art object exemplifies the rejuvenated political relationship between individuals and the liberal state he yearns for. Although this account in part resembles other recognized descriptions of autonomy—Adorno's or the New Critics' (and more recently, Peter Bürger's and Pierre Bourdieu's)—here we can see how the modernist autonomy I am identifying differs from theirs in critical ways that remain unexplained in standard accounts of the period and its aesthetics. Aesthetic autonomy for Adorno exemplifies political protest; for Stein, Lewis, and Williams, autonomy was understood as the art object's freedom from the *reader's* meaning and exemplified the subject's desired relation to political liberalism.

In other words, modernists like Williams often ignore or refuse ideological critique while simultaneously claiming that art exemplifies a political relation. It is in use and concrete relation that the politics emerge, not in ideological analysis or theory. While avoiding the contradictions in Adorno's account of art, they face different problems. In his challenge to Adorno, Peter Bürger argues that when organic (autonomous) works of art attempt to incorporate political or moral concerns, they invariably subordinate them to the unity of the whole because the institution of art neutralizes the work's political content.[55] Challenging the usual association between modernism and aesthetic autonomy, he locates a separate and distinct avant-garde movement within what is usually categorized as modernism (primarily in Dada) that bucks the trend toward organic form, breaking the frame and working to eradicate the boundary between art and everyday life in a political act.[56] Only by rupturing the distinction between art and the world did the historical avant-garde achieve the political, he argues, in an act that cannot be repeated successfully. As should be clear by this point, the writers discussed here simply were not avant-garde in these restricted terms (although they surely were in more catholic accounts); they did not feel that the political could be achieved by rupturing the distinction between art and life. Political "content" was not intended as a part of their work but as a model intended to be experienced in

the relation of the reader or spectator to the whole—to what Bürger describes as the organic, autonomous work of art. Whereas the European avant-garde has been understood as the true "prehistory" of poststructuralism and ideology critique, the causal connection between the American moderns and theory becomes far less certain than theorists of modernism have hoped.[57]

Polemical interest in the modernist aesthetic object—particularly in its relation to postmodern art, literature, and politics—remains vital and ongoing.[58] At the same time, these studies tend to be particularly interested in teasing out distinctions between earlier forms of autonomy in contrast to postmodern versions of autonomy or postmodernism broadly conceived.[59] Inadvertently, a distinct account of modernist autonomy has been lost. *Modernism's Other Work* substantially challenges this vital discussion and omission, fundamentally rethinking the conventional account of the art object's ontology to expand the political framework of modernist studies and beyond. From the very start, modernist autonomy was a fascinating compromise between poet, poem, and reader that enabled modern poets to resituate themselves, and their texts, in the world. My account does not seek to displace, undermine, or restore autonomy as an aesthetic truth (à la New Historicism, Deconstruction, and New Criticism, respectively) but to historicize the term conceptually within a twentieth-century cultural and theoretical debate, transforming our understanding of both modernism and postmodernism in the process.

FROM MEANING'S AUTONOMY
TO MEANING'S INCORPORATION

When Gertrude Stein realizes that despite her love of fresh air and the outdoors, her love for painting has nothing to do with that air ("There was no air, there was no feeling of air, it just was an oil painting and it had a life of its own"), she is insisting on a distinction between the literal world outside and the world inside the painting that is entirely opposite to the aesthetic and political position of incorporation that Olson and Baraka later take. For Stein and like-minded writers, the independent meaning of the art object always takes priority. In chapter 1, we explore how Stein proposes this expansive and novel aesthetic theory of meaning's autonomy by pointedly refusing normal punctuation. Unlike New Critical or Frankfurt School accounts of autonomy, Stein's also shows her support for universal suffrage. Instead of producing an art that merges content and context—a poem and its reader's particular space in the world—Stein respects both the text's independence and the reader's privacy by declaring everything specific to the reader irrelevant to her art.

Wyndham Lewis, like Stein, argues that the beholder's irrelevance to the work's meaning implies a number of philosophical, aesthetic, and political

positions in modernity, stating his case with a similar account of air. In chapter 2, we see how Lewis defends visual representation to defend political representation. In *The Childermass* (1928), he portrays two characters who step through a picture frame into a painting full of air, in the process nearly killing Thomas Paine and thereby threatening the very possibility of representation (whether liberal political or aesthetic). The "time-philosophy" he brilliantly satirizes in *Time and Western Man* (1927) damages pictorial, symbolic, and political representation alike. Expanding on this idea, as well as on related accounts in his novel *The Revenge for Love* (1937) and his drawings in the little magazine *The Enemy* (1927–29), I argue that Lewis is not the creator of postmodernism but, through his attempts to renew the possibility for representation under the dominance of time-philosophy, the first critic of it. By bringing Lewis's art theories into a conversation about liberalism in modernity, we discover that he is not theoretically opposed to a liberal politics but is determined to challenge its current manifestations.

As we have already seen, a polarity appears between spectator or readerly irrelevance on the one hand (what I have been calling "meaning's autonomy"), and bodily incorporation of the reader's body on the other (what I have been calling "meaning's incorporation"). But certain writers and artists struggle to articulate positions that negotiate between these poles. Chapter 3 examines one paradoxical figure in particular: William Carlos Williams, who understands collage as a way to productively complicate the notion of meaning's autonomy. The autonomous art object of Stein and Lewis finds its most serious early challenge in the Dada aesthetics of Marcel Duchamp and Mina Loy, who contest both the frame's integrity and art's removal from politics by insisting on the inseparability of art and life. Responding to Duchamp's and Loy's notions of framing, Williams's *Spring and All* (1923) negotiates a shifting compromise between art that rejects the incorporation of the spectator's world and art that insists on it, while a less-known work, *The Great American Novel* (1923), implies that this new theory of framing facilitates specific forms of social progress that hopefully could preempt the state's attempts to do the same.

Chapter 4 brings us into the mid-century period, where theorizations of framed, airless art enter the postwar era as adaptable and consumable "styles" competing with one another in the marketplace (Duchamp's and Dalí's versus Gris's and Picasso's). With Vincente Minnelli's blockbuster film *An American in Paris* (1951) setting the stage when Gene Kelly dances through painting frames, late modernist texts about frameless, counterfeit, or bad art—such as William Gaddis's *The Recognitions* (1955) and various poems in Elizabeth Bishop's *North & South* (1946)—grapple with the idea that kitsch is more egalitarian than high modern culture, in part because for kitsch to work it must value the spectator's experience. Granting this interdependent relationship between mass culture and high art, both Gaddis and Bishop develop a strategy

and a solution. They use the relationship between avant-garde and kitsch to develop a "neo" rear-guard aesthetic of modernism, one that follows both Stein's and Lewis's insistence on the spectator's irrelevance to the art object's meaning but situates it differently as an "aesthetic of criticism" for the mid-century's increasingly corporate culture. By defining art objects in relation to popular culture, they also consider how the frame of an art object could work to distinguish high art from popular culture, and debate what role different kinds or classes of spectators play in that selection process.

In contrast to this "neo" rear-guard position, chapter 5 returns to the avant-garde by exploring Charles Olson's and Amiri Baraka's various ways of letting the body into their writing. Olson's *Maximus*, for example, equates fidelity to a viewer's particular perception and body with fidelity to meaning, privileging American immigrant experiences in the process. He imagines that the puff of air he breathes (when speaking a word) can be an element of that world—like a piece of newspaper—captured by the poet. Drawing on archival sources, I show how Olson injects his pluralist poetics with the administrative ideology he developed in the 1940s at the Office of War Information. Such a relationship between perception, politics, breath, and meaning also characterizes Amiri Baraka's early writing (as LeRoi Jones), when he identifies Olson's influence on his work in "How You Sound??" (1960). Although Baraka's black nationalist poetry of the 1960s and early 1970s explicitly rejects white American poetry, his adoption of Olson's poetics of identity emphasizes racial qualities of voice over the meaning of words. The coda extends Olson's and Baraka's theories of breath and bodily incorporation to quite different forms of contemporary writing, including Native American Leslie Marmon Silko's photopoems, *Sacred Water* (1993), Juliana Spahr's post-9/11 poem, *This Connection of Everyone with Lungs* (2005), and a series of theoretical accounts challenging conventional claims of universality and liberalism.

Although the balance varies, each chapter moves between articulating aesthetic concerns on one hand and sketching the understood political ramifications of those aesthetic positions on the other. As such, *Modernism's Other Work* does not aim for exhaustiveness but to pinpoint striking examples and unusual intersections—such as Williams's focus on women's welfare from the perspective of an obstetrician, or Olson's administrative work at the OWI as an early model for his poetics—in the debate over meaning's autonomy. This professionalism or (in the case of many of these writers) dual professionalism returns us once more to their inquiries into the very nature of modernist work. The deliberate variability observed between different chapters (more biographical and archival discussion about Olson than Stein) is a consequence of an attempt to stay true to each of these writer's unique ways of tackling the problem of meaning and politics in terms that remain deeply their own. Twentieth-century writers understand their often quite different positions on framing to lead to disparate political or social consequences in the world. For

that matter, only some of those writers, their positions, and those imagined consequences could be included here. Despite the methodological variations, the unlikely bedfellows explored in the following pages—Stein/Lewis, Gaddis/Bishop, Olson/Baraka—prompt us to rethink our own intertwined relation between formal art objects and politics, complicating the stories we tell about modernism's and postmodernism's formal and political preoccupations. What is at stake in this genealogy of meaning's autonomy will be our future narratives of the relationship between art and the world.

1

Theorizing Art and Punctuation

Gertrude Stein's Breathless Poetry

ART WITHOUT AIR

Near the beginning of the essay "Pictures" (one of the six lectures of her American speaking tour of 1934–35, later published as *Lectures in America*), Gertrude Stein describes the formative experience—at age eight—when she first sees a large painting of the Battle of Waterloo:

> It was an oil painting a continuous oil painting, one was surrounded by an oil painting and I who lived continuously out of doors and felt air and sunshine and things to see felt that this was all different and very exciting. There it all was the things to see but there was no air it just was an oil painting. I remember standing on the little platform in the center and almost consciously knowing that there was no air. There was no air, there was no feeling of air, it just was an oil painting and it had a life of its own. (*GS2* 226–27)

Dwarfed by this room-sized panorama, Stein curiously invokes air to contrast her feelings inside the gallery to her other childhood experiences, "continuously out of doors." She loves fresh air, but the painting thrills her differently— as an art object with "a life of its own." The stimulating part of this experience, as she explains it, is not exactly the objects represented ("the things to see")— she already knew all about Napoleon. Instead, the representation itself electrifies her: "the thing that was exciting me was the oil painting" (*GS2* 226).

One way to read her interest in the painting (rather than the things painted) is as an example of what is usually thought of as the modernist critique of

referentiality. According to this view, modern works of art and literature attempt to displace the nineteenth-century naturalistic emphasis on external reality by problematizing the relation between a representation and the thing represented. Stein's focus on air—its absence in the painting versus its presence outdoors—suggests that her actual point is slightly different. She does not characterize the relationship between the painting and the thing painted as nonreferential; what she says instead is that "the relation between the oil painting and the thing painted was really nobody's business" (*GS2* 237). Thus, she compares the panorama to her experience of an actual battlefield in Gettysburg not to assess its verisimilitude (or lack thereof) but to assert that the oil painting is "an entirely different thing" (*GS2* 227). The point of insisting that there is no air in the painting is to shift her focus from the relation between an object and its representation to the relation between an art object (a representation) and its beholder.

This chapter explores Stein's account of meaning as it emerges explicitly in *Lectures* (such as "Pictures") as a theory of airless art and poetry. Like the painting of the Battle of Waterloo that had "no feeling of air," her poetry aims for airlessness or breathlessness: "an entirely different thing" from the spectator's world. However unusual or implausible this theory initially appears, and however off-putting or difficult her writing can be, Stein consistently defends the art object's independence from the beholder by employing striking, counterintuitive images to advocate for airless painting and the breathless punctuation of poetry. Likewise, we shall see how she relates her claims about punctuation to theories of framing in modernist collage. But her notion of the beholder's independence is more than a formal problem about poetic punctuation. A crucial feature of Stein's modernism understands aesthetic autonomy to demonstrate the political, revealing what Ulla Dydo has called the "possibilities of grammar for democracy."[1] I take this insight a step further to show how Stein's version of meaning's autonomy via punctuation and framing performs her support for universal suffrage: she claims that telling the reader what to do when reading her texts violates the reader's political rights. When she writes in *The Making of Americans*, "I write for myself and strangers," the duality of her intended audience foregrounds the freedoms of the individual: in writing for herself and in refusing to attempt to know the others she writes for, she helps maintain their status as unknown.[2] The strangeness of strangers denotes their privacy, their right to stay strange to the writer. Consequently, in the last section of this chapter, I compare Stein's politicized notion of poetic independence to competing conceptions of autonomy as represented by New Critics W. K. Wimsatt and Monroe C. Beardsley on the one hand and by two members of the Frankfurt School, Walter Benjamin and Theodor Adorno, on the other. Throughout, I aim to both articulate Stein's innovative vision of poetic independence and introduce the recurring political inflection of meaning's autonomy that appears throughout modernism. Instead of producing an art that

merges content and context—a poem and its reader's particular space in the world—Stein respects the text's autonomy and the reader's right to privacy by making everything specific to the reader irrelevant to her breathless art.

<div align="center">***</div>

Critics have read Stein's difficult, playful texts as speaking to the problem of reference and referentiality.[3] After all, her portraits—whether of artists, friends, or household objects—rarely resemble the people or things they portray. Yet we can catch a hint that Stein's primary interest is *not* referentiality when, in "Pictures," she strangely characterizes paintings as individual faces: "You cannot refuse a new face. You must accept a face as a face. And so with an oil painting" (*GS2* 237). Her point is that whether you feel elated, surprised, or shocked when seeing a new person or a new painting, you cannot dismiss someone's face as a copy of another face you already know. Understanding an oil painting is like becoming intimate with a new person, specifically with a new person's face: "Faces gradually tell you something . . . as you grow more and more familiar with any and all faces and so it is with oil paintings. The result was that in a way I slowly knew what an oil painting is" (*GS2* 236). Stein is not interested in how an actual person looks or does not look when compared with their representation (a painted portrait) or someone else. The relationship between a thing and its representation is not her focus. Instead, she emphasizes the singularity of a painting irrespective of its referent: a new painting is as unique as a new person would be. Thus, she comes to know "what an oil painting is" when she understands it as the face of an autonomous person with a "life in and for itself of an oil painting" (*GS2* 237). In other words, for Stein a painting is not simply another functional object in the gallery (like a bench) but an object that resembles a self-reliant subject occupying a private space all its own, with a "life in and for itself."

Or consider the unusual, childhood perceptual games she devises in Italian museums, when she begins—literally—"to sleep and dream in front of oil paintings": "There were very few people in the galleries in Italy in the summers in those days and there were long benches and they were red and they were comfortable at least they were to me and the guardians were indifferent or amiable and I could really lie down and sleep in front of the pictures" (*GS2* 231). The activity Stein describes is when, on waking, she can momentarily (albeit sleepily) identify with the paintings as faces "sleeping" in front of her. She perceives the paintings as sleeping because they are perpetually unaware of her. That is, the painting cannot "see" the viewer (Stein) sleeping—and waking—on a red bench in an Italian museum. By differentiating between states of consciousness (sleeping and waking) to describe painterly beholding, Stein introduces a sophisticated rendering of her relationship to painting here, one that is remarkably akin to Michael Fried's innovative claims decades later regarding the antitheatrical tradition in French painting. Fried writes:

The painter's task was crucially to negate or neutralize what I have called the primordial convention that paintings are made to be beheld . . . by depicting figures so engrossed or (. . .) *absorbed* in what they were doing, thinking, and feeling that they appeared oblivious of everything else, including, crucially, the beholder standing before the painting. (*AO* 47–48)

According to Fried, a successful rendering of absorption would thus bring "actual viewers to halt in front of the painting . . . in a virtual trance of imaginative involvement" (*AO* 48). Stein depicts this "virtual trance of imaginative involvement" by associating waking and sleeping with different stages of absorptive consciousness. Similarly, Stein's sleeping/waking activity dramatizes her vision of the total irrelevance of the beholder. In other words, her deep reverie is so complete that she can imagine a painting as another conscious person, even while she is asleep and not consciously beholding the painting. By imagining paintings as individual faces—and as persons with conscious states like her own, sometimes sleeping, sometimes waking, sometimes drifting off—Stein also imagines paintings utterly independent of her own consciousness.

Clarifying her point, Stein explains in "Pictures" that she was not merely playing an optical trick on herself ("convincing" herself she is somewhere else on awaking). On the contrary, the painting's status as a painting is crucial—if she fails to recognize it as a representation the sleeping/waking game fails. Thus, she reasons, unlike a Tintoretto or a Giotto, a naturalistic Botticelli is a poor painting to sleep in front of because the illusion (the "thing painted") overpowers the representation (the "painting"): "I used to walk in the country and then I concluded that the Botticellis being really so like the flowers in the country they were not the pictures before which one could sleep, they were to my feeling, being that they looked so like the flowers in the country, they were artificial" (*GS2* 231). Stein is not interested in sleeping in front of a simulacrum of the flowers (hence her complaint about the "artificial" Botticelli flowers). Instead, she must sleep in front of a representation that has "a life of its own"—the Tintoretto flowers. Each experience underscores her understanding of painting as representation: "As I say in sleeping and waking in front of all these pictures I really began to realize that an oil painting is an oil painting. I was beginning after that to be able to look with pleasure at any oil painting" (*GS2* 232).

We can begin to see why sleeping in front of an oil painting is such a crucial model for Stein, and why I am arguing that her interest is in the work of art not in relation to its referent but in relation to the beholder. When Stein realizes in the midst of the panorama that "there was no feeling of air, it just was an oil painting and it had a life of its own," she is claiming that the work of art inhabits a space that is different not only from the space inhabited by the things the painting represents but also from the space inhabited by its

beholder. She captures this idea by claiming that in the painting, there is no air. Her interest in the difference between the space of the painting and the space of the beholder explains what is otherwise very hard to explain—namely, her dramatization of the beholder in front of the painting as an insistence that the beholder is asleep and then waking. Stein illustrates a distinction between two spaces—the space of the painting versus the space of the beholder—as a distinction between two individuated consciousnesses: the awake person and the sleeping person.[4]

Yet Stein is primarily interesting to us as a poet and writer, and only secondarily as an art theorist. How does her position on the ontology of art objects, and her understanding of the relation between the art object and the beholder, align with her work as a writer? Certainly, she allies herself with painters throughout her career as a form of strategic self-advertisement: her unabashed affiliation with (and promotion of) the Parisian avant-garde fueled the popular success of *The Autobiography of Alice B. Toklas* (excerpted in the *Atlantic Monthly* in 1933).[5] But she also strategizes in a different sense. Stein aligns her poetry with Picasso's painting to increase the value of her seemingly inaccessible writing as an art with meaning. Thus she claims that she "was expressing the same thing in literature" that Picasso was in painting (*GS2* 508).

From the very start, literary critics interpreted this claim as Stein's espousal of "literary Cubism"—a jumble of words juxtaposed for their overall sound or appearance instead of their meaning. Thus, Michael Hoffman interprets Stein's *Tender Buttons* as "verbal collage," and Marjorie Perloff reads *Susie Asado* as matching "the instability, indeterminacy, and acoherence of Cubism."[6] But I suggest that Stein does not share Hoffman's and Perloff's views of Picasso's Cubist painting, and more pertinently, her literary work is not "literary Cubist" in their sense of an art of indeterminacy.[7] Her 1912 portrait of Picasso—written during Picasso's initial collage experiments—focuses on his ability to produce a definite art object with a precise meaning. According to Stein, Picasso creates "a heavy thing, a solid thing and a complete thing" which has "a solid meaning, a struggling meaning, a clear meaning" (*GS1* 282). She champions Picasso's Cubism because, like herself, Picasso asserts the completeness of the work of art; that is, an art object that "is completely contained within itself . . . this gives it at once its complete solidity, its complete imagination, its complete existence" (*GS2* 198). She aims to produce a similarly complete, entrancing object—albeit a poetic object—one that could produce that feeling of "no air" at the Waterloo panorama and replicate the sensation of waking up in a gallery and realizing "that an oil painting is an oil painting" (*GS2* 232). She wants her poetry to be so completely absorbing and meaningful that *where* the reader is does not matter to her meaning. As we shall see, she accomplishes this aim first by taking the air out of her poetry, and second by removing the literal frame around words. A single strategy eradicates both air and literal frames: eliminating punctuation.

POETRY WITHOUT AIR: THE POLITICS
OF INTRINSIC PUNCTUATION

In the essay "Poetry and Grammar," another adapted lecture from her 1934 American lecture tour, Stein explains why she rarely uses conventional forms of punctuation:

> A question is a question, anybody can know that a question is a question and so why add to it the question mark when it is already there when the question is already there in the writing. Therefore I never could bring myself to use a question mark, I always found it positively revolting, and now very few do use it. Exclamation marks have the same difficulty and also quotation marks, they are unnecessary, they are ugly, they spoil the line of the writing or the printing . . . When I first began writing I found it simply impossible to use questions marks and quotation marks and exclamation points and now anybody sees it that way. (*GS2* 317)

Her reasons are both aesthetic and functional: commas are "positively degrading," question marks are "entirely completely uninteresting," and exclamation and quotation marks are not only "unnecessary" but "ugly" (*GS2* 316–17). Her poetry and prose offer numerous examples of punctuation-stripped writing. *Tender Buttons* contains sentences that lack (among other things) sufficient punctuation marks. Critics tend to overlook Stein's explanation and focus instead on the removal of punctuation as a broader, deliberate strategy of ambiguation. For Perloff, *Tender Buttons* dramatizes "the arbitrariness of discourse, the impossibility of arriving at 'the meaning' even as countless possible meanings present themselves to our attention."[8] Thus, Perloff suggests that Stein creates transgressive indeterminacy; in a similar vein, Jayne Walker writes that *Tender Buttons* is "a text to play with."[9] Critics such as Perloff and Walker value *Tender Buttons* for the dramatic effects of its grammar games, syntax disruption, and language obfuscation. Meanwhile, other critics have framed her supposed indeterminacy as a subversive political strategy. Melanie Taylor argues that Stein's grammatical playfulness, in combination with her gender-bending, constitutes "a poetics of difference that is distinctly and, at times, rather wonderfully queer," and Juliana Spahr suggests that such "grammatical deviance" relates to Stein's transformation of immigrant speech patterns into nonstandard art.[10]

But the key reason she chooses to alter her grammar and to ignore or to eliminate punctuation is not, as Spahr argues, that "Stein abandons her own authorship and turns it over to readers," but the very opposite.[11] That is, Stein contends that her texts mean what they mean regardless of her readers. As she explains, she always intends to mean with her texts, even when the words she chooses "were not the words that had in them any quality of description"

(*GS2* 303). *Tender Buttons* is invariably a tricky text with which to produce any kind of conclusive analysis because it seems preemptively to mock any attempt to describe its meaning. Yet we might hazard a potential interpretation of a line from the poem "A box" to see her point: "Out of kindness comes redness and out of rudeness comes rapid same question, out of an eye comes research, out of selection comes painful cattle" (*GS1* 314). Stein appears to illustrate a box by abstracting its function.[12] Most basically, a box contains particular objects: "boxiness," she seems to suggest, embodies the relationship between a set and its examples. She defines "a box" by varying the formulaic phrase, "out of set-x comes y-example." Blushing ("redness") might indicate a compliment has been paid (a "kindness"), hounding someone with a repetitive "same question" might be an example of "rudeness," while "research" is produced by looking around (with "an eye"). If this reading has any validity, Stein would seem to save the most puzzling example for last: "out of selection comes painful cattle" might imply branding cattle to mark a rancher's *select* possessions, certainly painful for the cattle, as is, of course, their eventual slaughter when *select*ed for purchase. In each case, individual members of the set are potentially replaceable, marked by implied—but not printed—quotation marks. Each word is a potentially defined value for either x or y, where set-x equals "kindness," "rudeness," "an eye," "selection," and y-example equals "redness," "rapid same question," "research," and "painful cattle." Each set contains innumerable possibilities, but her overall meaning is not replaceable. "A box" represents boxiness, whatever the box might contain and whether the box or its meaning is clear or opaque.

Of course, to even attempt to understand her presumable meaning, you must know both a word's meaning and the entire sentence's repetitive formula, and neither is obvious. Indeed, part of what makes these sentences so difficult is the missing punctuation. Implied quotation marks signal a word as an example of a set without the presence of actual quotation marks helping us along. Punctuating the phrase with quotation marks to offset certain words—"out of 'kindness' comes 'redness'"—would make her meaning clearer, if still far from crystalline. Yet Stein aims to choose words so carefully and construct her sentences so scrupulously that punctuation marks would be rendered superfluous: the words and syntax could do the work the punctuation marks once did.[13] As she explains: "the longer, the more complicated the sentence . . . the more I felt the passionate need of [the words] taking care of themselves by themselves and not helping them" by adding punctuation (*GS2* 321). She often extends this point beyond quotation marks, claiming that all diacritical marks (question marks, exclamation marks, apostrophes, and commas) should be eliminated (*GS2* 316–21).

In a sense, Stein assumes that a poem can only succeed as "a complete thing" by not assisting the reader with the reader's difficult work: "An Audience is pleasant if you have it, it is flattering and flattering is agreeable always,

but if you have an audience the being an audience is their business, they are the audience you are the writer, let each attend to their own business."[14] She carefully distinguishes the writer's "business" from the reader's, whose presence is merely "pleasant" and "flattering." Although a reader might make mistakes while attempting to punctuate and understand one of these sentences, that, as Stein would say, is the reader's "business," not hers. At best, you as a writer can hope that your "force" is felt, that somebody "will have to realise that you know what you mean and so they will agree that you mean what you know, what you know you mean" (GS2 158). The author's intention to mean must be assumed as an act of faith on the part of the reader, but whether or not the reader offers such good faith, Stein knows what she means when she writes.[15]

One might argue that Stein flaunts her hostility to the reader and her indifference to popular success.[16] Certainly her pointed rejection of normal punctuation could be dismissed as an avant-garde affectation (which, on one level, it is). But the absence of seemingly helpful punctuation is not exactly intended to indicate hostility toward the reader. Instead, she describes a stance of carefully motivated disinterestedness toward the reader, which is critically different. Consider her specific argument against commas. Because commas make "you stop and take a breath but if you want to take a breath you ought to know yourself that you want to take a breath," she decides to eliminate commas in her prose (GS2 320–21). Similarly, she explains in The Autobiography of Alice B. Toklas that a sentence's "sense should be intrinsic and not have to be explained by commas" (GS1 793). Commas, in other words, unnecessarily attempt to dictate the literal experience of reading by telling you exactly when you need to inhale more air into your lungs. Moreover, the use of commas "is a way of replacing one's own interest and I do decidedly like to like my own interest" (GS2 320). By using the language of self-interest and pleasure—liking to like one's own interest—Stein characterizes her creative decision to remove punctuation not only as a formal decision but as an ethical decision based on a utilitarian and liberal philosophy. Your most fundamental interest is when (and where and how) to breathe air into your lungs, and removing commas proactively preserves that basic interest for her readers. She aims to protect the reader's particular, bodily interests and pursuits of private pleasure when faced with the author's (or a broader community's) interests. In effect, her theory of punctuation puts into practice Jeremy Bentham's important opening lines of Principles of Morals and Legislation: "It is in vain to talk of the interest of the community, without understanding what is the interest of the individual. A thing is said to promote the interest, or to be for the interest, of an individual, when it tends to add to the sum total of his pleasure."[17]

Critics have made various arguments either censuring or rescuing Stein's writing politically, but not in connection to the fundamental theory of liberalism—private versus public interest—that I do here. Most damning,

Wanda Van Dusen and Janet Malcolm criticize Stein for her sympathies with Nazi collaborationists such as Bernard Fäy and Philippe Henri Pétain, head of the Vichy government.[18] More positive recuperations of her politics, in contrast, emerged from the feminist reevaluations of Stein in the 1980s and now often invoke her poetry's lesbian affiliations and subversions.[19] By framing her decision to remove commas as an ethical or political choice, I do not want simply to disregard the difficulties of evaluating Stein's real-world political activity, but, instead, to make a very different argument about her own understanding of her politics in relation to her formal choices as participating in the evolving discourse of privacy rights in the twentieth century. Critics might ignore her intertwining of form and politics via punctuation, but Stein deliberately leaves out commas to put into practice a liberal policy toward the reader's privacy. Her aim is a theory of punctuation and meaning that protects the very strangeness—the unknowability—of the strange reader for whom she writes.

To put it slightly differently: the problem with commas, according to Stein, is that they prescribe your bodily will by replacing your interests with another's interests—the writer's. Commas are servile ("holding your coat for you and putting on your shoes") precisely because by telling you how to interact with the physical world at its most fundamental—namely, breathing air in and out of your lungs—these marks keep you "from living your life as actively as you should lead it" (*GS2* 320). As she later claims: "You cannot be strong if you do not lead a private life."[20] She wants not only to respect the autonomy of the text in relation to the reader, but also to respect the autonomy of the reader in relation to the text. She perceives the phenomenological space you possess as a reader—the space in and around your own body, in which you inhale air or put on your shoes—as separate from the space of the text. Instead of producing an art that merges content with context—a poem with its reader's particular space in the world—Stein respects both the text's autonomy and the reader's privacy by making everything specific to the reader irrelevant to her art. Counterintuitively, Stein writes difficult lines without commas to give the reader the private space to experience his or her own interests: a room of one's own within the sentence.[21]

Her argument against punctuation—and by extension, against air in her texts—reiterates her argument in "Pictures" that an oil painting lacks air. Just as the air you inhale while looking at a painting has nothing to do with the picture on the wall (because the painting has "a life of its own" and "no feeling of air"), the air you inhale while reading *Tender Buttons* has nothing to do with the meaning of Stein's written text. Throughout her career, Stein theoretically aligned these two examples of air (that is, the air inhaled while looking at a painting and the air inhaled while reading), to coordinate and mutually support her theories of avant-garde painting and avant-garde poetry. In this regard, her novel account of meaning's autonomy might be described as a

poetics of antiparticularity. Stein opposes a poetry that would compel you to breathe in the particular way that she as a writer chooses to breathe. Instead, she welcomes all possible experiences of breathing her poetry, in the same way that she attempts, in the *Making of Americans*, to "realize absolutely every variety of human experience that it was possible to have."[22] In the same interview she explains another reason she objected to punctuation: "it threw away this balance that I was trying to get, this evenness of everybody having a vote, and that is the reason I am impatient with punctuation."[23] Stein optimistically suggests that removing commas and quotation marks from her poetry dramatizes her support for universal suffrage. Relating commas to voting might be a startling claim, but it is consistent with her broader aims.[24] Just as the particularities of your body in the world (i.e., your gender, your race, your sexual orientation) are theoretically irrelevant to your value as a citizen and voter, the particularities of the reader's breathing body are also irrelevant to the meaning of her words.

Stein's political-poetics can be understood as reactionary in her refusal to give special consideration to bodily particularity and pluralism (and, in other contexts, her rejection of progressivism and the welfare state), but also as far-sighted in her anticipation of various libertarian arguments, whether leftist, feminist, or conservative, on the horizon.[25] Her complaint about commas' degradation and servility ("holding your coat for you") echoes a similar claim against acts of paternalism in *The Making of Americans*, where Hersland derides his daughter because she insists on performing what Stein imagines as the comma's role:

> He never liked to be helped in putting on anything and always Martha helped him on with his coat and always he would be completely then filled up with impatient feeling . . . she tried to help him on with his over coat when he was leaving and he never had wanted such a kind of attention and Martha always commenced again and again.[26]

The dislike of another person, or a comma, doing for you—or to you—something that you might want to do for or to yourself resembles both the laissez-faire arguments against state paternalism endorsed by Ayn Rand (whose similarity to Stein went unnoticed until recently) and the arguments around reproductive freedoms and sexuality that emerged most fully in the 1960s through the Warren Court, making up what Justice William Douglas called the broader "right to be let alone."[27] Stein's argument about breath and personal liberty presents the positive form of Michael Szalay's claim that she, along with Rand and Ernest Hemingway, were conservative writers opposed to the New Deal whose commitment to literary form took aim at governmental organization.[28] Here we can see that in addition to declaring her poetical-politics in oppositional terms, she also presents her theory of meaning as a classical liberal defense of self-ownership via property

rights, where one's property includes the performative act of reading and breathing a sentence the way you want it done.

Having rejected commas, Stein finally only accepts the period, but not because this particular mark of punctuation helps the reader know when to breathe. She describes being "completely possessed by the necessity that writing should go on" before eventually determining that "inevitably no matter how completely I had to have writing go on physically one had to again and again stop sometime and if one had to again and again stop some time then periods had to exist" (*GS2* 318). In other words, the *writer* inevitably needs to take a break. The crucial point here is that Stein's use of periods does not contradict her critique of diacritical marks, but proves her thorough commitment to the writer's absorption in her own writing and the irrelevance of the reader's body to the meaning of the text. If periods are a necessary condition for the poet to write and thus must be used, commas and other punctuation unnecessarily intrude on the reader's own "business" and should be avoided.

In contrast, the received account of Stein (by an authority such as the *Norton Anthology of American Literature*), is that texts such as the *Lectures* represent the "third phase of her work," marked less by avant-gardism then by "a campaign of self-promotion."[29] Critics such as Kirk Curnutt and Timothy Galow, for instance, note a shift in Stein's perception of identity and celebrity by the mid- to late 1930s.[30] Curnutt suggests that Stein's notion of the irrelevance of the reader is a complicated pretense she developed on experiencing the best-selling popularity of *The Autobiography of Alice B. Toklas* (1933).[31] According to this line of reasoning, Stein emphatically declares the reader's irrelevance precisely when she is most conscious of her readers (specifically, conscious that thousands of readers were finally buying her work) to keep up the facade of a blasé, avant-garde genius, hostile to her readers. Without a doubt, Stein emphasizes the reader's irrelevancy in the later *Lectures*. But she argues that the reader is irrelevant to her meaning in earlier work as well. This idea is already present in *The Autobiography of Alice B. Toklas*, published several years before *Lectures* (and, in fact, prompting the lecture tour), where she makes a nearly identical point about the uselessness of punctuation: "Gertrude Stein said commas were unnecessary, the sense should be intrinsic and not have to be explained by commas and otherwise commas were only a sign that one should pause and take breath but one should know of oneself when one wanted to pause and take breath" (*GS1* 793). A passage such as this one demonstrates that Stein established her punctuation aesthetic before the success of *The Autobiography of Alice B. Toklas*, and therefore, her theory of punctuation cannot be a causal result of that work's success.

From a purely literary historical standpoint, one purpose of my description of Stein's aesthetic theory is to rectify the mistaken lineages still often provided for her by contemporary literary critics. Resistance to her

antiparticularism has led to the characterization of her either as a manip-
ulative attention grabber (whose overt hostility to the reader paradoxically
masks her audience pandering), or as a poststructuralist or postmodern
poet whose meaning, in Perloff's words, "all depends on our angle of vision."[32]
The latter account, at any rate, is now more common. According to Perloff,
Stein intends to dramatize "the arbitrariness of discourse, the impossibility of
arriving at 'the meaning' even as countless possible meanings present
themselves to our attention," and Ellen Berry suggests that Stein's writing
"disrupts notions of the text as a discrete entity, an autonomous work
apart from everyday life."[33] Variants of these claims against the autonomous
artwork (and in support of the reader's privileged status) remain common
in Stein criticism, although important competing arguments have emerged
in recent years.[34] In contrast, I have been stressing that Stein remains con-
sistently unconcerned about the reader's particular "angle of vision" and the
multiple meanings readers might produce. She adamantly distinguishes
between the world of the text and the world of the reader, and in doing so,
suggests that her sense of the irrelevance of the reader connects to her
political values.

The next section explores how this vision of the reader relates to her
theories of avant-garde painting. When her Cubist painter friends (particu-
larly Picasso and Juan Gris) began to paste objects and pieces of newspaper
to their paintings, they changed our conception of the material frame in
relation to a representation. Stein recognized the changing role of the
frame as a problem in the history of painting, but also related it to issues
she grappled with in her own writing regarding the role of the beholder.
Although she is not a "literary Cubist" as that label has been traditionally
understood, she carefully considered how collage, an aesthetic development
in an entirely different medium, impacts her theory of poetic beholding and
punctuation.

COLLAGE AND THE PROBLEM OF THE LITERAL FRAME

In the same "Pictures" essay, Stein explains her understanding of modern art
not just in terms of breath but also in terms of framed completeness. Having
"accepted all oil paintings as oil paintings," she considers how a painting
relates to its frame:

> It may be in or it may be out of its frame, but an oil painting and that is a real
> bother always will have a tendency to go back to its frame, even if it has never
> been out of it. That is one of the things that an oil painting any oil painting has
> a very great tendency to do. And this is a bother sometimes to the painter and
> sometimes to any one looking at an oil painting.

Does an oil painting tend to go back into its frame because after all an oil painting belongs in its frame.

Or does it not.

It does and does not. (*GS2* 240–41)

This puzzling discussion challenges the reader to consider exactly how a painting both belongs in its frame and doesn't belong in its frame, while having "a tendency" to return to its frame. Stein's pondering of a painting's frame, I shall suggest, precisely echoes debates about framing that emerge in the discourse surrounding Cubist collage.[35] More relevantly to our concerns here, we shall see how her challenge to the painting's frame mirrors her challenge to punctuation. Literal frames, according to Stein, suffer from the same flaws as commas and quotation marks: they impinge on the beholder's pleasure by telling you when the painting begins and ends instead of requiring you to work out this distinction for yourself.

In even the earliest accounts of Stein's work, critics linked her texts to the new painting movement. Robert Rogers observes, in a 1914 review of Stein's *Tender Buttons*, that Picasso (like Stein), "has ceased to try to represent the emotions which certain things give him; he has determined to give the public the actual things themselves."[36] According to Rogers, because Stein is a writer and not a painter, she "can only use words" to present actual things, whereas Picasso can nail and glue "bits of wood, brass, glass, ribbons and silks" directly to his canvases.[37] Picasso might have the advantage, but he and Stein play the same game. By explicitly linking Stein's poetry to Picasso's synthetic Cubist paintings, Rogers characterizes both as materialist or literalist projects providing the audience with things instead of representations. This was a familiar argument. Although analytic Cubism began in 1907 when Picasso and Georges Braque abstracted painterly representations by using denotative shapes, lines, and iconic marks, it was their development of synthetic Cubism between 1912 and 1914 that led critics to interpret Cubism as the renewed contact with real things.[38] Instead of painting illusionistic details to make a painting look like wallpaper had been glued to it, Picasso and Braque affixed collage pieces (wallpaper, nails, etc.) and papier collé (pasted paper such as newspaper) to the canvas itself. Real wallpaper, the logic goes, trumps realistic depictions of wallpaper.

Without reiterating the entire history of Cubism, suffice it to say that this account of Cubism as literalism inadequately describes the totality of the movement. To consider just one exception, Juan Gris, the Cubist painter whom Stein particularly champions, provides a very different way to think about the Cubist inclusion of objects in paintings. Stein's notion of framing and meaning's autonomy closely resembles Gris's conception of collage. We can see Gris's understanding of Cubism from a September 1913 letter to his dealer, Daniel-Henri Kahnweiler, when he writes that a collector of one of his

paintings (perhaps *The Guitar*, which incorporates a reproduction of a painting; see figure 1.1) could substitute the piece of pasted paper with any piece of paper and the painting's meaning would remain intact: "In principle the picture should be left as it is. But, once M. Brenner has acquired the picture, if he wants to substitute something else for this engraving—his portrait, for example—he is free to do so. It may look better or it may look worse, like changing the frame on a picture, but it won't upset the merits of the picture."[39]

Gris's nonchalance about the alteration of his own work sounds odd, for it seems hard to imagine a modernist caring so little about a buyer altering his work. But regardless of the artist's true feelings about the substitution,

Figure 1.1 Juan Gris, *The Guitar* (1913). © CNAC/MNAM/Dist. Reunion des Musees Nationaux/Art Resource, New York.

he makes an interesting point, one that entirely defies Rogers's idea of Cubist collage as the reification of material things. If changing the pasted paper element is only "like changing the frame on a picture," then Gris does not value the particular object (the actual thing) pasted on the canvas. Instead, the piece of pasted paper acts as a token of a larger category of objects. Both the engraving and the portrait are of the type "painted pictures," just as either an antique wooden frame or metal stripping could serve as a literal frame. In other words, Gris associates the substitutability of the pasted paper/collage element with the substitutability of the frame. He wants some "thing" glued to his canvas, but which particular "thing" is irrelevant. The painting's beauty is unrelated to the painting's integrity, that is, "the merits of the picture."

One difficulty with Gris's reasoning is that although the frame is outside of (and thus distinct from) the representation, the collage element is internal to the representation. So if the collage element in a painting actually works like the frame, as Gris claims, he is condoning bringing the material frame onto the picture-plane—and thus inside the representation. The problem is that his two rationales for collage contradict each other. On the one hand, he implies that the pasted paper or collage element functions as a necessary material presence in the representation—necessary because Gris does not suggest that Brenner remove the engraving entirely but only replace it with something that will function equivalently. On the other hand, the artist dismisses the material particularity of the "thing" because it is outside of representation altogether: the collage element, he says, is like the frame. Thus, the collage element is simultaneously and paradoxically an intrinsic part of the representation and entirely outside of the representation.

This contradiction stems from the Cubist attempt—with collage—to reassert the frame and maintain painting as an art of representation. Stein alludes to this notion in "Pictures," when she describes a painting as both framed and independent: "there it is the oil painting in its frame, a thing in itself" (*GS2* 242). Between 1910 and 1911, Picasso and Braque create paintings of flattened pictorial space, producing the effect of a field of light, shape, and texture in which certain repetitive notational elements emerge (such as the spirals on a violin knob or a treble clef or four parallel lines as musical paper or violin strings). As Clement Greenberg famously explains, the flattening of pictorial space turns these notations into elements of design.[40] Thus, "the main problem at this juncture became to keep the 'inside' of the picture—its content—from fusing with the 'outside'—its literal surface."[41] The Cubists used pasted paper and collage to escape from literal flatness and to move the painting "into the non-pictorial, real space in front of the picture."[42] These experiments culminate with Picasso's *Guitar* construction (figure 1.2), a Cubist sculpture that Greenberg sees not as a sculpture but as a "drawing in space."[43] Painting had moved into the real space in front of the picture.

Although Greenberg does not extrapolate his claims about literal surface to the issue of framing, the same dilemma applies to the frame, a point Stein anticipated. Specifically, Cubists such as Picasso and Gris recognized that the literal frame increasingly could not limit a representation. Instead, the literal frame was approaching the surface flatness of the painting (that is, merely an object), providing them with an opportunity for artistic play. A work such as Picasso's *Guitar* construction might be understood to halt this challenge to the frame, sustaining representation and thus renewing the frame's potential regardless of the absence of the literal frame. Picasso's *Guitar* essentially resembles a Picasso collage minus its canvas and frame support. Following this logic, in paintings that incorporate collage and pasted paper, the representation as a whole implicitly works as the frame once did, signaling to the beholder the painting's end and the "real world's" beginning.

Figure 1.2 Pablo Picasso, *Guitar* (after 1914). Museum of Modern Art. © 2010 Estate of Pablo Picasso/Artists Rights Society (ARS), New York. © Digital Image © The Museum of Modern Art/Licensed by SCALA/Art Resource, New York.

Gris's comment to Kahnweiler makes the identical point: at the same time that collage brings the literal frame into the representation, collage must also extend the picture beyond its literal frame. Only then will the painting remain the same complete painting the artist intended. Stein's discussion of the frame in "Pictures" also follows this thinking. When she writes that an oil painting "will have a tendency to go back to its frame" and that it both "does and does not" belong in its frame, she alternatively considers two ways to perceive the frame. One way is to think of the frame as a *literal* frame that the painting "may be in or it may be out of." This type of frame is superfluous: whether a painting has an actual frame or is simply an unstripped canvas, the representation remains complete. The literal frame is unnecessary because Stein is committed to a different notion of the frame. Specifically, she advocates a *conceptual* frame: "I have passionately hoped that some picture would remain out of its frame, I think it can even while it does not, even while it remains there. And this is the problem of all modern painting" (*GS2* 241). Although this phrase at first glance appears to be a plea for an art that plays to the beholder's place in the world (a painting jumping out of its frame and into the beholder's lap, wherever that beholder might be), we have seen, in myriad different ways, how Stein means just the opposite. The conceptual frame remains intact while the literal frame is eliminated, "creat[ing] the necessity for cubism" (*GS2* 505). The dynamics necessary for a painting to leave its frame, unlike the representations of movement in Futurism (Umberto Boccioni's dynamic version of analytic Cubism, or Marcel Duchamp's *Nude Descending a Staircase*, 1912) must be "an internal movement, not of the people or light or any of these things but inside in the oil painting" (*GS2* 241). In other words, the painting "remains there" inside its implied frame, regardless of the literal frame's ability to limit it. For this same reason, Gris can indifferently permit Brenner to replace either the collage element or the wooden frame of the painting—both are versions of the literal frame, and thus neither impacts the existence of the intrinsic or conceptual frame of the painting.

Stein's theorizing of framing is not limited to "Pictures." A few years later, in "Picasso" (1938), she describes the artist's revolutionary, transformative vision as another account of the intrinsic frame:

> I was very much struck, at this period when cubism was a little more developed, with the way Picasso could put objects together and make a photograph of them. I have kept one of them, and by the force of his vision it was not necessary that he paint the picture. To have brought the objects together already changed them to other things, not to another picture but to something else, to things as Picasso saw them. (*GS2* 509)

In her view, Picasso captures his Cubist vision—in a photograph—without actually producing paintings. Although he produced photographs steadily

throughout his life, the particular type of photograph Stein refers to was limited to 1911–13 during the development of collage and pasted paper.[44] Picasso set up installations in the studio, photographed them from different angles, and then destroyed the installation. He treated the negatives as elements of a collaged composition, to be masked, cropped, or drawn over with ink before using them to produce a final print, such as *Photographic Composition with 'Construction with Guitar Player'* (1913). According to Stein, these photographs reveal how Picasso, with his vision alone, transforms a collection of single objects into art objects. She focuses on the artist's conceptual and complete vision (composed of "things as Picasso saw them"), almost incidentally caught on a photographic negative. Through "the force of his vision," he creates an invisible frame that defines a representation and obviates the need for him to produce an actual frame, as well as, more problematically, the canvas and support.

The point here is that Stein's theory of art, based on her interpretation of Cubist works such as Picasso's manipulated photographs, circumvents the literal frame by indicating a conceptual frame in the representation. The actual physical frame, cuing the viewer to the painting's beginning and ending, is unnecessary.[45] In the same way that the painting of the Battle of Waterloo eliminates the "feeling of air" in the painting, so should modern painting strive to eliminate the feeling of the literal frame in the gallery. When Stein describes (in "Pictures") sleeping in front of Giottos in Italian museums instead of the Botticellis (which "were less suited to that activity") she depicts how you can both know a painting has a limit as a representation and know that the painting can suppress its frame, without necessarily seeing the frame (for, at the moment of waking, the Giotto's frame would not be particularly evident). In *The Autobiography*, Stein claims that Gris continued working on important issues after Picasso moved on to other concerns (*GS1* 755). Perhaps Stein champions Gris, often over Picasso and always over Braque, because he consistently portrays fragmented internal borders just inside the picture plane, making the frame obviously internal to the picture.

Like Gris, Stein also includes "container" or frame objects embedded in her work. Consider again the poem "A box" from *Tender Buttons*, discussed earlier. As William Gass notes, Stein focuses on the way a box differentiates its contents from the world outside of a box such that "the manifest text contains a *coded commentary* on the covert texts."[46] Perhaps, then, the poem enables us to see boxes as frames and vice versa, reproducing the logic of her theorizing of the frame. We recall in the first sentence that she describes a series of not entirely straightforward relationships between container and contained by repeating the phrase "out of": "Out of kindness comes redness and out of rudeness comes rapid same question, out of an eye comes research, out of selection comes painful cattle" (*GS1* 314). Here it seems that Stein is not interested in representing the frame in the world (i.e., finding synonyms or metaphors for boxes) or, for that matter, by using a common, narrative

framing device that would insert the representation of the frame at the fictional level of plot. Instead, she hones in on the essential, spatial relationship of a set of containers (kindness, rudeness, eye, selection) to their respective contained elements (redness, rapid same question, research, painful cattle). For that purpose, a box works just as well as a frame.

We might wonder why the frame, even an internal or intrinsic one, presents more than a metaphorical or theoretical concern for a poet or writer. Indeed, in the foregoing example Stein essentially abstracts and analogizes the idea of the "frame" to portray it as a categorical "BOX." Moreover, her method must obviously be of a different kind than the painter's: the tools she works with to create spatial forms and framing are primarily syntactical and semantic, instead of line, form, and color (not to mention the more basic canvas and support). Once again, Stein's elimination of punctuation is crucial. In "Poetry and Grammar," she dismisses the question mark for various aesthetic reasons and then surprisingly claims, "it is therefore like a noun, just an unnecessary name of something" (*GS2* 317). Exclamation marks and quotation marks have "the same difficulty" (*GS2* 317). With *Tender Buttons* she attempted to "refuse [nouns] by using them" (*GS2* 325). She returns to this confusing point about nouns, explaining that with *Tender Buttons* she was "seriously troubled" with the questions, "Did I need the help of nouns [?] Was there not a way of naming things that would not invent names, but mean names without naming them [?]" (*GS2* 330). More basically, how is refusing nouns like refusing punctuation?

Whereas Stein's prejudice against nouns is well known, the fundamental alignment between refusing nouns, names, and punctuation is not. She attempts to mean names—without naming names—by producing an intrinsic frame in her writing, instead of relying on punctuation marks or noun names to display her meaning.[47] In other words, she wants to find a way to name a word without enclosing it in quotation marks. She makes the name intrinsic to the word itself. That is, the meaning of a word should be evident without a material frame such as quotation marks or other forms of punctuation, as is often the case in ordinary language (if I write "Boston is a six-letter word," you would understand that I really mean "'Boston' is a six-letter word"). Thus, when she says she wants to "refuse [nouns] by using them," she articulates a way to refuse the name of a name. Because nouns are, in Stein's words, "just an unnecessary name of something," a sentence such as, "A lake a single lake which is a pond and a little water any water which is an ant," essentially establishes a succession of replacement nouns: "a pond" for "a lake," "a little water" for "a pond," "an ant" for "a little water" (*GS1* 352). Stein substitutes one unnecessary descriptive name for another until she whittles down the description to a core example of a singular noun ("an ant"). She writes the successive names of a mentioned noun without using quotation marks and therefore without producing any additional names—or any literal frames.

Stein is grappling with a version of the "fallacy" John Searle identifies years later in *Speech Acts* (1970) regarding the use/mention distinction in the philosophy of language. When we describe a word as being talked about, philosophers of language say we are mentioning instead of using the word.[48] Placing a word or phrase in quotation marks mentions instead of uses it. Thus "Socrates was a philosopher" is an example of the normal use of "Socrates," whereas "'Socrates' has eight letters" mentions but does not use the name "Socrates." In fact, according to Bergmann, Moor, and Nelson, in writing "'Socrates' has eight letters," I have not written the name "Socrates" but the name of the name "Socrates." Searle challenges this account, arguing that it is "absurd" to imagine that by putting quotation marks around a word you are creating a proper name of the name while the name "Socrates" does not occur at all: "it is not harmlessly [absurd] but rests on a profound miscomprehension of how proper names, quotation marks, and other elements of language really work."[49] Although it makes sense to distinguish between the normal use of a word versus situations in which the "word itself is *presented* and then talked about," it makes no sense to call "a stretch of discourse" by a proper name, according to Searle, because it is unnecessary to name words when we can produce tokens of them.[50] Searle fiercely resists the idea that by mentioning a word it becomes an object. The precise purpose of proper names is to "talk in words about things which are not themselves words and which need not be present when they are being talked about."[51]

To an extent, Stein agrees with Searle that the orthodox use/mention account is absurd, if only because it produces more (useless) names: "just naming names is alright when you want to call a roll but is it any good for anything else [?]" (*GS2* 314). However, instead of rejecting the mention-case-as-proper-name problem outright (as does Searle), Stein solves the problem by removing the mark of the name—that is, the quotation marks. Because Stein views both quotation marks and the names of nouns as intrusions of the material frame onto her "writing going on," she can only defeat this frame by bringing quoted or collage elements into the poem the same way that Gris turns the collage element of his paintings into a component of the representation. In other words, when Stein claims that "commas were unnecessary, the sense should be intrinsic," her point is that we should know whether a word is being used or mentioned by the sense of the word itself (*GS1* 793). Sentence constructions in *Tender Buttons*, such as "no *x*, this means *y*, *z*, etc." ("a slender grey and no ribbon, this means a loss a great loss a restitution," from "Mildred's Umbrella," *GS1* 316) dramatize how quotation marks unnecessarily frame words because a phrase such as "a slender grey" operates like a painting with its frame implied. Just as she refuses to dictate the reader's breathing patterns, Stein refuses to disrupt the reader's "pleasure of concentrating" by incorporating punctuation frames in her text. Such marks hinder the reader's engrossment in the text by telling the reader how to breathe (with

commas) or making obvious when a word is being mentioned instead of used (with quotation marks).

When Stein gives aesthetic reasons for rejecting punctuation (as "positively revolting"), she is perhaps closest to explaining how, in her view, punctuation reduces the text to its literal marks: "if writing should go on what had colons and semi-colons to do with it, what had commas to do with it, what had periods to do with it what had small letters and capitals to do with it to do with writing going on" (*GS2* 318). Writing should "go on" without those interruptions that actively insert the world outside the writing (i.e., a comma indicating someone reading and breathing). We see that her attitude toward punctuation closely resembles Gris's point that changing the collage element is "like changing the frame on a picture." Just as Gris subordinates the literal frame to the painting by making the collage elements entirely substitutable, Stein defeats the literality of her own "framed" words and phrases by eliminating the (quotation) marks of language's framing device, all while substituting another word. She believes that her meaning a word's name suffices to imply a quotation-mark frame. Even if the reader ignores the difference between use and mention—the difference Stein's intrinsic frame insists on—the exact sense and the implicit frame are there for anyone to read.

MAPPING AUTONOMY, FROM BENJAMIN TO STEIN

We have seen how Stein relies on an interpretation of collage close to Gris's to relate her theories of art and writing to a notion of intrinsic framing and not, say, to a literary Cubism defined as literalism or indeterminacy. Thus, in her writing on painting and on punctuation, she theorizes the art object in a manner both familiarly modern, in its emphasis on a form of aesthetic autonomy, and unfamiliarly modern, in its suggestion that freedom comes not from giving the reader authority over the dead author but giving the reader the freedom over their own readerly activities, such as pausing for breath. Stein simultaneously deemphasizes the beholder's role by suggesting that the spectator or reader is irrelevant to her meaning and emphasizes it in her aim to liberate the beholder's body through her poetry. Punctuation like commas dictate the literal experience of reading and should be eliminated, and she implies that this strategy has political repercussions linked to universal suffrage. This paradox of the beholder explains why critics often struggle to determine whether Stein is a cooperative conversationalist or an indifferent dictator; as Barbara Will puts it, "General and democratic; or the 'private language' of 'genius'?"[52] The final section of the chapter explores this contradiction in full, teasing out Stein's version of the art object in contrast with others it partially resembles—such as that of Wimsatt and Beardsley, Benjamin, and Adorno—to clarify precisely why her novel and often

STEIN'S BREATHLESS POETRY 45

misunderstood account of meaning's autonomy neither follows expected accounts of modernism nor anticipates a postmodernist rejection of autonomy, as is often claimed.

Stein might, for example, be confused with an expatriate New Critic in avant-garde clothing, promoting the autotelic poetic object. New Critics Wimsatt and Beardsley argue that your affective responses to a poem fail to lead to satisfying critical inquiries: readers must avoid the "affective fallacy," that situation where the "poem itself, as an object of specifically critical judgment, tends to disappear" in the surge of the reader's emotional response.[53] Stein's theory of poetic meaning that I have been presenting might appear to resemble the New Critical poetic "objects" and their relation to the reader— Stein, Wimsatt, and Beardsley all want more emphasis on the poem as a formal object and less on the reader's emotional response. But Stein's account of the irrelevance of the reader crucially differs from the New Critics' privileging of the poetic object over the reader's response. Wimsatt and Beardsley argue that the affective fallacy threatens a poem's meaning, which could disappear in the presence of readerly emotion. They aim to protect the poem (like museum guards around a Monet painting) from the audience members whose enthusiasm (or extreme displeasure) might besmirch the work. But for Stein, the poem does not need protection from the reader because this particular hazard does not exist. To put it more precisely, this particular hazard cannot exist. A poem's meaning is never in danger of being effaced by the reader—however radical his or her interpretation—because the reader's response, by definition, cannot alter the poem's meaning in any way. Similarly, the absence of a literal frame (such as quotation marks) around a mentioned word or wood stripping around a painting does not alter the artwork's meaning. The meaning of a poem is entirely indifferent to the reader's emotion, the reader's context, or, for that matter, any type of judgment or perspective the reader could deliver. Unlike Wimsatt and Beardsley, Stein is not prioritizing objective over subjective responses: each is just as inevitable— and irrelevant—to the meaning of the text. This indifferent relation to the reader, or from Stein's perspective, this disinterested relation to the reader, secures the reader's privacy—protecting both your affective reactions and your particular way of breathing.

Thus, Stein's theory only incompletely shares aesthetic characteristics with New Critical accounts of autonomy. A more complicated comparison might be with the art object's status as defined by Walter Benjamin in "The Work of Art in the Age of its Technological Reproducibility." As is often mentioned, Benjamin challenges aesthetic autonomy, specifically the aesthetics of the nineteenth-century *l'art pour l'art* movement, as a counter-revolutionary, rear-guard response to historical reality that attempts to retain art's historical value at the very moment when that value is most threatened. Stein's account of the spectator's relationship to the work of art, at first glance, looks like a

version of the rear-guard nostalgia Benjamin derides. She apparently sub-scribes to what Benjamin calls the "negative theology . . . of 'pure' art" by dis-regarding the subject matter of a painting, preferring the completeness—the autonomy—of the represented thing, as when she claims that "the relation between the oil painting and the thing painted was really nobody's business" (*GS2* 237).[54]

For Benjamin, art objects, such as the painting of the Battle of Waterloo, relied on the power of aura.[55] This paradoxical concept is still debated at least in part, as Miriam Bratu Hansen discusses, because Benjamin alters its defini-tion over many years, incorporating heterogeneous traditions (including Jew-ish mysticism) into his theorizing at different moments.[56] Hansen suggests that in the artwork essay, aura is "the unique modality of being that has accrued to the traditional work of art" via authenticity, that is, its duration, uniqueness, and authority.[57] Invoking the idea of distance between the spec-tator and object, Benjamin ponders the nature of aura: "What, then, is the aura? A strange tissue of space and time: the unique apparition of a distance, however near it may be. To follow with the eye—while resting on a summer afternoon—a mountain range on the horizon or a branch that casts its shadow on the beholder is to breathe the aura of those mountains, of that branch."[58] Borrowing concepts from Alois Reigl, Benjamin depicts aura as the perception of an impassable separation between yourself and a thing in the world.[59] This distance requires both pastoral meditation and a certain kind of active, absorbed observing (of a mountain range or branch) in its natural en-vironment, because you "follow with the eye" the horizon or the branch's shadow. In contrast, art that destroys aura, such as dada paintings and film, distract and assail the spectator who waits passively for the physical "jolt" of the work.[60] The crucial point is that aura does not exactly represent the per-ception of distance but the recognition of ontological difference through the spectator's active perception of distance. Experiencing the remoteness of the mountain, you become aware of the "strange tissue of space and time" unlike your ordinary life experience. Space weaves together with time, distance ap-pears regardless of proximity, and uniqueness can be perceived in the most quotidian behavior.

A passage from "Convolute S" in Benjamin's *The Arcades Project* makes a similar point about aura and physical distance with a discussion of Marcel Proust's *The Remembrance of Things Past*. Benjamin notes how Proust singles out the way train travel between Paris and Balbec makes "the difference between departure and arrival not as imperceptible but as intense as pos-sible, so that we are conscious of it."[61] In other words, the "miraculous" aspect of this experience for Proust—and Benjamin—is not the immense distance covered by the train (an automobile could have gone just as far) but the fact that the train journey's "single sweep . . . united two distinct individualities of the world, took us from one name to another name."[62] A train, unlike a car,

permits us to feel both the relation and the distinction between the two place names, "Paris" and "Balbec."[63] It is the kind of mental journey we take when looking at a map—a "journey" we typically call "map reading." The journey between names, however, is a representation of a trip, in contrast to the actual journey taken between the places the map represents. Thus, Proust prefers train travel to car travel because the former resembles a map journey—the representation of a trip—whereas the latter is "only" an actual journey between two places. In this case, aura, for Benjamin, means experiencing Proust's train journey through France as a trip across a map.

Benjamin's various accounts of aura reiterate this idea, providing a telling, metaphorical description of the distinction between aesthetic experience (train travel/map travel) and ordinary experience (car travel). More pertinent to our interests here, such descriptions of aura as the art object's difference from objects of our world initially seem to resemble Stein's descriptions of the art object's independence. Her realization, standing in a gallery and observing a panorama painting, that "there was no feeling of air, it just was an oil painting and it had a life of its own" (*GS2* 226), seems identical to Benjamin's description of aura. She also claims that the work of art inhabits a space not only different from the space inhabited by the things the painting represents but also different from the space inhabited by its beholder.[64] Benjamin's striking example (borrowed from Proust) foregrounds these different spaces: we might think about ourselves as traveling with a map, but we rarely think of ourselves as traveling, literally, on a map. Similarly, we do not think of ourselves as literally trying to breathe the air in a painting.

By distinguishing between aesthetic and ordinary experience in this way, Benjamin and Stein seem at first to have a similar understanding of aura. However, they indisputably diverge in their attitudes toward aura: what for Stein is a marker of an art object's uniqueness is for Benjamin a marker of decay. Once art objects lose their aura, according to Benjamin, they lose their distinctiveness not only from one another but also from us; they start occupying our world through reproductions, which "reach the recipient in his or her own situation."[65] The impact of mechanical reproduction, such as the influx of ubiquitous cheap copies, leads to the decay of aura and "enables the original to meet the recipient halfway, whether in the form of a photograph or in that of a gramophone record," which could never happen when aura was still predominant and art works remained in temples and churches.[66] In other words, art objects now do not have a special space of art but exist primarily in our space of daily life and even in our bodily experience, such that "the distracted masses absorb the work of art into themselves."[67] Of course, much postmodern art embraces precisely this scenario: in principle nothing stops the art object from meeting us all the way by entering our space, as do site-specific, physiological works such as *Beauty* (figure I.3), Eliasson's luminous mist experience discussed in the Introduction. For Stein, the important thing

about all art—from ancient to contemporary, whether visual or written—is that it cannot exist in our physical space, and she explains this point by saying that a painting does not contain air. To put this in Benjamin's terms, for Stein, art without aura cannot be art, modern or ancient. For Benjamin, in contrast, art's current lack of aura is simply the inescapable condition of modernity.

We are seeing that Stein's and Benjamin's views on the art object are in one sense aligned, because they seem to agree on what counts as aura in art. Simultaneously and in another sense, they are completely opposed: they disagree on whether aura is desirable. From Benjamin's perspective, Stein resembles the contemporary bourgeois spectator: a well-off buyer who misguidedly seeks out the impossibly auratic art despite its counter-revolutionary status. From Stein's perspective, their versions of the status of the art object only superficially resemble one another, a similarity masking a vital, conceptual distinction. We can see the contrast from the divergent role breath plays in their respective theories of art. Consider again the last sentence of Benjamin's definition of aura: "to follow with the eye—while resting on a summer afternoon—a mountain range on the horizon or a branch that casts its shadow on the beholder is to *breathe the aura* of those mountains, of that branch" (emphasis added). For Benjamin, aura is precisely the sense of being physically connected to natural objects via light and air (the branch casts a physical shadow on you, and you can breathe in the mountain's aura), even if those objects are distant from you. Aura can be inhaled—like air—because it is of the world in which we live and breathe; the word *aura* itself is Greek and Latin for "breath" or "breeze."[68] He makes a similar point about aura in the "Little History of Photography," conceptualizing it not just as an effect of aesthetic experience but also as a sensual quality that can attach to ordinary objects. Aura emerges as the "breathy halo" in an old picture, and it also appears "in the person of every client, with a member of a rising class equipped with an aura that had seeped into the very folds of the man's frock coat or floppy cravat."[69]

Therefore, for all the ways aura differs from ordinary experience, Benjamin declares that it sometimes appears in ordinary things and experiences, such as the folds of a frock coat. Of course, this claim entirely contradicts Stein's distinction between air and art—as when she declares that in the world of the painting, in contrast to that of the museum gallery, "there is no air"—and the distinctions between breath and poetry in her statements about grammar. For Stein, an art object's relation to the spectator's world is indifferent to the spectator's experience of that object. Ultimately, then, Benjamin and Stein do not even agree on what counts as auratic. For Benjamin the meaning of a representation depends on the presence and placement of your body somewhere in the world, a place where a particular branch can cast a literal shadow on you. His account of breathing in aura, in contrast to Stein's adamant point that the painting's air is not the air in the gallery, makes clear

that their understandings of how art objects operate in the world fundamentally diverge. His conception of aura as a representation that is also lived experience (the map traveled on) sharply contrasts with Stein's strict distinction between representation and experience (your travels versus the map that could represent them).

Possibly Adorno, critical of Benjamin's dismissal of aesthetic autonomy, more closely aligns with Stein on the art object's independence. After all, Adorno acknowledges aura's rear-guard role while professing its usefulness in contemporary art and society.[70] In the process, he makes an argument for aesthetic autonomy: maintaining the distance between art and life (that is, a version of aura) realizes political critique. Autonomy, for Adorno, veils a political statement about the world rejected by art: "By emphatically separating themselves from the empirical world, their other, [artworks] bear witness that that world itself should be other than it is; they are the unconscious schemata of that world's transformation."[71] Thus Mozart's music, though not overtly political, possesses a crucial polemical quality because the music distances itself from falsity. From this perspective, the artwork's aesthetic distance from phony and impoverished life does not express apathy toward that life, but a pointed and politicized rejection of it. In other words, in Adorno's account, the artwork's autonomy negatively signifies its accurate recognition and acknowledgment of the world outside the work. What looks at first like indifference to the world transforms instead into total engagement, a pointed preoccupation with and critique of one thing (life) via its opposite (art): "the resoluteness of distance . . . concretizes the critique of what has been repulsed."[72] Maintaining the distance between an artwork and the world realizes—"concretizes"—political critique. Paradoxically, aesthetic autonomy creates the means to challenge society's status quo.

Stein's theory of spectatorship gestures down Adorno's path by predicting that a distinction between the artwork and ordinary life might have politically liberating effects: no commas enable the vote. Yet even here, at her most Adornian moment—where the art object's independence is imagined to improve equality and political life—Stein's claim that the lack of air in an artwork gives you, as a spectator, political rights crucially differs from Adorno's claim that artwork's rejection of society is a critique of society. Unlike Adorno, she is not refusing the reader's world to critique society; instead, she simply rejects the *relevance* of the spectator's world to the art object. By remaining immune from beholders' views, the art object does not challenge the status quo of society but dramatizes political life in that very society. Furthermore, Stein is not fundamentally critiquing Western society but upholding its most libertarian tendencies. Her poems grant political rights delicately, reflecting a newly found freedom to breathe. This light touch is often problematic, leading to ambivalent and unsustained cultural critiques.[73] *Tender Buttons* reveals this problem: arguably, the text obliquely challenges heterosexist subjectivity, but

it is hard to see how it effectively challenges bourgeois norms. The emphasis on commodities—umbrellas, dresses, purses—tends to reinforce such norms instead. Her focus on your bodily freedom and role in the democratic political process is decidedly middle-class American, compatible with a conventional, capitalist individualism embedded in American modernism.[74]

But faulting Stein for failing to present a fully Adornian political critique is hardly my aim here. Instead, the point has been to establish that her account of autonomous art, by which she means the art work's indifference to your role as a spectator, is entirely unlike Adorno's account of autonomous art's rejection of the world in the here and now. Her decision to remove all forms of diacritical, readerly assistance (commas, quotation marks, and all other types of framing devices) is the logical extension of her theory of textual meaning and aligns with her liberal accounts of individual privacy. Not only does her vision present a challenge to Frankfurt School notions of aesthetic autonomy and aura and to poststructuralist accounts of her own poetry, where meaning "all depends on our angle of vision," she also presents a challenge to the New Critical account of poetry as a cultural artifact endangered by the reader's misinterpretation.[75] Her argument for concentrated beholding aims to reject from her poetics any particularity of breath, such as breath as a component of and requirement for speaking voice (and thus an essential part of a particular dialect or language). Such a view was not hers alone. Stein's commitment to antiparticularism in her poetry and poetics, revealed through formal discussions of air, punctuation, and framing, exposes a major twentieth-century theoretical debate about the relation between authors, their politics, and their readers. The following chapters explore this evolving discussion of the art object's status in the world of the beholder in its literary variety and detail.

2

⌘

Satirizing Frameless Art

Wyndham Lewis's Defense of Representation

PAINTINGS WITHOUT AIR: *THE CHILDERMASS*

Wyndham Lewis—professional painter and prolific writer—still frustrates and intrigues. His fierce political views are problematic when not outright offensive to contemporary sensibilities, his creative texts (including dozens of novels, art-world satires, and aesthetic-philosophical treatises) are hilarious and fascinating, and his masterful pictorial creations, alternating between abstract drawings and figurative portrait painting, offer an extraordinary case study of twentieth-century art. In aesthetic-philosophical texts such as *Time and Western Man* (1927) he serves as a theorist and translator between media. Despite his evident engagement with the major aesthetic issues of his day, Lewis tends to be marginalized within the study of Anglo-American modernism, an aftereffect of his difficult politics. Only recently has his aesthetic theory begun to garner scholarship commensurate with that of the other major writers of his extended circle (Joyce, Woolf, Pound, Eliot). Often he is portrayed as unconcerned with the pressing issues of meaning in modernism, as when critics suggest he is "outside the formalist debate prevalent in the twenties to rethink painting as representation of ideas."[1] This chapter challenges precisely this view of Lewis. He almost *only* thinks of painting—and art more generally—in formal terms that for him impact the fate of representation in modernity. Meaning's autonomy from spectators is his rallying cry, as he imagines—sometimes quite fantastically—that alternative theories of meaning will devastate representation, whether pictorial, narrative, or, more elliptically, representation in both the capitalist marketplace and the political

arena. Whereas Stein's preoccupation with airless paintings may seem idio-syncratic, she is not the only major modernist to reflect on the possibility or impossibility of breathing in painting and to use this observation to make a formal, aesthetic argument about the irrelevance of the beholder to a work of art. Lewis, too, understands the art object's independence as impacting philo-sophical, aesthetic, and political issues in modernity, and he argues his case with similar metaphors of air and breath.

Take the case of *The Childermass* (1928), his novel sometimes labeled science fiction, sometimes satirical fantasy, sometimes theology, and most recently political allegory. Rarely is it described as art theory dramatized, even though the first half focuses on air in paintings to explore the ontology of the art object and the problem of representation, broadly conceived, in modernity. Set "Out-side Heaven" in a purgatory resembling England still grappling with the traumas of World War I, the novel resembles a hectic Samuel Beckett play.[2] Two recently deceased characters—Pullman (Pulley) and his bumbling companion, Satterthwaite (Satters)—wander around an otherworldly yet vaguely familiar landscape, eventually stopping to listen to a Godot-like figure (Hyperides) pon-tificating. It is the landscape we need to pay attention to, for the novel portrays an art full of air as a painting these protagonists can walk into—a point wholly ignored in the critical literature.[3] As the two "ghosts" study their new environ-ment, they notice that they are entering a place where "nothing seems to be moving on its surface" and everything "is a little faded" (*Ch* 104–5):

> "What the devil's this?" Pullman's voice is as sober as before it was all on fire. Satters does not like to say what he sees. . . . There is a wide view stretching as far as the eye can reach across flattish country. It is bounded by rain-clouds, they block the horizon. Then there is snow.
>
> "It's like a picture," Satters suggests, haltingly, afraid the word may not be right.
>
> "Exactly!" (*Ch* 104)

We soon learn that Pulley and Satters have inadvertently stumbled into a huge, nearly completed landscape painting that appears as "flattish country." In fact, Pulley identifies this painting as the same type that delights Stein at age eight: "we're in a panorama!" (*Ch* 123). Barely distinguishable from the broader environment, the painting is so large that Pulley advises they "go through it" because walking around it "would take hours" (*Ch* 106). Once in the painting, they notice that the foliage becomes progressively smaller, sug-gesting that they are walking "into" the illusion of depth: "Look at that hedge. Do you see its perspective? It's built in a diminishing perspective! I believe the whole place is meant to be looked at from behind there, where we have just come from" (*Ch* 123). Despite these painterly qualities, the panorama's canvas and frame are entirely invisible to them—they only perceive the "content" of

the representation (and, of course, its painterly effects). Thus, Pulley can only surmise the appropriate spectator position ("from behind there, where we have just come from") after entering the painting, traversing its imperceptible frame, and examining the shrinking hedges.

Nonetheless, palpable differences exist between their world ("where [they] have just come from") and the painting's world, variances the characters experience on approaching the picture: "After taking a few steps forward [Satters] encounters what by contrast is an icy surface of air. He stops, catches his breath. For a moment the hot wind beats behind him, then he steps into the temperature of the 'picture' or the 'hallucination'. It is moist and chilly but windless" (*Ch* 106). The air in this picture startles them. Satters "catches his breath," shocked by the temperature difference between painting-air and purgatory-air. Despite being colder, thinner, and windless, the crucial issue here—and the more startling realization from Lewis's perspective—is that they encounter the painting-air *as air*. Painting-air might be slightly different from purgatory-air, but both are of the same essential kind: breathable. Satters and Pulley can disregard the invisible frame of this painting, treating it as a window frame to step through (although not without some shock), placing them physically in the scene of representation. Lewis effectively equates the experience of walking into a place (through a window frame) with the experience of being absorbed in a representation (through a picture frame).

At this point, the contrast to Stein could not be more striking. Whereas Stein, in front of the painting of Waterloo, imagines that "there was no air, there was no feeling of air, it just was an oil painting and it had a life of its own" (*GS2* 226–27), Lewis imagines a painting so full of air that his two characters not only describe it in detail but feel it in their lungs. Stein divides the place of a painting from the place of the beholder, and Lewis combines these two spaces into one. Instead of a painting separated by its airlessness from the spectator's physical world, the panorama Pulley and Satters encounter *is* their world, albeit a slightly different part of their world, where the air "has a rarity of its own— it's really as though we were on the Matterhorn" (*Ch* 122). Most crucially, Stein invokes the example of painting to illustrate her commitment to the irrelevance of the spectator experience to the art object's meaning. Lewis, in contrast, emphasizes that these purgatory-paintings need active spectators—Pulley and Satters must be literally involved in the painting to complete it.

It is not, however, as if Lewis creates this entire episode of Pulley and Satters strolling into a painting to advocate air-filled painting as a theory of art. In fact, it is exactly the reverse. He satirizes those artists and critics who, if they did not exactly believe that art was full of air, believed that art was a frameless thing to be stepped into and completed by its beholders.[4] In Lewis's opinion, this belief exemplifies a broad, detrimental cultural trend, which he calls "time-philosophy," that had become all too common in modern, post-Impressionist art and literature. I discuss this idea at greater length in the next section; in essence, for Lewis the art

of time-philosophy captures a moment of time and thus competes with life, inadequately separating the art object from the world. When Satters mumbles that their new landscape is not exactly a picture but "like a picture"—and Pulley immediately agrees ("Exactly!")—Lewis takes aim at this vision and embodiment of the artwork (*Ch* 104). In other words, the panorama resembles a painting without actually fulfilling his requirement for representation. Instead of mindlessly imitating our temporal lives, art must be of a different order of experience from time and thus reality. Discussing Hume and Baudelaire in the unpublished essay "Critical Realists," Lewis makes a similar point: "no one who understands the function of a picture wants it to be like a real landscape, any more than he wants a statue to breathe and move."[5] When Lewis satirizes art that "breathe[s]" or is too much "like a real landscape," he makes the same point as when he satirizes art that needs its spectators' experience to be complete. In both cases, the art fails to differentiate between a painting of a panorama and one's experience of a view at the top of the Matterhorn. Although in discussing Lewis's dramatization of Pulley and Satters intruding into the painting I am describing precisely the opposite of Stein's theory of art, and although Lewis himself saw his position as completely opposed to Stein, in fact, Lewis also advocated an art that imagined the beholder as irrelevant. Of course, his work formally differs from Stein's poetry without punctuation, but, like Stein, he believes that only producing art "off-limits" to the beholder's interpretation would advance art. Both Stein and Lewis want to make everything about the beholder or reader irrelevant to their art.

As a novelist, painter, *Blaster*, and satirist, Lewis is frequently portrayed in his self-created role of "The Enemy": that is, as a conservative, vitriolic force—the "lonely old volcano of the Right" in W. H. Auden's estimation—warring against the popular modernisms of Bloomsbury or Paris.[6] In keeping with this line of interpretation, Fredric Jameson, in *Fables of Aggression: Wyndham Lewis, the Modernist as Fascist*, depicts Lewis both opposed to Marxism and advancing a precocious postmodernism. Although more recently critics have expanded on and modified these claims, Jameson's label of "the modernist as fascist" retains a certain authority. Lewis's theory of art—or more precisely, his defense of representation in relation to his political beliefs—has received less attention.[7] But accounts of Lewis's postmodern sensibilities and labels of his encompassing fascist-modernism must be revised. Lewis, like Stein, articulates a version of meaning's autonomy, opposing the spectator's relevance to the art object and understanding such a position to protect both viewers and representation. In this regard, he is not the creator of postmodernism but the first critic of it. His defense of aesthetic representation, moreover, was also a defense of political representation. Over the course of his lifetime, he increasingly posed this argument in terms reflecting his disappointment with the realities of the capitalist state.

In the next section, I examine the intersection of Lewis's aesthetic theory via air, time-philosophy (the idea that modern art and literature is flawed by its attempt to encapsulate time), and his political theory in a number of texts, such

as *Time and Western Man* and archival typescripts and manuscripts still unpublished. Lewis satirizes temporal art in *The Childermass* when Pulley and Satters wander through a modern purgatory and accidentally step inside a painting full of air, but we shall also see (in the third section) how in the process of destroying art these characters symbolically destroy liberal, democratic representation. In other words, as Lewis sees it, time-philosophy wreaks havoc not just on pictorial representation but on symbolic and political representation in the same way. Contemplating the fate of organized politics and representative democracy specifically when representation of any kind is under severe ideological strain, Lewis strives to renew the possibilities for representation. In the last section of the chapter, we see him at work at this difficult endeavor in novels such as *The Revenge for Love* (1937) and in his drawings from *The Enemy* (1927–29) by finding new ways to represent himself within a capitalist global economy that increasingly crippled artists' ability to represent themselves within society.

In addition to presenting a new literary historical account of Lewis in relation to postmodernism, my reading of Lewis contributes to new conversations and formulations about the relationship between modernism and politics, especially in the context of liberalism. Until recently this was an unusual lens through which to see Lewis. Pericles Lewis carefully considers how modernists such as Joyce, Conrad, and Proust responded to liberalism's wake, and Nicholas Brown and Douglas Mao introduce new ways for thinking particularly about Wyndham Lewis's relation to liberalism.[8] Brown characterizes Lewis's critiques "in terms of Left analyses of liberalism," whereas for Mao, Lewis and Auden are theoretical liberals who share certain "core tenets of liberalism," particularly the possibility of informed dissent, "to think *against* authority."[9] Following the lead of these critics while focusing more particularly on questions of democratic and aesthetic representation, I bring Lewis's art theories into a conversation about liberalism in modernity. In the process, we shall see a Lewis not theoretically opposed to a liberal politics but challenging its current manifestations. Indeed, he understands his commitment to the irrelevance of the spectator to promote a renewed political representation. As a more contextualized and less obscured version of this difficult, satirical modernist comes into focus, theories of meaning's autonomy are revealed in modernist political and aesthetic discussions in thoroughly unexpected ways.

TEXTS WITHOUT THE "BREATHING MATERIALITY" OF TIME: LEWIS'S PRECOCIOUS CRITIQUE OF POSTMODERNISM

Considering Lewis's and Stein's shared commitment to avant-garde art and literature and, more relevantly, their common interest in art's relation to the beholder, we might suspect some mutual understanding between them. Lewis generally amused Stein; he, on the other hand, despised her and her work,

scribbling in parodies of her writing even in the late, page-proof stages of his revisions.[10] In some respects, his dislike predictably duplicates the received account of him as a hostile, misogynous anti-Semite.[11] His antipathy surely reveals hysterical aversion: Stein is a phony avant-gardist—"a faux-naif" and "a sham"—because she produces fake art (*TWM* 49). Lewis also implies that she attempts to emasculate young (Anglo-American) male writers, such as Ernest Hemingway, by overpowering them with her monstrous, female (Jewish) persona.[12] But whatever Lewis's intentions, these deliberately offensive accusations also operate as rhetorical camouflage, masking a more basic anxiety. Specifically, Stein's well-known, avant-garde persona threatened Lewis's description and self-representation as "The Enemy"—that is, as the outspoken *artiste* in the liminal world of avant-garde modernism. "I defend my choice of her as an enemy at all times and in all places," he writes in "The Diabolical Principle and the Dithyrambic Spectator," an essay first published in one of his critical organs, a periodical he in fact named *The Enemy* (1927–29).[13] Even this indictment of Stein highlights his dilemma: if she is "The Enemy's" enemy in *The Enemy*, Lewis's singularity as the cultural adversary sine qua non is undermined. From this threat of erasure emerge thought experiments such as "If we blot out Gertrude Stein, and suppose she does not exist . . ."[14]

Yet these two "enemies" would have been better off joining forces. Although Lewis despises what he believes is Stein's "bad philosophy," that philosophy resembled his own more than he admitted. Like Stein, he repeatedly focuses not on the relation between a representation and the object represented but on the relation between the space of the painting and the space of the beholder. Consider, once again, the scene of Pulley and Satters encountering the painting in *The Childermass*. Lewis describes their interaction with the artwork in vivid detail. "Milky" wall surfaces dissolve instantaneously, and the dusky shafts of sunlight prove denser than they appear:

> These solid luminous slices have the consistency of smoked glass: apparitions gradually take shape in their substance, hesitate or arrive with fixity, become delicately plastic, increase their size, burst out of the wall like an inky exploding crysalid. . . . Satters surreptitiously reaches out his hand to the cutting edge of the light. It is hard, it's more like marble. It is *not* sunlight or it is frozen beams. He hastily withdraws his hand, looking to see if Pullman has noticed. (*Ch* 40)

With this brilliant description, Lewis depicts light filtering through air as a viscous but thickening substance, one with the consistency of oil paint as it is applied to a canvas (initially gooey but eventually solidifying). As if anticipating Hans Namuth's documentary film of Jackson Pollock at work—shot from behind a pane of glass gradually coated with poured paint—Lewis's image of enlarging apparitions that "burst out of the wall like an inky exploding crysalid" suggests a painting in the process of creation. But Satters is particularly

surprised because nothing else is visible besides the painting: not the canvas, not the paintbrush, and not anything surrounding the painting. The artist at work, who sometimes paints slowly and hesitantly and sometimes creates forms boldly and quickly, is also invisible: "apparitions gradually take shape in their substance, hesitate or arrive with fixity." Satters and Pulley experience this painting-apparition not as a representation exactly—although it resembles a representation in some crucial ways—but as a strange part of the physical world in which they themselves exist, a world in which Satters can touch a sunbeam and it feels "like marble."

Exploring the painting, Pulley and Satters begin to recognize why it is less than a satisfying representation: this large and powerful panorama interacts with them negatively. To begin with, the act of stepping inside the painting enervates Satters: "A painful lethargy taking possession of him like a rough drug engrosses his attention. It attacks his limbs first, he moves restlessly to counter it" (*Ch* 108). Pulley urges him to hurry through the painting to avoid the narcotic "auto-suggestion" that "the stillness of everything" causes (*Ch* 109). Satters, the weaker and more suggestible of the two, eventually becomes "a scowling sleep-walker," and Pulley must physically drag him through the painting (*Ch* 112). Out of all the possible responses one might have to stepping into a painting full of air, narcolepsy (not shock or fascination) is Lewis's obvious choice because such paintings require next to nothing of their viewers' minds—these are paintings you literally can experience in your sleep. But the broader problem with the painting has to do with the fact that the spectators (Pulley and Satters) can directly interact with the representations inside the painting. By the final scene inside the panorama, we see that this painting—sleep-inducing but otherwise indistinguishable from the physical world—does not fulfill Lewis's notion of a representation and in fact contradicts it when Satters becomes distraught by the hostile reception he receives from a representation of an eighteenth-century "ploughman": "His face terrified me! I didn't tell you at the time—I felt he knew quite well you were looking at him! . . . I feel we ought not to be here . . . I feel an intruder . . . I feel I'm trespassing" (*Ch* 112–13). Sensing that his gaze is acknowledged yet unwelcomed by the figures represented in the painting, Satters becomes anxious and dislocated. It is as if the painting—through the figural representations in it—wants to exclude him from the representation but cannot ("I feel we ought not to be here . . . I feel an intruder"). In other words, the invisible frame they have stepped through has failed as a barrier to halt them in front of the painting. Satters becomes so disturbed by the hostile reception he receives ("Did you ever hear such cheek! . . . Did you hear what he called me?" [*Ch* 128–29]) that he picks a fight with the ploughman, eventually mangling the representation "out of human recognition" (*Ch* 130). With this act of disfiguration, Satters and Pulley are violently expelled from the painting: "the light is extinguished in a black flash and they are flung upon their faces" (*Ch* 130). But the painting's last

attempt at maintaining its separation from its spectators fails as the panorama itself swiftly disappears: "They get up it seems almost immediately, breathless, but the Time-scene has vanished" (*Ch* 130). By violently defacing these painted representations, Satters brings about the destruction of the painting.

Thus, halfway through the novel, Lewis reveals the true function of this art object: to satirize the contemporary understanding of painting as a space the beholder can enter. The ultimate disappearance of the painting resolves this long scene, for Satters and Pulley are the satiric "puppets" who (unwittingly) bring about the result that Lewis felt was inevitable: art that a person can physically step into will lead to the destruction of that art object and eventually to the demise of art more generally. He does not simply present a modern version of purgatory as situational comedy (although the novel often does that, too). Instead, Lewis imagines a visual illustration of time-philosophy, the modern preoccupation with temporal experience he disparages and discredits in the 400-plus pages of *Time and Western Man*.[15] Pulley explains that they can enter a panorama that is "like a picture" because this panorama fails as a representation: "This is nothing . . . It's hollow! It's only Time!" (*Ch* 105–6). They need not treat it like a painting (that is, by standing in front of it and studying it) but can walk into it as an atmospheric disturbance: "It's a time-hallucination—we don't get them often but I've seen several" (*Ch* 105). The panorama might be disruptive, but it is not a true representation: the experience of air in time is only as interesting or uninteresting as the weather.

For Lewis, art—such as his own abstract, Vorticist painting—must not resemble life slavishly (as in the case of naturalism) but instead must be a different order of experience from reality.[16] Specifically, art is a form of life independent of time. As he writes in *Blast* 1 (1914), his early Vorticist polemic, art is "in no way directly dependent on 'Life.' It is no EQUIVALENT for Life, but ANOTHER life [what Stein calls "a life of its own"], as NECESSARY to existence as the former."[17] In contrast, the "time-hallucination" Pulley and Satters enter requires the viewer's experience in life to produce its meaning: they cannot simply stand outside of the painting and observe it but must enter into it. Tarr (another early Lewis surrogate) argues a similar point against time-painting: "*Life* is anything that could live and die. *Art* is peculiar; it is anything that lives and yet you cannot imagine as dying."[18] When Anastasya, Tarr's intellectual partner, counters with a familiar rebuttal, "Why cannot art die? If you smash up a statue, it is as dead as a dead man," Tarr remains adamant: "No, it is not. That is the difference. It is the God, or soul, we say, of the man. It always has existed, if it is a true statue."[19] The reason the work of art cannot die is because to die is to stop breathing, and the work of art cannot stop breathing because the work of art never was breathing. In other words, Lewis argues, art is a form of life, but with crucial differences: it is a life without air, without the particularities of a certain place at a specific time, and without the possibility of death. Art "has no inside" that you can

stroll into as do Pulley and Satters.[20] Or as he puts it in *Time and Western Man*:
"The moment an object of beauty, a picture or statue, affects you as a *living
person* would—to anger, concupiscence, or what not, its appeal as art, has
ceased" (*TWM* 530). All these characteristics he redescribes as life without the
experience of time. In contrast, the panorama Pulley and Satters encounter is
only a time-experience: they could go around it, but even "that would take
hours" (*Ch* 106). Instead they choose to go through it, which also necessarily
takes time, even if only "a few minutes" (*Ch* 106).

I am parsing Lewis's understanding of the relationship between art and life
here precisely because it remains critically obscured.[21] To be clear, in declaring
art's independence from time Lewis is not rejecting the role the social world
plays in his art. On the contrary, as Geoff Gilbert describes, he turns an under-
standing of the artist's subjection to social and political determination into a
comprehensive critical position.[22] But Lewis claims that whatever its starting
point, art by definition strives to be and do something different from life. This
very distinction, along with Lewis's overarching critique of a time-philosophy
society, might seem to some to transform his aesthetic theory into a political
(and ultimately fascist) undertaking.[23] In such accounts, Lewis becomes a
thoroughgoing avant-gardist in Bürger's terms, opposed to the high formalism
of Clive Bell and Roger Fry. But what we see in Lewis's writing, particularly in
the time-painting scene of *The Childermass*, is not an attempt to heal the divi-
sion between art and life. In Lewis's view, that division is no injury. Instead, he
attends to the crucial role for art both in relation to and in contrast to life. Like
Stein, he articulates his vision of the art/life relationship creatively and figu-
ratively, altering the terms of an aesthetic debate by examining the philos-
ophy of time that enables art to swap with life. Bringing art and life together
would not solve the issue of modern ideology as he sees it but exemplify the
problem he is identifying.

In *The Caliph's Design* (1919), *Time and Western Man*, and his other art crit-
icism, Lewis presents most of the major modern art movements (except his
own) as manifestations of "the prevalent time-doctrine" made enormously
popular by Henri Bergson (*TWM* 451).[24] For instance, the Impressionist
strategy of painting quick, *en plein air* sketches reveals a commitment to the
temporality of the moment. Just as Marcel Proust "embalms" his past in *A la
recherche du temps perdu*, so Claude Monet embalms his experience of morning
light (and, in other paintings, afternoon, midday, or dusky light) on the Rouen
Cathedral. Futurism fairs little better, brilliantly dispatched as Impressionism
with cars, or "automobilism."[25] Instead of a focus on the changing light over a
few moments in time, Futurists emphasize the speed of new technology over
a few seconds. But the focus on a time-experience, of whatever length, remains
the same. Surrealism, meanwhile, aims to make art "super-real" by mummi-
fying or deadening reality. The Surrealists "pass over into the living material of
all art, its ground and what it contemplates, and . . . tamper directly with the

cézannesque apples, for instance, before the painter has started his picture."[26] Thus, when the Surrealists transform an apple before painting it, they effectively alter life, instead of art. Because Surrealism is "the *merging of art in life*," it is "not an aesthetic phenomenon" at all but a social phenomenon.[27] In contrast, the spectator of art should "not be required to participate in any way in the real," for art is "something outside 'the real'—outside the temporal order—altogether."[28] Only Cubism, with its reliance on abstraction, occasionally receives a reprieve. When Picasso veers away from painting and ventures into creating paper constructions like *Guitar* (figure 1.2), discussed in the previous chapter, Lewis pounces for predictable reasons: "Picasso has come out of the canvas and has commenced to build up his shadows against reality."[29] That is, unlike his collages or Cubist paintings, Picasso's constructions move "from the convention of the canvas into life" and into the spectator's time and experience.[30] Whether discussing Impressionism, Futurism, Surrealism, or synthetic Cubism, Lewis fundamentally opposes art that requires the spectator to experience reality as presence—that is, he opposes art that insists on the spectator's experience of the object in real time.

For Lewis, one of the clearest articulations of time-philosophy's aesthetic is Oswald Spengler's theory of art in the popular *Decline of the West* (1926). Spengler conceives of art as a "full, coloured, breathing materiality . . . it not only dies *for ever*, but everything about it dies *for ever*. There is nothing 'universal' left in it" (*TWM* 267). For Lewis, when Spengler conceives of art as alive in time—with a "breathing materiality"—he describes an art *with air*. Such art is flooded by experiences of time—by the particularities and contingencies of its temporal existence. Air becomes time. Lewis presses his point further. The contemporary audience of time-philosophy art is dissatisfied with "a picture, a representation." Instead, "we exact *real* blood and tears. We want, in short, *reality*" (*TWM* 271). By opposing reality ("*real* blood and tears") to a representation ("a picture"), Lewis underscores the opposition between time-art and a representation. By breaking down the distinction between art and life, a time-philosophy object—whether it is a painting by Salvador Dalí or the painting Pulley and Satters walk through—is a worldly, social object as opposed to an aesthetic one. Time-art does not stand for itself, but stands like and among any other object in the world.

Lewis is rarely credited with a coherent theory of representation.[31] But we are seeing that he consistently (albeit critically and satirically) expresses one. Most important, what initially appears to characterize his divergence from Stein—the air in the painting—turns out to endorse her theory. Just as Stein removes commas from her poetry to exclude the audience's breath from the meaning of her text, Lewis scorns time-art for its "breathing materiality" (*TWM* 267). In fact, his condemnation of *The Childermass* painting as a "time-hallucination" takes Stein's theory and expands on it. By rejecting time from art, Lewis is not just ignoring the audience's physical existence via

their breath. He is attempting to withhold from art what any living creature needs to sustain itself: regular, repeated intakes of air over a sustained period of time. His repudiation of time-philosophy wholly rejects the temporal experience of the viewer or reader to the meaning of the work of art, because however fleeting a human experience might be, it must have duration.

From Lewis's and Stein's common understanding of the relation between painting and beholder, we can deduce a whole set of other issues. Consider, first, the literary historical claims: my reading goes against the accepted view of both writers. In the previous chapter, we saw that Stein is not trying to produce indeterminate meaning, and thus she cannot be satisfactorily categorized as a poststructuralist or postmodernist. Although the critical consensus on Lewis remains less unified, the style of his satirical writing has led critics to interpret his work in ways that imply his anticipation of postmodernism.[32] Perhaps the tendency to see him in this way has blinded readers to the time-art scene in *The Childermass*, which is not an example of Lewis revealing a disintegrating world through a cacophony of stylistic profusion to destroy some version of organic unity but, on the contrary, a satire that exposes time-art—the true waste land of modernity—precisely so modernist form can be rejuvenated anew.[33]

Most influentially, Fredric Jameson's early monograph, *Fables of Aggression*, stakes a claim for Lewis's postmodernism by noting "the striking similarities between Lewis' undertaking and the contemporary poststructuralist aesthetic, which signals the dissolution of the modernist paradigm . . . and foretells the emergence of some new, properly postmodernist or schizophrenic conception of the cultural artifact."[34] Jameson characterizes Lewis's narrative as an unconscious, postmodern critique of political ideology. His analysis is investigated at more length in the next section; here, I simply want to reiterate my point that Lewis's satire fails to produce the postmodern "cultural artifact" Jameson imagines. Instead, Lewis explicitly aims to critique the most egregious cultural phenomenon: the "Time Cult." The other effects generated, such as narrative discontinuity and prosthetic persons, cannot properly be understood as postmodernist, but as side effects of his comprehensive satirical goal. By rejecting the idea that the spectator's experience is part of the meaning of the work, Lewis also rejects any theory—poststructuralist, postmodernist, reader-response, or some other variation—that values the spectator's contribution to the work of art.

The "time-hallucination" painting in *The Childermass* does not raise issues in the realist tradition, such as how a painting depicting the world relates to the subject matter it represents. Instead, time-painting foregrounds the issue of whether an artwork has an impenetrable frame that stops you, physically, at the surface of the painting. In this regard, temporality is crucially connected to Michael Fried's notion of objecthood—the material presence of the art object itself—discussed previously.[35] Both Fried in "Art and Objecthood"

and Lewis in *Time and Western Man* believe that temporality is antithetical to art; for Fried, temporality is another version of objecthood, whereas for Lewis, temporality is the crucial aspect of experience and thus the chief threat to art. When Pulley and Satters are unable to perceive the physical conditions of painting as distinct from representation—that is, they cannot see the canvas, but they can perceive the oil painting emerging as "an inky exploding crysalid" (*Ch* 40)—the novel depicts time-painting simply ignoring its physical conditions (its objecthood), instead of acknowledging and overcoming those physical conditions. In a sense, Lewis is ridiculing time-painting's status as only an object in the world, and thus only an experience of time, that, by his definition, is anathema to art.[36] The writers and artists he denounces venerate time as a literal object (in his view) instead of aiming to defeat objecthood.

Lewis was apprehensively anticipating more recent trends. The time-art he attacks persists in varied ways in other postmodern movements, such as Conceptual, Earthworks, Happenings, Performance, and related art movements familiar today (video installation, new media, etc.). By the late 1960s, Earthworks artist Dennis Oppenheim observes that "sculptors have never been as dynamically involved in time as they are now."[37] Oppenheim's own work is a case in point: *One Hour Run* (1968), in which he creates a six-mile continuous track through a snowy Maine hillside, uses a unit of time as a creative parameter. The decision by artists such as Oppenheim to make art in and of the landscape or cityscape foregrounds the spectator's involvement in situational or durational art.[38] When Christo's *Gates* (February 12–28, 2005) in Central Park lasted only two weeks, the viewer's presence as a literal witness of the event gains value. Shows such as Eliasson's "Take Your Time" retrospective (discussed in the Introduction) and the 2002 "Tempo" exhibition at the Museum of Modern Art made temporal involvement even more explicit. The latter exhibit "focuse[d] on distinct perceptions of time—phenomenological, empirical, political, and fictional," by including performance pieces that required the spectator's physical involvement.[39] Thus, Erwin Wurm's *One Minute Sculpture* instructs each museum-goer to complete difficult, sixty-second actions ("hold your breath and think of Spinoza").[40] Although we are now used to thinking of such works as a powerful trend in contemporary art, they illustrate Lewis's point about the way he imagined *all* art to be moving as early as the 1920s: time-art involves "the *merging of art in life*" to produce an experience in life—"not an aesthetic phenomenon."[41]

For Lewis the stakes could not be higher: the battle being waged in the art world will result in the future of art and culture—the future of not just good art, but *any* art. Temporality, from this perspective, does not just destroy art but devastates the quality of one's life. Because time-philosophy mixes organic life with the deadness of the past—embalming or mummification—the result is mechanized half-life/half-death: "The inner meaning of the *time-philosophy* . . .

however much you paste it over with confusing advertisements of 'life,' of 'organism,' is the doctrine of a mechanistic universe . . . above all, essentially *dead*" (*TWM* 91).[42] (Now we can see a little more clearly why Satters was struck by narcolepsy, a kind of living death, when he walked into the painting: he was a half-dead man walking into an essentially dead painting.) The underlying problems with time-philosophy, then, are not just aesthetic but all-encompassing. As we see in the next section, Lewis also perceives these problems as having political effects: time-philosophy's manifestations threaten personhood by making our life and our person much more like—indeed, almost indistinguishable from—our death. As he puts it (loudly) in *Blast* 1: "THE ACTUAL HUMAN BODY BECOMES OF LESS IMPORTANCE EVERY DAY. It now, literally, EXISTS much less."[43] Like Stein's condemnation of the "servile" comma as a mark that "keeps you from living your life as actively as you should live it" (*GS2* 320), for both Stein and Lewis certain formal literary acts can be understood to undermine our personhood. For Stein, command over your own bodily particulars diminishes when literal frames, in the form of punctuation marks, are inserted into a text. For Lewis, spectators blundering into a time-painting challenge the possibility not just of aesthetic representation but of political representation as well.

ENDANGERING THOMAS PAINE

The entire supernatural scenario of *The Childermass* can be reformulated as a cautionary satire of a modern world dominated by time-philosophy. When art and death mix with life, we are living in a modern purgatory. In such a world, anything that even seems life-like, such as the small figures in the panorama, threatens our person. But for Lewis, this threat to ourselves extends beyond the possibility of physical harm to our bodies, as the potential danger turns out to be more systemic and alarming. Satters, we recall, mangles a small man in the eighteenth century–styled painting after this figure excoriates him for being less than a man: "You may have blown off some man but you are not one nor ever will be! You are a lout, . . . sir, in spite of your dimensions" (*Ch* 129). As we will see, this man has a crucial role in both the time-painting and *The Childermass* more generally.

The location of the small figure provides a clue to his function in the novel: Satters and Pulley find this Lilliputian at a miniature inn where "over the door of the main entrance *The Old Red Lion Tavern* is painted" (*Ch* 127). Satters, peering inside the inn's window, proceeds to snatch the figure out of the window "with a mischievous wrench" (*Ch* 128). Understandably outraged, the figure, "with a slight American accent" (another important hint) defends himself against Satters, first with words and finally by biting Satters's hand. This incident leads to Satters's fatal counterattack, ominously ending with "the mangled

creature stamped out of human recognition" (*Ch* 128–30). The small figure's distinguishing characteristics are literally pressed out of him, a form of physical attack on a representation that Lewis revisits in *The Revenge for Love*. As Pulley notes, the Old Red Lion Tavern happens to be the very inn "where Thomas Paine wrote his *Rights of Man*" in 1791 (*Ch* 127). Paine, born in England, emigrated to the American colonies in 1774, where he presumably picked up a bit of an American accent before returning to England in 1787. Thus, we are given another clue about the holder of the "slight American accent": the little figure Satters picks on is none other than Paine himself, the revolutionary liberal political philosopher and pamphleteer. Or, more correctly, Satters picks on a reduced-sized representation of Paine, the political writer who advocated for the natural and civil rights of all men, however disenfranchised—that is, however reduced or partial in society's view.

Paine produces a noteworthy argument for representational democracy in the third chapter of *The Rights of Man, Part II*. Dismissing hereditary government entirely, he argues that "representation ingrafted upon Democracy" is the best possible system of government.[44] Representative democracies improve so much on ancient "simple democracy" that if they had existed in Athens, then European aristocracies would have never existed at all.[45] Although the assumption has been that Lewis's attitude toward liberal democracy or Paine's account of representative democracy must have been hostile, more recent criticism modifies this view.[46] It appears that Lewis's attitudes toward democracy were erratic and shifting as early as the 1920s, a point Lewis himself makes: in *Time and Western Man*, he notes that his earlier writing "slighted too much the notion of 'democracy' by using that term to mean too exclusively the present so-called democratic masses" (*TWM* 25). He now wants to distinguish between mob rule and democracy. Slightly later, in *Men without Art* (1934), he offhandedly describes himself as "*fairly* democratic," still complaining pages later about the "undisciplined" and falsely sentimental aspects of liberalism and "Jeffersonian democracy."[47] Reserving most of his criticism for "mechanical" Marxism (brilliantly expanding on this analysis with scenes of wealthy English communists plotting their Spanish wartime holidays in *The Revenge for Love*), he treats democratic institutions in a much more qualified manner. He takes it "as axiomatic that the present type of Western Democracy cannot and should not survive," but the phrase "present type" holds out a small hope that a different form of Western democracy could and should thrive.[48] By the early 1940s, in works such as *The Vulgar Streak* (1941) and his critical review of the reissued De Tocqueville's *Democracy in America* (1946), Lewis clearly promotes liberalism.[49]

If Lewis is neither a well-known champion of representative democracy in the 1920s nor its especially virulent enemy, the question remains as to why he inserts a miniature version of Paine into the panoramic painting and then has the incompetent Satters destroy him. Manuscript evidence suggests that

Lewis added this scene late in the page-proof process; perhaps he includes Paine as a provocative afterthought.[50] Certainly his strategy tends to be all-encompassing, incorporating unexpected attacks (whether on Proust, Spengler, or Joyce) into his broadly adversarial stance. If his aim as "The Enemy" is "to lay bare the widely-flung system of cables connecting up this maze-like and destructive system in the midst of which we live," then Paine's destruction would simply be part of Lewis's conservative, sweeping indictment of romantic liberalism, as Daniel Schenker argues.[51] But we might consider that the inclusion of the champion of political representation in a scene about a flawed representation suggests another possibility. Lewis synthesizes his cultural critique even in the process of rewriting and revising that critique. Time-philosophy undermines political representation by creating a world in which persons and representations are on equal footing. Although Pulley tries to stop him, the "loutish" Satters destroys the figure of Paine because he feels threatened. Lewis dramatizes time-philosophy's corruption of both aesthetic and political representation: *aesthetic* because Paine is a figural representation in the painting, *political* because Paine is an obvious symbol of political representation within the history of democratic thought.

In other words, Lewis's inclusion of Paine speaks to the relation between time-philosophy and all forms of representation. The literalness of time-philosophy creates a scenario in which Satters feels endangered by the representative figure that would ordinarily empower him: Paine, the author of *The Rights of Man*. In the contemporary world of time-philosophy, Paine's representation menaces him instead of defending his political personhood.[52] Satters's violent act aims to injure Paine's egalitarian political philosophy (via the representation of Paine himself) by undermining his central notions: namely, the idea that one person can represent another and proportional political representation should be based on natural and civil rights regardless of one's standing or "size" (Lilliputian or human) in society.[53] To be clear: while Lewis's buffoonish puppet Satters aims to destroy Paine's political philosophy, Satters is hardly Lewis's mouthpiece. Instead, the author believes that time-philosophy is so caustic, its perpetuation will bring about the destruction of Paine's political theory through the semi-conscious actions of characters as ignorant and volatile as Satters. Time-philosophy, instead of Paine's egalitarian democracy, must be eliminated to stop this satirical account of purgatory from becoming the new reality.

Similar ruminations on political representation appear in other Lewis texts of the period, such as *Paleface* (1927), his critique of primitivist discourse focusing on "the philosophy of the melting pot."[54] As in *The Childermass*, he struggles with how we are to understand representations of ourselves or our political ideas in a world where "the word 'free' is merely, as it were, a magical counter with which to enslave us."[55] Therefore, it is first necessary to consider "the question of how we are to define (1) a person (2) the term 'human', and (3) the

conception 'the common good,'" and only then can he relate "this law of persons" to "the law of things."[56] Although Lewis often entirely rejects ethics, here he explicitly struggles to produce an account of moral principles. His resulting philosophizing can tend toward the Nietzschean, as when he labels himself a member of the new intellectual "outlaw" class of supermen, interpreters of laws instead of subjects to them.[57] But his essential quandary, regardless of the flawed suppositions along the way, is coherent: "If, again, we cannot all be 'free' in the roman sense, or be 'persons' as were all Roman Citizens, then should we use their words?"[58] In other words, he challenges our adoption of terms such as *personhood, freedom,* and *equal representation* if the notion of persons, freedom, and democracy are unrealized or phony concepts in contemporary society. Using such words erroneously makes a figure like Paine powerless to stop a puppet-man like Satters mesmerized by time-philosophy's ideology.

Time-philosophy leads to additional political consequences that Lewis wants to avoid. In *Time and Western Man*, he warns his readers that regionalism is time-philosophy's method of political order. If time-philosophy succeeds in destroying political representations, people will be moved to order the world through each person's physical connection to the particular spot of Earth he or she calls "home." Lewis sees a preoccupation with regionalism in those literary texts absorbed with time-philosophy, such as Joyce's *Ulysses*. When Joyce relies on the "locally-coloured material" of a particular June day in Dublin, he reveals that "time-fanaticism is in some way connected with the nationalisms and the regionalisms that are politically so much in evidence, and so intensively cultivated . . . since 'time' is also to some extent a region, or it can be regarded in that light" (*TWM* 83). Time-philosophy's reliance on a particular moment leads to a reliance on where you are at a particular moment in time; this is why he argues that "'time' is also to some extent a region." A reliance on region, in turn, leads to the atavistic return of parochial nationalisms and localisms. "What has to be reckoned with more than anything else," Lewis warns, "is this movement of return to what is anchored in the soil, and sunk deep in the past" (*TWM* 304).[59] Here, he gestures away from regionalisms and nationalisms and toward cosmopolitanism and a type of universalism.

For these various reasons, Lewis's alignment of aesthetics and politics makes him a particularly interesting figure for ideologically minded literary critics, as is clear from Jameson's argument that Lewis's "lifelong opposition to Marxism" can best be located in the smallest of stylistic details in his fictional texts.[60] Jameson is entirely right to focus on Lewis's challenge to Marxism; it is both undeniable and often particularly nuanced, as in his comment, anticipating Foucault, that Marxism fails to mount a sufficient challenge to systemic social structures: "when great *wealth* is eliminated, but great *power* remains, human liberty is no way advanced."[61] Jameson locates evidence for this critique in the unlikeliest of places to present a counteranalysis matching

Lewis's. If Lewis dumps all of modern culture into a garbage heap labeled the time-cult, Jameson, in turn, gathers not just Lewis's conscious aims but also his unconscious ones (his "libidinal apparatus") into a theory of entrenched anti-Marxism. By unraveling the seeming disconnect between Lewis's style and his narrative plotting as a division with an ideological purpose, Jameson suggests that not just Lewis's ideological beliefs but his ideological critique is in some sense unknowable to Lewis himself. What he labels Lewis's "protofascism" is assigned (in ways that can feel arbitrary) to different stylistic tropes in the novels, tropes otherwise explained in formal terms but now explained in political ones.

Yet it is precisely the issue of Lewis's (supposed) ignorance of his own critique's totality, his supposed unconscious satire, that presents problems. It is hard to make sense of a form of satire in which the writer is unaware of the current problem (or at least its effects) that he is diagnosing. Jameson's argument requires a certain self-delusion on Lewis's part to avoid legitimating his "ultimate fall-back position": namely, a "defense of the rights of the visual and the painter's practice."[62] In other words, this reading necessitates denying Lewis his undeniably modern defense of the pure artist by arguing that he is really attacking Marxism and thus defending something else besides modern art. Although he admits to some anachronisms in the portrayal, Jameson prefers a protofascist, proto-poststructuralist Lewis to the blemished modernist we have, sometimes supporting fascism and sometimes supporting liberalism (or vague cosmopolitanism), all while positing a clearly idealistic ideological freedom. This vision of Lewis misidentifies his more conventionally modernist aspects: namely, his interest in contemporary forms of government and meaning's autonomy. In Jameson's account, Lewis's protofascism becomes all-encompassing and inevitable, written in an unconscious—and thus unavoidable—style. But we have seen that Lewis is not opposed to political reform, and there is little evidence in the Paine incident of *The Childermass* that he presents his critique unconsciously.[63] On the contrary, his satire is entirely conscious and deliberate; after all, he names his critical organs *BLAST* and *The Enemy*, polemical labels implying a full awareness of what he was up to. Where Jameson sees Lewis dismantling the sentence in a manner at odds with his narrative strategy, I see Lewis writing sentences that deliberately mock time-philosophy through sophisticated stylistic mimicry.

Following Jameson, many critics explore the relationship between Lewis's interest in fascism and his fictional writing at length, although as Paul Edwards points out, "the objective of much recent criticism of Lewis has been no more than to demonstrate an essential Fascism in his work," in the process sidestepping its other qualities.[64] Lewis was undeniably attracted to some form of fascism in the first half of the 1930s. *Paleface*'s account of a private "outlaw" class who are "natural leaders in the World we live in," already hints at the direction

Lewis takes in this decade.[65] In texts such as *Hitler* (1931), Lewis exhibits sympathy to his titular subject, whereas in *Left Wings over Europe* (1936) he outrageously defends German and Italian fascist imperialism at a critical moment in world history. When the reality of Hitler's impact became clear to him after a visit to Germany and the Warsaw Ghetto in 1937, he renounces his earlier positions in *The Hitler Cult* (1939).

Depictions of his works as simply promoting fascist or protofascist ideology, however, deliberately obscure Lewis's ruminations on representative democracy—reflections at odds with postmodern challenges to the Enlightenment subject or universalized liberalism.[66] Even Lewis's proto-Foucauldian comment about power and wealth ("when great *wealth* is eliminated, but great *power* remains, human liberty is no way advanced") assumes a basic interest in "human liberty." His responsiveness to nonfascist politics confounds our expectations of an iconoclastic, modernist "blaster" of representative democratic politics (à la Paine in *The Childermass*), or antiregionalist cosmopolitanism (as he proposes in *Time and Western Man*). Whereas Jameson suggests that Lewis critiqued all "middle class ideologies" and their representation in society, at the very least Lewis committed himself to one such middle-class ideology: that of the professional, cosmopolitan artist roaming abroad and supporting himself in openly democratic societies (such as the United States and Canada, where he lived for years).[67] Indeed, Lewis openly and variously identified his political affiliation as internationalist, cosmopolitan, democratic, or even liberal, a point mostly ignored in the critical fascination with his moment of fascism.[68]

In a novel such as *The Childermass*, Lewis's explicit political and aesthetic aims can and should be seriously evaluated before we throw them into doubt. He carefully considers the fate of the modern democratic state when the reigning (time) philosophies of modernity undercut representation. The pointed conversation with Paine leading to the destruction of painting is not mere happenstance but critical to his arguments. *The Childermass*, moreover, is just one part of Lewis's massive production of satirical texts, all written with the aim of establishing the cultural ground for his own work. It was an endless and enemy-producing task, but his intentions were clear. By discrediting time-philosophy and its frameless art manifestations as not only destructive of art but also politically retrogressive, Lewis clears a space to challenge contemporary ideologies with his own art. He thus begins to envision the artistic possibilities of a version of meaning's autonomy (unintentionally) closely aligned with Stein's. Where Stein removed air and commas to undermine the physical frame while maintaining the conceptual frame of an art object, Lewis produces an art that can preserve representation and its conceptual frame at all costs, even if the imagined disaster of contemporary time-philosophy and its aesthetic formations did not abate in the years that followed.

THE ART OF THE BEETLE SHELL

We have seen thus far how Lewis theorizes the distinction between art objects and their outside life in the world beyond the frame—as a satire of its art object, as an attack on time-philosophy, and as a defense of representation writ large—but we have not yet seen a positive aesthetic alternative to this time-philosophy. That substitute emerges as Lewis's theory and creation of an art object that I call, following his memorable example described shortly, "beetle shell art." He develops this alternative gradually by formulating a unique compromise between two starkly opposed aesthetic theories. The paintings and drawings that decorate the covers of *The Enemy* reveal this negotiated compromise in a visual form, whereas his novels illustrate his active debating of these conflicting theories exegetically.

One theory is instantiated in Victor Stamp, the penniless painter of Lewis's late (and often considered best) novel, *The Revenge for Love*, and the other in Joseph Potter, a painter who appears late in *The Childermass*. Victor is the prototypical struggling painter, dejected by his lack of professional success. "No one should waste their time on *me*," he complains to his wife, Margot, before beginning the day's painting, "I'm a bloody washout!" (*RL* 75). The source of his distress has a real cause: he is unable to sell his paintings and thus establish himself as an artist in British society. Initially rationalizing this failure as the result of his provincial foreignness, he eventually acknowledges the larger problem: he cannot successfully render his intentions into any actual paintings. One of his paintings is "not worth the sail-cloth it was painted on: a thing outside himself that *would* not do what he wanted it to do: a monument of his inability to bring anything to life outside himself at all" (*RL* 82). Victor's problem is not that he lacks imagination or taste but that "he had reckoned without his *hand*. For his hand had proceeded to do something entirely different from what his eye had told it" (*RL* 82). His final self-criticism: "Victor Stamp would never make his mark. He was no good as an artist" (*RL* 83).

According to Victor, the essential criterion of art is not the conceptual idea of a painting—"what he wanted it to do"—but the successful manifestation of that idea on a canvas—"a thing outside himself" that the artist brings to life. But his hand stymies him, not allowing him to make good on his signature, and "The stake was Victor Stamp, Esquire, no less" (*RL* 82). In other words, the stake is his identity as an artist, every time he puts brush to canvas, and he repeatedly fails to realize this identity. His signature is so worthless that he is unperturbed when he learns that his (supposed) friends practice forging it. We might even say that Lewis practices forging it, because he twice includes his own hand-scripted depiction of Victor's forged signature into the text.

On only one occasion does Victor produce a piece of unique art. After his lament to his wife, he presents himself with a do-or-die scenario, fights his bad

habits, and manages to produce "a good thing": a still-life of their kitchen table "as a red monochrome" (*RL* 85). His artist friend Tristam and the narrator agree with Victor, who observes this singular work with pride: "He did know a good thing when he saw it—his training had taught him that much. And this was a good thing" (*RL* 85). Yet this victory is tragicomic: because he only has a history of producing bad art, his one object of good art fails to make its mark: "it was worth nothing . . . unless it had a Name attached to it (and Stamp was not a name) and not much then" (*RL* 85–86).

Victor stands in sharp contrast to that other artist Lewis conjures up: Joseph Potter, the painter introduced in the middle of *The Childermass* after Pulley and Satters have destroyed the frameless panorama and the possibility of actual representations. Potter manifests a completely different theory of art. Unlike Victor, Potter relinquishes the actions of his hand without anxiety. He is satisfied to draw "a sort of mental picture of what is before [him]" because the godlike Bailiff of purgatory (an embodiment of the time-philosophy Zeitgeist) will not persecute him if he promises "to carry [his] profession altogether inside [his] head" (*Ch* 252–54). As the Bailiff points out while interviewing Potter for admittance, "If you were not born a painter then it would be better to say something else—bank-clerk, for instance. We much prefer bank-clerks to painters" (*Ch* 251). Although Potter is unwilling or unable to submit to capitalism's preferred role for him, he does silently agree "to eschew all *outward* manifestation of [his] talent" (*Ch* 254), which means he also forgoes speech. The Bailiff allows him past the gate only after confirming his innocuousness "Luckily very little paper is manufactured by us, we have no books, pencils are unknown, he can't do much harm what do you think? . . . Pass Joseph Potter in!" (*Ch* 255). Because Potter does not add literal art objects to the world he is not a threat to the Bailiff's time-philosophy. Even with these draconian restrictions, he remains an artist via the creations in his head: "'I think I notice, Joseph Potter, that even at this solemn moment you are engaged in drawing a sort of mental picture of what is before you. Am I right?' Potter smiles" (*Ch* 252). The Bailiff is obviously correct. For Victor, *The Revenge for Love*'s painter, a "successful" representation works formally and succeeds through its high price: the object's monetary value represents the professional success of the painter who creates it. For Potter, in contrast, whether he is able to manifest (let alone sell) his art in the world is irrelevant to his status, and the material production of art is not a condition of being an artist. From these two examples, it seems that Lewis can't decide which account of the successful artist he wants to promote and is seeking a third way.

In his theoretical writings, Lewis sometimes advocates Victor's view of art and sometimes promotes Potter's. In *Blast* 1, he writes that "at any period an artist should have been able to remain in his studio, imagining form, and provided he could transmit the substance and logic of his inventions to another man, could have, without putting brush to canvas, be the best artist of

his day."[69] Imagining form without making new forms, this artist would be identical to Potter. Similarly, in *Caliph's Design*, his early book of art theory, Lewis argues that it is not for the artist's sake that work must be physically realized, but because the spectator requires it: "I can get on quite well, the artist always can, without this material realisation. Theoretically, even, a creative painter or designer should be able to exist quite satisfactorily without paper, stone or paints, or without lifting a finger to translate into forms and colours his specialised creative impulse."[70] He imagines precisely this theoretical possibility—the audience not only irrelevant but nonexistent—with Potter in *The Childermass*, aligning himself with this *entirely* conceptual artist by describing Potter's visualizations as distinctly Vorticist: Potter "is soon absorbed in disemboweling [an object] by planes and tones, and rearranging everything in a logical order" (*Ch* 254). Such a scene also resembles Stein's observation about Picasso's Cubist photographs (namely, that "by the force of his vision it was not necessary that he paint the picture" [*GS2* 509]). From this perspective, the problem with Victor's theory of the artist is that it places too much emphasis on the circumstances and interpretations of the art object in the world (as Victor laments, "it was worth nothing . . . unless it had a Name attached to it"). Not only does this situation lead to the creation of a social phenomenon instead of an aesthetic one, the interpretations spectators have of his painting might also be understood as relevant to the painting's meaning and worth, as in the case of the time-painting of *The Childermass*.

The pendulum between the theories swings back and forth. As taken as he is by Potter, a world of Potters leads to a situation in which anyone, including bank clerks who spend their time dreaming up paintings, might be labeled an artist. This scenario is repugnant to Lewis, not least because it could swell the ranks of the profession to include anyone with an artistic thought, undermining the prestige of the "artist" class. More dangerous, it would mean works of art would disappear, for if the art object is withdrawn from the world entirely or is made merely ancillary to it, one is left with lots of Potters and lots of artless air. This was a real anxiety for Lewis on both a personal and a cultural level. Complaining to gallery director Oliver Brown about his lack of exhibitions and about the Tate Museum's careless treatment of the single drawing of his they owned (they left it to rot in a flooded cellar), Lewis explains, "It is that I am *completely* unrepresented, that is the point I am labouring."[71] To remedy this lack of representation for his representations, Lewis sometimes turns to envisioning artists on the model of Victor, striving against his difficulties to produce at least one painting in the world that could count as an indelible, always valuable artistic signature. Moreover, Victor's painting style resembled Lewis's in the mid-1930s: the first painting Lewis ever sells to the Tate (thanks to Brown's intervention) is titled *Red Scene* (1933), echoing Victor's one successful "red monochrome" painting. Lewis paintings such as *Red Portrait* (1937) and *Froanna—Portrait of the Artist's Wife* (1937) are also dominated by

hues of red (they were painted the same year Lewis published *The Revenge for Love*, further supporting the identification between him and Victor). In addition, Lewis models Victor on himself by depicting his character as a roguish foreigner struggling to sell his art to British museums. Although Lewis is almost always identified as an English writer and painter, he spent the first years of his life in New England. Born on his father's yacht moored near Amherst, Nova Scotia—his father was a wealthy, upstate New Yorker—Lewis maintained a transatlantic affiliation throughout his life.

Clearly Lewis struggled with this conflict between Potter's theory of the artist and Victor's. Perhaps it is always an irresolvable conflict in art, a struggle between conception and concrete manifestation reformulated in movements such as Dada, Conceptual, and Performance art. But Lewis tries to resolve the conflict by imagining his literal signature—call it the failed stampiness of Victor Stamp—as something that could perpetually link conception and realization, thereby sealing representation's uncertain fate in the world of time-philosophy. In an essay from *Caliph's Design* (1919) titled "The Artist Older than the Fish," Lewis compares the artist's creative capabilities—that is, "to make something; and *not to make something pretty*"—to the "creative capabilities of certain beetles, realisable on their own bodies; beasts with a record capacity for turning their form and colour impulses into living flesh."[72] What fascinates Lewis about beetles is their ability to alter the designs on their shells to adapt to changing environmental conditions: "Such changes in their personal appearance, conceived to work on the psychology of their adversaries, is possibly not a very profound or useful invention, but it is surely a considerable feat. Any art worth the name is, at the least, a feat of this description . . . any invention or phantasy in painting or carving is such."[73] As he describes it, the morphing beetle shell suggests a fantasy of avant-garde art as a natural process of creation and Darwinian competition. Beetle shell art develops according to evolutionary forces and works on one's adversaries, or audience members, without requiring explanation in the form of dozens of pamphlets, fierce essays, and satirical novels that Lewis spent much of his life writing. It has a certain natural force. Moreover, suddenly coming across a visually striking beetle, whose message ("I'm poisonous!") is instantly comprehensible, corresponds to Lewis's goal for painting: "to display a strange world to the spectator" so that she will be "startled into attention by an impressive novelty."[74]

The key detail is that the beetle manages to produce something like an *objectless* art. By turning "form and colour impulses into living flesh" without adding any additional objects to the world, the artwork is simply materialized on the beetle's body instantaneously. Intentions are realized with no new objects created; this is painting that avoids contending with objecthood at all. Simultaneously, in a certain sense beetle art is distinct from life: only the beetle's shell is altered, not the beetle's inner physiognomy. As with body painters or tattoo artists, this art is on the skin (or shell) of the artist. In contrast,

a real painting out in the world takes a chance that its characteristics as a thing will overcome its status as art. As with the failed art of Victor, the artist might not be able to turn a thing into a painting (that is, a thing phenomenologically distinct from the artist's life—"a thing outside himself"), and in the worst case, that of time-art, a painting frame that fails as a painting might be mistaken for a window frame, and Satters and Pulley might simply stroll right through it. Beetle art avoids these possibilities.

So we might say that painting like a beetle—or, more precisely, having the same relationship to painting as a beetle has to the markings on its shell—is Lewis's aesthetic goal. Victor and Potter are two near attempts at this theory of beetle art, yet Lewis did not exactly want to imagine his artwork as another ordinary object in the world (like all but one of Victor's paintings), nor did he want it to escape manifestation entirely (as do all of Potter's). Instead, he repeatedly produces drawings of his signature mark. In this regard he is like Victor, determined to "stamp" his signature on the world. He also imagines this drawing-signature as his own mental picture of the world, like the drawing on the beetle's shell. In this regard he is like Potter, who does not need to produce any more art objects out in the world. By imagining his mark as both an object and a nonobject, Lewis envisions a way to maintain representation despite its perilous status—as evidenced by Paine (and a representation more generally) stamped out of existence by Satters. He aims to resolve the paradox of Victor's and Potter's theories by conceiving of and stamping his signature as a totemic object that is always a portable self-portraiture. This signature is a literal mark of his identity as a professional artist—a concrete mark in the real world—but it is also a symbolic representation that only could signify as such in the art world—the world of representation.[75]

We can see examples of such stamps beginning in the early 1920s, as Lewis produces imaginative, semi-abstract drawings and paintings resembling totems. Each one is usually drawn on a single page until they appear in their best instantiation on the covers of *The Enemy*, the combative magazine Lewis not only edits and publishes on his own but also illustrates. One of these attempts at totemic self-portraiture appears as a simple, striking image placed on the cover of the magazine's first number (1927), in which Lewis reveals his turn to beetle imagery to identify his social position (figure 2.1). In this intricate, vibrant watercolor painting, a cultural warrior represented as a stylized knight (wielding a paintbrush/sword) rides an oddly miniaturized pony. Triangular plates of red, blue, and green delicately encase the humanoid (or, perhaps, insect) form, and bright spots of outlined color highlight joints in the armature, identifying knees and ankles. These eye-like spots might also serve to frighten potential predators, like the "false eyes" on the inner wings of some moths and butterflies that mimic owl eyes. When our gaze moves up the beetle-knight form, shapes flatten out and the humanoid aspects become unrecognizable. The shoulder joint is

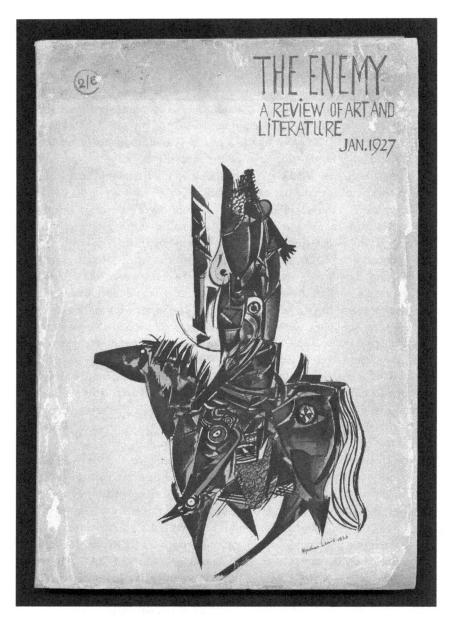

Figure 2.1 Wyndham Lewis, cover of *The Enemy*, no. 1 (1927). © By kind permission of the Wyndham Lewis Memorial Trust (a registered charity).

identifiable, but it is hard to determine exactly where the head begins or ends, or where his face, or even his mask, might be. The elaborate helmet fits of a piece with the body, suturing evenly together in precise rounded plates—like the hard exoskeleton of a beetle—but the neck and chest seem

to disappear into fractured, abstracted shapes. A bright yellow teardrop with a black pupil pushes out where we might expect a face (another false eye), yet the brown shell shape next to it, presumably the face itself, is an eyeless, oval blank. In sum, this beetle-knight disconcerts: a figure that initially feels recognizable becomes utterly alien and hostile under closer scrutiny. However odd it appears, the form dramatizes Lewis's self-representation as the culture soldier, the brave knight saving the world from time-philosophy, while his distracting "false eyes" and the absence of an obvious face defies any gaze of identification with a member of the human species.

This picture, I suggest, represents the enemy artist as beetle. The true artist, writes Lewis, "stands outside of life altogether. . . . He is the perfect outcast—more than any tramp" (*RL* 293). For the same reason, we cannot identify with the beetle-knight enemy—even if we agree with his cultural critiques—because his type and status exile him from society, albeit in such a way that he always maintains a negotiated relationship to that society (as bugs always do). We might say that Lewis's artistic outcast-warrior is an attempt to imagine the heroic beetle-artist as a distinct, professional class minus its members: "I had all the confidence of a herd—that was not there."[76] *Rude Assignment* (1950), Lewis's autobiography, focuses overwhelmingly on precisely this aim, the need for a class of professional working artists and on "*the nature of this type of work*, and about the paradoxical position of the workman—not myself alone—engaged in it."[77] Admiring Franklin Roosevelt's Works Progress Administration projects, he clarifies that this professional class must be sustained by a public structure for art in society because money "does not buy a function in a society."[78] The desire for a professional place within society, established in the taxation structure, motivates his magazine. Dramatizing himself as the "solitary outlaw" waging campaigns of "cultural criticism" against modern Western art and society (that is, the professional artist at work), he also clarifies that his "particular note of solitary defiance . . . what must have seemed an exaggerated individualism" was due "to a sense of *typicalness*: of a type out of place."[79] In other words, it is most crucial to Lewis that he represents himself totemically or sociologically as a type, albeit one that—he feels—barely exists in early twentieth-century England. Making *The Enemy* a serial production, presenting himself as its editor instead of its author, and lending it legitimacy via a fake publishing house were all devices to present this work as more "typical" of a professional artist.[80]

Furthermore, by creating his own emblematic totems that are recognized by other self-identified members of the tribe, wherever they might be hiding, he institutes and publicizes a clan for himself, replacing hereditary modes of identification with professional modes. The picture on the cover of *The Enemy* is the authentic totemic object of the outcast Enemy—that is, the signature of Lewis as a member of the professional avant-garde tribe. It is a form of self-representation—much more difficult to forge than Victor's signature—that

establishes a distinct relationship between art and life via the symbolic image. But these images of himself as a beetle are duplicatable and transformable, like a stamped emblem (or a beetle shell) that evolves over time: I take this to be Lewis's point in printing a different, bug-eyed totemic image twice (albeit smaller) on the cover of the third and last issue of *The Enemy* (see figure 2.2). Although these images are less beetle-like overall, their veiled bodies and horse-like bottoms suggest a similar man-beast amalgamation. More important, perhaps, their portability and iterability (all he needs to produce them is a pen and paper) make them a potential technology of cosmopolitanism, useful when he decided to move to Canada in 1939. In contrast to the regionalism and nationalism implicit in time-philosophy, his totemic stamp allows him to stay connected to his professional avant-garde clan (and by association, vestiges of North Americanness) while traveling all over the world and painting society portraits.

Finally, we might compare Lewis's totemic stamp on the covers of *The Enemy* to the scene of Victor Stamp striving to make his mark in the world. As the novel continues, Victor (increasingly indigent) eventually goes to work at a Van Gogh forgery factory, where he is paid a weekly salary to paint replicas of Van Gogh's "lost" masterpieces. This job ends shortly. When the factory owners decide his painting of Van Gogh's self-portrait (complete with ear bandage) is not yet finished, he rebels in disgust, definitively finishing the picture: "Throwing the picture down against the wall, he trod into the centre of it, putting all his weight upon his foot, which tore through the canvas . . . Stamp planted his heel upon Van Gogh's 'intelligent' eye, and ground it round and round with gusto" (*RL* 239–40). Just in case his point is not entirely clear, Lewis explains that this destructive act is Victor's signature gesture:

> Freddie indicated with his finger what first had been the work of Stamp's hand and had ended by becoming the work of Stamp's foot. *Victor Stamp—his mark!*
>
> They all looked at the badly battered oil painting upon the floor. No one left in the workshop after Stamp had withdrawn would have been capable of such a piece of work as that—such a piece of footwork in contra-distinction to handiwork. (*RL* 243)

If Victor had failed to make his mark as an artist by putting brush to canvas, he now definitively signs his "work" with the damaging mark of his foot.

Victor can only embody his name through performance—this one grand and ultimately destructive gesture ("such a piece of footwork in contra-distinction to handiwork"). In a sense, such a performance is his attempt at beetle art, producing a timeless art both on and of the body. It is indubitably a failed attempt: the performative act required to complete the work marks it as a piece of time-art, precisely the type Lewis spends his life satirizing. But Lewis's novels and drawings improve on Victor's attempt to stamp his mark without

THE "ENEMY" IS THE NOTORIOUS AUTHOR, PAINTER AND PUBLICIST, MR. WYNDHAM LEWIS. HE IS THE DIOGENES OF THE DAY: HE SITS LAUGHING IN THE MOUTH OF HIS TUB AND POURS FORTH HIS INVECTIVE UPON ALL PASSERS-BY, IRRESPECTIVE OF RACE, CREED, RANK OR PROFESSION, AND SEX. THIS PAPER, WHICH APPEARS OCCASIONALLY, IS THE PRINCIPAL VEHICLE OF HIS CRITICISM. ☰ FOR CONTENTS OF THIS ISSUE SEE BACK COVER.

WYNDHAM LEWIS

Editor.

Figure 2.2 Wyndham Lewis, cover of *The Enemy*, no. 3 (1929). © By kind permission of the Wyndham Lewis Memorial Trust (a registered charity).

making another piece of time-art. Where Victor destroys "Van Gogh's" false eye, Lewis creates the Enemy's impermeable false eyes as the beetle-knight's armor. He signs his name to *The Revenge for Love* by producing a fiction of Victor becoming the totemic object when his foot goes through bad art, substituting a narrative representation of the episode for a time-based performative act. The destruction of air-filled art is the Enemy's signature gesture par excellence, precisely what Lewis spent his entire life aiming to perform in his essays and satiric novels. It is also the analogous instance of the scene in *The Childermass* with which this chapter begins: Satters and Pulley step through and thus destroy the panoramic painting, stamping out a representation of Paine in the process. Repeatedly putting his foot through false eyes and bad art to make a representation, Lewis balances his work on a knife edge between blindness and destruction on the one hand and vision and creation on the other, between the art object's imagined nonexistence (in the world of Joseph Potter) and tenuous existence outside of the artist's head (in the world of Victor Stamp). In doing so, he also stamps his signature as a modern, cosmopolitan artist of framed representation.

3

⌒ᘰ⌒

Breaking Glass to Save the Frame

William Carlos Williams and Company

And yet American verse of today must have a certain quality of freedom, must be "free verse" in a sense. It must be new verse, in a new conscious form . . . It must be truly democratic, truly free for all—and yet it must be governed.
—William Carlos Williams, "America, Whitman, and the Art of Poetry" (1917)

WINDOW FRAMES, REVISITED

In the 1920s, William Carlos Williams's friend and fellow poet Mina Loy reworked certain Futurist and Dadaist ideas, forcefully countering traditional accounts of aesthetic framing. As the "it-girl" for avant-garde movements at "the radical edge of modernism" (in Cristanne Miller's words), Loy simultaneously questioned the integrity of the frame and insisted on the absolute inseparability of art and life, implying the opposite account of the relationship between the art object and spectator we examined in the first two chapters.[1] Her 1924 letter published in the *transatlantic review* puts the matter starkly. She chastises readers ignoring the impact of modernity and modernism:

> Modernism is a prophet crying in the wilderness of stabilized culture that humanity is wasting its aesthetic time. For there is a considerable extension of time between the visits to the picture gallery, the museum, the library. It asks what is happening to your aesthetic consciousness during the long long intervals?
>
> The flux of life is pouring its aesthetic aspect into your eyes, your ears—and you ignore it because you are looking for your canons of beauty in some sort of

frame or glass case of tradition. . . . Would not life be lovelier if you were con-
stantly overjoyed by the sublimely pure concavity of your wash bowls?[2]

Echoing her former lover Marinetti's contempt for museums ("Museums:
cemeteries!"[3]), Loy argues that one must seize the moment, accept the
impact of modernism, and recognize the beauty of unexpected, lowly, con-
temporary objects. Instead of experiencing modern art and literature at
particular times, such as when we pick up *Ulysses* or visit the Armory
Show, she asks us to acknowledge the everyday experience of both moder-
ni*ty* ("the flux of life") and moderni*sm* ("its aesthetic aspect") in daily life.
We should accept the aesthetic even when it appears, surprisingly, in the
morning bath.

When Loy writes that we mistakenly look for beauty "in some sort of frame
or glass case of tradition," she asks us partly to recognize the shock of art in
unaccepted ways and places (such as Duchamp's urinal turned on its side,
placed on a pedestal, and labeled "Fountain").[4] But she also makes the point
that picture frames and glass cases are similarly flawed examples of "stabi-
lized culture." Both cut off the spectator from "the flux of life"—the living
world of the art object—thus making art appear sterile, lifeless, and free of
air. Her logic implies that frames and glass cases function similarly: painting
frames (by keeping the "flux of life" out of the painting) and glass cases (by
preserving the art object from the supposedly corrosive effects of the "flux of
life") do equivalent work. That work, to Loy, is the truly corrosive aspect of
tradition. In effect, it is the work of *window* frames—separating two environ-
ments while permitting each to be mutually viewable. If a frame traps a
painting in the stifling, airless atmosphere of the museum just as a sealed
glass case removes a precious object from the world, then the physical world
as we experience it can enter—and should be allowed into—art. To free the
modern painting, we must eliminate the windows: the painting frames and
glass cases of tradition.

This particular discourse about frames as windows circulated in the early
1920s in little magazines such as the *transatlantic review* and *Apple (of Beauty
and Discord)* by Loy, Ezra Pound, and other poets. Like Marinetti and Loy, in
the early 1920s Pound was deeply critical of museums such as the Victoria and
Albert for ensconcing objects of aesthetic merit in the mausoleum of the past,
as Catherine Paul describes.[5] In "The Curse" he complains that taste has
"leak[ed] away into . . . the plate-glass cabinet in the drawing-room" and thus
out of our daily life: "we have lost the faculty to perceive beautiful form save at
the set moment when we are ready for the aesthetic tickle."[6] In response, Paul
rightly suggests, he seeks a creative modernism removed from the realm of
the stuffy museum collection to both renew art and reenergize the museum.[7]
On the topic of the museum's fate Marinetti and Loy ultimately diverged from
Pound (who was clearly more optimistic about improving museums), but they

all shared identical views of the typical museum picture frame: a closed window that suffocates art.[8]

In earlier chapters, we saw how Gertrude Stein and Wyndham Lewis both reject precisely this account of the interchangeability of windows and paintings: they characterize the frame of a painting as critically, even ontologically distinct from a window frame. They argue that windows set in frames might keep cold air out, but that air is essentially the same as the air we breathe. Pictures set in frames, in contrast, do not keep the cold air separate from the warm inside air. They do not separate different kinds of air at all. Instead, Stein realizes, pictures are different from windows precisely because they *don't* contain air: "there was no air, there was no feeling of air, it just was an oil painting and it had a life of its own" (*GS2* 227). Her point is that what makes pictures distinct from the world is that we can't breathe the air a picture depicts, an observation, she suggests, of relevance to literary interpretation. What we do as spectators or readers (breathing in air) has nothing to do with the world of a painting or a poem. Stein and Lewis aggressively reject the window frame as picture frame not just to illustrate the irrelevance of the spectator to a painting but also to explain the irrelevance of the reader to the meaning of a text. A piece of writing succeeds as a complete thing by ignoring the reader and the reader's breath, a relation of the spectator's or reader's bodily freedom that they frame in the language of civil liberties. Whereas Loy wants art reconnected to politics and imagines that eliminating frames is the way to do so, Stein and Lewis understand the painting frame as simultaneously protecting art and defending a liberal politics of bodily freedom.

Williams, publishing in the 1924 *transatlantic review* where Loy complained about "frame[s] or glass case[s] of tradition," struggles to formulate a coherent response to the problem of the frame that differs from those explored in the previous chapters. His view, more than others, significantly anticipates the poetics of the post–World War II generation, filled with artists and writers who understand art's role as eliminating the frame separating an audience member from the art object. For this reason, despite his works' earlier publication date, I treat him at this slightly later moment in the book. Sometimes he follows a version closer to that of Loy and Pound; other times he tracks a version closer to that of Stein and Lewis. His is an extensive aesthetic, poetic, and political compromise, one that explores—before ultimately reimagining—the idea that frames operate like windows. Seeking to enable and support the spectator's experience, often by using the language of democratic inclusiveness, he simultaneously looks for a frame to limit that experience, ultimately bringing the focus back to the poem as a formal object. He compromises between an art that rejects incorporating the spectator's world and an art that insists on it. By drawing out Williams's own internal debate about framing, we can better understand his sometimes complicated

position within modernism and make better sense of his impact on a later generation of poets.[9]

With that aim in mind, this chapter moves between different accounts of framing (from Loy's, Pound's, and Duchamp's to Stein's, Apollinaire's, and Juan Gris's) to situate discussions of meaning's autonomy as they first began to transform into a poetics of incorporation, or as Williams's famous dictum has it, to "no ideas but in things." The notion of the painting frame as paradoxically both containing and limiting the things that we experience is not Williams's alone but part of a discussion about frames that focuses on their commonalities with windows as ordinary, worldly objects. Duchamp's "window paintings" (discussed in the next section) particularly grabbed poets' attention, presenting options for Williams in *Spring and All* to respond to both Loy's and Pound's notions of framing. Although Williams's interest in Dada has been discussed, the movement's broad strokes are less a focus here; instead, my interest is in a particular Duchampian problem and its impact on poetics.[10] The last sections of the chapter show how Williams responds to this problem with two works published the same year. The first is "Flight to the City," a poem in *Spring and All* (1923) that integrates aspects of readers' experiences while simultaneously attempting to limit the relevance of that experience to the poem's meaning. The second is *The Great American Novel* (1923), an unconventional narrative that focuses particularly on the idea of maternal progress—the major goal of the 1921 Sheppard-Towner Maternity and Infancy Protection Act—as a stand-in for personal and social liberty. Slighting the role of the state, Williams implies that a novel rewarding readers' freedom to make meaning can best support social and aesthetic progress, a form of freedom of the self and society more broadly understood.

Like the other writers discussed in the book, Williams understands his formal poetics—whether expressed in poems juxtaposed with prose or in experimental novels—to facilitate political results in the world. Looking for a way to marry the reader's civil liberties with the artist's formal self-determinations, he alights on a compromise: a frame that distinguishes the world from the work in some ways, while in other ways merging with or incorporating the reader's worldly experience. With this conception of the frame he aims for a poetry that is "truly democratic, truly free for all—and yet it must be governed."[11] In later chapters of the book, we will see various riffs on the idea of an art that aspires to embody democratically-governable liberty. It appears in the struggle of mid-century writers, such as William Gaddis and Elizabeth Bishop, who tackled the democratic "equality" of kitsch against the power of an art that cannot be touched by the spectator. It also appears, more enthusiastically, as the hallmark of Charles Olson's projective poetry, inclusive of the body, and that of a host of contemporary writers and theorists searching for an alternative to universalism by bringing breath into their writing.

BREAKING GLASS

In one sense, the alignment between painting frames and window frames is unremarkable. The history of western art is also a history of picture frames (if not glass cases) understood as windows onto another world. This history might begin with Leon Battista Alberti's fifteenth-century description of the picture frame as "an open window through which I see what I want to paint," and Leonardo da Vinci's claim that "perspective is nothing else than the seeing of an object behind a sheet of glass."[12] By the nineteenth century, an expanded window/painting metaphor informed the development and theorization of realism such that French art critic Charles Blanc used "the window metaphor" to describe naturalism, and Emile Zola praised Monet's paintings as a "window open to nature."[13] For these painters and theorists, the window was used "as a heuristic device, as a metaphor that facilitated pictorial practice."[14] By the first decades of the twentieth century, when Georges Braque challenges the window metaphor—and referentiality more generally—by painting a violin in a way no one could ever actually see it (from three different vantage points simultaneously), he is not suggesting that his painting is interchangeable with a window but that it might be possible to abstract visual representation without losing the particularity of the violin. Whereas paintings through the nineteenth century were frequently formulated as metaphorical windows onto another world, and then, with Braque's and Picasso's analytic Cubism, *challenged* as metaphorical windows, by the 1920s writers like Loy and Pound were implying that aesthetic frames around art literally functioned like windows, albeit negatively. Frames blocked the "flux of life" from art. Duchamp's various "window" works from the teens and early 1920s, such as his masterpiece, *The Bride Stripped Bare by Her Bachelors, Even* (also known as *The Large Glass* [1915–23]), take this idea of pictures as windows and realize its aesthetic possibility.

Around 1912, Duchamp replaces the traditional canvas stretched over a wooden support with four sheets of clear glass held in place by a metal frame (figure 3.1). The *Large Glass* is the best known of Duchamp's "window" works, although others such as the *Small Glass* (1918), *Fresh Widow* (1920), and *The Brawl at Austerlitz* (1921) also fold together the window frame and picture frame by transforming modified windows into standing sculptures.[15] Each takes the idea of pictures as windows and dramatizes it anew. Inside the layers of the *Large Glass* is a convoluted and baffling diagram of frustrated, mechanized courtship: the "virgin bride" of the top half of the glass (represented in part as "draft pistons") is seduced by—and plays a hand in seducing—the "bachelors" of the bottom portion (represented in part as a "chocolate grinder" and "malic molds"). Despite the diagrammatic representations of courtship, the work's most noted characteristic is transparency: "The best part of *The Glass* is that it is a windowpane to look through; its actual configurations are forced into accord

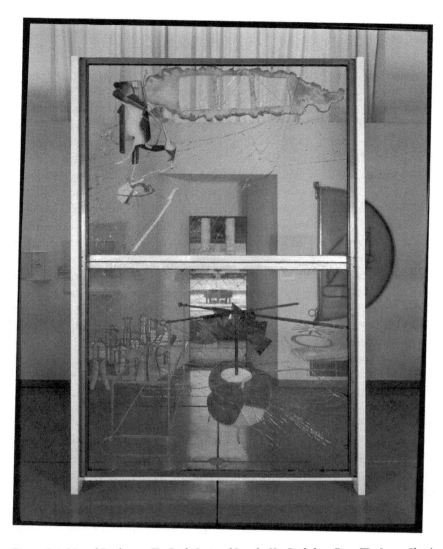

Figure 3.1 Marcel Duchamp, *The Bride Stripped Bare by Her Bachelors, Even (The Large Glass)* (1915–23). © 2010 Artists Rights Society (ARS), New York /ADAGP, Paris/Succession Marcel Duchamp. © The Philadelphia Museum of Art /Art Resource, New York.

with the visual environment beyond them, for instance, a chocolate grinder superimposed on a kid picking his nose."[16] As Allan Kaprow suggests in this description, even if the "windowpane" only opens onto another part of a gallery (where a kid picks his nose), the *Large Glass* is a window nonetheless. The frame effectively allows spectators to be incorporated into the artwork: first, by making our experience of looking through a window crucial to the painting's meaning, and second, by seeing other spectators through the work as one is

intently trying to look at that work. The object's current placement in the north wing of the Philadelphia Museum of Art, a collaborative installation between Duchamp and the curator, accentuates the comparison between window frame and picture frame: the *Large Glass* is set several feet in front of a floor-window (in fact, the only floor window) in gallery 182.[17] Looking at the *Large Glass*, we also look through to the window behind it to see the south wing of the museum.

On one level, Duchamp is simply replacing painting frames with window frames, swapping one type of background (defunct canvas) for another (industrial plate glass). But more precisely, a painting like the *Large Glass* negotiates between window frames and painting frames. Duchamp's copious notes, which he considered part of the work, suggest as much. On the one hand, he tells himself to focus attention on the work as a window. He explains that it should not be understood as a painting, reminding himself to "Use 'delay' instead of picture or painting."[18] Thus the work is not a "picture on glass" but a "delay in glass."[19] He feels that the *Large Glass* is a medium—not a painting—that impedes (delays) our vision of a scene through a window (light slows down and diffuses when passing through any medium). On the other hand, Duchamp offers more complicated and qualified explanations of the work as a traditional painting. Despite claiming not to be producing a "picture" and reminding himself not to use the term "painting," he often describes the *Large Glass* in just these terms: "the cinematic blossoming is the most important part of the painting."[20] He portrays it as "a long canvas, upright," which closely follows traditional painterly proportions (the Golden Mean is 1:1.60; the *Large Glass* is 1:1.58).[21] If the *Large Glass* is not exactly a window to step through, neither is it precisely a painting with a surface to be looked at, separate from the viewer's world. Instead, it is a surface to be looked through: a "painting" on a "canvas" trapped inside a window.

By melding the window frame and painting frame together, the *Large Glass* circumvents the traditional aesthetic components of painting. Duchamp avoids the canvas and its wooden support, rejecting the expected relationship between a representation (a painting's content) and its physical properties of surface and structural support (the canvas and its frame).[22] Hence, the significance of the phrase "delay *in* glass" instead of "painting *on* glass" (emphasis added). The paint and other materials between the two sheets of glass have not yet arrived at any one place but are delayed in suspended animation between two surfaces. This is why he colors the glowing sieves above the coffee grinder with the actual dust balls spawning on the surface of the *Large Glass* as it lay for months in his studio, as documented in Man Ray's photograph *Dust Breeding* (1920) (figure 3.2). By "painting" with the dust caught between two planes of glass instead of using oil paint adhered to a canvas surface, Duchamp captures the temporal life of the object in its very composition. It is literally an open window on the world of his New York City studio circa 1920. Dust, slowly floating through air and eventually falling on objects, is the physical evidence of air over time, air as experienced through an open window, now trapped inside a painting and its frame. Duchamp's

famous acceptance and even preference for the disfiguring cracks that the *Large Glass* later acquired in transit supports this idea: his window paintings visually obstruct or physically delay the transparency that windows typically provide.

We know from Williams's *Autobiography* that he saw the *Large Glass* in Duchamp's studio, singling out the work as simultaneously challenging, intimidating, and inspiring.[23] More important, he chose to adapt Duchamp's formulations about glass windows for his own account of framing. As critics note, in two different pieces of prose writing from this period Williams alludes to and supports the description of modern painting provided by his friend Walter Arensberg: "According to Duchamp, who was Arensberg's champion at the time, a stained-glass window that had fallen out and lay more or less together on the ground was of far greater interest than the thing conventionally composed in situ" (*I* 8).[24] This anecdote, from "Prologue to *Kora in Hell*" (1920), accords both with a work like the *Large Glass* as well as with Duchamp's readymades, yanked from their in situ environment to be transformed, ex situ, into art. Duchamp describes Dada "as a way to get out of a state of mind—to avoid being influenced by one's immediate environment, or by the past," and the ex situ art object dramatizes this scenario quite literally.[25] By publishing a series of poems in the March 1919 issue of *Poetry* with the group title "Broken Windows," Williams appears to endorse the example himself.[26] He also alludes to

Figure 3.2 Man Ray, *Dust Breeding* (1920). © 2010 Man Ray Trust/Artists Rights Society (ARS), NY/ADAGP, Paris. © CNAC/MNAM/Dist. Reunion des Musees Nationaux/Art Resource, New York.

the fallen-window anecdote in *The Great American Novel*, referring to the shattering of a stained-glass "rose window" as a paradigm of successful avant-garde writing: "One word: Bing! One accurate word and a shower of colored glass following it" (*I* 170).

With these examples in mind, we might reasonably expect Williams's writing from this period to be hostile toward the idea of constricting frames. A poem such as "Rendezvous" (1914) fulfills that expectation, providing a clear explanation of both his opposition to aesthetic framing and his aim for avant-garde writing. Similar to Marinetti's and Loy's stance on frames, here he imagines avant-garde poetry as the long-lost contact between the poet and the wind of the world:

> My song! It is time!
> Wider! Bolder! Spread the arms!
> Have done with finger pointing.
> Open windows even for the cold
> To come whistling in, blowing the curtains:
> We have looked out through glass
> Long enough, my song. (*CP1* 36)

By urging his poem to relinquish "finger pointing"—both the act of blaming others and, here, a gesture of distancing—the speaker insists on a new aim for representation because "finger pointing" implies a hostile relationship between sign and referent. In response, the speaker implores his poetic song to practice a kind of semiological calisthenics ("Wider! Bolder! Spread the arms!"), forgoing representation's glass window separating the poet from the world. Similarly, the speaker of "Tract" (1917) complains about the futility of glass windows in a hearse: "Knock the glass out! My God—glass, my townspeople!" (*CP1* 73). In both of these instances, Williams's (like Pound's) "songs" imply a literary rebelliousness. The wind that in Coleridge's famous poem once "caress'd" his aeolian harp is now gripped forcefully and without mediation: "Embrace the companion," writes Williams in the last stanza of "Rendezvous," "That is whistling, waiting / Impatiently to receive us!" (*CP1* 37).[27] The poem aims to render irrelevant the glass separating art from life because such an object—a medium—impedes art. Where a medium was previously understood as necessary for the very creation of an art object, here we see the medium being imagined quite differently, as an obstruction in the creation of the newly mimetic art object.

Urging us to forget the frame and allow in "the flux of life," Loy singles out this poem for praise, no doubt because it accorded well with her own notions of art as breaking the barrier between art and life: "Perfect also is a poem of Carlos Williams about the wind on a window-pane."[28] The glass window of "Rendezvous" that he conjures up and then rejects also clearly resembles

Duchamp's fallen church window, particularly with its literary and religious evocations. Beginning in 1912, Duchamp also selects the term *rendezvous* to describe the readymade as a performance at a given moment of time: "It is a kind of rendezvous" between the chosen object and a shocked audience.[29] "Rendezvous," whether Williams's version or Duchamp's, describes the exciting, illicit meeting between an audience member and an art object once art frames become window frames. Before art's frame kept air and time from art, this appointment was (theoretically) impossible. But in modernity, warm song-air meets the cold air of the world of the reader, whereas art objects incorporate the sharp intake of breath from a shocked gallery spectator or a reader. From Duchamp's, Loy's, and, it would seem, Williams's perspective, spectators' or readers' experiences complete the artwork.

Thus far, it appears that Williams's poetry is of a piece with that of the avant-gardists of his generation. But he does not fit as easily into their theoretical mold. Although "Rendezvous" follows Loy's approach to the frame, Williams's other writing from the period is less antagonistic toward framing art as something distinctly separate from life. "Contemporania," for example, suggests a more sympathetic account of the frame than Loy's or Duchamp's. The poem, as James Breslin notes, responds to Pound's *Contemporania* series, particularly, "Salutation the Second" (1913), in which Pound acknowledges his backwardness as an American in Europe: "I had just come from the country; / I was twenty years behind the times."[30] Williams's version of "Contemporania" shares the same general topic and heroic posturing, although he tames the tone and locates the poem in suburban America. Williams acknowledges his life in the cultural backwoods, "the barren country" of America, pointing out that only a small "corner" of the European Modernist storm has descended on barren America (*CP1* 16). Here, the first-person speaker wanders around his summer garden after a "very great rain" that simultaneously destroys— "branches broken, and the farmer's curses!"—as it rejuvenates: "green shoots" appear, and the leaves seem to come alive, "talking" and "praising" the rain.

In the fourth and last stanza, the leaves become a revealing analogue for Williams's own writing:

> We are not curst together,
> The leaves and I,
> Framing devices, flower devices
> And other ways of peopling
> The barren country. (*CP1* 16)

Following his Romantic predecessors, Williams illustrates organic form as poetic creation, comparing the "framing devices" of art and literature to the "flower devices" of a living organism growing and reproducing naturally.[31] Just as leaves and flowers thrive and bloom in his garden after the great rain, Williams enlivens

his cultural world by "peopling / The barren country" with his poetry. Of course, nature and poet work differently (flowers versus frames), which might be why "We are not curst together / The leaves and I." The poet "grows" forms imaginatively, whereas nature grows in the real, organic world. The key point is that Williams identifies poetry with "framing devices" and aligns such devices positively with flowers growing in the world. "When the speaker mentions three times that the leaves "follow" him as he strolls about, a sort of mutant heliotropism, the point is that his strong framing powers enable him to become a new and powerful (modern) sun following the great modernist rain. In sharp contrast to the rejected window frame in "Rendezvous," framing devices here *illustrate* Williams's heroic avant-garde poet at work.

If "Contemporania" were an exception, we could discount it as a youthful dalliance with Poundian poetry, but as it turns out, this poem is part of a trend in Williams's writing. By the 1920s and thereafter, he explicitly supports aesthetic framing in any medium as a compositional model, often advancing musical framing metaphors in his letters with Pound.[32] Similarly, after viewing Charles Demuth's painting *I Saw the Figure 5 in Gold* (1928), based on one of his own poems, "The Great Figure" (1921), Williams writes to Demuth with specific painterly suggestions that make a similar case for framing. While the poem seeks to outline an experience of the city that is uncontainably noisy (with its "gong clangs / siren howls / and wheels rumbling" [*CP1* 174]), Williams's criticisms of the painting underscore his poetic aim (and, he presumes, Demuth's) of unity and completeness in a work of art:

> I feel in this picture that the completion that was once felt and made the composition a whole has been lost and that you have tried twenty times to recapture and that every try has left a trace somewhere so that the whole is tortured. It needs some new sweep of imagination through the whole to make it one. It is no longer one but—not even 5.[33]

This "new sweep of imagination" that Williams urges is the force of artistic intention unifying the painting: one is more than five if the "one" is the artistic whole and the "5" are fragmented parts. Demuth could "frame the picture better" by painting the "5" more smoothly, overlapping the planes so that "the whole would gain by a unity of treatment which would cast a unity of feeling over it all."[34] According to Williams, the picture will be better framed—will be "one"—when it attains compositional unity. He requests that the spiraling composition of Demuth's picture be more integrated as a pictoral whole, the same conceptual "unity of feeling" he seeks in his own writing. A much later essay (from 1950) urges the same point, summing up the fundamental qualities of the short story by comparing the masterful work of Poe, Kipling, O. Henry, Kafka, and Hemingway: "What is the common quality in all these changing styles? . . . They all have a frame—like a picture."[35]

Juxtaposing "Rendezvous" with "Contemporia" exposes a fault line in Williams's poetics. On the one hand, he repeats Duchamp/Arensberg's example of a stained-glass window popped out of its frame and illustrates his dismissal of the conventional frame in a poem such as "Rendezvous." On the other hand, he writes "Contemporania" and various essays supporting "framing devices," complaining that the poetry in the little magazine *The Soil* fails because "it is not given a proper frame."[36] The ideas motivating these two sets of claims are hard to bring into line. Williams could either discard the idea of frames or sustain it, but it's not clear how he could permit both possibilities at once. Perhaps this contradiction also explains why criticism of his work since the 1960s has largely alternated between versions of these two poles, shifting between a materialism that rejects the frame and a formalism that requires it. Starting with J. Hillis Miller's *Poets of Reality* (1965) and Joseph N. Riddel's *The Inverted Bell* (1974), Williams became a path-breaker for theorists who saw in his work a "leap into things" and a poetry that "deconstructs itself in the same time of its unfolding."[37] On the other hand, a counterstrain in Williams criticism understands his poetry in terms of the formal properties that link it more directly to New Critical organicism. Henry Sayre's *The Visual Text of William Carlos Williams* (1983) and David Markos's *Ideas in Things* (1994) develop this opposing claim most comprehensively. For Sayre, Williams "constantly resisted the 'leap into things' of which Miller speaks."[38] Each side has, on occasion, complained about the dominance of the other, and the consequences of these competing interpretations are appropriately dramatic.[39] Either Williams emerges as a poet heralding postmodernism and championing the impact of the reader's things on the poem's meaning, or, surprisingly, as an unlikely spokesman of New Critical formal unity and consequently much closer to Eliot than he would have desired.

Although this summary undoubtedly simplifies the diversity of opinion on Williams, these contrasting positions nonetheless operate as critical benchmarks. Whatever the merits of their individual readings, these critical poles are equally hampered by an implicit attempt to fit him into a literary debate that he was not—and could not be—invested in, for the emerging clash between deconstruction and the heirs of New Criticism took place well after his major writing was completed. But those disputes had earlier antecedents in disagreements over the relevance of the reader to the meaning of the text. For Williams, Loy, and Stein (among others), the argument over materialist versus formalist interpretations of meaning was primarily understood as a problem about framing. The clearest examples of this issue emerge not in the teens but in Williams's poetics from the early 1920s, revealing his attempt to respond to Duchamp's challenge, just as he claimed he would do one day when he first saw Duchamp's work in Arensberg's apartment: "Watch and wait. Meanwhile work."[40] With *Spring and All*, Williams fully acknowledges the seriousness of Duchamp's critique of the frame as effectively turning the

spectator into a full participant in the creation of a work. Unwilling to follow Loy's and eventually Duchamp's path toward total framelessness, Williams conceptualizes the intrinsic or implied frame in both prose and poems. He puts the spectator to work, while severely limiting what that work could possibly involve.

REFRAMING DUCHAMP'S WINDOW: THE INTRINSIC FRAME OF CONCRETE POETRY

Williams's notion of the intrinsic frame appears most dramatically in his account of the Arensberg anecdote about Duchamp's fallen stained-glass window, and for that reason alone it is worth considering more closely. Implying that novelty is not simply a technical innovation or a shift in subject matter, he suggests instead that freshness is a changing notion of how an art object comes to be defined as such. For Williams the in situ rose window "conventionally composed" in a church (that is, in its original place or position) is an artistic form that no longer works (*I* 8). He sees that Duchamp solved the problem of nonworking form by moving the art object, "conventionally composed in situ," from its original place or position so that ex situ it undergoes a formal change. The readymade *Fountain* exemplifies this strategy. A urinal, once pulled out of its bathroom frame and placed in the institutional "frame" of a gallery or museum, might retain the shape of a urinal, but without its bathroom context and with the museum's we respond to the urinal's shape as an altogether different form: a sculpture created by the artist "R. Mutt" and titled "Fountain." But Williams faced difficulties when attempting to translate these ideas into poetry. In contrast to art objects such as *Fountain*, it is harder to see how language could be meaningfully separated into "shapes" versus "forms"; we perhaps come closest to it in the distinction between a signifier and a sign, a contrast Williams occasionally entertains in his poetry.[41] Perhaps owing to the difficulty of determining a word's so-called shape, he emphasizes a very different point about the ex situ object, noticing that falling out of its frame has not caused the window to shatter into a heap of glass shards. Instead, Williams writes, it stays basically intact, "more or less together on the ground," like the *Large Glass*, which six years later retains its "shape" and "symmetry" after cracking in transit.[42] Williams emphasizes that the window stays "together on the ground" to underscore what the ex situ art object (advantageously) now lacks and the in situ art object had: the *literal* windowpane or frame in a church. Despite Williams's notoriety as the poet who leapt into things, in this instance it is quite clearly the thing—the literal frame—that he wants to eliminate.

As strange as the notion might sound today, various other modernists also promoted the idea of an intrinsic frame distinct from the actual frame of a

work. Guillaume Apollinaire used the phrase "le cadre intérieur" (usually translated as "interior frame") in the "Picasso" section of *Les Peintres cubists* (1913), a book Williams read enthusiastically when it appeared in *The Little Review* in 1922.[43] Williams most likely focused on the idea of the interior frame in Apollinaire's analysis of Juan Gris (in the same book), the Cubist whom Williams champions in the prose section of *Spring and All* as "point[ing] forward to what will prove the greatest painting yet produced" (*CP1* 204). Exploring the logic of Cubist collage, Apollinaire reasons that "the impossibility of putting a flesh-and-blood man, a mirrored wardrobe or the Eiffel Tower on a canvas will force the painter back to the techniques of real painting, or else force him to restrict his talent to the minor art of window-dressing."[44] At some point, in other words, it will be impossible to glue certain things to the canvas that you want to represent: the canvases will not be big enough, strong enough, or, in the case of the "flesh-and-blood man," ethical enough for the intended collaged objects. When this moment strikes, one must stop painting and instead turn to another craft: for example, "the art of window-dressing." He admits that although such a "minor" art of window-dressing has influenced painters, it "will in no way harm painting because it cannot replace painting's ability to represent perishable objects. Juan Gris is too much a painter to give up painting."[45] Apollinaire's argument turns out to be brilliantly prescient. He effectively predicts (or maybe inspires) Duchamp's dilemma a few years later, when the artist first decides to make window-paintings and then claims to give up painting forever. He also argues that Gris is "too much a painter" to make the decision Duchamp makes. In effect, Apollinaire is both acknowledging the challenge that collage, and thus windows, present to the picture frame (by suggesting that window-dressing will alter the history of painting) and resolutely denying the seriousness of that threat: treating paintings like windows and vice versa "will in no way harm painting" or representation irreparably because great painting possesses an internal quality that unifies it. Painting can face the challenge of the window frame, if that painting is Gris's.

No wonder Gris's painting was Williams's model. The particular painting, *The Open Window* (1921), he discusses in *Spring and All* contains neither papier collé nor collage. What the painting possesses instead, and what Williams admires about it, is its painterly frame that doesn't rely on collage but simultaneously represents the world and detaches art from that world, "separat[ing] things of the imagination from life" (*CP1* 194). The other way he puts this is to say that the painting is intrinsically framed: it is "all drawn with admirable simplicity and excellent design—all a unity" (*CP1* 198), nearly the same language of his aforementioned letter to Demuth suggesting that a stronger framing device would give Demuth's painting "a unity of feeling." Williams must be particularly referring to the same thing that interested Stein—the way Gris's painting maintains its unity through a very deliberate, internal framing device, one he used in a number of paintings. In *The Open Window*, a

painted frame just inside the literal frame is rendered irregularly: there is a dark, flattened background of wavy triangles and rectangles between the shutters, sky, and edge of the canvas, allowing the bright sky and clouds to pop forward and mingle with the room's interior. The tension is between the inside of the internal frame and the outside, as if the frame is striving to pull the representation out, and the inner forms tug back by condensing into a solid mass. These battling forces give the intrinsic frame a palpable integrity. Gris mingles together the window and picture frame—nearly the entire painting is framed by the window-framing shutters—while keeping the painting unified through its pictorial elements alone.

Modifying both Duchamp's and Gris's models for his own, Williams promotes the intrinsic frame by describing an art object becoming ex situ, losing its external frame while retaining its internal one. As a poet, he makes this point relevant to his work by imagining those elements of writing compelled by the established demands of poetic convention equivalent to the wooden frame around a painting. That is, he argues that certain literary conventions— like the sonnet form—operate as a kind of literal frame that must be sloughed off. Although modern linguistics taught us that all aspects of language rely on a set of ultimately unstable but provisionally agreed-on practices, for Williams certain types of linguistic and literary conventions are particularly inflexible, operating like a restrictive literal frame. This is why, as he puts it, a poem must be shorn of its "sclerotic" (pathologically hardened) conventions "to get at the essential; the *formal* unit in its purity."[46] To rely on the literal frame or the sonnet form is to rely on a decrepit, hardened frame that no longer supports the work's essential form—understood as distinct from poetry's fixed forms, such as the sonnet—and cannot effectively pump "blood" into the artwork or poem. Instead of the sclerotic frame, the work must possess what the ex situ rose window has: a new environment without the traditional frame yet with an intrinsic, invisible frame keeping it "more or less together." Hence, "the essential; the *formal* unit in its purity." In this way, he disagrees with Duchamp, for whom removing the frame of the windowpane means eliminating the institution of art. As Williams puts it, "[the poem] is an engine that needs continual redesigning in each period of the world so as to increase its capacity in order to refresh the world (if possible) in each period by conceiving the world anew in terms of the arts."[47] For Williams, removing the frame of the windowpane permits art, and worldly institutions supporting art, to develop into their next, more effective, "refresh[ing]" form.

Despite his intriguing formulations, we still might wonder how a poem (in contrast to a painting or sculpture) becomes ex situ. This question leads to the much-ruminated problem of the physical status of the literary texts, that is, the issue of where exactly a text should be understood to be located when it is either ex situ or in situ.[48] F. W. Bateson precisely describes this issue when he ponders if the *Mona Lisa* is in the Louvre, then where is *Hamlet*?[49] Clearly, the

copy of *Hamlet* on my bookshelf cannot be considered the decisive location of the literary artifact itself. Bateson decides that the difference between the *Mona Lisa* and *Hamlet* has to do with the fact that *Hamlet*, unlike the painting, is "a temporal or oral artifact" and not a structure that we "freeze . . . into an artificial spatial immobility."[50] Like Stanley Fish's affective stylistics (and unlike Wyndham Lewis's antitime philosophy), Bateson's theory of meaning focuses on "the primacy of time in the literary artifact."[51] Building on Richard Wollheim's work, James McLaverty takes issue with this view, arguing for the consequence of books' physical appearances to their meaning, an issue even clearer in the case of concrete poetry or the calligrammes Apollinaire created.[52] We might add Williams's visual poetic experiments to the list of modernist visual experiments by Apollinaire, Loy, e.e. cummings, and others.[53] For McLaverty, "just because plays and poems are not objects like paintings and statues, it does not follow that they are not physical, or even that they are not visual."[54]

Williams's view was similar to that of McLaverty. In describing his work as *ex situ*, he understood his writing to blend the visual art object and the literary artifact, operating on the model of concrete poetry in having an essential visual component that novels, for example, often lack. We can see hints of this view in his letters to Pound from the period, in which he would sometimes draw rebuses, using a little picture to complete a sentence (figure 3.3). In this one he portrays his cultural remoteness from Paris in terms of the physical journey required to get there, and also as the conceptual switch required for the reader (or more accurately, spectator) to see and to make sense of his little line drawing of a sailing ship. The broken line of the sea, which takes more space than the rest of the words of the sentence put together, breaks up into a decorative swirl, seeming to point indexically to the next word in the sentence. Like the spectator's impeded view through Duchamp's glass windows, such a verbal-visual amalgamation slows us down, requiring us to access different perceptual and interpretive tools before we can translate his picture into a synonym for the phrase "so far over." Such drawings are rare, of course, and often seem to reveal a private language game between the two poets. But the point is that they precisely align with Williams's paradoxical ideas of writing more generally, in which writing's visual, literal component is transformed into a literal frame that needs eliminating. Struggling with the concrete aspect of his own writing, he sometimes acknowledges and boasts of its "thingness" and other times negatively identifies it with the literal frame. He imagines that its concrete aspects (like the rebus's) enable him to change or alter the frame of his poetry in a way similar to Duchamp altering the frame of his window. Doing so, he feels, allows him to free his work of conventions and institutions that constrained art in the past and—more speculatively—permits him to dramatize civil freedoms in writing, sometimes specifically (as we'll see in the next section with *The Great American Novel*) and more generally in *Spring and All*.

Paris seems just there!

Figure 3.3 William Carlos Williams, Line-drawing from a letter to Ezra Pound, (December 23, 1924). By William Carlos Williams, from *Pound/Williams*. © 1957 by William Carlos Williams. Reprinted by permission of New Directions Publishing Corporation.

Individual poems in *Spring and All* illustrate the intrinsic frame's palpable integrity in different ways, but one poem in particular, simply titled "IV," best illustrates both a desire to eliminate the literal frame of his poetry and the difficulty of accomplishing it in practice:[55]

> The Easter stars are shining
> above lights that are flashing—
> coronal of the black—
> Nobody
> to say it—
> Nobody to say: pinholes
> Thither I would carry her
> among the lights—
> Burst it asunder
> break through to the fifty words
> necessary—
> a crown for her head with
> castles upon it, skyscrapers
> filled with nut-chocolates—
> dovetame winds—
> stars of tinsel
> from the great end of a cornucopia
> of glass (*CP1* 186–87)

This poem tends to be read as a dual-voiced response to the pastoral following its alternate title, "Flight to the City," because it oscillates in irregular triplets between what James Breslin calls a "hypnotic romantic voice dreaming of ascendancy" (as in, "Thither I would carry her / among the lights—") and a "more prosaic voice" ("Nobody / to say it— / Nobody to say: pinholes").[56] The two voices gradually create a view of the city as "empty and sterile" by stripping away the city's allure and revealing "a place whose abundance cannot nourish," presumably the "cornucopia" of barren glass.[57] According to Breslin's account, the poem moves negatively with the flight to the city as a misguided quest thwarting nourishment. Williams should have remained in the Rutherford suburbs after all.

Breslin's interpretation of the poem's contrasting voices seems accurate, yet certain details do not make sense as anti-city, Dada pastoral. First of all, another of the poem's alternate titles, "Cornucopia," places the emphasis less on the idea of the city as refuge from the suburbs and more on the idea of the poem's, and the city's, images of abundance. Second, the prose section immediately following the poem hints at an interpretation of the poem preceding it by explaining why the word *sky* is such a problem. According to Williams, "So long as the sky is recognized as an association," it fails to have the richer meaning, the "residual contact between life and the imagination," that it once had for "the farmer and the fisherman" (*CP1* 187). The word *sky*, in other words, is hampered by its poetic history as a symbol for various emotional and metaphysical properties no longer deemed meaningful. Thus the contemporary poet who tries to use that word "contends with the sky through layers of demoded words and shapes," often failing to represent the actual experience of sky in the process (*CP1* 188). Crucially, the words are demoded "not because the essential vitality which begot them is laid waste"—the sky in all its glory is still there to be represented—but because the noun *sky* has become another of those literal frames or sclerotic forms that "let words empty" of the meaning they once possessed (*CP1* 188). To combat the decrepit frame a modernist poet must contend with the sky like the farmer or fisherman, that is, "bare handed," without the old frame of the word *sky*. Only when the word is "put down for itself" (that is, "bare handed"), and "not as a symbol of nature," will the poem "be in the realm of the imagination as plain as the sky is to a fisherman" (*CP1* 189). Writing "bare handed" means avoiding the *actual* signifier "sky" to mean "sky." To clarify, his point in emphasizing the fisherman's and farmer's conception of "sky" is not to endorse the rejuvenating value of nature (i.e., the pastoral) but to endorse the artistic value of the fisherman's and farmer's primitive *barehanded-ness* as a convention-free and sometimes signifier-free modernist poetics. Just as the farmer in "III" is praised for his aesthetic ability in challenging nature's (or God's) authority—"the artist figure of / the farmer—composing / —antagonist" (*CP1* 186)—the farmer and fisherman are praised here for meaning "sky" without using the "crude symbolism" of the signifier "sky" attached to their words (*CP1* 188).

Now we can look again at the poem "IV" and see that the alternating voices Breslin identifies are not debating the spiritual value of the city, but are composing like the farmer. In other words, these two voices dramatize a struggle between two very different ways to avoid using the signifier "sky"—a word that never appears alone—in a poem that portrays (among other things) a distant city skyline at night. The first is the voice of convention, heard in the first, third, and fifth triplets (beginning, respectively, "The Easter," "Thither," and "a crown"), which rely on metaphorical and mythological imagery and conventional scansion. Between the twinkling of the Easter stars above (promising renewal and maybe ascension) and the man-made city lights of the

skyscrapers below lies the narrow band of sky (a "coronal of the black") that is too bright to reveal stars and yet too dark to reveal anything else. It rests on top of the city like a halo or a wreath, promising the cornucopia to come as one nears the city from afar. The third and fifth triplets extend this fairly conventional imagery: the third proposes a heroic rescue or resuscitation ("Thither I would carry her // among the lights—") that is undermined by the triplet's missing second line, hollowing out its heroic core. The fifth triplet stretches the coronal imagery into whimsical, hackneyed images—a crown of castles and nut-chocolate skyscrapers—perhaps suggesting that the coronal metaphor for sky has become unwieldy. Altogether, these three triplets reveal that the traditional way of avoiding a word such as *sky*—namely, by relying on metaphorical imagery in its place—has serious drawbacks.

The second voice, meanwhile, urges modernist experimentation. Emerging in the second triplet, this voice suggests an alternative, innovative, and preferable means of doing without the signifier *sky*. The fourth and sixth triplets support this technique through veiled allusions to the same fallen rose window discussed earlier. "Nobody / to say it— / Nobody to say: pinholes," has been interpreted as poetic Dada, or perhaps as Cubist collage (with the inexplicable "pinholes"). But consider a simpler explanation: Williams is abandoning the voice of the historical poet who previously imagines coronals and names the sky. Now, there is "Nobody / to say it." In its place, he writes concrete poetry: the sky depicted as the surface of a page, stretched taut, with two dots puncturing it—": pinholes"—representing the light poking through the page. In other words, the colon takes on the additional visual signification of "stars," like a rebus. Punctuation, then, takes on a dual role: it divides two clauses in the line, and it visually represents two pinholes in the page, which in turn represent stars in the middle of the poem. The advantage of the colon, a purely grammatical sign and graphical mark, is that "nobody" needs to say ":" for the colon to appear as the stars in the sky. In fact, the colon signifies with its silence; it is a pause that indicates a relation between two clauses, between a statement and an example. Williams extends this point, implying that *any* phonetic signifier (that is, any *word*) for "sky" is equally inadequate, requiring a poet to "say" something. Only the physical page, transformed into a stage backdrop for its pinhole stars, depicts the "sky" like the farmer or fisherman: barehanded, without linguistic imagery. Yet this is not "sky" purely as experienced by the reader, for we are still observing imagery or representation of a kind. The page has become a visual representation of sky. In other words, Williams has not given up on the representation of "sky," he just implies that the words (and diacritical marks) in the poem can indexically create a representation elsewhere: in this case, the entire page the poem is printed on.

To expose the shock and significance of this new, extralinguistic representation of sky, Williams returns once more to Duchamp's shattered window allusion: "Burst it asunder / break through to the fifty words / necessary—" and

"the great end of a cornucopia / of glass." In this poem, "sky" is not one of those necessary fifty words, but "pinholes" is. Thus, the last image of a glass cornucopia is not the negative image of failed abundance, but Williams's privileged image of poetry renewed: the dramatic event of a glass window falling out of its frame transforming into a better art object in glass pieces on the ground. "Dovetame winds," perhaps now blowing through the empty window frame, and "stars of tinsel" (more modern than the romantic Easter stars of the opening line) emerge from the *"great* end" of this glass abundance. By giving up on the word *sky* and replacing it with a colon, the printed page, and the roughly "fifty words necessary" to illustrate what he is doing, Williams effectively eliminates an empty literal frame (the signifier "sky") and replaces it with a substitute: the page as a visual and physical metonym for sky. As he writes in the prose section following this poem: "What I put down of value will have this value: an escape from crude symbolism, the annihilation of strained associations, complicated ritualistic forms designed to separate the work from 'reality'" (*CP1* 189). In place of the symbolism of Easter stars, we have a colon iconographically representing pinholes as stars, and in place of "sky" we are directed to the page: a condensed, metonymic representation of the sky.

Like Stefi Kiesler, an artist Katherine Dreier supported, whose *Typo-Plastic* compositions (1925–30) generate an abstract image out of repeated, typed, diacritical marks, Williams transforms the typed page into an art of concrete poetry (see figure 3.4).[58] Both Kiesler and Williams find ways to transform marks on the typed page and the page itself into a different kind of representational object. Moreover, "Flight to the City," if we accept this later title, follows Duchamp triumphantly into his New York City studio with its many picture/window frames. But just as the literal frame proves difficult to eliminate when Williams substitutes the period at the end of this poem for the subsequent prose, so does he fail *entirely* to eliminate the literal frame, the signifier "sky." After all, the colon is still there, and it still signifies something (albeit not what it typically does). He can only substitute the literal frame for an apparent better one: in this case, the physical page as representation. Once window frames and picture frames are combined—a move Williams shares with Duchamp, Pound, and Loy—the problem that Williams sets for himself to eliminate the literal frame becomes, perhaps, impossible. A window requires some *thing*, a piece of metal or wood, to separate it into two spaces. The desire for a colon or some physical mark in lieu of the signifier "sky"—in lieu of the literal frame—proves irresistible.

Although we have been focusing primarily on the poetry of *Spring and All*, only half of the book is composed of poetry; the rest is prose. In the prose, too, Williams exemplifies the freedom of the intrinsic frame as revealed through comments on the very relationship between prosody and poetry. He elides the distinction between text and commentary (as Suzanne Churchill describes), between found object and creation, and so on, to suggest that what

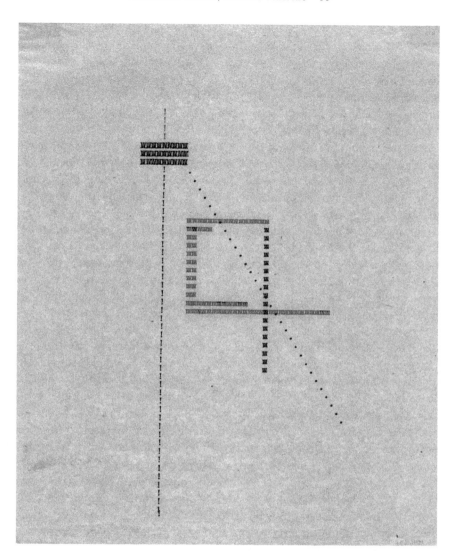

Figure 3.4 Stefi Kiesler, *Typo-Plastic* (1925–30). Yale University Art Gallery. © 2010 Yale University Art Gallery.

distinguishes prose from poetry cannot be a frame but must be something else.[59] While deliberately confounding generic distinctions, conventional narrative, and expected definitions of language, he justifies his decision to include prose and poetry in the same work not as an attempt at art/life conflation but as another instance of intrinsic framing: "Poetry does not *have* to be kept away from prose as Mr. Eliot might insist, it goes *along with* prose and, companionably, by itself, without aid or excuse or need for separation or bolstering, shows itself by *itself* for what it is."[60] His point is that poetry's identity

(that which reveals "*itself* for what it is") is so compelling that even if the difference between poetry and prose is essentially indistinguishable to the reader, the two forms will always keep themselves distinct by virtue of the writer's original aim (*CP1* 230). A writer gives poetry an integral form regardless of conventions such as meter because the distinction between poetry and prose is located "in the fact of a separate origin for each" (*CP1* 230). In other words, a poet's original poetic "source" is the intention to write poetry versus the intention to write prose. Whatever happens afterward is irrelevant to its status as poetry. Marianne Moore writes poetry not because her poems look or sound like what we think of poetry but because her source—before she even picks up her pen—is purely poetic. Real toads become poetry when they are newly positioned (ex situ) in an imaginary garden. Even when the poetry Moore writes isn't working, it does not stop being what it is: "when poetry fails it does not become prose but bad poetry" (*CP1* 230).

Another way he makes this distinction is by suggesting that prose is a "prose thing," a phrase that comes up several times in his letters from the period.[61] Prose is a thing, but poetry, in contrast, includes but is not synonymous with things, because it is a thing that can also be art. Poetry also possesses the one quality prose lacks: an intrinsic frame. Although prose explains, clarifies, and enlightens, these qualities do not create formal unity: "There is no form to prose but that which depends on clarity. If prose is not accurately adjusted to the exposition of facts it does not exist—Its form is that alone" (*CP1* 226). In other words, prose's only form is the logic of its argument or explanation, whereas poetry is "the perfection of new forms as additions to nature—." Prose's thing is the literal frame: framing devices, flower devices, once again. Dramatizing the distinction between poetry and prose, Williams floods his prose with dashes, interruptions, and sentence fragments, while keeping his poems, as he puts it later, "pure—no typographical tricks when they appear."[62] Although this claim is not entirely true (we have already seen an exception in "Flight to the City"), such an inconsistency does not refute his larger point of illustrating just how unfinished and unframed prose is by filling it with typographical additions that attempt and fail to contain it: "Is what I have written prose? The only answer is that form in prose ends with the end of that which is being communicated—If the power to go on falters in the middle of a sentence—that is the end of the sentence—Or if a new phase enters at that point it is only stupidity to go on" (*CP1* 226). Determining where "form . . . ends" is, of course, another way to talk about the action of framing. Stopping mid-sentence when "the power to go on falters" is not an issue when he writes poetry because poetry's "crystallization of the imagination" is always complete and thus always framed. Prose retains the literal frame of convention (the period at the end of the sentence), whereas poetry possesses the implied frame of aesthetic unity (the completion of an idea).

In fact, Williams thinks of prose as so formless—so material—that it can if necessary actually become a frame for poetry. When he fails to find an American publisher for the entire text of *Spring and All* (poetry and prose) he agrees to have ten of the poems printed separately as a chapbook by Monroe Wheeler's small Mannikin Press.[63] In the entire book containing both poetry and prose he omits each poem's final period. But, as Mariani explains, Williams felt that the situation was altered when the poems and prose were printed separately: "without final punctuation, [the poems] had the feel of being unfinished."[64] Thus, for the poetry chapbook, he asks Wheeler to include periods at the end of each poem to help the reader (an addition unnecessary in the complete book because the poems would be separated by prose). This apparently minor typographical concern sums up Williams's Duchampian poetics in every tiny, included period. A single period at the end of a poem does the same work that *all* of the prose surrounding the poem does in the original version of *Spring and All*: it completes the poem. Following this logic, he reasons that prose can be abandoned as unnecessary framing material, but periods cannot because they are part of the very syntax of language. Stein, of course, makes a nearly identical point in "Poetry and Grammar" when she explains why she abandons punctuation such as commas as too much of a literal frame around words, but retains periods: "physically one had to again and again stop sometime and if one had to again and again stop some time then periods had to exist" (*GS2* 217). If periods are a necessary condition for the poet to write—and thus must be used—commas, like prose for Williams, are frames that unnecessarily intrude on the reader's world and can be left out, just as Duchamp's ex situ window, when shattered on the street below, is released from its literal frame. Resembling Stein's argument about punctuation but following his poetics' unique trajectory and logic, Williams repeatedly imagines that removing the literal frame around a word manifests a new form of freedom for poetry, and a freedom expanding beyond art objects.

REFRAMING FREEDOM, PROGRESSIVELY

With *Spring and All*, Williams searched for strategies to remove the literal frame such as the signifier "sky," permitting a little more air of the reader/spectator's world into the work. We have also already seen in the introduction how he used similar tropes to discuss the complicated relationship between the art object and the broader world, as when he writes that by incorporating objects into his poetry and protecting them from the observer ("like a fly in amber"), his poem effectively regenerates society. Here I want to connect these ideas to suggest that Williams sought a form of democratic governance that, while controlled or managed by the author's dominating will, aimed not to repress readers but to enable them to fully experience their free

will.[65] As early as 1917, his essay "America, Whitman, and the Art of Poetry" articulates the compromise he seeks for his poetry in explicitly political language: "[New verse] must be truly democratic, truly free for all—and yet it must be governed."[66] Poetry, he suggests, will promote civil liberties and democratic freedoms while also paradoxically embodying control and authority. Whitman's democratic verse would essentially "fall apart structurally but the sweep of his mood, the splendor of his pigment blends his work into some semblance of unity without which no work of art can be said to exist."[67] His point is that Whitman's mood serves as a unifying color or feature when other aspects of his form supposedly fail. "Democratic" freedom is held in check because it is governed by the still-vibrant, charismatic, Whitmanian personality. This vision of poetry as a system of checks and balances runs through the essay: new verse form "must not be too firmly cemented together as they are in the aristocratic forms of past civilizations. They must be perfectly concrete or they will escape through the fingers—but they must not be rigidly united into series."[68] Duchamp's metaphor of bits of glass fallen but held in a whole pattern echoes here, with the literal frame portrayed as an "aristocratic form." Aligning aesthetic and political freedom, Williams demands that internalized forces control and contain the reader's total liberty.

Before the 1920s, the particular language of civil liberties was not a major trope of Progressively inclined leftists such as Williams; they tended to feel instead that the nation-state embodied democratic purpose and only from that source could civil freedoms emerge.[69] A focus on civil liberties was perceived as part of the problem of individualism Progressives were attempting to combat to support child labor and living wage laws, union protection, conservation, and so on.[70] But after the unprecedented rise of the nation-state during and after World War I led to the country's most severe repression of civil liberties by both state and federal governments, they changed their outlook. Already by the early 1920s, Progressive discourse shifted "from the language of major rule and effective democracy to a discourse of rights, checks on state power, and individual autonomy."[71] Two discourses opposed before the war began uneasily to unite, as the Progressive movement started to appreciate the rights individuals could assert against their government.[72]

Williams's experimental poetry and prose of the 1920s works not only to rejuvenate the intrinsic frame and eliminate the literal one, but uses that very aesthetic development to participate in this evolving discourses of progressivism and civil rights—rights he understood as intrinsic instead of specifically enumerated.[73] This alignment is clearest in his improvisational short prose work, cheekily titled *The Great American Novel* (1923), which tries to imagine a compromise between socially progressive advances orchestrated by the state and civil liberties demanded by the people. He understands that his attempted compromise with frames—wanting to eliminate their literal features, while maintaining their conceptual ones—parallels the compromise between civil

liberties and progressive governance that he also struggles to articulate as an aesthetic position in his Whitman essay. He demands the individual reader's or citizen's freedom while simultaneously holding that freedom in check so that a broader purpose—perhaps the artist's, perhaps the state's—can be realized. By aligning political, cultural, and aesthetic progress, *The Great American Novel* depicts particular cultural and political details of his moment within a liberating experimental form. Closer to a truly intertextual collage than anything in *Spring and All*, his antinovel incorporates—apparently verbatim and with few explanations—found texts, such as letters from his friends, magazine articles his wife read from *Ladies' Home Journal*, advertisements from *Vanity Fair*, clippings from the *New York Times*, and ethnological accounts of Alaska Eskimos.[74] Its nineteen chapters aim to capture the particular things that make up "the background of American life" (*I* 196), a phrase summing up both the breezy tone of the plotless text, which has no "foreground" to speak of, and something of its range in exploring what counts as an American setting.[75] But what this richly experimental text truly attempts is to represent the various different forms of progress he is imagining, without feeling constricted by the fixed form of a traditional novel. Thus, he advances authorial freedom (through narrative experimentation and surrealist methods) and readers' freedom to participate (through their interpretations of its Dada collage) in the work's final meaning.

The novel focuses on the word *progress* from the very start: "If there is progress then there is a novel. Without progress there is nothing" (*I* 158). He begins with aesthetic progress in particular, pondering whether a modern novel needs a plot or if it can "progress" abstractly. Novels both signify modern progress and rely on narrative progression; without that progression "there is nothing"—no novel. As in *Spring and All*, he struggles to eliminate the sclerotic, conventional form. In this case, he wants to avoid the historical narrative form of the novel—the literal time implicated by temporal progression—while still writing a novel that advances modernism. Challenging typical notions of narrative progression by including textual fragments that refuse alignment or coherence (letters, advertisements, newspaper clippings, etc.), *The Great American Novel* frustrates narrative continuity and demands that we think of novelistic advancement and the possibility for new kinds of progress in different ways.

Variations on the word *progress* flood the text, with more than a dozen instances in the first two pages. Sometimes he uses the word straightforwardly: "The year has progressed" or "He smiled and she, from long practice, began to read to him, progressing rapidly until she said: You can't fool me" (*I* 158, 161). But at other points, its definition is more ambiguous: "Words progress into the ground"; "It is words that must progress"; "Progress is to get" (*I* 158–59). These examples tend to conflate two definitions of progress: advancement in terms of literal movement and advancement as social transformation and attainments, as in "to get." Yet he aligns both of these

definitions when he focuses on the progressive capabilities of the maternal body. At 3 a.m., hearing a woman scream through her labor contractions, the narrator, a stand-in for Williams-as-obstetrician, decides he "had better see how things have progressed" (*I* 163). The maternal body progresses "things" with her painful contractions, literally pulsing the fetus down the birth canal. While the automobiles and electrical dynamos hum, "filling the house and the room where the bed of pain stood with progress," only the mother's scream from the "bed of pain" overpowers the technological hum: "Ow, ow! Oh help me somebody! said she. UMMMMMMM sang the dynamo in the next street, UMMMM. With a terrible scream she drowned out its sound" (*I* 162). The woman matches and even exceeds the social and technological progress of modernity—we might even say that by giving birth, the maternal body turns into a symbol of progress.[76]

Maternal progress might have been on this poet-obstetrician's mind for another reason. In 1921, when Williams was writing *The Great American Novel* in the spare moments while waiting for his patients' labor to progress, Congress was debating the single most important piece of Progressive legislation of the 1920s, focusing on a different but no less crucial aspect of maternal progress. The Sheppard-Towner Maternity and Infancy Protection Act, the first U.S. federal-state social welfare legislation, was designed to provide prenatal and basic infant care (mostly through visiting nurses) to impoverished mothers and infants.[77] By 1921, the act had been publicized by women's organizations for at least a year, with women's magazines such as *McCall's* and *Good Housekeeping* (the type he explicitly quotes in the novel) urging women to send letters to Congress in its support. It finally passed the Senate that July, signed into law by President Warren Harding in November.[78] Later incorporated into the original Social Security Act of 1935, Sheppard-Towner aimed to improve the country's embarrassingly high infant and maternal mortality rates.[79] During the seven years the law was in place, infant and maternal mortality declined. Yet the American Medical Association (AMA) actively lobbied against Sheppard-Towner from the start, perceiving it negatively as a form of federal health insurance that would impinge on the independence of doctors and their fee-for-service system. That is, the AMA correctly interpreted the law as impinging on their freedom to set high prices in the marketplace. In suburban New Jersey, where Williams's poor and pregnant patients often had to barter with him to pay for their healthcare, Sheppard-Towner only became law in 1922 over the governor's veto.[80] Working in conjunction with conservative and antifeminist organizations, the AMA helped repeal the law in 1929.[81]

To be clear, *The Great American Novel* does not refer to the new congressional legislation specifically. Williams was rarely that explicitly topical in his writings of the 1920s. But the text neatly echoes the act's major goals by forging links between the ideas of technological progress, Progressive political reforms, and maternal bodies. Oddly, breastfeeding connects them. In

this novel, Williams explicitly aligns breastfeeding and universal progress: "To progress from word to word is to suck a nipple" and "you cannot deny that to have a novel one must have milk . . . Progress from the mere form to the substance. Yes, yes, in other words: milk. Milk is the answer" (*I* 159). Progress flows from the maternal, lactating body: not just child and social progress but poetic advancement requires human milk. The speaker's sexual love for the mother stems from the way she can transformatively realize this abstracted, formal idea of progress—"to progress from word to word"—into "substance," both a baby and her sustaining milk. Breastfeeding's importance was a well-established infant care standard in the early 1920s (although ignored and undermined for decades thereafter); because contaminated formula was a major public health problem, nearly all of the states used Sheppard-Towner funds to promote breastfeeding campaigns.[82] In a sense, supporting breastfeeding, Sheppard-Towner's main goal, naturalizes Williams's aim of poetic "contact" with the world. Women, via their (essentialized) bodies, directly and naturally dramatize Williams's famous dictate, "no ideas but in things." In contrast, the doctor's own attempt to turn himself into a word culminates in a monstrous baby: "one big blurb," an autobiographical burp of failure instead of creation (*I* 160).

The point here is not just that Williams might have been particularly interested in maternal health issues based on his still-primary career but that he seems to have recognized in this particular national debate a larger metaphor for the interaction of federal policies, personal liberty, and progress broadly conceived. Williams had an abiding interest not just in obstetric metaphors of progress (which he often used), but in the question of how to realize progressive developments more generally, and how his poetic ideas fit into this notion of progress.[83] On a personal level, he clearly supported many progressive social developments, specifically ones that would assist women. During the Depression he lectured on birth control and raised funds for the East Rutherford Day Nursery so working mothers could hold down jobs.[84] Focusing on Williams's long-standing commitment to portraying working-class life in New Jersey, Michael Denning suggests that he was "the figure who best exemplifies [the] radical modernism" of the 1930s.[85] But already a few months before starting work on the novel in 1921, Williams was involved in local political issues reflected in his text. He complains to Kenneth Burke that his suburban enclave of Rutherford is hostile to the world of art, and he uses as an example his recent difficulty convincing his colleagues on the local school board to allocate expenditures: "I have had a fine rest of late fighting the town in order to get the shitasses to take their hands off the lid long enough for us to get a new high school built. It has gone through at last."[86] Progressive advances, like the building of new public schools to further support education and the arts, require heroic acts from individual citizens against the conservative impulses of a parochial town and, more problematically, of the administrative state.

Here, then, we are starting to see another division in his thinking. While Williams held progressive principles overall, values manifested in the Sheppard-Towner Act, he also regularly upheld a primarily anti-Progressive view of *state* authority. The same view appears in the middle of the novel, as he struggles with the role of individuals versus the function of the state in realizing progressive reforms. The narrator challenges the government's role in improving maternal affairs, implying a more defiant attitude toward state-organized Progressive reforms and perhaps reflecting the era's increasing skepticism regarding government bureaucracy.[87] In a surreal scene, the narrator imagines himself helping raise money "to fit up a room in our hall where the colored working girls can come and rest" (*I* 198). As with Sheppard-Towner and the East Rutherford Day Nursery for which he later raised funds, the purpose of raising this capital is to provide some material support for poor working (and often minority) women. But the request for financial benefaction leads to a fantasy about something different than mere paternalism. Specifically, he imagines a scene of abundant interracial sex acts leading to actual paternity: "Impregnate eighty of them, right and left as you see them here in this room. It would not be impossible. I cannot think of my children running about in the environment in which these have to live" (*I* 198). In this fantasy, the narrator can only imagine improving the lives of women if the children they bear are his own. Because he won't let himself "think of my children" living in poverty, pregnancy—maternal progress—is once more the answer. Attempts to provide social support mask reform's potential sexual perversions and sinister paternalism, expressed here as a grotesque act of mass paternity (and, most likely, rape). Williams satirizes the paternalism of the state and mocks the moralism and racism of earlier Progressive reform activities (such as Prohibition), while also on some level admitting the doctor's own desire to be the rakish savior.[88] As the scene continues, these desires increase dramatically, whether for the "Malodorous" or "the wrinkled hard-put-to-it" mother: "his great heart had expanded so as to include the whole city, every woman young and old there he having impregnated with sons and daughters" (*I* 198). His once private paternalism and desired paternity expands city-wide and, presumably, with the new federal legislation, state- and nationwide. In this satire, he will be every poor American child's *actual* father.

Despite Williams's genuine and long-standing interest in progressive political reform, the novel is clearly betraying considerable anxiety about swelling government bureaucracy, precisely the kind required for New Deal social security programs a decade later. In the very next episode, *The Great American Novel* explicitly depicts state authority perverting the individual's desires for progress. Whereas the narrator imagines his own love for women and children as godlike—he wonders "who will understand the hugeness of [his] passion"— the state's similarly huge desires are demonized as lacking a husband's and

father's passion. "Card-index minds, the judges have. Socialism, immorality and lunacy are about synonyms to the judge. Property is sacred and human liberty is bitter, bitter, bitter to their tongues" (*I* 199). Progressive aims will be perverted when practiced by the capitalist state and a judicial system that chiefly values "sacred" property rights over "human liberty." The insensitive judges ignore the benefits of socialism and defend the often exploitive right of contract. As the chapter ends, the narrator presents a stark scene in which the indigent child he apparently fathered becomes a helpless ward of the state, and more specifically of the state medical clinic: "Walk up the stairs there little girl. But she is naked! These are all doctors. So the little tot struggled up the very high clinic steps, naked as she was, and all the doctors looked at her. She had some spots on her body that had been there a year. Had I been her father I would know why I am a fool" (*I* 199). The scene vaguely threatens: the toddler girl climbs dangerous steps, she is naked in public, and the state-doctors' potential sexual perversions are dismissed but linger as a possibility. The narrator, even when he imagines himself as her father, only knows that he is "a fool," helpless to treat whatever her disease might be. The final sentence of the chapter, "We will look after her said the head doctor," only adds to the sense of foreboding. The individual's love, whether the father's or the father-doctor's (although not, apparently, the mother's, whose scream could drown out the dynamo), is helpless when facing the state clinic.

Finally, one last piece of context might help explain this passage. Keeping the dynamics of individual versus state bureaucracy in mind, it is particularly fitting that while readying this novel for publication, Williams consistently found a way to realize progress, accomplishing what the narrator of his novel could not. Namely, he supported Pound's infamous idiosyncratic Bel Esprit movement to help poets, first and foremost T. S. Eliot, unable to sustain themselves through their writing alone. Arguing that both state-democracy and wealthy philanthropy had failed the arts, Pound requested small, regular donations from various individuals (Williams, H. L. Mencken, Harriet Monroe) to create a private annuity that would free proven artists to do good work.[89] "Only those of us who know what civilization is," wrote Pound, "only those of us who want better literature, not more literature, better art, not more art, can be expected to pay for it."[90] Bel Esprit was envisioned as a security measure for exceptional artists—a very small, local, proto–National Endowment for the Arts. Pound likened the organization to a small corporation, one created by a heroic group of individual supporters with avant-garde preferences.[91] Although Williams would seem to have had little desire to financially support "Elliot" (his impertinent misspelling of Eliot's name in letters to Pound), he repeatedly sent Pound money received from surgeries and delivery of babies. Indeed, Williams seemed to relish in the transformation of his bloody, messy medical labor into a noble and elite aesthetic work.[92] To assist young American sculptor Paul Rudin, Williams even offered Pound

$100 that he was to receive for *The Great American Novel*.[93] Perhaps in these private gestures of philanthropy, we can see in a more palpable way his preference for the individual (and not the state) as the trailblazer for all forms of progress. Indeed, his private-progressive metaphor goes full circle: Williams earmarked the money he received from delivering babies (in the secluded domestic space of women's homes) to the exclusive Bel Esprit, aligning maternal progress and cultural-social progress while bypassing the state and public sphere entirely.

By depicting the blending of new forms of political and social development with an aesthetic transformation of the frame as something that can both incorporate the messy world and transcend it, *The Great American Novel* tries to align different accounts of progress: aesthetic, social, and political. Like other writers we have examined, Williams turns to the language of civil liberties and the freedom of the individual to imagine a way of making progress in the world. This focus on freedom is, in fact, a less progressive version of Williams than the social poet of the 1930s critics have sketched out. Crucially, Williams is not promoting an *apolitical* poetics of the 1920s, but a poetics that reiterates classical libertarian thinking in its goal to find an open-minded role for the individual and her body. In the same way that the reader of "Flight to the City" needs to make sense of punctuation marks perceptually, transforming the colon into stars and page into sky, *The Great American Novel* requires the reader's work to transform idiosyncratic selections of background context and personal fantasy into meaningful foreground, and thus into novelistic value. The intractable objecthood of the novel's sometimes uninterpretable prose must be transformed into a work with meaning and thus with an intrinsic frame. Fragmentary pieces of a text can be stitched together into a coherent whole with the reader's help. By doing so, we are fulfilling part of "our duty as Americans" as Williams understood that duty: reviving the essence of a broken form "and put[ting] it into something which will be far more liberating to the mind and the spirit of man."[94]

Most speculatively, Williams takes issue with state power when it gets athwart populist Progressive reforms precisely because the state, as he sees it, frames the world and its problems in the bad sense of framing, the conventional type he is determined to avoid. The strange fantasy of Doc Williams producing a miracle culture-cure by impregnating impoverished, ethnoracial Others is hard to explain without setting it against the bureaucratized state he clearly frets about. Whether the school board or the court, the establishment—the very basis of conventions—threatens the intrinsic value he desires, a value that Williams imagines as freedom in its purest form. In these terms, bureaucracies are just another literal frame. Whether perceived as the ex situ art object escaped from its constraining limits in a church window, or as the signifier "sky" reimagined as the page on which a piece of poetry is

typed, or as the progress of an individual woman "naturally" delivering a child and breastfeeding her, in each case freedom is an intrinsic value that he hopes only the individual's desires or abilities will limit. The constraint of historical and literary tradition or contemporary social and political conventions is held at bay, if only for a fleeting (albeit repeatedly realized) moment.

4

�ување

Challenging Kitsch Equality

William Gaddis's and Elizabeth Bishop's
"Neo" Rear-Guard Art

In a bourgeois society, and generally in a meritocratic one, the passage through kitsch is
the *normal passage* in order to reach the genuine.
 —Abraham Moles, *Le Kitsch: l'art du Bonheur* (1971)

AMERICANS IN AND OUT OF KITSCH

The movie *An American in Paris* takes over the debate we have been tracing
between window and painting framing from where Stein, Williams, Loy,
Duchamp, and others left off.[1] Now, however, their modernist aesthetic no-
tions are absorbed—and conflated together—as Hollywood style. At mid-
century, following the film's logic, all modern art is available for kitsch
adaptation by corporate art, and the dilemma of the beholder's function to the
meaning of an art object has shrunk to a stylistic choice between two equally
imitable fashions.[2] This scenario is dramatized as the movie opens, when we
peer through supposed Parisian windows from the outside looking in, illicitly
strolling through this "museum" to gawk at nearly pornographic scenes, as we
might peer into Duchamp's peep-show tableau *L'étant Donnés* (1946–66).
Eventually we see a painter's window filling the screen, his paintbrushes,
tubes of paint, and other painterly accoutrements placed on the windowsill,
"framing" the scene as a painting. The painter, Jerry (played by Gene Kelly),
faces us from the other side of the window frame, lying on a bed in a tiny room,
his body oriented to the right of the screen. When his voice-over pronounces,

110

"Voilà!," the recumbent Jerry's eyes pop open and he props himself up, glaring straight at the camera, presumably annoyed at his narrator-self, and us, for waking him (figure 4.1). He then turns over in bed, his back to the camera (figure 4.2). Jerry acknowledges and then physically spurns our gaze through the picture plane and painting frame. The next shot dramatizes his rejection of the beholder in a different way, changing the scene entirely. Revolving 180 degrees and moving to a medium close-up of Jerry's face on the left side of the screen instead of the right, we are now on the other side of the window frame, inside his room and inside the construction of a painting, seeing this "picture" of mid-century Parisian life from the inside out. When Jerry's eyes pop open a second time, his blank, wide-eyed gaze is fixed beyond or perhaps in front of the camera (figure 4.3). Although he faces us, he does not perceive us: his slightly crossed eyes seem unable to see the camera and thus the spectator. In fact, he is staring at one of his paintings on the wall of his bedroom (the position from which we watch him). Looking out of the frame *as if* at the viewer, he now ignores or is oblivious to our presence on the other side of the picture frame entirely. He is simply waking up in his bedroom in apparent solitude. Signaling this shift, his voice-over narration ends abruptly; we are back inside the film's absorbing reality.

This opening scene, although not the movie as a whole, illustrates a modernist account of painterly beholding articulated by Stein and Lewis decades earlier. As Jerry wakes up on either side of the axis of action, speaks in a

Figure 4.1 *An American in Paris*, dir. Vincente Minnelli (1951).

Figure 4.2 *An American in Paris*, dir. Vincente Minnelli (1951).

Figure 4.3 *An American in Paris*, dir. Vincente Minnelli (1951).

disembodied narrative voice, and becomes an object of the narrator's commentary, the film creates the striking impression of a lively "painted" figure who stares, turns his back on us, and then, a moment later, rejects our gaze entirely. Apparently, he is unable to see us watching him, just as Lewis dramatized in *The Childermass*.[3] The film's violation of the 180-degree rule acknowledges the theatricality of art (when Jerry first stares at us watching him), and then literally reverses its viewpoint, reasserting the absorptive qualities of painting by having him ignore our gaze by being absorbed in his own painting hanging on the bedroom wall.[4] Yet after this point, the film quickly moves into more ordinary kitsch, domesticating the Parisian expatriate art scene already years past its zenith. Jerry's elegant patron, Milo ("as in Venus di"), hails from Baltimore, as did Stein and her friends Claribel and Etta Cone, heiresses who created phenomenal modern art collections by supporting mostly male, Paris-based artists.[5] With Milo and Jerry's flirtation, the film unites repeated references to the dynamics of painterly spectatorship—theatricality, absorption, framing— with parodies of the mid-century expatriate art scene. Wealthy, sexually liberated American women buy indigent young men's paintings in Paris. The film not only reveals an attentiveness to modernist theories of painting, reflecting Vincente Minnelli's knowledge of the discipline and its history, it also dramatizes, contextualizes, and caricatures art patrons such as Stein.[6]

Eventually, the film also contextualizes and caricatures not just Stein's person but precisely the account of painterly beholding she and others promoted. In its long final sequence, Stein's and Lewis's account of spectatorship is abandoned and the film turns to another perspective, following the collapse of painting frames into window frames, the same view we saw realized in Loy, Duchamp, and (more ambivalently) Williams. Window frames explicitly become painting frames in the eighteen-minute-long, climactic ballet that portrays Jerry dancing into Henri Rousseau, Maurice Utrillo, and Henri de Toulouse-Lautrec paintings that have come to life. A fountain's water "freezes" in a moment in time (like a Raoul Dufy painting) as Kelly and Leslie Caron dance around it; later, figures from Toulouse-Lautrec paintings pose as immobile backdrops—Hollywood tableaux vivante—while Caron performs around them as a Moulin Rouge showgirl. While Jerry's dull street paintings of mid-century Paris lie flat on the canvas, they come to life when the dancing Kelly leaps into set designs of the same scenes. In this way, the ballet precisely rejects Stein's account of painting without air and exemplifies Lewis's satire in *The Childermass*: spectators must enter bad art to give it some semblance of the "life" real art possesses on its own. Most important, by transforming modernist aesthetics into fashionable Hollywood set design, it's not so much that the movie can't decide whether it prefers its paintings in frames or as windows but that it assumes that there is no need to decide. Both sides of the aesthetic debate we have explored in the last three chapters are equally useful modern styles to be copied or ignored at whim, just as Jerry sometimes scowls at the

viewer and sometimes simply ignores us, or shrugs bemusedly when strolling through his neighborhood and spotting radically opposed styles of art. Ultimately, it doesn't matter how art objects relate to the viewer or how artists paint, because all modern art is equally useful for kitsch adaptation. Sometimes the beholder will be invited into the pictures and sometimes she won't be, but which happens is now understood as a stylistic choice as opposed to a theoretical claim about the way paintings work.

This chapter juxtaposes two very different mid-century writers, William Gaddis and Elizabeth Bishop, whose aesthetic views resemble those we have seen in earlier chapters but who simultaneously grapple with the issue Minnelli's film inadvertently raises: the problem of kitsch equality. That is, both writers struggle, first, with the sense that kitsch makes contrasting understandings of modernist beholding equally available and useful, and, second, with the idea that kitsch and mass culture (its close cousin, if not one and the same) are inherently more egalitarian—and thus more American—than high culture. As Dwight MacDonald put it at the time: "Mass culture is very, very democratic; it absolutely refuses to discriminate against, or between, anything or anybody."[7] Just as Jerry implies that anyone as talentless as he is can be part of the avant-garde (he is a former GI flaunting his ordinariness), the film also proposes that any kind of modern art can be brought to the American masses via a blockbuster musical. What we are seeing is the problem of beholding being refocused. For Stein and Lewis, the irrelevance of the reader supports their staunch commitment to civil liberties, entailing a conventional version of classical liberalism. For Williams, the reader's role in an art object's meaning requires a more tempered compromise, requiring him to balance authorial governance with readerly democracy and freedom. But for Gaddis and Bishop, these similar problems are viewed through kitsch's democratic impulse to represent and include the spectator completely, a development both inspiring and threatening their art. As a commodity, kitsch only works when it sells itself to the average consumer, such that the idea of the spectator's—or, more accurately, consumer's—irrelevance makes little sense in this scenario. Yet the strangely symbiotic relationship between avant-garde and kitsch also triggers both writers to turn the problem around and arrive at a new solution. They use kitsch strategies to develop a "neo" *arrière-garde* (rear-guard) modernist aesthetic that insists on the work's immunity from the spectator through a tactic we might call, following Gaddis's lead, an aesthetic of criticism.

No doubt aligning Gaddis and Bishop seems as improbable as juxtaposing Lewis and Stein. Gaddis often appears as the masculine genius (on the model of Joyce and Pynchon), whereas Bishop emerges as the spirited, feminist poetess (on the model of Dickinson and Moore). Gaddis's honored yet rarely taught novels, such as *The Recognitions* (1951), *J R* (1975), and *A Frolic of His Own* (1994), are notoriously dense satires of postwar American life that tackle the art and literary world, the media, material and corporate culture, and law. Bishop's writing, in contrast, seems private and approachable; books of poems

such as *North & South* (1946), *Questions of Travel* (1965), and *Geography III* (1976) contain brief, personal, and often formally structured poems that focus on overlooked or undervalued subjects. Despite these divergences, Gaddis and Bishop imagine a critically aware, surprisingly modernist late modernism, putting their long-standing serious interest in the art world to good use. Bishop painted as an amateur, while studying books about painters and writing important poems about the visual arts. Gaddis studied the contemporary art world earnestly: in the 1953 autobiographical novel *The Subterraneans*, Jack Kerouac describes the Gaddis-character as "chattering about every tom dick and harry in art."[8] Crucially, both Gaddis and Bishop are fascinated and troubled by kitsch's relation to high art.

We can begin to see this interest in *The Recognitions*, Gaddis's masterful novel about the mid-century New York art world, when a character named Agnes Deigh is described wearing "on her browned wrist, complemented with gold in all the garrulous ugliness of the Modernism heresy [. . .] a Mickey Mouse watch" (*R* 178).[9] Modernism becomes kitsch—"garrulous ugliness"— with one piece of Disney merchandise. But the concern with kitsch appears in less obvious places in the novel as well, as with the struggles of an American painter, Wyatt Gwyon, first painting in Jerry's same Parisian neighborhoods, shortly before an art critic named Crémer creams his work in a savage review as "dérivé sans coeur, sans sympathie, sans vie [derivative without heart, without sympathy, without life]" (*R* 74). Thereafter, *The Recognitions* depicts another kind of "dérivé" art: forgeries. Wyatt successfully counterfeits fifteenth-century Flemish painters such as Hans Memling and Jan Van Eyck when he fails to sell his authentic work, following in the footsteps of the real Dutch counterfeiter Han van Meegeren, who successfully sold his garish, wildly popular (and to contemporary eyes, completely kitsch) "Vermeers" to Hermann Göring during World War II.[10] By focusing on the aesthetic logic of counterfeiters such as Wyatt, *The Recognitions* anticipates Matei Calinescu's argument that kitsch fundamentally centers on questions of "imitation, forgery, counterfeit, and what we may call the aesthetics of deception and self-deception."[11] As we shall see in the next section, Gaddis invokes kitsch interchangeably with the notion of the counterfeit to incorporate a historical-critical perspective on art in relation to other media (such as photography) and, most important, to critique spectators' increased prominence in artistic meaning.

In contrast to Gaddis's focus on counterfeits, Bishop's concern with kitsch appears in her ekphrastic poetry about derivative or primitive art. Amateurish "large bad picture[s]" (the title of one poem) provide the opportunity to highlight different modes of critical or visual analysis: aesthetic and formal versus anthropological and social. Thus, in "Filling Station" (1965), the dirt, oil, grime, and general tastelessness of a gas station's furnishings, where "comic books provide / the only note of color— / of certain color," are gradually resignified over the course of the poem (*CP* 127). What affluent patrons might view as signs of vulgarity and carelessness—that condescending "certain color," the

dirty oil in an "oil-permeated" room—become signs of value: "Somebody embroidered the doily. / Somebody waters the plant, / or oils it [. . .] / Somebody loves us all" (*CP* 128). She reframes the gas station's pervasive evidence of popular culture, grime, and visual deficiency as, instead, evidence of care and value. Someone, probably a woman, places comic books on the table as colorful decoration; someone oils the desiccated plant to improve its appearance, if not its overall health. Focusing on the use of kitsch motivates comparative, critical thinking about aesthetic judgment. Yet simultaneously, the poem's meticulous form and witty wordplay affirm her own nonkitsch, high art principles. The obsessive repetition of "*oil*" and "*dirty*" in the first three stanzas is recombined in the fourth stanza to become "*dim doily*" and then, in the next transformative iteration, "Embroi*dered* in *daisy*" (emphases added). Beautifying literary language dramatizes the poem's theme—the resignification of kitsch crudeness for art production—as good New Critical practice. Both Bishop and Gaddis explore the art object's relation to kitsch to create a highly self-conscious, critical poetics about an art object's ontology. By focusing on the definition of high art objects in relation to an expansive media and popular culture, they also consider how the frame of an art object works to distinguish high art from popular culture, and what role—if any—the affluent, elitist spectators or the average consumers plays in that process.

The gas station's vulgar decor, Wyatt's counterfeit Memlings, and Jerry's insipid paintings (transformed into large-scale movie sets) all fulfill Clement Greenberg's definition of kitsch in his influential essay "Avant-Garde and Kitsch" (1939). For Greenberg, kitsch is the avant-garde's trite and dangerous cousin, the rear-guard: "popular, commercial art and literature with their chromeotypes, magazine covers, illustrations, ads, slick and pulp fiction, comics, Tin Pan Alley music, tap dancing, Hollywood movies, etc., etc."[12] The list goes on because kitsch is indefatigable, parasitically scrounging on "genuine culture"—whether folk or avant-garde—by simulating, debasing, and selling it for profit: say, a Dufy painting dramatized and danced around, creating a blockbuster hit for a corporate entity such as MGM.[13] Greenberg is especially hostile to *The New Yorker*, the magazine with which both Gaddis and Bishop were (years later) professionally affiliated, as "high-class kitsch for the luxury trade."[14] These arguments return with renewed zeal in the early 1950s, when MacDonald (ironically himself a contributor to *The New Yorker* during this time), expands on Greenberg's distress about kitsch in the hysterical, gendered language of emasculation and suffocation: "a tepid, flaccid Middlebrow Culture . . . threatens to engulf everything in its spreading ooze."[15] More recently, however, Calinescu sees the competitiveness between kitsch and avant-garde as masking a strong reciprocated attraction, with the avant-garde using kitsch for "subversive and ironical purposes," while kitsch uses the avant-garde for "its aesthetically conformist purposes."[16] The latter dynamic is in play in *An American in Paris*, whereas *The Recognitions* and "Filling Station"

dramatize the former, which is to say that while Hollywood found profitable uses for avant-garde art, mid-century writers such as Gaddis and Bishop discovered ways to use kitsch ironically and cunningly reimagine the modern.

Here we might also incorporate William Marx's argument that a rear-guard, or what he calls a "neo" *arrière-garde*, is in fact the most accurate description of avant-garde literature in the twentieth century because such art struggles with an overwhelming sense of being out of sync with time and culture.[17] The rear-guard is a distinctly modernist concept, occurring when everyone else feels solidarity with the avant-garde, and it consists of two main categories. The first group follows a dated aesthetic movement, fighting the avant-garde of the next generation, and the second is a "neo" rear-guard who deliberately look back to literature and art history's past.[18] Interest in neoclassicism around 1910 is one example of a "neo" rear-guard actually masking a powerful avant-garde.[19] The "neo" category is the one I want to focus on, for it aptly describes Wyatt's calculated decision in *The Recognitions* to give up contemporary painting to paint like an Old Master and Bishop's fascination with fixed forms such as the sestina long after earlier modernists such as Williams declared them sclerotic and passé. Such members of the rear-guard combat the feeling of being out of sync with history by attempting to return to a moment before the critical break with history, as "writing means rewriting and thus rewriting history."[20] Marx's phrase speaks well to Bishop poems, such as "Brazil, January 1, 1502" (1960), which reframes the original myth of New World discovery, and "One Art" (1976), her obsessively redrafted villanelle that insists on writing and rewriting "the disaster" (*CP* 91–92, 178). More generally, Bishop and Gaddis create a "neo" rear-guard out of kitsch that hides a powerful avant-garde, one that revisits anew the issue of meaning's autonomy we have seen in earlier chapters.

THE RECOGNITIONS AS "NEO" ARRIÈRE-GARDE: KITSCH SPECTATORSHIP

New York's mid-century spectators, critics, and consumers were a varied group, each participating in the art world's shift from artistic patronage to art consumption. As Serge Guilbaut describes, the immediate postwar period saw the art world's focus move from Paris to New York, as artists were spurred on by the unprecedented commercial art boom of the period.[21] Some New York art dealers increased their sales by 250 percent each year, signaling changing consumption patterns for art. While super-rich collectors such as Peggy Guggenheim and Nelson Rockefeller bought Pollocks and Mattas, large numbers of the upper middle class became first-time consumers of paintings, specifically, old paintings like the ones Wyatt copies.[22] Duchamps and Dalís graced the cover of *Vogue*, Légers and Mondrians advertised dresses in *Harper's Bazaar*,

and New York department stores began to sell Old Master paintings in 1943 to supply the new demand for authentic art. Macy's sold small-sized Rubens canvases and Gimbels sold Rembrandts.[23] This new, mass-cultural consumption realizes the triumph of high-class kitsch anticipated by Greenberg a few years earlier. When Dalí paintings and Duchamp sculptures sell dresses for *Vogue*, high art merges with consumer culture. Or, as one unheeded but surely prescient character puts it in *The Recognitions*, "A deodorant company reproduces the *Madonna of the Rocks* in an ad [. . .] a laxative company reproduces the portrait of Doctor Arnolfini and his wife in full color [. . .] if there's one single cancer eating out this country, it's advertising" (R 666).

In this situation we find Wyatt, *The Recognitions'* idealistic painter to whom all modern and contemporary art looks like consumer-driven kitsch, who (if he had wanted to) could have made a fortune selling his "Memlings" and "van Eycks" at Bloomingdales. Before he begins forging, he views post-Impressionism and surrealism as part of the tasteless mass culture he wants to avoid:

> [Wyatt] knew no more of *surréalisme* than he did of the plethora of daubs turned out on Montmartre for tourists, those arbiters of illustration to whom painting was a personalized representation of scenes and creatures they held dear; might not know art but they knew what they liked, hand-painted pictures (originals) for which they paid in the only currency they understood, to painters whose visions had shrunk to the same proportions. (R 67)

Wyatt disdains "*surréalisme*" as just one more form of insipid illustration, a version of high-class kitsch as Greenberg also describes it: "shrunk[en]" tourist art for the wealthy. He feels instead that an art object's aesthetic unity and quality will determine a work's value, a view openly mocked by the various profiteers around him who argue that economies of spectatorship determine its only worth. When the art critic Crémer offers to write puff-piece reviews of Wyatt's authentic paintings for a cut of the profits, Wyatt balks: success in selling his pictures is "up to the pictures" themselves (R 71). Yet when art's value is determined by consumers who "might not know art but they knew what they liked," then art—whether modernist heresy, surrealist daubs, or something else—sinks to the status of the kitsch commodity, worth the only currency these painters comprehend.

Art's status as kitsch permits middlemen, such as Crémer and the demonic art swindler Recktall Brown, to profit enormously. But Gaddis also presents Abstract Expressionist painters, such as the artist who presents an abstract painting titled *The Worker's Soul* (more fake and mass-produced than anything Wyatt produces) profiting similarly from "counterfeits." In a Greenwich Village party scene, the reception of the new painting is satirized:

No one was looking at [the painting]. The unframed canvas was tan. Across the middle a few bright spots of red lead had been spattered. The spots in the lower left-hand corner were rust, above them long streaks of green paint, and to the upper right a large smudge of what appeared to be black grease. It looked as though the back of an honest workman's shirt had been mounted for exhibition, that the sleeves, collar, and tails might be found among the rubble in the fireplace. (R 176)

Many of the painting's details resemble that quintessential American assembly line product—the automobile—with its "red lead," "rust," "streaks," and "smudge of . . . black grease." We never know whether this "honored" painting actually is an honest workman's shirt, a dishonest workman's shirt, a painting of a workman's shirt, or a painting designed to counterfeit a workman's shirt. But we know that this painting (or counterfeit of a painting), alludes to an Abstract Expressionist artwork. Perhaps it is intended to resemble a Pollock, a Kline, a De Kooning, or, slightly anachronistically, an early work of Pop Art such as Rauschenberg's Bed (1955), a paint-splattered quilt and pillowcase mounted on a canvas (figure 4.4). Whosoever it is exactly, the allusion is not flattering. Abstract Expressionism, Gaddis seems to suggest, is indistinguishable from mass-produced consumer products.[24] Hannah, another Village artist, inadvertently calls attention to this confusion by sometimes describing the work as representing blankness—she tells Stanley (an organ music composer) that "the composition's good" (R 184)—and then at other times praising the work for simply being blank: "the emptiness is shows, it hurts to look at it. It's so real, so real" (R 182). We never know whether the shirt is intended as art, or whether the shirt has simply been misidentified as such. The meaning of kitsch-inflected art (such as later Pop Art) is never certain, always determined by spectators such as Hannah labeling the object either well composed or simply empty.

With all modern art now kitsch-inflected, Wyatt's transition to Old Master counterfeiting would seem to make practical sense. When Rembrandts and Rubenses are being sold at department stores, the market has clearly established their commodity value, if not their meaning. Similarly, the fake painting relies on an outside economy of critic and art buyer—even if it is an economy as false as the painting it circulates. But Wyatt's decision to become a counterfeiter is never presented as financially practical or even as self-preserving: after burning his own forgeries in an attempt to clear his name (R 547), he stabs art critic Basil Valentine, terminating (if not resolving) their aesthetic debate (R 692), and ends up living penuriously in a Spanish monastery. To the very end, he is the character least interested in real-world compensation or fame. Instead, what is particularly interesting about Wyatt is his paradoxical yet absolute artistic integrity, so much so that he responds to the flood of contemporary, mid-century kitsch in terms of the youthful conception of

Figure 4.4 Robert Rauschenberg, *Bed* (1955). Museum of Modern Art. Art © Estate of Robert Rauschenberg/Licensed by VAGA, New York, NY. Digital Image © The Museum of Modern Art/Licensed by SCALA/Art Resource, New York.

painting and beholding he still maintains. For Wyatt, kitsch and forgeries present a problem identical to the modernist aesthetic problem of meaning's autonomy he wants to solve: the need to eliminate the spectator's relevance to a work's meaning.

Here we finally can identify Wyatt's essential problem: he cannot realize meaning's autonomy. As much as he tries to fight it, spectators remain relevant to the completion of his paintings. The very first instance of this dilemma occurs early in the novel, when, as a precocious young boy, he paints a remarkable portrait of his dead mother based on a photograph. By leaving "its lines of completion to the eye of the beholder," the painting profoundly bothers Wyatt's puritanical father, the Reverend Gwyon:

> Once [Reverend Gwyon had] seen it he was constantly curious, and would stand looking away from it, and back, completing it in his own mind and then looking again as though, in the momentary absence of his stare and the force of his own plastic imagination, it might have completed itself. Still each time he returned to it, it was slightly different than he remembered, intractably thwarting the completion he had managed himself. (R 57)

For Reverend Gwyon, grief-stricken by his wife's premature death, his son's painting presents a problem similar and perhaps alluding to that of Dorian Gray gazing at his own portrait in Oscar Wilde's *The Picture of Dorian Gray*. In both instances the representation alters repeatedly, fascinating and horrifying the men. Just as Dorian's bad deeds cause sneers to appear suddenly in his portrait, so every time Gwyon looks at his wife's image, "it was slightly different than he remembered."[25] The mutability of her image distressingly stands in for the daily changes of a once-living woman. Yet leaving aside the thorny question of immorality (a preoccupation of both Gaddis's and Wilde's novels), there is an important difference between the novels' two paintings that makes Gaddis's particular interest in meaning's autonomy all the clearer. If Dorian Gray's portrait always requires the referent of the sinning Dorian to be complete (man and picture are symbiotically entwined), in *The Recognitions*, the portrait's relation to its referent is entirely irrelevant to the painting's completion. Wyatt's portrait of his dead mother transforms in his father's eyes not because his mother changes but because Wyatt never finishes the painting. His art object needs not the referent but the "eye of the beholder" to finish the work.

In other words, the one thing relevant to Wyatt's painting is the beholder of that painting, and he understands the spectator's new responsibility, undesired by the artist, to be the central problem of modern painting. As a young man, Wyatt first tries to change this situation by devaluing any kind of actual beholding, a bizarre position for a painter, whose livelihood surely depends on looking. Yet to Wyatt, even artists themselves can be a problem when they rely too much on the act of beholding in the creation of their work. Thus he

observes and rejects his fellow painters in Paris "painting the same picture from different angles, the same painting varying from easel to easel as different versions of a misunderstood truth, but the progeny of each single easel identical reproduction" (*R* 67–68). These painters and their work are dismissed not because they choose to paint street scenes but because they mistake their particular visual perspective of being in one alley and not another for originality of vision—having something unique to show the world. They might each have "different angles" on the world, but their pictures are similarly flawed for their reliance on subjectivity over meaning, on "different versions of a misunderstood truth." The alley painters undercut art's possibilities by elevating literal perception, reducing painting to the physical perspective of beholding en plein air. Moreover, by focusing on the outdoors artist, Wyatt tacitly accuses Impressionist and post-Impressionist art for making painting habitual, resembling the act of "men whitewashing walls" (*R* 68). When the literal, automatic "eye of the beholder" becomes the critical aspect of a painting, the true artist must labor to neutralize the beholder's role, even if (more problematically), the original beholder is the painter herself.

Wyatt's fear that painting had become as habitual and easy as whitewashing walls bespeaks an anxiety that the painter's work had become *identical* to the beholder's work. In this regard, Wyatt is really suggesting that painting had come to resemble that act of quick, democratic, reflexive spectatorship called photography. After all, he himself learns to paint by copying photographs, and when he condemns the Parisian painters for painting "the progeny of each single easel identical reproduction," he is calling them out as documentary street photographers posing as painters. They peer through their viewfinders when they spot a slightly different view and click away with abandon. Keeping this point in mind, it is especially intriguing that Gaddis modeled Wyatt on his contemporary Walker Evans, the photographer best known for the Depression-era photojournalist project *Let Us Now Praise Famous Men* (1941), created with James Agee.[26] Evans aimed to turn photojournalism into art, as evidenced by the Museum of Modern Art's 1938 exhibition of his work, *American Photography*, the museum's first ever solo exhibition of a photographer.[27] Although Gaddis later demurred that the resemblance to Evans was only physical (lean, craggy, Protestant types), the allusion to the photographer makes a certain sense.[28] Evans highlights documentary photography's status as art, whereas Wyatt, seeming to echo Walter Benjamin's work of art essay, argues that painting is struggling, and now often failing, to distinguish itself from photography.[29] Like kitsch, photographic-like art is presented as the more democratic medium, generating dozens of artistic "progeny" instead of selecting elite apprentices and rejecting many other aspirants. Photography's egalitarianism, moreover, reflects the spectator's increasing prominence in art creation because it seems to conflate artistic vision with the act of spectatorship: looking through the viewfinder.

Wyatt makes the same point when passionately defending his own choice to produce art by impersonating a fifteenth-century Flemish painter and imitating past creations. His forgeries, he suggests, are in fact a new strategy to consistently and strategically undermine the role of spectatorship. Defending himself to the art critic Basil Valentine, Wyatt explains that in a Flemish painting, in contrast to a modern one,

> There isn't any single perspective, like the camera eye, the one we all look through now and call it realism [. . .] the Flemish painter took twenty perspectives if he wished, and even in a small painting you can't include it all in your single vision, your one miserable pair of eyes, like you can a photograph, like you can painting when it . . . when it degenerates, and becomes conscious of being looked at. (R 251)

Wyatt rejects "the camera eye" of post-Impressionist modern art because it embodies and privileges spectatorship, just as a camera captures the particular perspective, light, and time of a moment and place. A particular, individual perspective on the world ("your single vision, your one miserable pair of eyes") has become far too important to such art, as modern painting, according to this logic, has become too much like photography, a "witness" of one's past that actually "recall[s] nothing" (R 286). Instead of representing a conception of a world, modern painting limits itself to becoming an automatic witness, mechanically capturing a single person's literal perception of the world without reflecting on that experience.[30] When an artist values his physical perspective on the world over his entire worldview, he reduces his art to the literal world of his audience over the world of his own created meaning. A painting becomes something that "knows" it has an audience—it "becomes conscious of being looked at"—and plays to that audience, like Jerry in An American in Paris, making faces at the camera when it wakes him up. In Wyatt's view, the art object's awareness of spectators leads it to "degenerate," losing the essential characteristic distinguishing a representation from just an ordinary object in the world, becoming a poor embodiment or counterfeit of reality—and an unconvincing one at that.[31]

Wyatt's argument against the role of spectatorship and in support of a particular kind of forgery is, to say the least, atypical. Historically, counterfeiting or art forgery has been interpreted not as an aesthetic strategy such as Wyatt's but as a special case of crime, intending to deceive maliciously for financial profit. The Vermeer forger Van Meegeren (on whom the character of Wyatt was based) was arrested in 1945 and very narrowly escaped capital punishment. Shortly after The Recognitions appeared, philosophers of aesthetics began to debate the ontological status of forgeries more seriously, at the moment when conceptual artists were increasingly scrutinizing the relationship between museums and the art objects in them. For Joseph Margolis, Mark Sagoff, and Nelson Goodman, forgeries are particularly interesting because

when they succeed, it is because the marketplace and the museum endowed them with value; when they fail, these same networks and institutions obliterate their value completely.[32] From this perspective, forgeries begin to look less like a special problem of art history and more like a case study revealing the institutional circumstances of *all* artistic value and meaning.

Gaddis anticipates these later philosophical debates by primarily focusing on the ontological provocations of forgery—that is, on what will count as giving an art object its "recognition," and thus its value as an art object.[33] In *The Recognitions*, "counterfeiting" becomes a term for the contemporary situation of art that Lewis also blasts against, the problem produced when beholders are privileged in art's creation. We have seen how Gaddis's novel depicts photography as one instance of privileged beholding, but any art that relies on the spectator's involvement for its completion—unfinished painting, performance art, site-specific sculpture, situational art, counterfeits—is part of this new economy. (Perhaps precisely for this reason the later Gaddis novels *J R* and *A Frolic of His Own* parody site-specific art, especially Richard Serra's.[34]) In other words, counterfeit art in *The Recognitions*, in addition to representing the mid-century feeling of life's total falseness, just as significantly establishes the changing conception of art objects' ontology as incorporating the spectator's world. Wyatt struggles to create real avant-garde art within this new "false economy" and often seems to fail (*R* 4). Yet his aesthetic perspicacity, his ability to see the contemporary situation in which beholders are on the ascendant, surely marks him as more authentically avant-garde (or, perhaps, "neo" rear-guard) than many of his fake artist "friends."

Literary criticism more or less follows Wyatt's lead in rejecting or at least ignoring the contemporary scene of American painting as sketched thus far. In the process, criticism has failed to address the novel's complicated relation to modern art and Gaddis's interest in its debates.[35] Instead, interpretations of *The Recognitions* follow two alternate models: on the one hand, critical accounts focus on the redemptive, religious, and humanist aspects of art, such that "Gaddis's position seems to be that genuine art atones not only for false art, but for false life as well."[36] On the other hand, accounts focus on the novel's postmodernism, particularly its Baudrillardian theory of art as simulacrum and its fascination with networks. Wyatt's forgery, according to this view, "eludes the very opposition between an original and a copy."[37] In a way, both alternative models make sense. Just as Wyatt appears to reject modern painting, Gaddis himself appears contemptuous of current trends in the art world, beginning with post-Impressionism and continuing through surrealism, Abstract Expressionism, site-specific art, and so on. Gaddis would seem to condone Wyatt's and Stanley's atavistic return to historical art by rejecting the contemporary avant-garde aesthetic. But choosing one of these accounts or trying to mediate between them as interpretive poles—art as atonement versus art as simulacra—does not entirely illuminate the narrative we have been tracing thus far.

Instead, Gaddis's "neo" rear-guard satire of the contemporary art world reinvents an avant-garde by imagining criticism incorporated into art. If art that resembles photography is a "witness" of one's past that actually "recall[s] nothing" (R 286), then Wyatt aims for an art that *can* represent and recall the past. The future of painting, according to Wyatt, must incorporate historical criticism. Trying to convince Basil Valentine of the value of his forgeries, Wyatt explains: "criticism? It's the most important art now, it's the one we need most now. Criticism is the art we need most today. But not, don't you see? Not the 'if I'd done it myself . . .' Yes, a, a disciplined nostalgia, disciplined recognitions" (R 335). Wyatt tries to incorporate real criticism into his own art because such intellectual work respects and requires "disciplined nostalgia, disciplined recognitions," also the very aim of his forgeries. For instance, his dedication to his craft prompts his use of farm-fresh eggs for his tempera paint and real lavender oil for his medium. He does these things to be accepted, in theory, into the long-disbanded Flemish painter's guild and not incidentally to throw off experts spying nineteenth-century paint technology in a supposed sixteenth-century painting. But he also follows such an exacting technique to put his "disciplined nostalgia" into practice, much like the Arts and Crafts movement committed itself to handicrafts at a moment of increased industrialization.[38] By using an archaic practice to forge old Flemish paintings, Wyatt performs a disciplined act of remembering to critique modern painting. In a sense, he intends his forgeries as both an art object and a form of criticism precisely because they are not automatic reproductions (photographs) of a cultural artifact. The artist painting as a disciplined "nostalgist" asserts her imagined world vision instead of reducing her painting to pure spectatorship, the physical view of reality (the view from a camera). These forged reproductions, and the techniques Wyatt uses to create them, involve the mannered and methodological act of recognizing, transforming, and placing a cultural artifact into his personal memory and conceptualization—his vision of the world in a philosophical (instead of a literal) sense.

We can see another version of his same attempt in an earlier scene: when Wyatt complains about the role of "cheap fakes," referring to photographs or print reproductions in magazines, Basil dismisses his argument by pointing out that "every piece you do is calumny on the artist you forge" (R 250). According to Basil, Wyatt is in no position to condemn reproductions of art because his own counterfeits denigrate famous painters, leading to lesser, newer works being attributed to Old Masters. At this accusation, Wyatt defends himself fiercely:

Do you think I do these the way all other forging has been done? [. . .] the recognitions go much deeper, much further back [. . .] some of them [the experts] aren't fools, they don't just look for a hat or a beard, or a style they can recognize, they look with memories that . . . go beyond themselves, that go back to . . . where mine goes. (R 250)

Wyatt is arguing that forgery creates something new when it is an act of appropriation instead of plagiarism or counterfeiting: no calumny is committed because the new art incorporates recognition of art's historical trends and developments. This is why his forgeries cannot be understood as simply imitating "a style." Instead, his forgeries recognize painting as a discipline, an understanding accompanying the recognition of great art. Perversely, Wyatt's act of forging the Great Masters is also the act of one man willfully instantiating a discipline and a cultural memory in himself and via his art. More striking perhaps is that Wyatt makes a claim for his work's avant-garde status on Greenberg's terms in "Avant-Garde and Kitsch." As Greenberg puts it, "The avant-garde culture is the imitation of imitating—the fact itself—calls for neither approval or disapproval."[39] Avant-garde art has copying at its very core, a fact without moral purchase. Wyatt similarly observes about his own work: "to have copied a copy? and that was how it began" (*R* 360). Although Greenberg would no doubt stamp Wyatt's art kitsch, Wyatt's view of art resembles Greenbergian modernism more than it resembles the posthistorical scenario Arthur Danto depicts, where "artists, liberated from the burden of history, were free to make art in whatever way they wished."[40]

Simultaneously, with Wyatt's decline Gaddis acknowledges the peril of being part of a "neo" rear-guard while surrounded by a pervasive culture of counterfeit, spectator-created art, alluding to various real contemporary artists' situations in the process. After stabbing Basil, Wyatt flees to a Spanish monastery, supposedly to restore—but actually to mutilate slowly—Titian school paintings (*R* 692, 870–72). In this detail, Gaddis might have been alluding to the notorious "creation" of *Erased de Kooning* (1953), when Rauschenberg erases and then exhibits the remains of a valuable de Kooning drawing. Whatever Wyatt's precise intention, his situation is tenuous: he appears to have a psychotic break, his mind's response to his art's irreconcilable aims.[41] His breakdown parallels the dangerous situation the real forger Han van Meegeren found himself in after World War II, when he was exposed for selling a "Vermeer" to Göring (the latter arguably a model for *The Recognitions*'s psychopathic, wildly acquisitive art collector Rektall Brown). Not suspecting that van Meegeren was forging the Vermeers, the Dutch police assumed he had looted a hoard of art treasure from wealthy Jews and profited outrageously by selling them to the Nazis, a treasonable collaboration punishable by death.[42] In a well-reported court case at the time, van Meegeren confessed to painting Göring's "Vermeer" to save himself from conviction; he even painted a new "Vermeer" while incarcerated to prove his skill. By demonstrating that his forgery was authentically his own and not Vermeer's, van Meegeren touted his supposed patriotism, resisting Nazi domination by selling Göring fake art. Ironically, his forgery demonstrated his "integrity" as an artist, because he actually could paint works that might be mistaken for Vermeers—at least by the Nazis. The argument turned the media and popular opinion to his side, as van Meegeren was proclaimed as a Dutch hero: "the man who swindled Goering."[43]

Although the story worked out well enough for van Meegeren (he was acquitted), the case highlights one danger of an art of beholding: for better or worse, the artist must rely on the masses, that democracy of beholders, buyers, and media. In this case, van Meegeren's dependence on Göring and other Nazi collectors to validate and purchase his art placed him in political peril after the Nazis lost the war. Gaddis implies that Wyatt is similarly endangered since the substance of his attack on contemporary art could easily be mistaken for Nazi propaganda. From this perspective, it seems significant that Wyatt uses the word "degenerat[ing]" to complain that contemporary work cannot maintain the spectator's irrelevance because its painterly integrity is spent (R 251). Undoubtedly the word *degenerate* in combination with *art* signified a specific cultural, racial, and ideological disapproval at this moment, since the Nazi "Degenerate Art" exhibition attacking modernist and abstract art opened in Munich in 1937 (the same city in which Gaddis has Wyatt study in the late 1930s). Although Wyatt never specifically attacks modernist abstraction and seems entirely oblivious to race, politics, or world events, the novel pinpoints his complaints as taking place in 1949, that particular postwar moment when Holocaust survivors and family members were tracking down their valuable "degenerate" art stolen and sold off during the Nazi occupation. Thus, although *The Recognitions* does not imply that Wyatt sympathizes with Nazi ideology (although van Meegeren certainly did), the point seems to be that Wyatt's theories of disciplined nostalgia place him in obvious political and even mortal peril. The logic and constraints of forgery and high-end kitsch as an aesthetic strategy suggest that Wyatt's ideas, and their manifestations in counterfeit works, are especially prone to ideological misreading or appropriation. Although he attempts to undermine or downplay the spectator's role in the art object's meaning, Wyatt's forgery-based art risks being manipulated by those same beholders. For his pains he is rejected by society, struggling with a vision the profiteers around him cannot accept.

Outside of Wyatt's lonely quest, *The Recognitions* (and *J R* even more so) increasingly immerses itself in the inescapable, overpowering, and spiritually deadening kitsch of U.S. corporate and art culture without holding out much hope for art's future. As the ad man Morgie puts it:

> The whole goddam high standard of American life depends on the American economy. The whole goddam American economy depends on mass production. To sustain mass production you got to have a mass market. To sustain a goddam mass market you got to have advertising. [. . .] We've had the goddam Ages of Faith, we've had the goddam Age of Reason. This is the Age of Publicity. (R 736)

The Age of Publicity might be the only era not routinely cursed by Morgie, but Gaddis damns it many times over through various media-exhausted characters yearning for death. Morgie and his co-workers plan advertising

campaigns promoting "Necrostyle" (a sleeping pill shaped like a communion wafer) during a TV show called *The Lives of the Saints*, in the process unintentionally filming the jumping suicide of Benny, one of their own workers. Morgie is hardly bothered by this glitch and is impressed by the skill of his proto–reality television crew: "You handled it beautifully, it came over like a dream. [. . .] This happened. We happened to be there. What the hell, it's all in a goddam day's work. [. . .] Come on, I'll buy you the best lunch in town. You'll bounce back" (*R* 738). Unlike the dead Benny (who failed to bounce back), a pricy meal on the corporate tab erases all unpleasant feelings. Sacrilegious TV programming about the saints goes on. When Agnes Deigh also attempts suicide, the reader identifies her not by her physical or personality characteristics but by the particular market niche she inhabits, revealed in the bit of kitsch she wears: that same Mickey Mouse watch we noted earlier, now battered such that "Even Minnie wouldn't know him" (*R* 741). Advertising spots, radio quiz shows, and TV discourse flood these pages, potentially overwhelming Wyatt's idealistic aims for transforming kitsch or counterfeit into art. Finally, when Mr. Pivner spots a classified ad in his evening paper, we see a different and entirely ominous view of the destiny of skilled painters in the mid-century economy: "THE GHOST ARTISTS . . . We Paint It You Sign It Why Not Give an Exhibition?" (*R* 741). Even if Wyatt does not fully recognize the risks and problems of his aesthetics of criticism—the risk of becoming one of the nameless, indigent "ghost artists"—Gaddis surely does.

ELIZABETH BISHOP'S SMALL GOOD POEMS
ABOUT LARGE BAD ART: KITSCH AS FOUND OBJECT

Gaddis deploys a particular kind of kitsch (forgeries) for counterintuitive purposes, repurposing it to satirize postwar art trends privileging the spectator's or consumer's relevance. Faced with either producing works that require the beholder for their completion or copying works that are complete in their original form, Wyatt chooses to copy. He assumes that aesthetic completion trumps spectatorial involvement. Juxtaposed with Gaddis's involved account, Bishop's interest in kitsch initially looks more sympathetic and less theoretical, although she turns out to be just as perturbed about the increasing role of both spectators and kitsch. We can begin to see one instance of this concern in "Gregorio Valdes" (1939), her bemused and generally respectful memorial essay about an impoverished Cuban factory worker and primitive painter she knew in Key West. Although Valdes could not distinguish between "one of his good pictures and his poor pictures"—a lack of acuity Bishop makes clear that she doesn't share—she envies his utterly natural, primitive "undemocratic state of grace."[44] On occasion, he could produce a work with "a peculiar and captivating freshness, flatness, and remoteness."[45] But despite possessing an

"undemocratic" characteristic that would surely elevate his art beyond ordinary market values, Valdes in another way betrays a very democratic, or more accurately, a very market-driven quality—one that, unluckily, does not even help lift him out of the bleakest poverty. When Bishop purchases one of his paintings that "charmed" her for $3, her disgusted landlady (herself an amateur painter) offers to paint the same picture "for fifteen cents."[46] And although Bishop seems entertained by instead of in agreement with her landlady's loathing, her defense of Valdes's art is cautiously measured. Indeed, Bishop repeatedly describes his work precisely in her landlady's terms: as a commodity, or worse yet, as a poorly made copy of an already cheap commodity. From a postcard he accurately copies a Pan American airplane (logo included) and a "church in Cuba [is] copied from a liquor advertisement."[47] His paintings were "almost all copies of photographs or of reproductions of other pictures," usually "nothing more than the worst sort of 'calendar' painting."[48] His art is likened to a mechanical factory art designed to be disposed of quickly, just as calendars were often given away as promotional advertisements for companies and potential consumers threw them away at the end of the year.

We might recall that Wyatt (and Gaddis by extension) worried that artists were turning into mechanical cameras: mere spectators of the scene in front of their eyes. Such painting adopts a spectatorial dynamic, playing to its audience once it "becomes conscious of being looked at" (R 251). In a similar fashion, Bishop is both disturbed and fascinated by Valdes's camera-like eye that turns his vision into disposable kitsch. She commissions him to paint a picture of her house; when it arrives, propped up next to her actual house, she delights in its trompe l'oeil verisimilitude: "I had the feeling that if I came closer I would be able to see another miniature copy of the house leaning on the porch of the painted house, and so on—like the Old Dutch Cleanser advertisements."[49] Despite her delight at beholding the work, the painting's resemblance to her house does not remind her of similar high art trompe l'oeil experiments by Picasso or Braque but of the verisimilitude employed in advertisements for cleaning supplies. When she recounts an episode where Valdes tricked his uncle by replacing a towel and rack with a naturalistic painting of the same objects, the point is that his art functions as a prop for a practical joke in which the uncle is unable to dry his eyes with the painted towel: "'Me laugh plenty, plenty,' Valdes said."[50] An art emphasizing verisimilitude, like Valdes's, ends up needing the beholder's confused delight (or annoyance), turning into a work that plays to and requires the spectator just as a cleanser advertisement tries to sell itself to the consumer. The poem, "Varick Street" (1947), employs factory production as a backdrop for love to play on similar concerns. Its refrain, "*And I shall sell you sell you / sell you of course, my dear, and you'll sell me,*" suggests that love, like art, has been degraded by the mere aural presence of the factory (CP 75). Focusing on that same disposable commodity of reproducible calendar art ("The presses / print calendars / I suppose"),

Bishop implies that lovers and artists alike adapt the discourse of buying and selling to express their most intimate, noble feelings.

Unlike Gaddis, Bishop only occasionally focuses on the discourse of verisimilitude in painting to portray the encroaching role of spectators to the meaning of art. More often, she reflects on what happens to art objects and to aesthetic experience when spectators become too aware of their job as spectators and thus when, as Gaddis puts it, the painting "becomes conscious of being looked at" (*R* 251). For example, in the ekphrastic poem "Large Bad Picture" (1946), Bishop once more examines a primitive painting. The title immediately signals its inferior status. It's not a painting but a "picture," it is "bad," and its largeness might lead us (at least in 1946, if not later during the height of Abstract Expressionism), to label it kitsch, which was often of an inappropriate size for its cultural context.[51] In a tone similar to that of "Gregorio Valdes," she delineates precisely what makes the painting fail as art. It begins with a speaker depicting her great-uncle's landscape painting of either "the Strait of Belle Isle or / some northerly harbor of Labrador" (*CP* 11). The *or* illustrates the title: the speaker seems to know this stretch of Newfoundland well, but the indeterminate painting rebuffs attempts to identify the place depicted. And how could she? The painting's waves are indistinguishably "perfect" and its nondescript sun, "rolling, rolling, / round and round and round" is "in perpetual sunset." Space and time are unhinged from either a specific place or a particular time, representing a vague, repetitive, stasis (captured with the single, alliterative *r* sound) instead of a particular time and place. But this type of painterly ineptitude is primarily a problem of resemblance, a concern modernism disposes of quickly enough.

The speaker's ensuing description further reveals that the lack of verisimilitude is not the most serious problem with this large bad painting. Instead, to put it in Wyatt's terms, the problem is our awareness of the painting's self-consciousness and theatricality, the sense that it is being looked at. In a letter to Anne Stevenson from the 1960s, Bishop echoes Wyatt repudiation of painting's self-awareness when she writes that what "one seems to want in art, in experiencing it, is the same thing that is necessary for its creation, a self-forgetful, perfectly useless concentration."[52] Juxtaposed with "Large Bad Picture," Bishop's comment implies that the artwork fails because it does not achieve this "self-forgetful, perfectly useless concentration." The painting makes us too conscious of it. The black ships that are "motionless, / their spars like burnt match-sticks," fail not only because their rendering conflicts with the painting's perspective (they should look like tall wooden beams) but because they draw one's attention to the actual matchstick size of the painterly marks on the canvas (*CP* 11). The painter's representation of black birds suffers from the same flaw: he has "scribbled hundreds of fine black birds / hanging in *n's* in banks" (*CP* 11). Trying to paint flocks of flying birds, he ends up writing letters. His representation of birds fails as graphical because it

betrays a writerly (as opposed to a painterly) hand, thrusting us into a different kind of seeing entirely: that of close, readerly study of elaborate cursive *n*'s. Unintentionally, her great-uncle manages to produce the effect Williams was deliberately trying to produce in "Flight to the City"—that is, prompting the viewer/reader to interpret one medium (in this case, painting) as if it were another (writing).

Throughout the poem, Bishop delineates exactly what makes the large bad painting bad: it renders the spectator's experience too much a component of the work. She represents a gesture of distraction—the experience of seeing a mark on the canvas as writing, or simply as a nonrepresentative mark, instead of seeing it as a boat mast—to dramatize representation's failure. As in *The Recognitions*, this poem carefully parses out and dramatizes its criteria for badness, reformulating a seemingly minor problem of resemblance as a more serious absence of aesthetic integrity. Consequently, the poem ends with interpretive failure: "Apparently [the ships] have reached their destination. / It would be hard to say what brought them there, / commerce or contemplation" (*CP* 12). The spectator cannot know the meaning of these ships if she can neither determine their kind (fishing or sailing) nor justify her interpretation in relation to the painting as a whole. By ranking the relative levels of aesthetic badness, Bishop shows how a painting that fails to be "self-forgetful" is worse than a painting that does not resemble its referent. Finally, the painting's largeness distracts the viewer by making its clumsy brushwork more obvious. Bishop, like Gaddis, throws up an oblique barb at the expansive (and brawny) surrealist and Abstract Expressionist paintings gaining prestige and value in the 1940s. Whether or not she condemns contemporary art wholesale, she challenges the antiabsorptive trend.

As in "Valdes," her tone is not condemnatory overall but gently empathetic and amused by her great-uncle's amateur effort "before he became a schoolteacher." This lightness can be misleading. Yet it surprisingly signals her *own* work as a bricoleur, making a new, more valuable art object (her poem) out of a found and often kitsch object.[53] With "Large Bad Picture," we see her evaluate and exploit bad artwork in precisely this way. Bad art becomes the crucial element in a new assemblage establishing her own poetic enterprise, like Duchamp's graphic adjustments to cheap reproductions of bad paintings to make new "Readymades aided."[54] Whereas Duchamp installed found objects—a bad painting, a urinal, a rake, a coat rack—in a gallery and understood them to be complete only when the spectator walked in, Bishop's use of found objects more closely resembles the assemblage boxes of Joseph Cornell or the collage of Eliot's *Waste Land* (work of two artists she deeply admired) in which the artist orders the chaos and repurposes mass culture or kitsch for another purpose. "Large Bad Picture" presents an example of the bricoleur at work, whereas the short story, "In Prison," published in the March 1938 issue of *Partisan Review* (edited by MacDonald) condenses these ideas into a new, measured aesthetics.[55]

"In Prison" depicts a lively prisoner who "can scarcely wait for the day of [his] imprisonment."[56] Apparently, the enforced confinement of a prison cell (in contrast to the voluntary solitude of a "hotel existence" or a "religious order") will allow him to "realize" his "faculties" fully.[57] He imagines the particular decorations and designs of a prison cell that will concentrate the view from his prison window into a "beautiful completeness," permitting him to compose "sentences and paragraphs" on the walls of his cell.[58] These manic discussions of visual patterns, reading like a mash-up of Kafka and *Martha Stewart Living*, must have seemed anomalous to the *Partisan Review*'s readership in 1938. But the story marked a turning point for Bishop. In a letter to Marianne Moore, she describes it as "the first conscious attempt at something according to a *theory* I've been thinking up down here out of a combination of Poe's theories and reading 17th-century prose!"[59] The most revealing part of her "theory" is the narrator's desire "to be given one very dull book to read, the duller the better. A book, moreover, on a subject completely foreign to me; perhaps the second volume, if the first would familiarize me too well with the terms and purpose of the work."[60] This dull, boring, foreign book is to be read and used against the book's stated purpose as a kind of philosopher's stone for the poems then scrawled on the cell wall.

Whereas Poe, in "Philosophy of Composition," claims to begin with first principles to delimit the field of composition (beauty and melancholy thus lead to the topic of a beautiful woman's death), the prisoner's first principle is appropriately random, peculiar, and bad: "from my detached rock-like book, I shall be able to draw vast generalizations, abstractions of the grandest, most illuminating sort, like allegories or poems."[61] The dejected, fragmented, and boring book—the large bad painting's literary analogue—prompts his musings. The prisoner even suggests that the bad book organizes his good work, claiming that he would never know how to write from outside the prison, "where the sources are so bewildering."[62] Using the "rock-like book" enables him to meet the world's more pressing claims—the world's patterns, whether cultural, political, or biological—by absorbing them as an alternative first principle. Instead of starting with Poe's concept of beauty, Bishop's prisoner starts with the world's random and mediocre cultural objects that she then exploits for her own purpose.

Just as Wyatt's kitsch becomes a source material for the new avant-garde of "disciplined nostalgia," Bishop's ekphrastic poetry employs a "rock-like" muse to define the view from her prison window of poetic forms, creating a new thing of aesthetic value. In this way, bad art is not used to highlight her sympathy (or lack thereof) with primitive or amateur artists but to dramatize her conception of art's current dilemmas. Her sympathy, when it appears, highlights her recognition of another potential use for the work of the primitive artist. Like Gaddis, she illustrates how bad art gives readers or spectators a role in a work's meaning, whether by being distracted by an experience of a

mark in the painting or by easily allowing a poet like Bishop to assimilate the found, bad art object into her own work. In this regard, the term *rock-like* is crucial. If bad art is a rock—a thing—it is forever available to the perceptual experiences (as opposed to the interpretations) of readers, spectators, or enterprising poets. The reader's reading experience is always relevant to bad art and irrelevant to good, and Bishop, unlike Valdes or her great-uncle, distinguishes between the two.

Bishop's interest in ranking levels of aesthetic failure differs from the sharp distinctions made between art and nonart during the high modernist aesthetic of the 1920s, in which Ezra Pound's "Make it New" allocated traditional art on the side of nonart. So Eliot, in "Tradition and the Individual Talent," notes that art which conforms to tradition "would not be new, and would therefore not be a work of art."[63] In contrast, evaluating—not simply rejecting—the relative types of badness in art preoccupies postwar writers such as Gaddis and Bishop, but others as well. The problem of the rear-guard is raised once more. John Ashbery, in a 1968 lecture, debates the relative merits of traditional art versus avant-garde art: "It is a question of distinguishing bad traditional art and bad avant-garde art from good traditional art and good avant-garde art. But after one has done this, one still has a problem with good traditional art."[64] Good traditional art cannot compare with good avant-garde art; in this sense, Ashbery follows Eliot. The problem of value becomes trickier for Ashbery when he weighs traditional art against bad avant-garde art, a problem Gilbert Sorrentino also grapples with when attempting to compare radically different kinds of contemporary poetry.[65] Similarly, although Bishop's poetics diverge widely from Gaddis's, the intricate task of judging the relative badness of paintings enables each of them, sometimes indirectly or satirically, to establish not just the worth of the art object but its ontological limits in relation to the world.

That task is precisely the aim of "The Monument" (1946), a poem that perfectly establishes her negative aesthetics of badness, yet is often understood, instead, as her egalitarian support of a primitive, kitsch artist such as Valdes.[66] She begins with a voice questioning the work's value: "Why did you bring me here to see this?" asks one speaker of the other. The dubious monument apparently lacks beauty, a coherent idea, or the ability to transcend its surroundings. It must defend its existence: "A temple of crates in cramped and crated scenery, / what can it prove? / I am tired of breathing this eroded air, / this dryness in which the monument is cracking'" (*CP* 24). Like "Large Bad Picture," this poem dramatizes spectators beholding art objects differently than the way the artist intended. Following the cranky interlocutor of "The Monument," we are asked to ponder why Bishop brings this art to our attention. Possibly she is attempting to define what counts as art or to authorize the interpretations of strong readers, or, in contrast, perhaps she is aiming to empower and validate self-taught artists.

Such divergent possibilities immediately foreground the issue of Bishop's aesthetic sensibility. On the one hand, if she wants to emphasize an art object's aesthetic failure to erase the distinction between good and bad art, she is postponing or even denying an aesthetic judgment. If, on the other hand, she attempts to use bad art to define the good, she is aiming to shore up her value judgments. Each leads to radically different interpretations of her poetics and, more generally, of her role in modernism or postmodernism. The former view dominated discussions after Bishop's death, beginning with Adrienne Rich's argument that the conditions of marginality and lesbianism provided Bishop with uncommon perceptions and empathetic access: "the outsider's eye enables Bishop to perceive other kinds of outsiders."[67] Critics followed Rich's lead, such that the catalog of Bishop's amateur watercolors in 1996 seemed to suggest that she was herself a primitive and outsider artist, even though she adamantly rejected the notion that her paintings should be labeled art of any kind: "They are Not Art—NOT AT ALL."[68] Although such a statement indicates that her standards for art were much higher, the recent critical consensus implies, instead, that Bishop undermines the categories of good versus bad art, the cultured versus the primitive, and representation versus experience.[69] As we have already begun to see, however, it is far from clear that her work undermines such aesthetic distinctions by sympathizing with primitive or kitsch artists.

In "The Monument," as in previous poems discussed, the issue of sympathy seems to operate as a red herring, masking an entirely different relation. When the spectator complains about "breathing this eroded air, / this dryness in which the monument is cracking," we are being led to consider certain details that dramatize how the monument's incompleteness leaves it perpetually vulnerable to the spectator's criticism (*CP* 24). Not only is it "cracking," it is disintegrating in the same "eroded air" the spectator breathes. Perhaps the monument has value as "an artifact" or even as "an object" (both words Bishop uses to describe it), but the imprecision of its details clearly undermines its value as art: "those decorations, / carelessly nailed, looking like nothing at all, / give it away as having life, and wishing; / wanting to be a monument" (*CP* 24). Most counterintuitive and striking is her ambivalent use of the word *life* here. Instead of using the term to suggest, as do the New Critics, that an art object has organic unity (a life of its own), Bishop depicts the monument's "life" in the spectator's air as indicating its *failure* to have a life distinct from the contingencies of the spectator's world. "Once each day the light goes around it / . . . or the rain falls on it, or the wind blows into it," and the object lives and cracks another day. It is, we might say, living but also dying ex situ (following Williams's reading of Duchamp), no longer protected by the glass and frame of a window. The monument's wretched "life" as an object in the spectator's world, a life that incorporates the spectator's climate, paradoxically distinguishes it from the art object it is "wishing; / wanting" to become

(CP 24). Or, to put this another way: whereas the ex situ art object in Williams's account marked the object's newly rejuvenated life as an art object, in this case the monument's artifactual "life" in the real world signifies its failure as a representing art object. With this strange poem, Bishop is not supporting short-lived situational and earthworks art out in the environment but the complete reverse.

One might object, and rightly so, that Bishop depicts real sympathy in the face of failure: one speaker defends the abject object from the second speaker's critiques. Her poems often express sympathy in this somewhat alienated way—for objects rather than people, whether an iceberg, a fish, a mechanical wind-up toy, or seals. But the relevant point is that sympathy is not exactly being expressed for the failed artist or even for an art object, but for the monumental and even anthropological artifact, which is to say that her sympathy works causally and in the opposite direction then we might expect. She seems to suggest that the object fails as art precisely because it is personified and alive in the spectator's space, and once personified, and thus failed, the object deserves our sympathies: it's like a person now, after all. Sympathy signifies its breakdown as an art object. However odd it might sound to our ears, sympathizing with bad art was an accepted art historical convention in the 1940s, with art historian Max Friedlander describing his vocational responsibility in similar terms: "The historian considers it as a duty of neutrality to extend sympathy to every expression of art."[70] Like Bishop's speaker, he seems to assume that although good art needs no sympathy—indeed, it cannot in any way be affected by sympathy—failed art always desires and needs such validation from the external world.

What we see here is that Bishop's posturing as a sympathetic and feminine poetess—a pretense she no doubt encouraged—masks her strategic interest in bad or unfinished art as an inverted aesthetic about finished representation and the proper role of the spectator outside of the artwork's space. Whereas the artist-prince might have intended to "mark a tomb" with this monument, by the end of the poem the monument is obviously not a representation—a grave marker—but the grave itself, an unmarked tomb: "The bones of the artist-prince may be inside" (CP 24, 25). Her careful use of the modal phrase "may be" is key (as it is in "One Art"), implying that we cannot be certain what the monument contains because its representation is ambiguous. Unlike an art object whose relevant properties are, by definition, available to spectators, the monument has the hidden interiority of the person (dead or alive) now personified: that which it "shelter[s]" within it (implying protection of a living thing) "cannot have been intended to be seen" (CP 25).[71] Along the same lines, the title of the poem underscores the unseverable relation between the thing or place it commemorates and the strange object doing the commemorating. Unlike modern art's active dispensing of referentiality, "the monument" only means when it successfully refers to and memorializes something else.

The poem's final sentence, "Watch it closely," is itself a tricky, ambivalent invitation: while alluding to the object's value as a thing to be looked at, the command also refers to the absolute necessity of spectatorship required to make this incomplete art object into a complete one. We must "Watch it closely" because its continuously changing characteristics of a living, breathing thing require the spectator's active presence, just as Wyatt's mutating first painting of his mother had to be daily observed by his father in *The Recognitions*. Bishop could make art out of "an artifact / of wood," and she makes a successful poem out of this incomplete art object. But when we assume that an unfinished monument straightforwardly models her aesthetic goals, we miss her point entirely.

Undoubtedly, the issue of sympathy discussed here becomes more complicated in Bishop's last collection of poetry, *Geography III* (1976), where she focuses on the slightly different problem of evaluating the objects of cultures radically different from her own. We can see this developing interest in "Poem," where she appears to reverse her earlier stance toward her relative's art in yet another poem about painting—a poem that takes on an even more nostalgic, memorializing tone about a primitive painter than does "Gregorio Valdes." Here the speaker equates one of her great-uncle's small, flawed landscape paintings with memory and thus with life: "art 'copying from life' and life itself, / life and the memory of it so compressed / they've turned into each other" (*CP* 177). This collapse of art, life, and memory renders the painting valueless as a commodity, while simultaneously and paradoxically that compression of qualities also liberates the work: "About the size of an old-style dollar bill," it is "useless and free," passed to the speaker "collaterally," a term that ironically underscores the financial value the painting cannot secure (*CP* 176). Painted quickly—"in one breath"—the flawed painting also fails to be absorbing: the speaker points out that an awareness of the bugs trapped on the paint surface detracts from the representation, or the potential representation: "A specklike bird is flying to the left. / Or is it a flyspeck looking like a bird?" Yet by the end of the poem, the speaker's own memory of the same depicted place in Nova Scotia lends the work the value it lacks as a complete art object: "Life and the memory of it cramped, / dim, on a piece of Bristol board, / dim, but how live" (*CP* 177). In contrast to "Large Bad Picture," in this poem resemblance ultimately trumps aesthetic absorption. The work might be "dim" (not the strokes of an illuminating master painter) but it is also "live." This liveliness enables the speaker to empathize with the great-uncle she "never knew."

"Poem" has been understood to encapsulate Bishop's evolved aesthetic understanding; if previously she overvalues the high modernist art of conceptual vision, this poem has been used to show how she moves on: "'visions' is / too serious a word," so she reevaluates art as a series of experiential "looks" (*CP* 177).[72] When experiential "looks" overcome representational "vision," experience is

being privileged over representation. But her particular focus on the painting's exchange value as an art object ("useless and free") in relation to its artifactual value as a historical thing (not just a dollar bill, but "an old-style dollar bill") gestures toward something else: a new interest in appraising and understanding different orders of value—aesthetic, memorial, kitsch, exchange—in relation to one another. While her great-uncle's "look" is just that—his experience of the place—her "look" when combined with some "poetic license" (as she admitted in a letter) becomes "Poem's" value-added quality, its poetic vision.[73] Here we might add that although the small painting "never earned any money in its life," her "Poem" was published in *The New Yorker* on November 13, 1972, and, according to her first-read contract there, earned Bishop a return "25 percent above the regular per-line rates."[74] Although the commodity status of kitsch or primitive art objects clearly bothered Bishop, this poem—with its "vision" and not just its "look"—is presumably able to make money and then transcend and disguise its clear connections to the world of capital, when one type of value (aesthetic) is ultimately able to use and to trump others (memorial, kitsch, and exchange). Reducing the poem to the camaraderie between her "looks" and her great-uncle's "looks" misses the very nuanced, deliberate work Bishop is doing to establish and order different types of value.

Like Wyatt's and Gaddis's art, Bishop's deeply critical and self-reflective poetry simultaneously attempts to produce a thing of value and to understand itself in relation to other systems of value. For Gaddis and Bishop, that other system is U.S. corporate culture and its production of kitsch; for Bishop, it is also outsider art in America and Brazilian art. In "Poem," with both the painting's exchange value and its historical value so low, she is not interested in the painting's quantifiable value per se but instead wants to use the question of value to distinguish between different modes of analysis: an aesthetic gaze on the art object determining its painterly significance and worth as an art object, and an anthropological or sociological gaze on the artifact determining its historical and socioeconomic value as an index of a particular culture at a particular time.[75] Where her *Questions of Travel* strains against one's limited ability to understand another culture's choices, this and other poems from *Geography III* struggle with a different, more pluralist dilemma. While participating in the hierarchy of artistic value in America, she attempts to evaluate another culture's art without reducing it—as she surely does in her earlier work—to its instrumental use (as artists have been doing, via primitivism, for decades if not centuries). Even Bishop's poetry about the anthropological evaluation of cultural objects does not collapse aesthetics into problems of comparative anthropology, but frames this gaze as an issue for aesthetic judgment.[76] She can incorporate her great-uncle's "look," and acknowledge its identity with her own memory, but in refusing to call his painting or her own memory "a vision," she maintains a function for her own synthetic, poetic vision to incorporate

and transform any and all "looks." Bishop's late work might present multiple, measured gazes, but her gaze on the art object is unwavering. We gaze at good art standing distinct from us; we walk into and breathe with bad art in our world and our memory—"in one breath," as she writes in "Poem."

Dramatizing a utilitarian attitude toward bad art, both Gaddis and Bishop refuse simply to denigrate kitsch, forgery, and primitive art, choosing instead to identify these forms as a productive tool for a new aesthetics. Despite the obvious flaws of Wyatt's "disciplined nostalgia"—its political and economic susceptibility, moral dubiousness, academicism, aesthetic eccentricity—this unusual and rigorous defense of art that we might otherwise dismiss as kitsch or counterfeit attempts to promote and instantiate a new avant-garde within the cultural and economic conditions of mid-century life. As such, their "neo" rear-guard poetics looks forward to later art—Pop Art especially—that incorporates and reflects on mass culture subject matter with less overt hostility and more nuanced engagement (think of Jeff Koons's *Banality* series, which includes gold statuettes of Michael Jackson with Bubbles the chimp). Yet both Gaddis and Bishop carefully articulate a different aesthetic point than did Koons or other examples of mid-century American kitsch. Whereas Jerry of *An American in Paris* "dances" into paintings to experience them, Gaddis and Bishop hypothesize an alternative by imagining all the negative ramifications of a spectator's journey through the picture plane. Negotiating between enmity toward bad art on the one hand and amusement of it on the other, they mark the conceptual boundary of Stein's and Lewis's positions on the role of the spectator to art by assuming that the spectator's relevance, for all its flaws, is an inescapable reality. They write explicitly and carefully about the possibility of making an autonomous art at a moment when, for many artists, art demanded beholders' involvement, and in the process, they find themselves negotiating with the art object's increasingly unavoidable status as a commodity. The writers discussed next assumed and even desired the spectator's—or increasingly, the reader's—relevance, and factoring the reader's role into the work's creation from the very start leads to their quite different problems, solutions, and political positions.

5

cᴧᴐ

Administering Poetic Breath
for the People

Charles Olson and Amiri Baraka

LETTING THE BODY IN

In the late 1960s, Charles Olson obsessively wrote poetry on unexpected things: used envelopes, restaurant placemats, check stubs, clipped coupons, paper towels, old maps, and—strangest of all—interior window frames of the apartment he was renting at 28 Fort Square in Gloucester, Massachusetts (figure 5.1).[1] Although barely legible, his frame-writings record various reflections, including meteorological measurements complete with date and time: "Wind still West / [2 weeks? / since February 10th? / *11 days*" and "Sat February 3—SE: 29.5."[2] Presumably, these notes characterize the air, particularly the wind direction and speed, in his immediate environment at the very moment he peered out of the window to observe the weather. Incorporating the particularity of a moment, Olson also captures his individual body scribbling at—and on—this place. Another photograph of his writing captures the scrawl, written over a crack in the paint, "So let the body just come in" (the last word could also be "into" or "inside").[3] As odd as the phrase seems when scrawled on part of a house, the line captures the essential aim of not only Olson's poetics but also, in a slightly different way, Black Arts poet Amiri Baraka's 1960s poetry when he was writing as LeRoi Jones.[4] Just as Olson blurs the distinction between outside and inside when he represents measured qualities of his environment on a window frame, both Olson and Baraka choose to ignore the

139

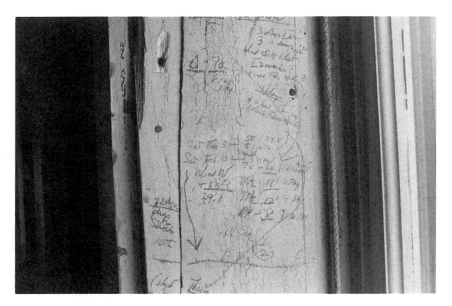

Figure 5.1 George Butterick, *Photograph of 28 Fort Square, Gloucester* (interior of Charles Olson's house, writing on window frame, March 1970). F148, Charles Olson Research Collection. Archives and Special Collections at the Thomas J. Dodd Research Center, University of Connecticut Libraries. © University of Connecticut Libraries. Used with permission.

distinction between text and context when they invite specific, contextual bodies into their poetry as wind or breath drifting through an open window.

By scribbling "let the body just come in" on a window frame, in a single writing act Olson connects the major discourses and terms we have been considering in this book: spectatorship, framing, perspective, freedom, and the relationship between the art object and the world. He captures his perspective about the world (his view of Gloucester) *on* the world (his window frame in Gloucester), transforming the window-frame object framing his actual perspective into a new poetic-visual medium, a new kind of "page." As he takes on the role of attentive ship captain, his act of spectatorship turns his apartment window into a measured, site-specific object in and of Gloucester, following Duchamp's lead in creating art out of frames. And as with Duchamp's window painting, when bodies are allowed into the text or art object, readers or spectators and their bodies have a relevance to the work that must be acknowledged. Recording one's physical perspective through a window on a particular day, at a particular moment as a brief, site-specific poem, makes that body relevant. That is, by incorporating one body's experience of the world at a particular time, he endows a particular body the freedom to enter the artwork and affect its meaning.

In interviews from the period, Baraka described a similar sentiment in terms of the specific attributes of his body's voice: his goal is to capture the body's

breath and speech rhythms "to get closer to the way I sound *peculiarly*, as opposed to somebody else."[5] By alluding to breath, speech, and sound, Baraka adapts the terms of the older poet, with whom he corresponded sporadically between 1958 and 1965.[6] In particular, Baraka republishes and modifies the philosophy of Olson's "Projective Verse" (1950), the aesthetic manifesto that dramatically breaks from the modernist sacred cows of both symbolism and imagism to establish the new movement of Black Mountain poetics.[7] In this brief but complex text, Olson contrasts the older form of verse with the type of poetry he aims to write, "in which a poet manages to register both the acquisitions of his ear *and* the pressures of his breath" (*OPr* 241). Abandoning rhyme schemes, Olson focuses instead on the syllable (the core "particle of sound") and the line (*OPr* 241–42). Considering sound and line together, he suggests, enables the poet to mark one's breathing pattern. Whether we follow Baraka's version (emphasizing voice) or Olson's (focusing on breath), projective verse aims to produce something besides a poetic representation. It also aims to represent—or more accurately, capture—the body's trace, condensing the essence of the poet's historical specificity for the reader to read and thus perform—a literal manifestation of the poet's bodily response to the world. Such breath provides evidence for particularism: the present puff of air which, when in my lungs, cannot be in anyone else's simultaneously, is precisely that which provides oxygen for my blood. By "capturing" place, and also time (what happens at that place), both poets "let the body just come in" to a particular instance of poetry.

This poetry of air inscribed on a window frame extends Duchamp's art of the frame and challenges Stein's and Lewis's critiques of painting frames as window frames, which is to say that the projective poetics of both Olson and Baraka dramatize precisely the opposite of Stein's theory of breath and readerly experience and the opposite of Lewis's theory of "timeless" art. Whereas Stein is adamant that the reader's breath be kept out of the text (to protect the reader), and Lewis insists that the viewer should never be able to breathe the air of paintings (to protect the paintings), Olson and Baraka insist that the writer's breath and voice—those mostly ephemeral but still material traces of the body—be brought into the text to make art relevant to the reader's body by extension. Although the precise subjects of their arguments differ (whether reader, viewer, or writer), in each case all of these writers track the role of breath or air in an artwork. By making a claim to bring air directly into the poem, Olson and Baraka envision an art object whose meaning is inseparably linked to the experience of the reader whose breath, by definition, completes it. The poet breathes first, and the reader performatively follows after him.

Both writers' embodied poetry posits fidelity to a particular bodily awareness—the view through a Gloucester window in Olson's case, the view of a black man in Harlem in Baraka's—as the essence of poetic meaning, and each foresees and articulates a body politics emerging from this view. By exploring unpublished archival sources, we will see Olson's poetic particularism aligning with his

conception of the particularity of immigrant perspectives as central to twenti-eth-century American culture and citizenship, ideas entirely compatible with his 1940s government and party politics work in which he targeted specific groups of immigrant Americans instead of speaking to all Americans as undifferentiated citizens. His point is to find meaning in actual American immigrant perspectives because they are obviously particular, permitting him to avoid universal notions of political identity. According to this logic, immigrant perspectives are valued precisely because they must be located in the world, circumventing the universal-izing rhetoric of citizenship. So Olson writes in the epic *Maximus Poems* (1950–70), "I speak to any of you . . . not to you as citizens" (*M* 15). His pluralist poetics in *Maximus* correspond with the managerial and political agenda he developed in his political work, even though this pluralism had major blind spots.[8]

Meanwhile, Baraka strategically appropriates and alters Olson's poetics of immigrant identity to remake an essential quality of Olson's administrative po-etics for a new historical moment and a different constituency. Although he has neither Olson's bureaucratic interests nor his New Deal political agenda, Bara-ka's work shares a similar organizational strategy that aims to consolidate par-ticulars and then share them with his readers, who then perform them anew.[9] In his case, it is specifically racial particulars, and the group he targets is African Americans. His early books of poetry, *Preface to a Twenty Volume Suicide Note* (1961) and *The Dead Lecturer* (1964), as well as various prose pieces, all reveal Baraka straining to gather the ineffable particulars of selfhood into a palpable, locatable identity. By the time he publishes the volume *Black Magic* (1969), this identity is explicitly racial. As he puts it in "Numbers, Letters" (1969): "A black nigger in the universe. A long breath singer, / wouldbe dancer, strong from years of fantasy / and study."[10] Such a poem clearly reflects the impact of the Black Power movement on Baraka's thought (he had already been distancing himself from the Beat and Black Mountain poets for several years).[11] But despite the complicated relationship between the two poets and their diverging politics, the same breathly connection Olson instantiates in his poetry between perspective, identity, particularity, and meaning appears here (with the "long breath singer") as it does in Baraka's writing throughout the 1960s. When Olson says, "talk is no longer a sufficient form of explicitness" and Baraka, in "How You Sound??" (1960), explains that "You have to start and finish there . . . your own voice . . . how you sound" (ellipses in original) to emphasize racial qualities of voice over the meaning of words, each follows an identical argument about the way nonlin-guistic signifiers (breath, sound) mean in poetry.[12] A politics emerges from an account of poetic meaning integrated into the body and interpreted and per-formed by living, breathing readers, even while Olson's pluralist commitment to the individual immigrant's perspective looks dramatically different from Bara-ka's black nationalist commitment to the racial collective's perspective.

In relating Baraka's poetics to Olson's, my aim is not to overlook the profound differences between two poetic projects sustaining seemingly

incompatible political affiliations. Instead, the point is that each writer's particularist poetics generates an equally strong commitment to a body politics, one that contrasts sharply with the notion of meaning's autonomy—and the traditional liberal politics affiliated with it—at an earlier modernist moment. For Olson and Baraka, a poetics dedicated to recognizing and managing minority perspectives emerges in their formal opposition to art objects distanced from the reader's body. While Olson focuses on the immigrant's breath and Baraka focuses on African Americans' racial voices, their commitment to both embodying and administering a perceptual, physicalized angle of vision for a group of people remains the same. As such, their poetry of the 1950s and 1960s formally responds to the longer story of modernist beholding, while they simultaneously develop quite different political stances associated with these theories of beholding, stances now familiar and common. In surprising ways, Olson and Baraka anticipate better than many others the recent theoretical trends in feminism and cultural studies of borrowing and bestowing embodied perspective to inform contemporary techniques of social and political belonging and, at times, strategic exclusion.[13]

POETRY'S TRAFFIC MANAGERS: FROM *PROJECTIONS OF AMERICA* TO PROJECTIVE VERSE

Before Olson presided over the artistic, alternative Black Mountain College outside Asheville, North Carolina (from 1948 to 1956), even before he began the epic *Maximus Poems* in 1950, he labored as a Washington bureaucrat. As assistant chief, he helped administer the Foreign Language Division in the Office of War Information's (OWI) propaganda machine, confidently promoting World War II to America's ethnic minorities.[14] After the war he directed the Foreign Nationalities Division of the Democratic National Committee, where he was in charge of (and succeeded in) getting out the ethnic vote for Roosevelt's fourth-term victory.[15] Olson is most often viewed as rejecting government and turning toward the countercultural and antiestablishment movements (such as Black Mountain College and, more distantly, New York's Lower East Side poetry scene of the 1960s), yet as he formulates and begins writing his most important poetry and prose of the 1950s and continues writing his late *Maximus Poems* of the 1960s, he remains preoccupied with both the problems and promises of governmental management, staying far more open to the possibilities of state organization than his poetic predecessor, Williams Carlos Williams. Specifically, he stays focused on the New Deal legacy epitomized by the administrative state in contradistinction to other, typically corporate forms of organization.

The unpublished essay "Culture and Revolution" (1952), which characterizes contemporary poets as an undervalued cultural-managerial class of the American establishment, brilliantly captures this preoccupation:

> It is very boring that Americans, and the world in general, still won't see that there is no real discrepancy between the monster America—the Traffic Managers, of anything, even an Eisenhower, of war—and, say, the American poets, dancers, music-makers. . . . The virtues of these latter are the true evidence of the culture and are closer in the fineness of the management of the energy—and as fresh as, more fresh than—as more like the Traffic Managers than they are like the Culture Mongers of the universities, the radio, the movies, publishing, television, the magazines.[16]

According to Olson, unlike the parasitical "Culture Mongers" of academia and the corporate world, poets and artists work seamlessly as part of American daily life in their "management of the energy," resembling hard-working, indispensable, cultural "Traffic Managers." These supervisors help direct and map the world for the American masses disoriented by the war and by the nation's new global ("monster") status. Following this logic, Olson's task in *Maximus* of appraising, managing, and representing the bureaucratic details of one particular New England town—doing its administrative-editorial work—turns him into American poetry's most dedicated public servant. Even if he never would have described himself professionally in this way, only a masterful knowledge coordinator could write the all-encompassing, epic poem. Not only did Olson know administrative work intimately, he identified with many of its basic assumptions and strategies throughout his literary career.

Against this view, Olson's New Deal roots have long been interpreted in opposition to his poetic ambitions, specifically as a political and cultural retort to post–World War II political events.[17] Despite Olson's "strategic withdrawal" from centers of culture and politics, Robert von Hallberg argues that *Maximus* might be understood as a transformed—or gutted—New Deal poetry extended into the postwar era hostile to New Deal programs, and other critics have expanded on this idea.[18] Early Olson has looked like a conflicted poet weighing political withdrawal against political engagement, angry and disillusioned when plum Democratic political posts failed to be offered to him in 1945.[19] His most famous early poem, "The Kingfishers" (1949), would seem to reflect this disappointment, warning against the dangers of "pejorocracy," although the poem's opening line also might be heard as a cross-generational, Progressivist rallying cry even familiar in the Obama era: "What does not change / is the will to change" (*OPo* 86).

Keeping in mind his complicated feelings toward institutional politics, we might turn our attention to that untapped resource of Olson's actual

professional, governmental administrative work at the most influential pro-
pagandistic coordinating agency and institution of the 1940s: the Office of
War Information.[20] Olson's unpublished late 1940s to early 1950s writings
reveal a writer in tune with the administrative, bureaucratic world of Wash-
ington, D.C., he had chosen for years to make his own. Instead of minimizing
his early administrative interests as those of a reluctant amateur, forced by
wartime circumstances into the public sphere of government bureaucracy to
avoid the more dangerous situation of active military duty on the front, we
might ask how a poet heading toward an administrative political career at the
end of World War II, a poet dedicated to advancing progressivism within the
structures of government, transforms these institutional convictions into a
poetics preoccupied with projecting a community body, via the poet's and
reader's breath, onto the poetic object. Because his most basic aims did not
change, his evolution from government bureaucrat to projective poet was far
smoother than we might expect.

Although the study and training of public administrators was still in its
infancy during the first part of the twentieth century, its rapid rise began in
the 1930s, coinciding with and influencing Olson's graduate education as well
as his later poetic career. New Deal policies promoted the establishment and
expansion of public administration as an academic discipline; Olson partici-
pated in this expansion, taking six credits of American government at Har-
vard while enrolled in F. O. Matthiessen and Perry Miller's newly formed
interdisciplinary American Civilization doctorate program (a program itself
affiliated with the rise of administration).[21] In 1939, the Second New Deal and
the Reorganization Act extended public administrators' roles further and
more closely linked management to academia, aiming to create a new, profes-
sional bureaucrat.[22] Lucius Wilmerding defines the exceptional characteristics
of this new "administrative class" in *Government by Merit* (1935), revising
Emerson's line ("a man is a method") to refer to the newly imagined adminis-
trator: "Although [the capable administrator] must be learned in the law . . .
His specialty is method rather than subject matter. He is a coördinator of
knowledge."[23] In the administrative state, shrewd observations, study, and
forethought about the consequences of processes—here described as
"method"—triumph over narrowly focused, specialized knowledge. In "The
Present Is Prologue" (1952), Olson describes himself in precisely these terms,
as an administrator of method living in the "heterogeneous present" filled
with diasporic immigrants: "This is the morning, after the dispersion, and the
work of the morning is methodology: how to use oneself, and on what. That is
my profession" (*OPr* 205–6).

As the United States entered World War II, Olson worked for a few months
as publicity director for the American Civil Liberties Union and then for a year
as chief of the Foreign Language Information Service for Common Council for
American Unity (both jobs in New York City).[24] But his administrative career

and interests developed and matured at the OWI from 1942 to 1944. Created by FDR's Executive Order in June 1942, the OWI was created to synchronize "information activities" to the country "by using press, radio, and motion pictures."[25] Part war propaganda machine, part liberal New Deal PR firm, part news clearinghouse, the organization projected the story of America that the administration (or at least the agency) most wanted told. It did not always create the stories but adapted and retransmitted them as the war required, a coordinated multimedia effort between press, radio, and film.[26] FDR appointed a popular CBS radio commentator and former print journalist, Elmer Davis, as the agency's first chief and the Voice of America radio programs quickly became the OWI's "premiere service."[27]

Olson felt particularly well suited for his job of assisting in administration of the division, in liaising with other government agencies, and writing and editing speeches, correspondence, memorandums, and graphics for foreign language editors (i.e., planting pro-American stories in local ethnic newspapers around the country).[28] The job required him to coordinate and manage ten subordinates assigned to particular regions who filed reports to him that he then organized and evaluated, making sure that pro-American propaganda was being effectively transmitted to "foreign nationals" (immigrants) in various ways, mainly through ethnic newspapers, films, and ethnic radio stations. They also created programming for those media outlets: the Foreign Language Division's propaganda included *Uncle Sam Speaks*, a weekly radio program broadcast in Italian and German on ethnic radio stations.[29] Olson, who regularly identified himself as half-Swedish and half-Irish, saw his particular value as being a minority expert who could triangulate various American diasporic groups to facilitate U.S. government interests. When his job was threatened, he recommended that his supervisor (later senator) Alan Cranston defend his value to superiors in precisely this way: "the whole line of [Olson's] career, himself the son of immigrants and a specialist in the growth and character of American society, gives him special qualifications for work such as ours."[30]

Biographies and career paths such as Olson's were narratives the OWI sought to shout out to the world through its signature creations: the ideological *Projections of America* directives, dedicated to promoting aspects of "US life and culture from a liberal democratic view" using various media formats.[31] Twenty-six films in the documentary series *Projections of America* were produced while Olson worked at the agency (between 1942 and 1945).[32] According to Ian Scott, the distinction of the *Projections* series (in contrast to Frank Capra's *Why We Fight* films, which the agency also distributed) was that they "attempted to encapsulate the essence of American identity and ideology for its foreign allies," often using a "history from below" style more closely associated with documentaries of the 1960s and later.[33] Examples of *Projections* films included the pro-assimilationist *Sweden in America*, narrated by Ingrid Bergman, *Cowboy*, which revealed that the iconic heroes actually were

hard-working and committed to their culture, and *The Town*, about the small town of Madison, Indiana, as it dealt simultaneously with the war and its immigrants.[34] Although Olson was never involved directly with *Projections*, sometime after the war (between 1946 and 1948) he began writing documentary film treatments modeled on the genre's characteristics, if not its single message. For instance, in Olson's documentary film treatment, a "story of American Anyman," a character named "Citizen" wanders restlessly around a noisy, monotonous world, finding only "the cocoon and the suspension."[35] Although the OWI would never have produced it, Olson's imagined film resembles a dark, alternative *Projections* film. Aiming to reach the same audience and with an identical lives-of-immigrants topic, the film only lacks the OWI's optimistic, nationalistic rhetoric.

Toward the end of the war, the OWI transformed into a more intensely corporate propaganda machine, as the more creative liberal types dominating the agency at the beginning of the war (poet Archibald MacLeish, literary critic Malcolm Cowley, playwright Lee Falk, and artist Ben Shahn) were pushed out by the "merchandise men," Olson's term for the more business-oriented advertising and salesmen governing the agency by the war's end.[36] Olson was obviously a member of the former group, and in 1944 he and many others finally resigned in protest. But the leftist, anticorporate incarnation of OWI, with poet-administrator MacLeish at the helm of the domestic division, with artists and cultural ambassadors as its staff, and where Olson could serve as an administrator, editor, and in-house minority expert, had been, for him, a nearly ideal institution in which to serve. Though he might not always have been comfortable with the nationalistic rhetoric, he identified with the basic ideological aims of the OWI and the immigrant-focused directives of *Projections of America*. Arguably, he never gave up this identification.

When the war ended, Olson could have simply left politics altogether and begun teaching once again. He did not. Instead, he moved into a more partisan, labor-oriented version of the same immigrant-focused work while—and this will prove crucial to his later poetics—insisting on multimedia as a strategy. In 1946, he worked for the CIO's new National Citizens Political Action Committee (NCPAC), an organization aiming to spread progressive politics beyond the unions, "advanc[ing] a truly progressive spirit," such that "The majority must become a body of real integrity."[37] Like many liberals in the 1940s, he was troubled by the difficulties of disseminating this progressive, prolabor voice in the postwar political cacophony (perhaps anticipating the postwar expansion of corporate power over radio and thus over the political imaginary of national community).[38] Olson notes that "The voice of Roosevelt had a way of getting into all the corners of America" via regular radio broadcasts, but he warns that circulating the progressive agenda had become more difficult after the president's death.[39] At this point Olson begins to sound the promise of multimedia as a solution. Different methods, he suggests, are

required to achieve results: film, photographs, and "the graphic" must become part of the progressive voice to and for the people (he would have been pleased to see today's viral grassroots campaigning via Twitter and the Internet).[40] For the NCPAC he taught a seminar, "Religion, Racial, and National Origin Factors in Political Campaigns," that taught participants how to put these theories into action, outlining ways the labor movement could better appeal to minority groups through more flexible, local approaches.[41]

Olson's story does not typically run this way. The only major biography of him argues that he had essentially given up on politics by 1946, when he plots a major poem and drafts parts of the innovative essay that will become "Projective Verse" a few years later.[42] But that same year he actively advocates outside his immediate political circle for a Foreign Nationalities division in some government agency, sending F. O. Matthiessen a letter lamenting the unpreparedness of U.S. leaders, carefully explaining the need for "continuing action . . . among foreign nationality Americans for a least fifteen years more, until the momentum of immigrant spends itself. I myself believe it is precisely in these years that these groups will play their climactic role."[43] Edited collections of Olson's prose and letters tend to obscure the extent of this political engagement, presumably due to their commitment to establishing a consistent formal poetics.[44] "Projective Verse" is so often linked to Black Mountain poetics and the Happenings zeitgeist of the 1950s that we have lost sight of its historical connection to *Projections of America*, which was both literally and figuratively the "Voice of America" to millions. But "Projective Verse" reiterates the same issues Olson grapples with at OWI: the new media challenge of reaching diverse groups with the unified messages of a single, charismatic, progressive voice. The first complete draft of "Projective Verse," with its struggles to make a practical, embodied poetry "of *essential* use" to readers, was written not in a secluded bungalow at Black Mountain but in Olson's Washington studio, two miles from the Capitol building, National Mall, and the White House—the source of government's own "projective" voice (*OPr* 239).[45]

From this perspective, we can see how "Projective Verse" is an attempt at a new media, technological innovation for progress, where "progress" is as broadly intended as it is in Williams's *The Great American Novel*. In the late 1940s and early 1950s Olson was grasping for ways to use media like radio or documentary film to disseminate not just progressive messages but the feeling of a real, live, breathing voice, one resembling FDR's in the fireside chats. By expressing lived experience, this voice could both inspire and convince. In the process, Olson brainstorms new and different formats, genres (such as drama), and media, including the before-mentioned "American Anyman" film.[46] His poems of the period reflect this desire in their attempts to capture bodily performance through the aspiration of spoken words, as with "Gli Amanti" ("The Lovers") (1950), which describes exactly how a particular tarot "card / is to be pronounced."[47] The letter "l" in "love," is "formed / with the tongue point on

the teeth ridge, with / the nasal passage closed."[48] Each letter is to be sounded out and dramatized: the "o" is the one in "honey" and "tongue" and the "e" is silent. The poem phonetically demonstrates how the speaker wants the reader to pronounce "love" such that the "v" corresponds to the "voiceless f."[49] His body will be present via his precise instructions for pronunciation to determine the meaning of a particular instantiation of the word "love." Thus, often in America the "l" is "noticeably dark" instead of "clear," as he takes a complaint about mispronunciation and transforms it into a commitment to national specificity.[50] By lingering over these details of pronunciation, Olson uses poetry to convey the pronunciation of "love" unique to his voice and his body in a particular historical situation.[51]

Finding a way to capture the particularities of his embodied voice and projecting them to the reader through poetry becomes a major idea underlying Olson's poetics, as he searches for a technology to help him with his poetic, administrative work of organizing people in a relation of American nationhood. "Gli Amanti" takes an entire poem to embody a single word ("love"), but spelling out idiosyncratic pronunciation using that method would surely prove cumbersome over an entire poem. By turning to the typewriter, Olson begins to identify what he sees as a technology of embodiment that resembles radio, photography, and film but requires a more basic piece of technology and a single (male) creator who can function without the bureaucracy of the OWI and an army of (female) secretaries. Specifically, as he writes in "Projective Verse," the typewriter proves invaluable because it provides a means and shorthand to literalize the presence of the poet's syllables and breath, marking out his meaning on the "field" of the page:

> Due to its rigidity and its space precisions, [the typewriter] can, for a poet, indicate exactly the breath, the pauses . . . which he intends . . . For the first time he can, without the convention of rime and meter, record the listening he has done to his own speech and by that one act indicate how he would want any reader, silently or otherwise, to voice his work. (OPr 245)

According to his logic, the typewriter permits the composing poet to mark out his "breathing spaces" with a mechanical device instead of relying on the ancient literary conventions of "rime and meter" or the new and awkward convention of spelling out each phoneme as spoken by the poet. Just as Williams used the colon as a substitute for the signifier "stars" in "Flight to the City," Olson tries to avoid an older form of signification while simultaneously attempting to incorporate something of the poet's bodily experience.

The typewriter is imagined to work in other intriguing and contradictory ways. If the goal of Olson's work at the OWI, NCPAC, and the DNC is to find a way to speak to "foreign nationals" directly with the projective voice radio technology made possible—and which Roosevelt mastered—typewritten

projective verse is imagined as a new multimedia technology that the poet can use to realize the same aims, with the added visual component that radio lacks. Poetry could then more closely resemble a multimedia, kinesthetic *Projection of America* film and radio-poem combined, as each breathy reader—or, more accurately, vocalizer—transforms him- or herself into a particular, heterogeneous multimedia receiver while reading. Each person brings his or her own personal voice and bodily experience to the process of reading and thus breathing the text. At the same time, echoing Marx, Olson imagines typewriter technology as a way to eliminate the structural alienation between "producer" and "reproducer" (reader), enabling him to bypass the limitations of his beloved particularism, which almost by definition privileges the small and local (*OPr* 245). Just as radio enabled the singular "voice of Roosevelt . . . a way of getting into all the corners of America," projective verse imagines Olson's embodied voice reaching all members of the contemporary poetic avant-garde.[52] Projective verse might even improve on radio by taking the technology of experience to its next logical step. Olson explains in a lecture that what a stereo fails to capture is "the way the air [is] full of the droplets of event."[53] In contrast, projective verse, the typewriter, and the visual field of the page are together envisioned to achieve that impossible contradiction of expansive, full embodiment: "breath allows *all* the speech-force of language back in (speech is the 'solid' of verse, is the secret of a poem's energy), because, now, a poem has, by speech, solidity, everything in it can now be treated as solids, objects, things" (*OPr* 244). By including a breath of air, the poem becomes full of experiential particulars. Projective verse turns air into a particular thing. More speculatively, we might say that Olson's projective poetics bypass theorizing the major 1950s medium (television) to anticipate, via radio, a different account of the more recent technology of virtual reality and kinesthetic video games.

At this point his poetics become almost impossibly dialectical, as he demands both embodiment, "the coming into his verse on the part of the poet of the pressure of his own voice," and a kind of modernist impersonality.[54] As he puts it in "Proprioception," he wants the "working 'out' of 'projection' . . . wash the ego out, in its own 'bath'" (*OPr* 181). The typewriter, once again, becomes the miraculous device enabling this poetry cleansed of the self, embodiment-without-ego, as he attempts to shift the responsibility of representation away from the personal (or Whitman's social) and onto an inanimate object, thus purportedly withholding his ego from the act of capturing embodied breath on the page.[55] That is, mechanical devices (the keys, hammer, and ribbon of a typewriter) intervene to permit Olson to measure and record his breath. "Projective Verse" aims to modify the yardstick used to measure a person's relationship to poetry, where syllables replace iambs and the typewriter replaces handwriting (*OPr* 246). With one human breath as the scale by which a poem is constructed, the subject matter will also shift, enabling the

poet to see himself as an object in the world among "the larger field of objects, [which] leads to dimensions larger than the man" (*OPr* 247). Olson imagines the figure of Maximus and the theory of projective verse as solving the riddle of subjectivity, an alternative to Eliot's more aloof version of impersonality.[56] But this unresolvable tension between embodiment and impersonality extends across his entire oeuvre and his theory of poetics.

Despite this paradox, by staking his claim as a poetic "traffic manager," Olson takes the progressive administrator's notion of measurement and organization to new heights, depicting a corporeal relation to poetry and the reader by using his own breath as a unit and his body to provide a sense of measured scale. He revises Whitman's song of himself by insisting on extrapolating his relation to his song and to his sources within his song: "I measure my song, / measure the sources of my song, / measure me, measure / my forces" (*M* 48). Using the self as a ruler permits Olson to negotiate between competing ideologies: on the one hand, the objectivity demanded by social science and the scientific-management movement dominating the New Deal political world and, on the other hand, the subjective narrative and personal accountability crucial to the alternative-educational movement that Black Mountain College epitomized and Olson administered in the 1950s until the school closed. Like Stein, he understands a visual, graphical technology of writing to change the reader's experience of breathing while reading poetry. In his case, he uses the typewriter to capture breath; in her case, she eliminates nearly all forms of punctuation to liberate the reader's breath. Yet both understand their use of a writing technology in connection to breathing to lead to a kind of political action—for Stein, a liberating experience of personal choice, for Olson, as we will see, an emancipating experience of relating to people and experiences different from your own. Olson's administrative particularism aims to enable the reader to experience a political subjectivity—and connect to other political subjects—beyond what typical accounts of citizenship support.

"LET'S YOU AND ME BE CHINESE": *MAXIMUS*
AS IMMIGRANT PERFORMANCE

In *Maximus*, Olson puts both projective verse and the *Projections of America* into poetic practice. Just as he triangulates between the state and ethnic groups while at OWI, his poetics of the 1950s and 1960s aims to triangulate between the reader, the state, and the figure of Maximus (substituting for the state but also incorporating aspects of Olson himself). Olson attempts to speak to and for America's "foreign national" population but in a new way, through acts of identifying with—or perhaps more accurately, impersonating—immigrants and their perspective. Throughout the poem he realizes this aim in different ways, but almost always by some form of performative or

embodied mapping. The epic floods over with the discourse and visual tropes of diagramming the self in whatever place he happens to be, and with whatever idiosyncratic landmarks he happens to focus on. Poems morph into map drawings and narratives read as walking directions in an early American town: "125 paces Grove Street / fr E end of Oak Grove cemetery / to major turn NW of / road" (*M* 150) (figure 5.2). This particular map-poem surveys a small area, formerly called Meeting House Plain, in an early settlement area of Glouces-ter. By literally sketching out the physical relation between words, the speaker symbolizes the relations between hills, marshes, houses, fences, and so forth. At the map's center, below the slanting line where the "hill falls off" (repre-sented by an open-ended parenthesis), there is an erratic, vertical line of six falling o's to represent the hill. The combination of representing linguistically and depicting visually is a familiar Olson motif. But most important, Olson measures with his own, individual gait ("70 paces hill falls S to marsh") and maps with his own particular perspective on the world, including the specific landmarks ("Babson House") that catch his eye or jog his memory.[57]

There is a history of this: Olson is revising an arcane and very personal form of mapping called *mappemunde*, hand-drawn maps of the world made by sailing cartographers in the fifteenth century. Maximus declares as much when he says, "I am making a *mappemunde*. It is to include my being" (*M* 257). Here, he partially follows Pound, who also privileges the sailors' view of the world in *The Cantos*: "the great periplum brings in the stars to our shore."[58] Pound's *periplum* refers to geography "as a coasting sailor would find it"—with the horizon line limiting one's vision.[59] Where a contemporary atlas gives you a vision of the world that no one, including the mapmaker, ever actually had, the periplum or mappemunde allows you to see what the mapmaker saw. De-scribing cartographer Juan de la Cosa, who sailed with Christopher Colum-bus, Olson imagines himself "looking out through Juan de la Cosa's eyes" and seeing not only the maps de la Cosa made but the Atlantic of 1493 that de la Cosa experienced (*M* 81).[60] As a reputed "first view" of the Western world, such a map captures de la Cosa's own experience navigating to and from Amer-ica: "before La Cosa, nobody / could have / a mappemunde" (*M* 81). Thus, Maximus's claim to create a map that "is to include my being," describes a map that unlike a modern-day atlas, includes the mapmaker's particular experi-ence of the place. Although historically the mappemunde would incorporate a universal philosophical viewpoint (a worldview), Olson chooses instead to emphasize the perceptions of the individual, immigrant mapmaker: "through Juan de la Cosa's eyes."[61]

In essence, the entire *Maximus* epic works as a series of mappemundes like de la Cosa's, in which one poet's localized perspective—the view through Olson's eyes—is transferred on a specific historical place embodied by the figure of Maximus (a wandering Greek philosopher). "I, Maximus of Glouces-ter, to You" is the poem's opening line, introducing Olson's dialogue between

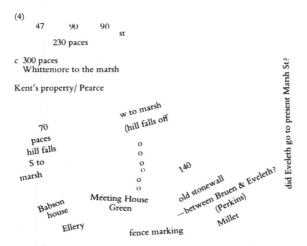

Figure 5.2 Charles Olson, selection from *The Maximus Poems* (p. 150), by Charles Olson, © 1985 by the Regents of the University of California. Published by the University of California Press.

himself and a huge, projected, imagined person sometimes representing Gloucester historically and sometimes representing the poet himself in Gloucester (*M* 5). In this sense, Olson puts his mappemunde into poetic action by incorporating the living perspective of the poet as a projective poem that can be transmitted to the reader through a somewhat mysterious movement of poetic energy. As he describes in "Projective Verse," "A poem is energy transferred from where the poet got it (he will have some several causations), by way of the poem itself to, all the way over to, the reader" (*OPr* 240). Reading a poem means having that energy successfully transferred and managed. Even non-*Maximus* poems from the period, such as one titled "The Intended Angle of Vision Is from my Kitchen" (1959), formulate this same alignment between breathing, embodied perception and transmitted perspective (*OPo* 489–90). The poet reproduces for the reader the phenomenological relation between the objects viewed from the speaker's kitchen window and the poet's body in his kitchen.

Olson adds one additional, crucial component to this configuration of perspectival embodiment, seen most clearly in "Let's You and me be Chinese," an unpublished poem from 1950.[62] What makes this relatively slight, offputting poem intriguing is the suggestion that poetically impersonating an immigrant ethnicity or foreign nationality—"be[ing] Chinese"—can relate not only to his idealistic hope of escaping from the corruptions of contemporary

politics but also to his yearning for progressivism or avant-gardism. Being Chinese, he suggests, means "put[ting] back energy force / where it can go ahead / ahead."[63] Participating in the long history of Chinese racial stereotyping (and adding to it an idealistic admiration for the little he then knew about the new People's Republic of China), Olson intends "be[ing] Chinese" to mean "step[ping] the hell outside" of Western civilization and its corruptions of "titles, salaries, position."[64] He clarifies that this desire is "for no reason of / evasion, no / lack of interest, no / unwillingness to act" but so "only / that act may be / reborn."[65] It is significant that the language here closely resembles that of "Projective Verse" from the same year, which depicts the poem as "a high energy-construct" and the goal is "to keep it moving as fast as you can, citizen" (*OPr* 240). That cheeky address to "citizen" suggests that representing citizenship was always a subtext of projective poetics. Whereas "Projective Verse" posed the typewriter as a method to achieve a paradoxical form of high-energy, embodied impersonality with the voice of the nation, this poem imagines "be[ing] Chinese" as another way round to the same goal by impersonating a foreigner's or an immigrant's perspective. Whether we look out through immigrant Juan de la Cosa's eyes by glancing at his mappemunde of America or look at America through the imagined eyes of a Chinese foreigner or immigrant, we are in each case performing a different, embodied perspective ostensibly advancing us beyond our former selves.

This fascination with embodying an outsider or immigrant perspective helps explain something that might otherwise be rather difficult to explain: why Olson takes seriously and even accentuates the discoveries of self-taught mathematician Paul Donchian, an Armenian American who invented a form of modeling three-dimensional objects from two-dimensional ones by "projecting" them out in space. As Olson tells the story, the day he wrote "Projective Verse" he just had been reading at the Library of Congress about projective geometry in Harold Coxeter's textbook *Regular Polytopes*.[66] According to Coxeter, illustrations of geometrical figures can be constructed either by the conventional method of sectioning (where a three-dimensional solid figure is successively penetrated by two-dimensional planes, like successive slices of cheese) or by the unconventional Donchian method of projective illustrations (which allow you to see "the shadow of the solid figure in various positions").[67] Both methods are accurate, but the first, sectional slicing, does not imply any particular viewing position, nor can it represent more than one part of the whole at a time, so (in Olson's view) it fails as a faithful experience of a cube in the world. "Selecting from the full content some face of it, or plane, some part" is, according to Olson, precisely what makes much of life "unsatisfactory" (*OPr* 157).[68] Projective illustrations, in contrast, imply a viewer looking at the figure from a particular position, just like de la Cosa's mappemunde. Most important, projective illustrations do not artificially chop up our experience of a

cube but capture it with a single perspective—and thus an implicit point of view—included. Because projections are produced with shadows of the object from various positions, the light source must always come from one place and land somewhere else.

In addition to embodying an individual's perspective, projective illustration is so important for Olson—and perhaps what ultimately convinced him to focus on the term "projective"—precisely because Paul Donchian's childhood experiences as an immigrant enabled his mathematical discovery privileging subject position:

> [Paul Donchian was] a boy working for his father in Hartford, Connecticut, selling rugs—and because they were Armenians and it was new, they worked hard, and the boy didn't get any further education at the time that he dreamt all the new forms of possible [polytopes]. . . . But he knew these were something crazy, and he then went on to study, and find, and try to learn, himself, how to make those shapes. If you ever go into the Harvard Library, there they are, on floor seven or something.[69]

In Olson's version of American self-education and self-invention, the self-taught mathematician's deprivation (being unable to learn advanced geometrical sectioning in college) becomes an auspicious opportunity to dream up new forms and use the ancient geometrical images from his Armenian father's rugs as sustenance for new, projective visions.[70] In other words, Donchian's immigrant status and worldview become absolutely crucial to the discovery of projective geometric illustration; the distinctiveness of his immigrant experience distances him from the notion of a "universal" American citizen who would, by definition, lack the perspective of any particular person at a given place and time. Donchian and his projections foreground Olson's commitment to the particularities and unique subjectivities of the living, breathing creator, in this case the Armenian immigrant inventor of projective illustrations.

One of the final poems of *Maximus* takes up Olson's privileging of the immigrant's nonuniversal perspective on the world to imagine how this view might be physically mapped and embodied in projective poetry. The beginning of this eight-page poem narrates the personal struggles of Olson's father before expanding to include the immigrant population of Worcester, Massachusetts, of which the Olsons were members (*M* 495–502). The poem challenges sentimental immigrant stories (like the OWI's optimistic *Projections of America*) for dramatizing the first-generation struggles of the fathers and the second-generation lives of assimilated and accomplished sons. Cynical about this melodrama of hybridity and miscegenation, Olson nonetheless suggests that both he and Baraka (i.e., LeRoi Jones, here misspelled as "Leroy") bear the same fate:

how many waves
of hell and death and
dirt and shit
meaningless waves of hurt and punished lives shall America
be nothing but the story of
not at all her successes
—I have been—Leroy has been
as we genetic failures are
successes, here
it isn't interesting
Yankees—Europeans—Chinese (*M* 498)

Although purportedly uninterested in conventional narratives of assimilation, Olson reveals his fascination with projective embodiments of immigrant perspectives, whether African American ones ("Leroy's"), European ones like his own, or "Chinese." The poem continues by focusing less on Gloucester—Maximus's domain—and more on the geographical feature of Worcester Olson remembers best: "this Ararat this mountain / of rubbish taken from used up anything and made a hill and home for / rats big scared rats my father and I shot / off the back porch Worcester" (*M* 498). Ararat, the biblical name for the mountain Noah's ark landed on after the flood, symbolizes the chosen people's glorious arrival after a harrowing journey. There is also a real Mount Ararat in eastern Turkey (what had been the ancestral homeland of Armenians before the genocide began in 1915), both then and now a symbol of Armenia. Most pertinently for our purposes, there is an Ararat Hill (located close to Olson's childhood home), named by the Armenian immigrants of Worcester in memory of their homeland. In the early twentieth century, Worcester had sizable recent immigrant populations of Armenians, Swedes, Irish, African Americans, and Italians. Olson grew up only a few blocks away from the expanding Worcester Armenian community, then the largest and most active Armenian diaspora community in the United States—perhaps the projective geometer Paul Donchian reminded Olson of home.[71]

These biographical details reveal how "Ararat" simultaneously serves several functions in the poem. It not only connects Olson's childhood memory of a place (shooting the rats hiding in Ararat Hill) to the ancient, biblical history of Noah's Ararat and the "first dispersion" after the flood, but "Ararat" also refers to a real mountain that continues to symbolize home for a diasporic population of Armenians living in Worcester. By looking out from his back porch in Worcester and seeing Ararat—albeit an Ararat whose mythos is spent, an Ararat made of rubbish and filled with rats—Olson imagines he can capture an Armenian's immigrant perspective: the view of Ararat Hill as Mount Ararat. He concurrently incorporates his own perspective as a member of a broad, mythic, human diaspora stemming from Noah. Following in Noah's

footsteps, Olson insists that he, too, must do his creative work "after the dispersion" as "an archeologist of morning" (*OPr* 206–7).

The poem's final section, and the particular relation that Olson imagines between the poem and the reader, brings us full circle in various ways to contrast Stein's refusal to breathe for the poet (that is, her refusal to dictate the reader's work and thus impinge on his or her personal freedoms). On the final page of Olson's poem, each reader's particular, physical relation to the text becomes intrinsic to the poem's meaning. Imagining himself as a secularized disciple of Christ, Olson writes a prayer for his father in a spiraling circle that the reader is meant to read either by physically turning the page to the right or, alternatively and improbably, by standing up and walking around the book (figure 5.3). The reader, in other words, is offered the same immigrant perspective Olson inherited from his own father. Earlier in the poem Olson explains that, "my father also / he turned / as I tend to too to the / right when we / left the house he walked and I / grew up to meet him or stride after him" (*M* 495–96). As Olson and his father both habitually turn to the right when leaving their home, so we are prompted to turn the page to the right to read the poem. We embody father and son's bodily tendency and their proprioceptive relation to the world. That the shape also outlines the iconic figure of a man suggests that Olson directs his reader to step back from the page and consider the poem as a visual whole—yet another geometric projection of a whole from a particular perspective. We perform and re-create this projection by embodying the poet's particular relationship to the page, continuing—with each reader turning the page around—to fulfill Olson's requirement for art: "particularism has to be fought for, anew" (*OPr* 156). The risk of not maintaining this fight for particularism, of not embodying the particular life of his father, is that Gloucester will lose what makes it most valuable to Olson: "the choice of Gloucester is particular—that is the point of the interest, particularism itself."[72] Without particularism, Gloucester itself becomes an unrooted diasporic object, drifting away from America at the poet's behest: "a life America shall yield / or we will leave her / and ask Gloucester / to sail away / from this / Rising Shore / Forever Amen" (*M* 499).

Olson's poetry, then, imagines a way for everyone to be part of a diaspora of "foreign nationals," and thus, in a certain sense, both extends and complicates his political work in the 1940s. That bureaucratic work was devoted to representing U.S. government positions to immigrant Americans, creating at least a wartime unity out of disparate or even conflicting groups—the famous (or infamous) melting pot. But the move to the poetry of individuated breath—projective verse—turns the nation of immigrants as melting pot into the diasporic home of preserved particularisms.[73] Olson provides a way to represent and embody a particular immigrant perspective—in this case, his own via his father's—for a large audience of Americans. He tries to re-create his father's "angle of vision" for himself while at the same time making that angle,

Figure 5.3 Charles Olson, selection from *The Maximus Poems* (p. 499), by Charles Olson, © 1985 by the Regents of the University of California. Published by the University of California Press.

that distinctiveness, available to others. As the coordinator of varied peoples, Olson incorporates the audience's breath—along with his own breath and his father's angle of vision—as a way to enact each American's personhood and provide a groundwork for political representation.

Understandably, we might wonder why he is especially privileged to represent an immigrant perspective for us; perhaps he felt that his background or political work provided him this expertise. Whether or not we choose to accept his authority, with "Projective Verse" he is trying to articulate an original poetic method or technique of relating to identities that are not our own. It is a form of identification that does not involve participating in a representative democracy in the way the OWI would have imagined but involves participating in a certain kind of nation-work by performing (reading) a circular poetry and enacting the immigrant's diasporic relation to place. By exploring the formal theory of poetics in "Projective Verse" and parts of *Maximus*, we not only see Olson's opposition to modernist accounts of the spectator's relation to the art object, we also see his poetics enmeshed in and developing out of his early political work at the OWI, DNC, and other political organizations. Olson's work—both literary and political-bureaucratic—illustrates the connection between a formal poetics and a politics more clearly than almost any other. Understanding the art object's unique relation to the reader results, for him—and for the countless poets he continues to influence—in a politically pluralized account of that world.

HOW YOU SOUND

In their 1962 issue of the small literary magazine *Yūgen*, editors Amiri Baraka and his then-wife Hettie Cohen published, alongside texts by William Burroughs, Edward Dorn, and Gilbert Sorrentino, one of the earliest interpretations of Olson's epic poem: Robert Creeley's, "Some Notes on Olson's *Maximus*."[74] Creeley takes pains to defend Olson's historical method and general poetics, explaining that the writer uses a challenging *"particularizing* vocabulary" because "all meaning is local to an instance."[75] Most striking and compelling is Creeley's opening line: *"Eyes* have a major place in [*Maximus*]" because the Gloucester people's "perception constitutes their city."[76] Following Creeley's interpretive analysis, we find Baraka's version of a place-specific prose-piece, "The Largest Ocean in the World," about a man mapping his lonely wasteland of a city ("An 'X,' on the graph, where you paused"), putting into practice Creeley's point and showing how Baraka's perception vividly constitutes *his* particular city.[77] Cementing this version of Olson's project, Baraka and Cohen then complete the issue with two pieces by Olson, including one called "Place; & Names," in which Olson writes that places or names are like "parts of the body" that have "cells which can decant / total experience."[78] Whether or not they were perceived as such, these various editorial decisions make a consistent set of points: they frame Olson's work as focusing on particularism, perception, and the body; they connect Baraka's own perceptual, mapping writings to Olson's in *Maximus*; and they highlight work of Olson's

that explicitly focuses on the body's physical "decant[ing]" of an experience at a place. Through their editorial process, Baraka and Cohen reveal their own role as savvy facilitators, publishers, and interpreters of New York, Black Mountain, and Beat poetry.[79] They brilliantly administered the contemporary poetic energy in their own way, making sure that their account of this poetry was the one presented to the world.

However, this issue of *Yūgen* was both the final collaboration between the two editors and, in a certain sense, the last editorial alliance between Baraka and the white poetry world. Baraka was closely affiliated with Olson and the Beats beginning in the late 1950s, but by the mid-1960s he moved far away from them in spirit, as he felt that these poets were failing to put into practice the political ramifications of their poetics.[80] After the assassination of Malcolm X in 1965, Baraka left Greenwich Village, divorced Cohen, and moved to Harlem, "declaring himself a black cultural nationalist, that is, one who is committed to black people as 'a race, a culture, a nation.'"[81] His writings of this period, particularly *Home: Social Essays* (1966) and the avant-garde novel *The System of Dante's Hell* (1965), explicitly reject white America and, seemingly by extension, white American poetry.[82] As Baraka explains in an interview with Debra Edwards, "When I came to *Dante*, I then consciously determined that I was going to stop writing like other folks, like the Creeleys and the Olsons and all those other people."[83] The problem with writing a novel "like other folks" is that it also entails writing other people's words: "White people's words. Profound, beautiful, some even correct and important. But that is a tangle of nonself in that for all that."[84]

In myriad ways, Baraka's work from the period attempts to escape from the "tangle of nonself." We can trace his evolving strategy beginning with the early poem "Vice" (1961), which depicts this "tangle" as the "Mosaic of disorder I own but cannot recognize. Mist in me."[85] The feeling of a diffused, colorless, partially absent ("missed") self is palpable. Later, the "mist" and "tangle" becomes more clearly racialized. In "Poem for HalfWhite College Students" (1969), Baraka states that one's words should sound like the words of "who it is you are," and he takes an antagonistic stance toward his addressee: "How do you sound, your words, are they / yours? The ghost you see in the mirror, is it really / you, can you swear you are not an imitation greyboy[?]"[86] In addressing the "halfwhite" student, Baraka is not exactly directing his scorn at mixed-race students but at middle-class black America (of which he was once a member) actively seeking out and participating in an American culture he perceives as overwhelmingly white: "can you look right next to you in that chair, and swear, / that the sister you have your hand on is not really / so full of Elizabeth Taylor, Richard Burton is / coming out of her ears[?]"[87] In contrast to his earlier explanation of "how you sound" (which he paraphrased as how you, as a particular individual, sound), in this instance "How do you sound" is a demand to contextualize your voice racially: to make sure that *you* as an individual

sound the way *we* sound as a race. The question, then, is not to figure out what you want to say or even how "your own voice" sounds to you but to "ask in your black heart who it is you are, and is that image black or white."[88] Similarly, in the short story "Words" (1965), he emphasizes the racial qualities of voice over the meaning of the words that are spoken, pinpointing the nonlinguistic black utterances that exist in his breath, those "bodies of material, invisible sound vibrations, humming in emptiness."[89]

But even in this mid-1960s work and after, where the racial aspects of "invisible sound vibrations" trump the meaning of spoken words, we can still clearly see Baraka's commitment to the alignment of particularism, perspective, and bodily incorporation that marks Olson's *Maximus* and that Baraka explicitly supports and expands on in *Yūgen*.[90] Whereas Olson's understanding of particularism leads him to privilege immigrants and more generally to privilege a theory of immigrant embodiment, Baraka's version of particularism leads him to privilege the experiences of racial difference in America, specifically his experiences as a black man in the Village and Harlem. Yet both share the same theory of and commitment to a poetic particularism as a way to safeguard, represent, and then share a perspective on the world, whether racial, ethnic, or political. Perhaps this is why Olson is given a key epigraph to a chapter of *Blues People: Negro Music in White America* (1963), Baraka's important history of blues and jazz: "the race / does not advance, it is only / better preserved" (*BP* 122). Both Olson and Baraka seek new and better methods (technologies) for acts of preserving particulars. Over time, race becomes Baraka's privileged particular over all other possible particulars, just as "how you sound" goes from meaning how *your* particular voice sounds to how *we* sound as a race.

What will count as a particular, in other words, slowly and steadily shifts for him during the 1960s. At the beginning of the decade, Baraka privileges particulars in relation to place instead of in relation to a particular body color. For instance, in 1961 he writes that his newsletter *Floating Bear* should only exist in one place, "from some point where it is ultimately realized and consistently available."[91] For this reason, newsletters are better than books because "What that book wont have is where we are!"[92] That is, a published book lacks the precise relation to the site of its original writing, whereas an issue of *Floating Bear* is hand-typed, often by one person who probably also edited it, the original is manually mimeographed, and the whole thing is distributed from a single Village apartment. It belongs there. Likewise, in his edition of *The Moderns: An Anthology of New Writing in America* (1963), Baraka echoes Olson's "The Intended Angle of Vision Is from my Kitchen" by focusing on "landscape, in the way the poet Charles Olson has used the word: what one can see from where one is standing."[93] Most important is the relation between where one is and what can be seen from that "exact location." Even early poems depicting the problem of selfhood, what he called the "mosaic of disorder," tend

to depict the self not in racial terms but in spatial ones. "It's so diffuse / being alive," laments the speaker in "Look for You Yesterday, Here You Come Today" (1961), suggesting that the difficulty of managing subjectivity is experienced as the dissolution of particulars into space.[94] Later in the poem, this anxiety turns into a particular worry about the air that surrounds him. His failure to belong in this place is experienced as his inability to inhale as freely others: "What is one to do in an alien planet / where the people breath New Ports? / Where is my space helmet, I sent for it / 3 lives ago[?]"[95] By transforming the very "breath" of projective verse into a noxious, alien atmosphere (before Newport cigarettes were marketed almost exclusively to African Americans), the poem projects the speaker's cultural dislocation onto a literal aspect of his incomprehensible, unsustainable surroundings—the asphyxiating air.

Just a few years later, Baraka completely shifts from Olson's literalized conception of place to a racialized conception of place, insisting on environment as indicative of a person's membership in a particular group existing at a specific time and place: "[A writer] must be standing somewhere in the world, or else he is not one of *us*, and his commentary then is of little value."[96] In this essay from 1966, he begins to use the idea of a perspective on a local place as an expression of one's racial identity. The "one of *us*" is quite explicitly an analogue for racial belonging, and writing what you can see from "where [you are] standing" is not just a matter of accurately representing your landscape but of declaring an allegiance to other people in that place. In other words, the local transforms from physical environment to social space and communal grouping: "An artist, any artist, must say where it is in the world that he actually is. And by doing this he will also say who he is."[97] Baraka suggests that writing from one's particular socioeconomic and racial perspective—writing "what one can see from where one is standing"—is necessary not only for keeping Negro culture alive but for keeping his self-image alive ("a portrait of the Negro in America at that particular time") (*BP* 137). Transforming what one man sees from his kitchen, he replaces it with what African Americans see in America.

As Baraka builds his career as a jazz critic, African American music becomes the primary discourse for his developing vision of racial difference as perspectival difference. *Blues People: Negro Music in White America*, his sociological history of blues, articulates the connection between one person's view and one race's view by suggesting that American citizenship, as available for white Americans, is not an available option for blacks. Crucially, instead of making this point by relying on the history of legalized racial segregation and the countless forms of oppression this segregation took, he argues that this difference stems from a basic perspectival difference between the races. Black and white Americans historically maintained "radically different, even opposing, *Weltanschauung's* [worldviews]," and "each man . . . must have a way of looking at the world—whatever that means to him—which is peculiar to his particular culture" (*BP* 4). American citizenship, according to Baraka, either ignores

the differences between these opposing worldviews or discriminates against African Americans' worldview. Thus whereas "a freed serf" might "find some genuine niche in the mainstream of that society in which to function as a *citizen* . . . the freed black, was always apart. A freed Negro, and there were quite a few of them even before the so-called Emancipation, would always remain an *ex-slave*" (*BP* 4). Distinguishing between economic and cultural identity, Baraka quickly dismisses the black middle class because its members supposedly ignore their racial history by fashioning themselves "as vague, featureless Americans" (*BP* 124). In contrast to the African American bourgeoisie, "ex-slaves" represent themselves in America by maintaining an independent and representative music instead of by challenging the oppressive political structures of U.S. government (presumably through civil rights campaigning) (*BP* 86).

As Baraka describes it, the specific advantage of the blues is that it simultaneously captures each person's individual voice while maintaining that person's place in the black group (or culture) of America. Exploring the primitive blues that freedmen developed, Baraka explains that "Each man had his own voice and his own way of shouting. . . . The tenders of those thousands of small farms became almost identified by their individual shouts. 'That's George Jones, down in Hartsville, shoutin' like that'" (*BP* 61). The blues, then, is not just a way to distinguish between two people's voices (i.e., George Jones versus John Smith); it is also a way to connect George Jones's voice to a specific place (i.e., *George Jones's* small farm in Hartsville) and to connect George Jones to the person listening to him and identifying him "shoutin' like that." Primitive blues, from Baraka's perspective, was an identificatory private language of an individual in a particular place that nonetheless emerged from and helped define the group's needs (*BP* 82). As jazz bands became more assimilated to white America, the "autonomous blues" went "underground" and were disseminated by the radio to become a subculture of collective expression (*BP* 166). This new type of Underground Railroad frees black culture instead of just black bodies, sending the blues "over the airwaves into the various black communities: a kind of blues continuum wherein almost all blues styles were made available to Negroes since they existed side by side on records, and the performers still lived in the same ghettoes as the audience" (*BP* 170). Listening to and singing along with local black radio music in urban areas enable individuals to perform the same role as sharecropper George Jones of Hartsville, singing out his particular perspectival blues to his neighbors and thus reaffirming his particular view and experience as a black man. It is an aestheticized technology of racial community that mirrors the goals of Baraka's poetics.

"The Screamers" (1967), his short story depicting a particularly memorable evening at a nightclub in Newark, New Jersey, dramatizes this technology in action.[98] The narrator describes a general cultural and racial malaise combined with his own fear of being swept into the (dreaded) black professional middle

class: he yearns "for any experience, any image, any further separation from where my good grades were sure to lead. Frightened of post offices, lawyer's offices, doctor's cars . . . the imaginary fat man, advertising cemeteries to his 'good colored friends.'"[99] Ripping into this scene, tenor saxophonist Lynn Hope's music "erased" his anxieties. A converted, practicing Muslim who wore a black turban at concerts in the 1950s, Hope is depicted as deliberately staging a subversive, transformative jazz Happening, turning the competitive concert into a rally and parade that moves "out into the lobby and in perfect rhythm down the steps . . . five or six hundred hopped-up woogies tumbled out into Belmont Avenue."[100] Although when threatened by the unruly, unidentifiable crowd the "Nabs" finally violently intercede—"America's responsible immigrants were doing her light work again"—Baraka portrays Hope's musical performance, along with the audience participation it arouses, as a form of empowering, revolutionary protest: "We screamed and screamed at the clear image of ourselves as we should always be. Ecstatic, completed, involved in a secret communal expression. It would be the form of the sweetest revolution to huckle-buck into the fallen capital, and let the oppressors lindy hop out."[101] This music has adapted from its rural roots into an urban multiracial cultural form to maintain a continuous source of both disruption and racial identity.

As extraordinarily different as Baraka's work is from Olson's, the theoretical affinity is unmistakable. Baraka's emphasis on the racial perspective blues offers not only resembles Olson's focus on performing particular American stories (like Paul Donchian's) instead of representing American citizenship in the abstract but pushes and develops Olson's political claim into a fully worked-out argument. Likewise, for both, a new technological method or medium is crucial to their poetics, and both use local radio to help envision it, perhaps because such radio was inexpensive, accessible, and adaptable for public use, more so than expensive, commercially supported corporate television. Baraka sees local, African American radio stations as affirming a countercultural identity for its listeners, whereas Olson adapted the Foreign Language Division's strategy of using ethnic radio stations to try to convince minorities of their role in America's broader narrative.[102] Each understood ethnic or racial radio as a means to create a collective voice out of a single voice; for each, some version of "projective voice" enabled poetry to fulfill ethnic or minority radio's objective. In some ways, Baraka more than Olson consistently understands and develops their common endeavor. Even in the latest edition of *Blues People* (published in 1999), his new introduction restates Olson's stated aim in *Maximus*. Just as the role of Maximus in relation to a person "is to measure" our role in history, so the goal of *Blues People* is "how to measure this world in which we find ourselves . . . how to measure my own learning and experience and to set out a system of evaluation, weights, and meaning" (*BP* viii). Each poet measured using different criteria (for Olson, it is a single body in world history,

for Baraka, it is a single race in America), but they both employ the notion of self-measurement to affirm and transmit a particular identity.

We can see all these issues of perspective, bodily incorporation, and racial identity come into play by contrasting a poem from Baraka's first collection, *Preface to a Twenty Volume Suicide Note* (1961), to a poem from his third collection, *Black Magic* (1969). The early *Preface* poem "For Hettie" focuses on the manifestation of one particular genetic trait: "My wife is left-handed. / which implies a fierce de- / termination. A complete other / worldliness. ITS WEIRD, BABY."[103] Much of this wry poem recounts these feelings of otherness her left-handedness arouses in the speaker and his determination to "correct" her by attempting "to tell her / whats right. TAKE THAT DAMM / PENCIL OUTTA THAT HAND. YOU'RE / WRITING BACKWARDS." Hettie's innate (and involuntary) physical trait of left-handedness is paralleled to her personality traits of recalcitrance and resistance to authority: "she's been a bohemian / all of her life . . . black stockings / refusing to take orders." In this way, he connects a physical characteristic of a person's body (left-handedness), to a stance of social rebellion in connection to a specific social group—her "black stockings," which suggest both feminist "blue stockings" and her Bohemian, mixed-race relationship to Baraka.

As the poem continues, the speaker's anxiety about Hettie's left-handedness reveals another fear: "& now her belly droops over the seat. / They say it's a child. But / I ain't quite so sure." The caginess could suggest a general anxiety about a new baby or the conventional anxiety about paternity. But in the context of a poem about left-handedness, Baraka seems to be alluding to something more sinister (on the left side, but also unlucky) growing inside Hettie. For of course, although this child might or might not turn out to be left-handed like its mother, it is a surer bet that the child will be mixed-race, and labeling someone "halfwhite" will soon become one of Baraka's sharpest racial epithets. Thus the anxiety about Hettie's left-handedness ultimately substitutes for an unspoken anxiety about her and his unborn child's race. Perhaps most revealing is Baraka's focus on left-handedness as a kind of genetic particularism that modifies Hettie's whiteness into a sinister bodily trait—her own pigment of experience. She is a member of a group of left-handed people, while simultaneously her left-handedness is actualized by her particular left hand. Similarly, her whiteness is a physical trait she both shares with other members of a group, but one that always manifests itself as her own; in this case, whiteness (like left-handedness) is a sinister and inauspicious particularity to have. In contrast, in *Home*, Baraka depicts being black as the most useful particularity for a rebellious, avant-garde poet, "the most extreme form of nonconformity available. . . . The vantage point is classically perfect—outside and inside at the same time."[104] In this spin on "black is beautiful," blackness becomes an ideal "vantage point" because it naturalizes social rebellion. If Hettie's involuntary left-handedness is somehow seen as an overstriving attempt

at eccentricity ("some folks / are always trying to be / different"), the advantage of blackness as a particularity is that it is inherently radical: "merely by being a Negro in America, one *was* a nonconformist" (*BP* 188).

By 1969, any interest or anxiety in his (now) ex-wife's left-handedness is scorned as time spent away from "home" and among other folks' words: "For Hettie" is left out of later anthologies of Baraka's work as racial particularity eventually trumps all other types of particularity. In the poem "Numbers, Letters" (1969), published in *Black Magic*, the opening lines interrogate Baraka himself at an earlier stage in his life, when he was living in the Village: "If you're not home, where / are you? Where'd you go? What / were you doing when gone? / . . . What was you doing down there, freakin' off / with white women, hangin' out / with Queens[?]"[105] Looking "down there" from his new uptown home in Harlem, Baraka mocks his time spent among the white and gay culture of the Village— "all that spilling of white ether"—when he is now able to see and position himself by using an historically pejorative racial label positively, as a black man: "Everett LeRoi Jones, 30 yrs old. / A black nigger in the universe."[106]

If Olson's poetry ultimately imagines a way for everyone to be part of an immigrant community or diaspora by incorporating each audience member's breath, Baraka's late 1960s poetry aims for the opposite. As he writes in "Black Art," "We want 'poems that Kill.'"[107] But despite these differences, my point is that the relationship between perspective, particularism, and meaning that characterizes Olson's work also characterizes Baraka's writing. Baraka can easily become a black nationalist because he is already committed to administering a form of particularism to people he identifies with; the shift from a commitment to a single person's angle of vision to a commitment to a collective, racial angle of vision relies on an identical understanding of the relationship between individual particulars and the poem. Not only liberal-pluralist–leaning philosophies such as Olson's insist on a commitment to perspective; at least one version of militant black nationalism does too. The close resemblances between Olson's pluralism and Baraka's black nationalism might not be acknowledged, but close resemblances exist nonetheless.

Such resemblances might also suggest just how far we have come in the historical shift in modernist aesthetics, exemplified by Stein's and Lewis's indifference to the spectator's angle of vision as it relates to the meaning of the work of art. Where Olson and Baraka write poetry to and for spectators (albeit for different groups of spectators and for different reasons), Stein and Lewis insist on the spectators' irrelevance to their works' meaning and contend that their commitment to the viewers' irrelevance has real consequences in the world. By privileging the particularity of immigrant and minority perspectives, Olson and Baraka imply that the libertarian freedom both Stein and Lewis imagine results from theoretical positions no longer deemed plausible or desirable. Perhaps such an account of freedom has not only become tainted with the consumer society Gaddis and Bishop struggle with but also with a

more recent, widespread, leftist distaste for universalism. Such an aversion has led to various theories of identity, related to Olson's and Baraka's, that we are familiar with today.

With this point in mind, we should note that Olson and Baraka are not alone in their dreams for perspectivalism: both their poetic projects are entirely consistent with the logic of perspective and self-positioning that became common by the 1990s in theories of feminism and cosmopolitanism. When Donna Haraway, in *Simians, Cyborgs, and Women* (1991), champions the "politics and epistemologies of location, positioning, and situating . . . the view from a body . . . versus the view from above, from nowhere," she clearly also appeals to particular—in her words, "partial"—perspectives, to generate epistemological and political claims.[108] Laboring to align scientific objectivity and feminism, Haraway concludes that partial perspectives are the best solution because they permit her to criticize knowledge claims as she produces them. Similarly, in *Feeling Global: Internationalism in Distress* (1999), Bruce Robbins rejects the "luxuriously free-floating view from above" to promote a version of cosmopolitanism that incorporates multiple, unique, and grounded perspectives on the world.[109] The point, ultimately, is not that Olson and Baraka are closet cosmopolitan feminists and Haraway and Robbins are closet projectivist, black nationalist poets. These are labels hard to fathom for each of them. Instead, the same theory of perspectivalism, and the understanding of perspective's relationship to a desired political stance, continues to inform and inspire literature and theories of feminism, queerness, and revamped universalism or cosmopolitanism.

CODA

༄

Universal Breath

Near the whiff of lemons / The air is not an error
—Brenda Hillman, "Altamont Pass," *Pieces of Air in the Epic* (2005)

Stein's breathless poetry and Lewis's and Gaddis's satires of time-filled, air-filled painting exemplify some of the modernist texts preoccupied with breath and air. After Olson's and Baraka's breath-inspired poetry, breathing and air waft with increasing significance through the postmodern and contemporary literary, art historical, multimedia, and theoretical landscape. Samuel Beckett's half-minute play, "Breath" (1969), consists of recorded birth cries, the sound of someone taking an audible slow breath, and a stage littered with rubbish.[1] Damien Hirst's film version of the play (2001) leaves out the birth cries to concentrate on inhalation and exhalation.[2] So does performance artist VALIE EXPORT's *Breath Text, love poem* (1970), as she breathes heavily at the video camera lens while slowly moving her face across it, fogging up the entire space with her lung's volume (figure 6.1). Her piece takes Olson's breathy love poem "Gli Amanti" a step further, not just aiming to capture the particularities of one's pronunciation in an individual speech act but substituting the specific marks her body creates—her "breath text," the moist gasp on the window glass in front of her—for the signs one would use to write an actual, linguistic "love poem." In a different medium entirely, although working with a similar premise, Luce Irigaray employs "the forgetting of air" to critique Western philosophy's basic hierarchy of language over body, and thus signs over marks: "to recall that air is at the groundless foundation of metaphysics amounts to ruining metaphysics through and through."[3]

In each of these texts we see some version of poet Brenda Hillman's observation that "The air is not an error," but an intentionally depicted substance or

Figure 6.1 VALIE EXPORT, screen shot from *Breath Text, love poem* (1970). © VALIE EXPORT, courtesy Charim Galerie, Vienna. © 2010 Artists Rights Society (ARS), New York/ VBK, Vienna.

scent ("the whiff of lemons") now used as a trope to challenge humanism's rigid binaries and privileged terms: signs over marks, certainty over error (or, maybe, "air-or"), written language over speaking body, representation over experience. For all the different ways it might be manifested, this critique revisits Olson's and Baraka's aesthetics of breath, an aesthetics that led them to challenge traditional ideas of liberal representation. Olson's and Baraka's notions of renewed citizenship required the performance and imitation of immigrant or minority bodies by others—the fantasy captured by Olson's phrase, "Let's you and me be Chinese"—while in his late writing Olson sometimes takes this idea a step further. Promoting a form of universal connectedness that simultaneously denies the concept of culture while affirming the distinctiveness of the body and one's experiences of life as a Chinese person or as a projective poet measuring the wind out the window of his Gloucester apartment, Olson writes, "I don't believe in cultures myself . . . I believe there is simply ourselves, and where we are has a particularity which we'd better use because that's about all we've got. . . . Put an end to nation, put an end to culture, put an end to divisions of all sorts."[4] As described here, he aims to find a postnational, postcultural ethics of social and political connection—"an end to divisions"—that still finds a way to "use" particularity because it's "all we've got." Although his

dismissal of cultures looks unfamiliar compared to the post-1960s embrace of all cultural identities, his determination to make particularity count for more—to count for some version of personhood—is entirely consistent with and even illuminates the post-1960s world. Which is to say that, with these ideas, Olson anticipates various recent attempts such as VALIE EXPORT's, Hillman's, and Irigaray's, whether in art, literature, or critical theory. Each depicts communitarian or other forms of social "connection"—if not communication—via breath or particularity to avoid universality's central terms.

A number of contemporary thinkers—Paul Gilroy, Lisa Lowe, and Judith Butler, to name a few—critique universalist claims as inescapably racist, heterosexist, or otherwise Western-hegemonic in terms remarkably similar to those of Olson and Baraka. We can begin to see this argument in Gilroy's endeavor, with *The Black Atlantic: Modernity and Double Consciousness* (1993), to "draw out the particularity that lurks beneath the universalist claims of the Enlightenment project," just as his *Against Race: Imagining a Political Culture Beyond the Color Line* (2000) seeks an "alternative version of humanism" that confronts the racist "failures, silences, lapses, and evasions" of liberal universalism.[5] Searching for new ways to critique universality—the view from nowhere, the view "beyond the color line"—without simply privileging the act of speaking from a single subject position or identity—the view from one particular somewhere—takes on new intensity in different kinds of texts. In attempting to challenge conventional universality, writers and thinkers who would never think of themselves as especially aligned—Gilroy, Juliana Spahr, Hayden Carruth, Leslie Marmon Silko, Butler, and Alain Badiou—actually rely on the same substrate of ideas, and at times the same basic argument. While deploying different formal strategies and political claims, a common enemy unites them: status quo liberalism. Most surprising is that regardless of genre or political affiliation, their attempts insistently employ the same idea of meaning and autonomy we have just examined, as they effectively extend the logic of Olson's and Baraka's formal and theoretical moves. Writers such as Spahr, Silko, Badiou, and Butler unite in their support of one side of the debate we have been tracing throughout the book: defending meaning's incorporation—the notion that an art object's meaning inextricably connects to the reader's breath and thus her body—their arguments morph into critiques of universality that "make us breathe differently," as Butler puts it.[6] Whatever the variety and novelty of these accounts, we have hardly developed beyond Olson's and Baraka's positions. Their field of preserved particularisms is very much ours—and breath remains a frequent touchstone—even when current debates seem preoccupied with other sets of issues.

Consider, for instance, Juliana Spahr's elegiac "Poem Written After September 11, 2001" (2002), a poem that begins by investigating a scientific ontology of the body but eventually turns once more to a poetics of air connected to a particular politics:

There are these things:
cells, the movement of cells and the division of cells
and then the general beating of circulation
and hands, and body, and feet
and skin that surrounds hands, body, feet.
This is a shape,
a shape of blood beating and cells dividing.[7]

Ruminating on our thingness as living beings, Spahr focuses on small component parts of the body, our constantly dividing cells fueled by bloodborne oxygen. Gradually, the poem's concerns expand beyond our "shape" to the "space" outside of our bodies: between our hands, around our feet, between us and other people.[8] We are not separate from this space but contiguous with it: "The space goes in and out of everyone's bodies. / Everyone with lungs breathes the space in and out as everyone / with lungs breathes the space between the hands in and out."[9] By "space," Spahr obliquely refers to air as a substance creating a new space inside our bodies from the air that was once outside our bodies, a common requirement for life that bears the burdens of the global, geopolitical relation implied by the book's title, *This Connection of Everyone with Lungs* (2005).[10] In this alignment between poetics, breath, and global linkages, her project connects to modernism's foundational problems of agency, freedom, and politics in relation to the trope of breath and the formal possibilities of poetry.

Depicting such expansive, interconnected air is one of the poem's aims. Through a repeating stanza that portrays more space with each iteration, the poem locates the body from an increasingly aerial or satellite perspective—as if performing the Google Earth "zoom out" feature—dramatizing air slowly dissipating across a vast distance, expanding over oceans, troposphere, stratosphere, and beyond. Invariably, we breathe in some of this same air from both near and far, "all of it entering in and out" of our bodies:

The space of everyone that has just been inside of everyone mixing inside of everyone with nitrogen and oxygen and water vapor and argon and carbon dioxide and suspended dust spores and bacteria mixing inside of everyone with sulfur and sulfuric acid and titanium and nickel and minute silicon particles from pulverized glass and concrete.[11]

Blended in with the basic elements required for life (oxygen, carbon dioxide, and so on) are the everyday harmful ones that irritate and infect our lungs (dust, bacteria) and, more grimly, the poisonous and inert materials that might kill us. "Minute silicon particles from pulverized glass and concrete" clearly refers to the chemical compounds that eventually led to debilitating and often terminal lung diseases for many workers at Ground Zero, exposed

for days to the noxious debris cloud from the collapsed World Trade Center.[12] Using the technical language of molecules and minute particulates as they constantly diffuse through the air, Spahr alludes to this expanding poisonous air mass—and not the terrorist attacks themselves—as an encroaching disaster. Locating herself in Brooklyn, where the drifting cloud was visible for days (if not weeks), she also suggests that the physical law of entropy—the expansive force that diffuses everything everywhere over time—paradoxically brings us together, enabling us to realize "how connected we are with everyone."[13] We will all breathe the same polluted air eventually, whether in Brooklyn or elsewhere. In this regard, her poem dramatizes the global political camaraderie emerging immediately after 9/11, when on September 12, 2001, the French newspaper *Le Monde*'s headline proclaimed, "Nous sommes tous Americains," a line that became a model to generate other versions, such as the ubiquitous "We are all New Yorkers" and the decades-old publicity campaign logo, "I ♥ NY," that took on a new meaning after 9/11.[14]

But if Spahr's trope of air as universal connection was simply a metaphorical commonality, then there would be no need to point out, as she does, that breathing physically connects us all to one another, that because you and I both breathe from the same capacious but ultimately limited supply of the planet's air, we are therefore essentially, even particularly, connected to one another. That physical connection is precisely her point. The same fallen-towers-air we reluctantly breathe in Manhattan, Brooklyn—or eventually Paris—is also, literally, the 9/11 victim's last breath: "the space of everyone that has just been inside of everyone mixing inside of everyone"[15] Some part of these bodies—air molecules and air pockets once inside them—will eventually be dispersed not just everywhere but in everyone.[16] What is especially striking about Spahr's portrayal of New Yorkers' worldwide connectivity is her reliance on the logic of bodily incorporation to do so. It is a form of perspectivalism precisely reiterating both Olson's and Baraka's poetics. We all are New Yorkers on September 12, 2001, not because we live in New York, or agree with Rudolph Giuliani's policies, or identify with New Yorkers' shocked point of view in a moment of catastrophe and feel equally assaulted. Instead, we are all New Yorkers because our bodies connect to all other bodies through the air we breathe, a perspective we typically ignore, presumably because it renders any account of locality basically meaningless. We incorporate New York into our bodies wherever we are because molecules of bodies and buildings from the WTC have melded with global air. For that matter, following the logic of Spahr's poem, we are connected to everyone and anything that ever did or ever will breathe, at least for as long as these basic chemical elements and molecules exist.[17]

Borrowing from ecological and cosmopolitan discourses of global interconnectedness, Spahr takes this idea one step further to show how our common reliance on air actualizes something close to the absence of autonomy over our own bodies. Thus the poem ends, "How lovely and how doomed this connection

of everyone with lungs."[18] Her point is that thinking of our bodies as systems that poorly filter the outside world underscores our vulnerable yet harmonious oneness with the world (presumably, this is why the experience is "lovely") even as the same unifying experience with the universe reminds us that our person-hood, and our person, is "doomed." Perhaps we can now see why she insists on describing bodies with the term "shape," a word implying the absence of form, instead of using "organism" or "animal" or "human being" or "person." In other words, "this connection of everyone with lungs," the alternative form of partic-ularity-within-universality she proposes, is simultaneously a connection that transforms each human form into a shape, each person into a no-person, and each place into utopia in its literal sense—that is, a no-place. This last point sounds especially odd, but consider: if we are all New Yorkers because eventu-ally we all breathe some particular bit of New York air, what stops us from being Texans, or Californians, or Afghanis for the very same reason? (I ♥ Kabul.) We are simultaneously everywhere and nowhere, as situatedness becomes,]appar-ently, impossible. Perhaps this is why Judith Butler describes universality in nearly identical terms: as "an 'emergence' . . . or a 'non-place.'"[19] For Spahr, our inevitable connectedness with other inhalers and exhalers is precisely what makes it impossible to be a people, or simply *persons*. Out of cosmopolitan post-nationalism emerges the impossibility of political subjectivity of any kind, because we become the "lovely" and also the "doomed" citizens of utopia. (I ♥ utopia.) How exactly the lovely and doomed way of this world might be orga-nized or even lived in she leaves unimagined and maybe unimaginable, or at least unsaid.

By using breath to realize our commonality with all human beings, Spahr—like Olson and Baraka—depicts a particularist alternative to a human relation based on universalism. There are other political implications of "Poem Written After September 11, 2001," but consider first a formal and theoretical conse-quence of her position that turns air into one type of particularity among many possible manifestations. Although air seems to be fundamental matter without substance, environmental discourses—of global warming, carbon emissions, and the industrial particulates that degrade air quality—insist that we be more aware of or receptive to air as matter or object. What connects us to every other human being, according to Spahr, is not just our need to breathe but the partic-ular *things* that we inevitably breathe: oxygen, carbon dioxide, and nitrogen, but also particles of titanium, pulverized concrete, glass, steel, books, papers, bodies, indeed all that was the twin towers. It is the difference between a shared trait that characterizes our existence as living things—the category or concep-tual relation of everyone breathing—and an actual, physical relation with someone else via the shared matter we inhale. By the very same logic, someone who could live in an entirely separate, air-sealed space—perhaps behind the sealed windows of two colossal office towers, or in what Loy called "the glass cases of tradition"—would not be connected to us or possess our humanity.

September 11, 2001, becomes the day that made us—or at least the some of us now breathing the unfiltered air of the world—human to one another. In a sense, the events of that day are reimagined as producing an apocalyptic transformation, one that had the unintended but useful effect of altering universality to seamlessly incorporate biopolitics or even the breath of particular bodies in a literal communitarian connection.

If it still is hard to see why exactly tiny, poisonous air particles matter so much to Spahr as a way to imagine our post-9/11 global New Yorkerness (our new, universal-particularity), Hayden Carruth's earlier poem "Particularity" (1996), shows us the possible alternative, the "awful" experience of losing "it," that is, losing the particularity realized for Spahr in molecules of pulverized concrete:

> How it is blurring, oozing
> slowly away from
> me. This is an
> awful moment
> every time. The grove
> of sumac I've known
> so long becoming
> a lump of
> undifferentiated land-
> scape . . .[20]

This moment is not awful because what had been a familiar place is now an unfamiliar one. That would be the effect of defamiliarization, an experience Carruth describes only two pages later in "Surrealism." Instead, the moment is awful because everything about this place is equally familiar. "The grove / of sumac" becomes "a lump of / undifferentiated land- / scape." He depicts the feeling of singular sameness—experiencing everything in the landscape as uniform—as a moment of despair: "Then / everything is one, is nothing."[21] In sharp contrast to that unifying moment with particularity in Spahr's poem, when we breathe in the disintegrating air of the twin towers and all become New Yorkers, Carruth experiences a moment of unification without particularity as terrifying stasis, disintegration, and uniformity. Oneness becomes nothingness. Descriptive particulars have vanished and all that remains is pure, monotonous presence as existence: "where I am, / where I am / existing."[22] The poet's particulars have been lost and must be recaptured before he can transmit them to anyone else. When Olson warns that "particularism must be fought for, anew" (*OPr* 156), he is perhaps anticipating Carruth's dystopian world where the logic of particularity exists but the material particulars supporting it have apparently vanished, or at least have disappeared from representation.

Here is another way we might understand Carruth's poem: as a dramatiza-tion of the thought experiment exploring what it might feel like to phenome-nologically experience pure universality as the noumenal domain, which is understood to be beyond our experience (following Kant's description in the *Critique of Practical Reason*). As in Spahr's account, the result is the loss of our autonomy, and perhaps it is no wonder that in Carruth's view we have to avoid that loss at all cost.[23] Even a representation of the industrial particulars released from the World Trade Center on 9/11—whatever their other inju-rious effects—would have produced the differentiating outcome he requires. To be sure, these effects are not absolutely alike: for Carruth, the experiences of these particulars are visual, whereas Spahr's are depicted as inhaled. Yet the variance between the two poets' conceptions of particular experience actually makes their shared point all the clearer: the particles and particulars that con-nect us might be seen with our eyes or breathed into our lungs, or our bodies may sensorially experience them in entirely different, unexpected ways. Olson's spiral poem, in which particularity is "transferred" through a precise, reenacted physical relation of your body to a poem, tries to account for these potential differences so you might have the phenomenological experience he intends you to have, but Olson's work more generally accepts these differences as a reality that projective verse poetry must always endeavor to negotiate.

We can see another version of the experience of particularity in Leslie Mar-mon Silko's work, which presents yet another anti-universalist variation on the increasingly recognizable poetics of meaning's incorporation, one that theorizes particularity not as breath or sight but closer to Olson's gestural in-corporation. Whereas Olson requires us to incorporate particulars by imi-tating his father's habitual bodily tendency to turn right, Silko allows us to incorporate particulars when, by reading her books, we travel to an actual if very small place. Her novels, poems, and essays seem far more invested in cultural and political claims about Native American land rights than in formal issues involving the ontology of the art object, yet to realize this very different worldview she makes nearly identical theoretical and formal moves to the ones we have been considering so far. Her Pueblo's land claims lawsuit was especially formative: taking twenty years to settle, the lawsuit spanned most of her childhood and young adulthood and prompted her to study law.[24] Although she left law school disenchanted and without a degree, she is so taken by the authority of narrative within legal testimony—with the way "the old folks testified with stories"—that she aims to create a structure in fiction that might operate as or despite legal authority, a way of taking sovereignty over a land you no longer legally possess.[25]

Emphasizing the inherent interconnectedness of Native American land rights and culture via the act of storytelling, Silko's performative narratives feature details of the differentiated, indigenous landscape, precisely the type of details Carruth fears he has lost in the language of universality. Despite these

additions, the possibility of lost particularity worries Silko, too. When stories about her ancestors fail to anchor the land sufficiently, she turns to another medium—photography—to do this same work within the text, with pictures that do not "illustrate the text, that don't serve the text, but that form a part of the field of vision for the reading of the text and thereby become part of the reader's experience of the text."[26] In her account, a photograph's indexical relation to the real effectively captures one's experience of a place itself, transmitting it to the reader so it becomes "part of the reader's experience of the text." Her understanding of photography as experience resembles Wyatt's in Gaddis's *The Recognitions*, although for the same reasons he rejects photography as art. In another sense, she reiterates the same relationship to technology we saw in Olson's "Projective Verse" (in this case, with the camera instead of the typewriter), where he imagined that he was mapping his breath or the particular angle of vision of his father via the typed line breaks and orientations of the words on the page. She also shares his belief that using the visual field of the page can translate orality into writing by varying spaces and indentation "so the reader can sense, say, that the tone of the voice has changed."[27]

But from our perspective, her most significant choice is not exactly in replicating Olson's breathly projective verse and field poetics but in extending the logic of the body beyond visuality and into tactility. Choosing to self-publish a limited edition book of poems, *Sacred Water* (1993), Silko has it printed on paper embedded with indigenous objects from her homeland. By literally incorporating unreadable and even unseen objects into her text, the reader can touch the place with their hands while reading:

> The hand-made editions are covered with Stephen Watson's "Blue Corn" paper, which is made in Albuquerque, and actually contains bits of blue corn. A limited edition was covered in Watson's white "Volcanic Ash" paper, which contains small amounts of fine ash obtained from the volcanoes just west of Albuquerque.[28]

A handmade book of narrative poems is an autobiographical text that not only combines words and images but also incorporates her actual, historical place in the world via regional food—"bits of blue corn"—and the indigenous land of her people: "small amounts of fine ash" from local (albeit dormant) New Mexico volcanoes that are melded with the soil that nourishes the corn. As with Spahr's interconnecting air, with Silko's book particular bits of the dispossessed land unite a dispersed group of people, and like Spahr, an aesthetic decision (in this instance, about the details of book production) aligns precisely with her theoretical claims. By creating a book with photographs and particles of local objects that "become part of the reader's experience of the text," Silko invites the reader not only to see the places she sees but also to experience her text as the place where she is, thus also resembling Olson's window frame writing in Gloucester. In a sense, *Sacred Water* operates as a

kind of portable homeland for Laguna Pueblo Native Americans living away from ancestral homelands, just as Silko lives off the reservation in Tucson, herself a particle of the greater, fluid Native American diaspora. To dramatize a physical (and, in her case, a territorial) relation to the real world, she uses an aesthetic experience not of reading but of one's physical relation to a book.

With *Sacred Water*, Silko rehearses the original trope with which *Modernism's Other Work* begins. That is, when an art object incorporates a physical fragment or object of the world—whether a bit of blue corn in a book, a "fly" fact trapped in a poem's "amber," a piece of braided rope surrounding a collage, or some air in a glass jar—our relationship to the art object becomes a crucial way to scrutinize and philosophize our connection to the world at large. However different many of these postwar writers are, a common set of concerns unite them and help us see how Silko's portable homeland-book takes to its logical extension Olson's, Baraka's—and Spahr's and Carruth's—poetics of preserved particularism. As with Olson and Baraka, Spahr's and Silko's analogous, incorporative poetics lead to political positions that initially appear quite different. While particles of the WTC caught in the air anchor Spahr's postnational cosmopolitanism for the world's population, bits of volcanic ash embedded in the pages of *Sacred Water* secure Silko's diasporic nativism for members of her tribe. But in other ways, these writers' attitudes toward their politics are identical—a point we might put more polemically to say that all political claims emerging from a theory of meaning's incorporation (spectator-experienced meaning) present an opposition to conventional liberalism at their very core.

Spahr's view that our lungs' connections to others inevitably destroy status quo accounts of personhood implies that she is extremely skeptical about the emergence of a breathly politics that could incorporate the liberal subject—let alone a conventional democratic or representative politics. Similarly, Silko's blue corn and volcanic ash paper and the text on it appear, to her, to be the only alternative to the "Anglo-American legal system" which systemically failed, over hundreds of years, to protect Native American people and their land rights.[29] Each of their utopias of connection responds to the failures of liberal politics by rendering those disappointments not just obsolete but unimaginable, not solved but dissolved. We carry out our postnational or nativist citizenship—such as it is, and which end up amounting to the same thing—by inhaling and exhaling the polluted, post-9/11 air or, with Silko's book, by reading and thus revisiting a homeland on a piece of paper embedded with volcanic ash from New Mexico. Although other political actions or beliefs might follow from this shared approach, they would seem to hardly matter after breathing or touching accomplishes our minor, even inadvertent prerequisites for citizenship. In this way, their political-poetic acts imagine not so much an alternative to liberal politics as a complete end to politics in any recognizable form.

But we do not need to search for the embedded politics of a poet and a novelist to see this perspective realized, because their cultural-political strategies are scarcely the only ones associated with attempts, understood as a politics, to capture and transmit particulars like breath or blue corn to others. The same logic informs a number of leftist accounts that endeavor to avoid or critique universality. After Haraway and Robbins, the work of Gilroy, Lisa Lowe, David Lloyd, and Dipesh Chakrabarty aimed, in Chakrabarty's words, "to destabilize this abstract figure of the universal human."[30] Gilroy and Lowe, for example, privilege the particularity of one person's perspective—one's view of the world from *this* window, to use Olson's language—to critique notions of liberal citizenship. Each champions perspectival subject positions over a universalist interpretation of political belonging, as when Gilroy posits "the distinctive historical experiences of the [black] diaspora's populations" to critique "the versions of modernity that . . . myopically Eurocentric theories construct."[31] Lisa Lowe's *Immigrant Acts: On Asian American Cultural Politics* (1996) advocates for particularity by urging the addition of more subject positions to counter "the concept of the abstract citizen."[32] Specifically, she argues that universities ought to provide "more sites and practices than those permitted by one generic subject position," that is, the subject position of a "universalized," "dehistoricized," white, male student.[33] Chinatowns around the country are her focus because they establish an immigrant culture that remains distinct from "American" culture. Like Silko, Lowe values such particular, physical sites of culture precisely because they nurture nonwhite subject positions; indeed, they continually perform Chinese American subject positions anew, instantiating the multiculturalism she envisions. But whatever the specific goals of these theories, both Gilroy and Lowe contend with abstract citizenship by arguing for the same prioritizing, duplicating, and performing of particularity that Olson and Baraka advanced decades earlier.

As these arguments expanded beyond cultural and literary studies at the end of the twentieth and in the first decade of the twenty-first century, critics attacked the underlying identity claims with which particularity seems almost inexorably intertwined, even as they sympathized with the critique of universalism. The most serious potential challenge has emerged from psychoanalytic, Marxist, political theorists who challenge identity politics and its situatedness or embodiment; their ultimate aim is not simply to attack universalism with preserved particularity but to reclaim universality after profoundly altering it.[34] Often they assert reframed versions of concrete universality to counteract what they argue are both the serious problems of identity politics on the one hand and universalism on the other hand.[35] Yet the temptations of particularism prove formidable even in these accounts. Take *Saint Paul: The Foundation of Universalism*, Alain Badiou's fascinating exegesis of Paul's creation of universality, in which he considers how the formulation of particular, ever-changing contingencies allows universals to become known to

us as concrete universals. As Badiou puts it, "What matters, man or woman, Jew or Greek, slave or free man, is that differences *carry the universal that happens to them like a grace*" (emphasis in original).[36] This commitment to concrete universalism aligns with his insistence on the singularity of Paul's Christian "truth event," as when Badiou claims that universality is "neither structural, nor axiomatic, nor legal."[37] Simultaneously, he asserts that categories of identity and ethnic or communitarian belonging—precisely the kinds of particularity we have been examining—"must be *absented* from the process" of this truth event for it to achieve universality.[38]

It is precisely here, in an attempt to retain a structure of singularity within a definition of universality, that certain contradictions emerge that Badiou cannot or will not explain. To realize the Christian "truth event," which Badiou at times depicts as a public, performative speech act in which one declares "the event by its name, which is 'resurrection,'" one must have a basic belief in the precise strictures of Judaic law and the truth of the Greek logos.[39] Both law and logos are rejected anew when one declares Christ's resurrection, a structure captured in Paul's line, "'for you are not under law, but under grace' (Rom. 6.14)," which to Badiou means that "the subject of the new epoch is a 'not . . . but.'"[40] That is, the subject that "*bears the universal*" can only be an inherently divided subject (in the psychoanalytic sense) who must reject the "closed particularities" of the Old Testament's copious legal strictures to receive the gift of grace.[41] Yet with this temporal, performative "not . . . but" structure of universality, Paul's truth event (in Badiou's account) can only be an ever-failing attempt at antifoundational universalism, along the lines of Beckett's "Try again. Fail again. Fail better." Fail again it must. This is because the "not . . . but" formula *requires* the obstinate "closed particularities" of the law and logos to enable the speech act event to work. If the truth event occurs, law and logos will also endure, albeit in the form of the dejected, rejected "not" that sets in motion and makes meaningful the copular "but." On Badiou's account at least, Paul's attempts at universality and antifoundationalism ultimately retain some of the particulars—of law and logos but also of ethnic identitarianism—that Badiou is determined to "absent."

The same snag of irrepressible particulars appears more starkly in a recent essay by Judith Butler, where we also see the resilience of perspectivalism in an attempt to rejuvenate universality. Indeed, her position ends up reclaiming particularism in a version strikingly similar to Olson's and Baraka's. "Universality," she has suggested in various books, is a tainted and potentially violent term that nonetheless might be rehabilitated because its taint endows it with "power, the potential for its resignification."[42] Discussing Monique Wittig's argument that lesbian writers "must assume both a particular *and* a universal point of view . . . to be part of literature," Butler locates the power of the French writer's work in the shock created when the accustomed (heterosexist) presentation of universality shifts to reveal a lesbian presentation

of universality.[43] That is to say, when we suddenly recognize that universals can only be represented within media (as concrete universals), we simultaneously realize that "the universal depends fundamentally upon its appearance in certain forms, that is, its presentation under certain kinds of descriptions. Further, the categories of sex determine in advance whose perspective will qualify as universal and whose will not."[44] In other words, Butler is arguing that by producing the effect of "universalization" through a lesbian's perspective and not through expected, heterosexual versions of masculinity or femininity, Wittig unsettles our typically gendered, heterosexist accounts of universality.[45]

But consider the move Butler makes here. Instead of simply privileging a lesbian perspective over a heterosexual one, she privileges the shift from one perspective (that of a heterosexist) to another (that of a lesbian), declaring that this adjustment itself amounts to a shocking, interventionist act of resignified universality: "The change in concept takes the wind out of us, makes us breathe differently, changes our gait, our posture, our way of living corporeally in the world."[46] In a sense, the changes in our breath and posture operate like Badiou's transformative, performative, "not . . . but" truth event. One can see the force of her point: recognizing and accepting the habitual (mis)alignment between heterosexism and claims for universality might very well cause us to reconsider how we act in the world, and for good reasons we also might prefer a lesbian's account of universality to that of a heterosexist. Much harder to see, however, is how shifting from one point of view to another could possibly count as universality—the view without perspective—instead of the view from two somewheres in succession, temporalized, spatialized, and particularized. Shifting between views is not universality. Just as Badiou's "not . . . but" formula retains material traces of its rejected particulars, Butler's reification of a third perspective—even if an interstitial, fluid perspective—gives us our breath back (if the universal ever could have been understood to have taken it away) and clarifies, once more, that the preserved particularisms of Olson and Baraka are still the order of the day. Although critics such as Badiou and Butler try to remove the breath from words, the particularity of the breathing air lingers palpably in their formulations.

On some basic level, the problem in these accounts stems from the arguably flawed reasoning that because all of our accounts of universalism are formulated with particulars (they are accounts, after all), particulars must therefore contaminate every abstraction or universality as well.[47] Such theoretical claims about the strategies and flaws of revamped universalism have not been this book's primary goal, although we could extend these arguments further to support Walter Benn Michaels's distinction between ideological differences on the one hand and differences in perspective on the other.[48] Indeed, Butler's critique of "old" universalism conflates ideology (believing in gay civil rights) with point of view (Wittig's personal perspective on the world), a confusion

Wittig herself was determined to avoid. But more basically, these theoretical claims belong here because they make apparent that the postliberal critical moves in Lowe, Gilroy, and Butler, as well as the renewed focus on concrete universality in Badiou and Butler, have a long and engaged history. This history, this modernist debate about beholding in relation to a view of the liberal subject, is precisely what we have been exploring throughout this book. While Slavoj Žižek hints at this connection by vaguely alluding to modernist theories of framing in relation to his broader discussion of universality, in a more extensive and serious way this debate has been unacknowledged and unexplored.[49] By tracing a twentieth-century genealogy of the spectator's relation to the subject via articulated connections between art, the particulars of the reader's world, and politics, *Modernism's Other Work* begins to tell this story.

Silko's and Spahr's views represent the apotheosis of one side of this debate within literature (that of meaning's incorporation) and relate most directly to Olson's and Baraka's attempts to situate themselves, via breath, within the broader context of a minority politics. Extending to more recent poets and theorists, we mapped attempts to incorporate the particulars of air and the broader reader's world into the poem in the service of diverse worldly aims. In contrast to this largely postwar sweep of poetry, earlier chapters traced a radically different, interdisciplinary narrative arc that often uses the exemplar of air to depict meaning's autonomy. Starting with Stein, who contrasts the breath of a reader to air in a painting or a poem, we see the description of meaning's autonomy build with Lewis's sense that painting as a world we can literally enter and breathe in is a characteristic of bad art alone. In a surprising turn, both Stein and Lewis depict the spectator's irrelevance to the work of art in relation to forms of democratic liberalism. Whereas Williams develops Stein's attempt to remove the literal frame from poetry by making punctuation signify differently in relation to the field of the page, Minelli, Gaddis, and Bishop expand on Lewis's theorizing of bad art in different ways, in the process altering our notion of kitsch and reimagining what might count as avantgarde art in relation to other systems of cultural value in the postwar world. From a literary historical perspective, then, the debate explored in these pages proposes a very different lineage within modernism for writers such as Stein and Lewis, and beyond these two, for various twentieth-century writers usually embraced by (or relegated to) theories of the postmodern.[50]

From our revised perspective on this debate, we might reexamine other literary figures, such as Marianne Moore or Ezra Pound, only alluded to here. Although Mina Loy's aesthetics rightfully deserve the proto-postmodern appellation, Pound's do not, at least in the case of his music criticism with its unexpected emphasis on the necessary role of a frame separating the audience and the music. A literary criticism of Pound that takes seriously the larger discourse within which his music criticism emerges, written around the same time he was conceptualizing *The Cantos*, would diverge radically from accounts

that rely on his later imbrications between Mussolini's fascist politics and literary merit. Willa Cather is another figure whose various novels imply a theory of the art object—often disguised as gender-bending performance—that attempts to negotiate between the relationship of the artist to the meaning of the work and the role of the spectator to that meaning. When she writes that "A light seemed to break upon [Thea] from far away—or perhaps from far within," we might wonder where the "light" illuminating *Song of the Lark*'s Thea in her moment of creative power comes from.[51] Throughout the novel, Cather mediates between inner power (aligned with femininity, the domestic arts, and meaning's autonomy) and outer power (aligned with masculinity, imperialism, and meaning's incorporation). Finally, we might consider Wallace Stevens's struggles in *Owl's Clover* to define the art object in the unstable world of fascist imperialism and consumerism, and examine his later attempts to bolster the role of the American poet in this new world order in *Parts of a World*. In both cases, Stevens seeks a new role for reading or beholding in the changing economic order. He reconciles his theory of art and reading with his politics via a series of varied poetic strategies that reflect America's expanding role in global capitalism, aiming to reposition the poet within the world's complex networks.

The case of Stevens brings up a final way we might reframe this book as focusing on a series of formal responses to a generalized fear that autonomy, more broadly conceived, was under threat in modernity. American modernity in particular was rife with increasing anxiety over the role of the state, and institutions generally, in standardizing and thus constraining local and regional control over political affairs. The increasingly integrated economy of the 1920s gave Americans "every reason to be distraught about lost autonomy," Lynn Dumenil suggests.[52] Though the New Deal was a popular success, the huge increase in the federal government in the 1930s scarcely mitigated anxiety about threatened independence. From this perspective, Stein's explicit linkage between meaning's autonomy and political autonomy—conceived in her poems as the freedom of individuals to breathe—indicates an anti-Progressive libertarianism within American modernism. Williams's understanding of the relationship between Progressivism, the power of the state, and the literary object is more conflicted but not entirely unrelated to Stein's view, because *The Great American Novel* tries both to incorporate the terms and goals of social reform legislation supporting mothers and infants while simultaneously implying that poetry (and not the U.S. Congress) is the proper place to actualize these reforms. Though Gaddis and Bishop are hardly preoccupied with the question of political autonomy, the issue of self-determination arises for them at moments, as when their art vies with kitsch's inclusivity, or in the predicament Gaddis depicts of an artist whose formal theories are promoted by Nazis.

With writers such as Olson, Baraka, Spahr, and Silko, the trend is toward a form of authorship that claims administrative control over both the text and the world to organize and structure that world in all its parts. In a sense, autonomy has remained critical, but increasingly bureaucratic and social. As literature gives itself over to incorporating things, the work of measuring and organizing an art object's air, maps, breath, or New Mexican ash takes on a greater role. Shaping or situating an experience replaces representing an experience. At the heart of these recent contemporary critiques of liberalism and universalism is a theory of meaning and a related aesthetics that emerges out of a debate about the modernist conception of the art object. We could put this point more strongly to say that modernist aesthetic autonomy was always a political event that attempted to defend fundamental forms of liberal relations. Critiques of liberalism and its cultures almost invariably rehearse a theory of meaning and particularity that Olson and Baraka had mapped out by the 1960s. Modernism's formal terms engaged with liberalism from the very start, and current cultural critiques of liberalism replay arguments from decades past without acknowledging this history and its underlying aesthetic framework.

Modernism's Other Work, then, enables us to see within modernism the roots of debates continuing today. It also alters our understanding of twentieth- and twenty-first-century literature as pivoting on the axis of 1945. Instead of eliminating the historical distinctions in this work by predating postmodernism as modernism, or finding in modernism its repressed alterities, we can see within modernism distinctions suppressed and ignored by literary criticism and theory. These distinctions speak to, predict, and offer warnings on debates continuing now. Olson's and Baraka's hope for a politics of preserved particularisms is only incrementally distinct from Lowe's, Haraway's, and Robbins's theorizing, whereas Bishop's ruminations on the relationship between aesthetic autonomy, commodity value, and cultural pluralism, and Williams's attempts to connect formal progress in poetry to extragovernmental sources of Progressive reforms speak to current theoretical attempts by Badiou, Butler, and others to contextualize and resituate universality within a changing framework of politics, nation, and globalization.

That shifting framework was anticipated long ago, and we might conclude by returning to one of the objects examined in the introduction to juxtapose the aims of this book to that of the curators of the Pompidou Center's "Airs de Paris" show (2007). The curators based their exhibition on Duchamp's *50cc of Parisian Air*, suggesting that "Duchamp's work contains within it the idea of international citizenship—citizen-of-the-world—shifting borders, and an interweave of different geographical context. Almost 50 years ahead of the pack, it foreshadowed the emergence of a 'transnational social space'."[53] Duchamp's nearly 100-year-old work, they propose, captures air's political affinities by "anticipat[ing] the shift towards internationalization" and globalization.

Whether or not they are correct about Duchamp's prediction of postnationalist theories—although it certainly seems plausible from an artist who arguably anticipated nearly every post-1960s art movement—their analysis also reflects the spirit of my book. Understanding the political valence of the world's particulars was always part of the discourse of modernism as it struggled to conceptualize and perform the relation between the object of art and the subject of the beholder. By reclaiming that political connection—and repositioning works such as Duchamp's in the process—we sweep away the stale modernist air that seemed to linger and, I argue, never really was.

NOTES

INTRODUCTION

1. Wallace Stevens, *Opus Posthumous: Poems, Plays, Prose.* rev., enl., and corr. ed. (New York: Knopf, 1989), 307.
2. Ibid.
3. Wallace Stevens, *The Collected Poems* (New York: Knopf, 1954), 76.
4. Writers, of course, do not reliably maintain and act on their own political commitments outside the space of their texts. The problem of consistent political action (as opposed to the representation of political belief) is largely outside the scope of this book.
5. Although the later date is somewhat arbitrary, it indicates a generational transformation because many modernist poets died (and were canonized as "Modernist") toward the end of this period.
6. Stevens, "Adagia," in *Opus Posthumous,* 187.
7. The writers I discuss would refuse precisely the kinds of historical and contextual delineations of visual cultures made familiar by Rosalind Krauss and Jonathan Crary, as well as much recent work in film studies. Examining visual cultures by focusing on the particular role of distraction and technology in viewing experiences, contemporary art, literature, and film critics have established that a range of material practices and habits changed the ways spectators saw the world in the nineteenth and twentieth centuries. From these critics' perspectives, Williams's and Stevens's willful blindness to the varieties of spectatorship might look like inattentiveness, a negligent denial of the increasingly complex visual world's nuances. See Rosalind Krauss, *The Optical Unconscious* (Cambridge, Mass.: MIT Press, 1993); Jonathan Crary, *Suspensions of Perception: Attention, Spectacle, and Modern Culture* (Cambridge, Mass.: MIT Press, 1999); Karen Jacobs, *The Eye's Mind: Literary Modernism and Visual Culture* (Ithaca, N.Y.: Cornell University Press, 2001); and Sara Danius, *The Sense of Modernism: Technology, Perception, and Aesthetics* (Ithaca, N.Y.: Cornell University Press, 2002). For examples in film studies, see Susan McCabe, *Cinematic Modernism: Modernist Poetry and Film* (Cambridge: Cambridge University Press, 2005); Francesco Casetti, *Eye of the Century: Film, Experience, Modernity* (New York: Columbia University Press, 2008); and Alison Griffiths, *Shivers Down Your Spine: Cinema, Museums and the Immersive View* (New York: Columbia University Press, 2008).
8. Elizabeth Bergmann Loizeaux, *Twentieth-Century Poetry and the Visual Arts* (Cambridge: Cambridge University Press, 2008), 5–6.
9. Gertrude Stein, "Answers to the *Partisan Review*," in *How Writing Is Written: Volume II of the Previously Uncollected Writings of Gertrude Stein,* ed. Robert Bartlett Haas (Los Angeles: Black Sparrow Press, 1974), 55.

10. Peter Bürger, *Theory of the Avant-Garde*, trans. Michael Shaw (Minneapolis: University of Minnesota Press, 1984), 35.

11. Arthur Danto, *After the End of Art: Contemporary Art and the Pale of History* (Princeton, N.J.: Princeton University Press, 1997), 15.

12. Stevens, *Opus Posthumous*, 103. For an extended discussion, see Lisa Siraganian, "Wallace Stevens's Fascist Dilemmas and Free Market Resolutions," *American Literary History* 23, no. 2 (2011), 337–61.

13. Perhaps for similar reasons, *50cc* was one of the readymades Duchamp selected for miniaturization and reproduction in his *Boite-en-Valise* (1935–41), a set of hand-painted reproductions of his best works collected in a small suitcase and often displayed in this arrangement.

14. The term *particularity* has a long critical history both preceding and within modernism, weaving in and out of the general discourses surrounding theories of the art object. Modern writers and artists discussed in my book rarely appropriated the word entirely accurately in the philosophical sense, if they used it at all. Indeed, when they referred to "particulars," it was in the loosest and most associative way. Thus, there seems little point in arguing that Williams's response to Duchamp, say, was also a direct response to a nineteenth-century philosophical-aesthetic debate. I use the word *particular* throughout the book in the more associative context used by Williams, Olson, and Baraka, but it is worth bringing up here because it might have echoed with the complex significations of collage and effected poets' understanding of the relations between art objects and readers or spectators.

15. This work "acquired legendary status," writes Christine Poggi, as the first major work of art to appropriate untransformed material from everyday life and force them into painting's hallowed domain: *In Defiance of Painting: Cubism, Futurism, and the Invention of Collage* (New Haven, Conn.: Yale University Press, 1992), 1.

16. The latter view is my paraphrase of Poggi, *In Defiance*, 257. Henri-David Kahnweiler and Clement Greenberg portray collage's formal coherence, whereas Poggi, Rosalind Krauss, and Peter Bürger present collage as critiquing that coherence. In Greenberg's account, collage is the sign of modernity's biggest challenge and hence, grandest triumph; Clement Greenberg, "Collage," in *Art and Culture* (Boston: Beacon Press, 1961), 71. Collage would seem to subject the news of the day to the coherence of the work of art, now triumphing over life. However, Greenberg ignores the particularly of the collage elements: all collage becomes an instance of flatness, which the successful modernist art object overcomes.

17. As Krauss observes, the rope operates as a thing in itself, a vertically oriented picture frame surrounding the canvas, but it also represents a circular tablecloth edge oriented horizontally (a circle perspectively compressed as an oval). Krauss, *The Originality of the Avant-Garde and Other Modernist Myths* (Cambridge, Mass.: MIT Press, 1985), 38–39. See also Thomas Crow's analysis of collage as a postmodern critique of "bourgeois formalism" in *Modern Art in the Common Culture: Essays* (New Haven, Conn.: Yale University Press, 1996), 28.

18. Poggi, *In Defiance*, 66.

19. Ibid., 73.

20. As an "extraordinary example of this proto-history" of postmodernism, collage could be favorably compared to the self-conscious pastiche and bricolage of contemporary postmodern artists such as Jasper Johns, Robert Rauschenberg, and Barbara Kruger (Krauss, *Originality of the Avant-Garde*, 38–39). For Yve-Alain

Bois, *Still Life with Chair-Caning* is "a transitional work" for a slightly different, albeit related, reason: the painting presents "the very possibility of the transformation of painting into writing" because the vertical space of seeing—rope as frame—alternates with the horizontal reading space—rope as tablecloth on tabletop (Yve-Alain Bois, "The Semiology of Cubism," in *Picasso and Braque: A Symposium*, ed. Lynn Zelevansky [New York: Abrams, 1992], 186–87). Collage-as-writing exemplifies "Cubist semiology," his term for Picasso's (supposed) early poststructuralism (187). Anticipating Derrida's theorizing of the sign, Picasso's collage thus illustrates the sign's arbitrary status, suggesting that interpretation is only provisionally stable.

21. The avant-garde history of modernist painting seemed to relate directly to the modernist *writers* also increasingly understood as proto-poststructuralists. Interdisciplinary work by Bram Dijkstra, Dickran Tashjian, Marjorie Perloff, Randa Dubnick, and others explored the relation between Cubist and post-Cubist art and the writings of Lewis, Stein, Ezra Pound, George Oppen, Jean Toomer, and Louis Zukofsky (among others). In gaining prominence throughout the 1980s and 1990s, these critics promoted a view of the interplay of Cubism and modernism that employed poststructuralist interpretations of Cubist collage. Wendy Steiner, who considers Stein's failures to translate painting into literature, presents an important early exception to this trend; Wendy Steiner, *Exact Resemblance to Exact Resemblance: The Literary Portraiture of Gertrude Stein* (New Haven, Conn.: Yale University Press, 1978), 160. In order of their publication dates, relevant critical works include Fredric Jameson, *Fables of Aggression: Wyndham Lewis, the Modernist as Fascist* (Berkeley: University of California Press, 1979); Jessica Prinz Pecorino, "Resurgent Icons: Pound's First Pisan Canto and the Visual Arts," *Journal of Modern Literature* 9, no. 2 (May 1982), 159–74; Marjorie Perloff, "The Invention of Collage," *New York Literary Forum* 10–11 (1983), 5–47; Ann Marie Bush and Louis D. Mitchell, "Jean Toomer: A Cubist Poet," *Black American Literature Forum* 17, no. 3 (fall 1983), 106–8; Randa Dubnick, *The Structure of Obscurity: Gertrude Stein, Language, and Cubism* (Urbana: University of Illinois Press, 1984); Philip Cohen, "The Waste Land, 1921: Some Developments of the Manuscript's Verse," *Journal of the Midwest Modern Language Association* 19, no. 1 (spring 1986), 12–20. There are also a few early exceptions that are not explicitly poststructuralist: Bram Dijkstra, *Cubism, Stieglitz, and the Early Poetry of William Carlos Williams* (Princeton, N.J.: Princeton University Press, 1969); Hugh Kenner, *The Pound Era* (Berkeley: University of California Press, 1971); and Dickran Tashjian, *Skyscraper Primitives: Dada and the American Avant-Garde, 1910–25* (Middletown, Conn.: Wesleyan University Press, 1975).

22. Theorizations of postmodernism are varied, but I focus on Perloff's account because it has dominated the field of Cubist/modernist criticism. Perloff argues that Eliot and Pound understood collage in the classic postmodern terms of "refusal of unity and coherence" (Perloff, "Collage and Poetry," in *The Encyclopedia of Aesthetics*, vol. 1, ed. Michael Kelly [Oxford: Oxford University Press, 1998], 384–87).

23. These discussions are sometimes explicit, as with Stein's collage poetics and Williams's response to Duchamp, and at other times more broadly conceived, as when Lewis satirizes people breathing the air of paintings (as they might after the art/life dichotomy had collapsed). When our discussion turns to Olson and Baraka, the discourse of collage is no longer dominant, as debates about beholding and

reading enter their mature late phrase, blending into later aesthetic discourses (although Olson's and Baraka's imagining of verse as an aesthetic technology of incorporation could be seen as a natural outgrowth of the discourse of collage).

24. Jacques Derrida's *Truth in Painting*, trans. Geoff Bennington and Ian McLeod (Chicago: University of Chicago Press, 1987), suggests, both graphically and rhetorically, that the material world exceeds the conceptual frames we try to impose on it. He brilliantly performs what he sees as the inescapability and multiplicity of literal frames, whether as punctuation marks or beveled edges within his text, revealing how difficult it can be to say for sure whether we are reading what is inside a frame (content) or outside of it (context). In this way, every system is opened up to its outside, dividing "the unity of the line [trait] which purports to mark its edges" (7). In his account, content and context become essentially indistinguishable. But as we will see in the next chapter, Stein's point is quite different: she aims not to erase the distinction between context and content but to show the uselessness of the literal frame as a reliable determinant of that distinction.

25. Artists such as Robert Smithson, Robert Morris, Joseph Kosuth, Kiki Smith, and later, art historians such as Krauss, Hal Foster, and Stephen Melville, discuss the legacy of modernist painting versus Minimalism, conceptual art, Earthworks, and later related movements.

26. Such art includes the illusions created by op-art painter Bridget Riley, shocking performance pieces by Vito Acconci, the temporary "Gates" erected in New York's Central Park by Christo and Jeanne-Claude, or the sculptural sky apertures of James Turrell, among many others.

27. Quoted in Doug Aitken, *Broken Screen: 26 Conversations with Doug Aitken; Expanding the Image, Breaking the Narrative*, ed. Noel Daniel (New York: Dia Arts Press, 2006), 114.

28. Brenda Hillman, "A Nextopia," in *Pieces of Air in the Epic* (Middletown, Conn.: Wesleyan University Press, 2005), 70.

29. See Caroline A. Jones's discussion of Clement Greenberg's privileging of opticality over the other senses such that "modernism's *habitus* was imagined as having no smell at all—the clean white cube was its apotheosis"; Caroline A. Jones, "The Mediated Sensorium," in *Sensorium: Embodied Experience, Technology, and Contemporary Art*, ed. Caroline A. Jones (Cambridge, Mass.: MIT Press, 2006), 13–14.

30. One might argue that the beholder's role had an important early formation in Dada in particular, with its attempt to "reintegrate art into the life process" and thus transform the nature of artistic reception from an individual's quiet meditation into the collective's shock (Bürger, *Theory of the Avant-Garde*, 50, 53). That avant-garde moment played a critical role in the history I describe, particularly in the case of William Carlos Williams's response to Marcel Duchamp. But I would argue that the avant-garde's theorizing of spectatorship was more diffuse and political than that of the modernists I am depicting here. Similarly, recent work such as Eliasson's, which does not seek the avant-garde's aim of undermining the institution of art, is much closer to the trajectory of meaning's autonomy to meaning's incorporation described throughout the book.

31. In a series of major books, Fried's own art historical career has brilliantly mapped out the history of the French antitheatrical tradition and the relationship between painting and beholder, from art critic Denis Diderot, to painters Jean-Baptiste Greuze, Gustav Courbet, and Édouard Manet. But Fried also insists that

we not read this art historical work as an unbroken line with his art critical work of the 1960s, explaining that there is not "an actual continuity" between these different texts and arguments (*Art and Objecthood: Essays and Reviews* [Chicago: University of Chicago Press, 1998], 52). In part, I am responding to Fried's call to fill in this gap between Manet and the impact of Impressionism at the end of the nineteenth century, and the mid-century modernism of the twentieth. As he puts it, "A great deal more remains to be discovered about the vicissitudes of the relationship between painting and beholder from Manet to [Frank] Stella. But that is a task for other occasions and in part of other writers" (*AO* 53).

32. Critics such as Gerald Graff, John Guillory, Fredric Jameson, and Michael North established the political and economic ideologies and histories of modernism and the New Critics so that other stories of modernism—more attuned to and critical of its internal discrepancies and nationalistic foci—could be written. See John Guillory's rereading of Brooks's "The Language of Paradox" in *Cultural Capital: The Problem of Literary Canon Formation* (Chicago: University of Chicago Press, 1993), 155–66; Fredric Jameson, *Fables of Aggression*, and *Postmodernism, or, The Cultural Logic of Late Capitalism* (Durham, N.C.: Duke University Press, 1991); Gerald Graff, *Professing Literature: An Institutional History*, 20th anniversary ed. (Chicago: University of Chicago Press, 2007); and Michael North, *The Political Aesthetic of Yeats, Eliot, and Pound* (Cambridge: Cambridge University Press, 1991).

33. The term is Andreas Huyssen's in *After the Great Divide: Modernism, Mass Culture, Postmodernism* (Bloomington: Indiana University Press, 1986), whereas examples of this work include David Chinitz, *T.S. Eliot and the Cultural Divide* (Chicago: University of Chicago Press, 2003); McCabe, *Cinematic Modernism*; and Sean McCann, *Gumshoe America: Hard-Boiled Crime Fiction and the Rise and Fall of New Deal Liberalism* (Durham, N.C.: Duke University Press, 2000). Denunciations of aesthetic autonomy are now customary and take varied forms. Cary Nelson's *Repression and Recovery: Modern American Poetry and the Politics of Cultural Memory, 1910–1945* (Madison: University of Wisconsin Press, 1989), Walter Kaladjian's *American Culture between the Wars: Revisionary Modernism and Postmodern Critique* (New York: Columbia University Press, 1993), Alan Filreis's *Counter-Revolution of the Word: The Conservative Attack on Modern Poetry, 1945–1960* (Chapel Hill: University of North Carolina Press, 2008), and John Lowney's *History, Memory, and the Literary Left: Modern American Poetry, 1935–1968* (Iowa City: University of Iowa Press, 2006) explore how modern poetics engages the social and political world both subtly and overtly—and how the cold war critical establishment obscured this fact. Critiques emerging out of the new modernist studies have established that few, if any, modernists ever believed that poetry is entirely hermetically sealed from the world. Most unreceptive to modernist aesthetic autonomy are postmodernist accounts, such as Marjorie Perloff's *21st-Century Modernism: The "New" Poetics* (Oxford: Blackwell, 2002), which dispute the newness of postmodernism and the oldness of modernism by aligning odd couples (T. S. Eliot/Charles Bernstein) to question whether any modernist really believed in the art object's autonomy. My work is obviously indebted to the new modernist studies' historical methodology and recovery, wide-ranging interdisciplinarity, and sociopolitical insights, qualities that have rejuvenated the field now known as modernist studies. But the basic purpose of this project is to expose the limitations of these claims to challenge conventional accounts of modernist autonomy. The problem is not that critics hold back the full force of their critiques, but that

working definitions of modernist autonomy fail to account for the dynamics discussed here, leaving the actual workings of poetic independence in modernist texts more vilified than vanquished.

34. Perhaps this is because aesthetic autonomy is "a bad word," as Hal Foster puts it in "The ABCs of Contemporary Design," *October* 101 (2002), 191. From this perspective, it becomes a modernist fallacy that must be overturned by the clear-sighted critic, postmodern art, or both.

35. As Ástrádur Eysteinsson points out, critics long used the term "modernist criticism" to describe New Criticism (*The Concept of Modernism* [Ithaca: Cornell University Press, 1990], 11). But by presenting aesthetic autonomy as a marginal aspect of modernism erroneously foregrounded by New Criticism, he grants the New Critics their definition even while denying aesthetic autonomy's primary role. Fredric Jameson also makes a calculated conflation between modernism and New Criticism when he categorizes together "all the ideologues of the modern, from Leavis and the American New Criticism all the way to Adorno and the Frankfurt School" to highlight the stark contrast with postmodernism (Jameson, *Postmodernism*, 2).

36. T. S. Eliot, "Preface to the 1928 Edition," in *The Sacred Wood: Essays on Poetry and Criticism* (London: Methuen, 1928), ix.

37. Eliot, *Sacred Wood*, x. For an extended discussion, see Peter Howarth, "Eliot in the Underworld: The Politics of Fragmentary Form," *Textual Practice* 20, no. 3 (2006), 441–42.

38. William K. Wimsatt Jr. and Cleanth Brooks, *Literary Criticism: A Short History* (New York: Knopf, 1957), 476. They make a cosmopolitan or at least a transnational claim for the spread of the "art-for-art's-sake" movement by quickly foregrounding Edgar Allan Poe's notion of aesthetic autonomy via "Philosophy of Composition" and "The Poetic Principle" (478–80).

39. Eliot, "Religion and Literature," in *Selected Prose of T.S. Eliot*, ed. Frank Kermode (New York: Farrar, Straus and Giroux, 1965), 100.

40. Though my book explores this seemingly "unknowable" space, there have been challenges to the conventional accounts of Eliot and New Criticism that my argument supports and expands, including the claim that *The Sacred Wood* is more concerned about the respective roles of minor and major poetry (Guillory, *Cultural Capital*, 141–55); that Eliot was far more engaged with American mass culture than has been understood (Chinitz, *Eliot and the Cultural Divide*, 4–10); that the New Critics' rejection of the political and ethical interpretations of literature was not always a defining feature of the movement (Graff, *Professing Literature*, 145–61); and that Eliot's criticism was more politicized than was previously understood (Michael North, "Eliot, Lukács, and the Politics of Moderns," in *T. S. Eliot: the Modernist in History*, ed. Ronald Bush [Cambridge: Cambridge University Press, 1991], 175).

41. Theodor Adorno, "On Lyric Poetry and Society," in *Notes to Literature*, vol. 1, ed. Rolf Tiedemann, trans. Shierry Weber Nicholsen (New York: Columbia University Press), 39–40.

42. Ibid., 43.

43. Robert Kauffman, "Adorno's Social Lyric, and Literary Criticism Today: Poetics, Aesthetics, Modernity," in *The Cambridge Companion to Adorno*, ed. Tom Huhn (Cambridge: Cambridge University Press, 2004), 357.

44. Adorno recognizes the problems and attempts to contain it in his essay, when he predicts that his critics will immediately complain that "it is precisely what is not

social in the lyric poem that is now to become its social aspect" (Adorno, "Lyric Poetry," 42).

45. I am indebted to critiques of Adorno in Frances Ferguson, *Solitude and the Sublime: Romanticism and the Aesthetics of Individuation* (New York: Routledge, 1992), 63–69; and Jacques Rancière, *Aesthetics and Its Discontents*, trans. Steven Corcoran (Cambridge: Polity, 2009), 40–41.

46. Adorno, "Lyric Poetry," 43.

47. Many Anglo-American moderns are unbothered by the bourgeois/realism split that Pierre Bourdieu sees as critical to the development of the art-for-art's-sake movement in nineteenth-century France. Although my book does not primarily concern itself with modernism's field in a socioeconomic sense, this designation might help explain or contextualize the unusual theoretical positions that writers such as Stein and Williams take with regard to aesthetic autonomy, especially when compared with the apolitical account Bourdieu describes. In *The Rules of Art*, he suggests that the art-for-art's-sake movement was understood as "a double refusal" against bourgeois art on the one hand and realist/social art on the other (Pierre Bourdieu, *The Rules of Art: Genesis and Structure of the Literary Field*, trans. Susan Emanuel [Stanford, Calif.: Stanford University Press, 1995], 71). Forced to create a place or field for this new position, these artists and writers invented "that unprecedented social personage who is the modern writer or artist, a full-time professional, dedicated to one's work in a total and exclusive manner, indifferent to the exigencies of politics and to the injunctions of morality, and not recognizing any jurisdiction other than the norms specific to one's art" (76–77). Their structural exclusion from the literary and artistic field as they find it mirrors their aesthetic's *deliberate* exclusion from the political world. If we grant Bourdieu's point but focus on a later and different field—that of American writers from the 1920s through the 1960s—we see a very different position and aesthetic emerge, no doubt reflecting the very different make-up of the literary and artistic field in this country and in a later period. Of course, representations of both bourgeois art and realist art exist in American literature, but these categorical poles did not have the same force as in France to exclude all other aesthetic categories. Writers such as Robert Frost, Marianne Moore, Bishop, and Williams tried to appeal to a middle-class audience by attempting to place their work in popular magazines and seeking affordable publishing avenues (as did Stein with her popular autobiographies). Moore threw out pitches for the Yankees, Williams loved seeing his work in affordable pamphlets, and Bishop delightedly published in the *New Yorker*. Simultaneously, they attempted to appeal to aficionados of a high art, autonomous aesthetic, even while making "contact" with the real world (as Williams put it). In other words, for various reasons, the bourgeois/realism schism was not as potent a division in American poetry. This literary field was far more variable and pluralistic, and thus the art-for-art's-sake "double refusal" that Bourdieu describes in France was, for American modernists, not a strident opposition to the world and the literary field as they found it. Meaning's autonomy was a crucial concept for these writers that also modeled a political relation they had no desire to relinquish.

48. See Charles Taylor, *Multiculturalism and "The Politics of Recognition": An Essay* (Princeton, N.J.: Princeton University Press, 1992); Michael Sandel, *Liberalism and the Limits of Justice*, 2nd ed. (Cambridge: Cambridge University Press, 1998); Judith Butler, "Competing Universalities," in *Contingency, Hegemony,*

Universality, ed. Judith Butler, Ernesto Laclau, and Slavoj Žižek (London: Verso, 2000), 11–43.

49. William Carlos Williams, "(Revolutions Revalued:) The Attack on Credit Monopoly from a Cultural Viewpoint," in *A Recognizable Image: William Carlos Williams on Art and Artists*, ed. Bram Dijkstra (New York: New Directions, 1978), 108.

50. Ibid., 109.

51. Marianne Moore, "Poetry," in *The Poems of Marianne Moore*, ed. Grace Schulman (New York: Penguin, 2003), 135.

52. Problems emerge throughout the essay, as when he describes art as "disruptive seeds," implying that the seeds' independence from the world is merely temporary; Williams, "(Revolutions Revalued:)," 105.

53. Ibid., 106.

54. Adorno, "Lyric Poetry," 39–40.

55. Bürger, *Avant-Garde*, 89–90. For Bürger, aesthetic autonomy is "a category of bourgeois society" that conceals its historical development and forces of cultural production (46). For a related critique, see Terry Eagleton, *The Ideology of the Aesthetic* (Oxford: Basil Blackwell, 1990).

56. Bürger, *Avant-Garde*, 50.

57. See Valentine Cunningham, *Reading after Theory* (Oxford: Blackwell, 2002), 80, and Eysteinsson, *Concept*, 47–49.

58. Key recent studies by Charles Altieri, Jennifer Ashton, Bill Brown, Robert Chodat, Jonathan Loesberg, Walter Benn Michaels, and Jacques Rancière revisit the status of objects or art in twentieth-century writing, a concern my book shares. Their work overlaps with my interests by refocusing interest on the overlooked issue of aesthetic autonomy for modernism. Charles Altieri, "Why Modernist Claims for Autonomy Matter," *Journal of Modern Literature* 32, no. 3 (spring 2009), 1-21; Jennifer Ashton, *From Modernism to Postmodernism: American Poetry and Theory in the Twentieth Century* (Cambridge: Cambridge University Press, 2005); Bill Brown, *A Sense of Things: The Object Matter of American Literature* (Chicago: University of Chicago Press, 2003); Robert Chodat, *Worldly Acts and Sentient Things: The Persistence of Agency from Stein to DeLillo* (Ithaca, N.Y.: Cornell University Press, 2008); Jonathan Loesberg, *A Return to Aesthetics: Autonomy, Indifference, and Postmodernism* (Stanford, Calif.: Stanford University Press, 2005); Walter Benn Michaels, *The Shape of the Signifier: 1967 to the End of History* (Princeton, N.J.: Princeton University Press, 2004); and Jacques Rancière, *The Politics of Aesthetics*, trans. Gabriel Rockhill (London: Continuum, 2004) and *Dissensus: On Politics and Aesthetics*, ed. and trans. Steven Corcoran (London: Continuum, 2010).

59. I owe much to Michaels's precise argument that the modernist preoccupations with the relation between the work of art and the beholder "are themselves produced in relation to the accompanying invention of racial identity and then of its transformation both into the pluralized form of cultural identity and into the privileging of the subject position as such" (Michaels, *Shape of the Signifier*, 12). However, I am arguing slightly differently that these aesthetic concerns *themselves* were understood to produce a politics and thus a political history, one inclusive of but extending beyond race and pluralism.

CHAPTER 1

1. Ulla E. Dydo and William Rice, *Gertrude Stein: The Language That Rises, 1923–1934* (Evanston, Ill.: Northwestern University Press, 2003), 17.

2. Gertrude Stein, *The Making of Americans: Being a History of a Family's Progress* (1925; Normal, Ill.: Dalkey Archive Press, 1995), 289.

3. Catherine Paul discusses Stein's *Tender Buttons* with precisely this opposition in mind: "By presenting representations of these objects masquerading as the objects themselves, Stein examines the relationship between a thing and its representation." Catherine Paul, *Poetry in the Museums of Modernism: Yeats, Pound, Moore, Stein* (Ann Arbor: University of Michigan Press, 2002), 223.

4. My reading here stands in contrast to Paul's discussion of the same sleeping/waking passage that, she argues, "express[es] [Stein's] preference for occupying the same spaces as pictures" (ibid., 205). Stein's point with the sleeping/waking game is that paintings can never occupy the same space as the beholder.

5. See Helga Lénart-Cheng, "Autobiography as Advertisement: Why Do Gertrude Stein's Sentences Get under Our Skin?" *New Literary History* 34 (Winter 2003), 119–31.

6. Michael Hoffman, *Development of Abstractionism in the Writings of Gertrude Stein* (Philadelphia: Pennsylvania University Press, 1965), 162; Marjorie Perloff, *Poetics of Indeterminacy: Rimbaud to Cage* (Princeton, N.J.: Princeton University Press, 1981), 76–77.

7. For a brilliant, comprehensive critique of the poetics of indeterminacy more broadly framed, see Jennifer Ashton, *From Modernism to Postmodernism: American Poetry and Theory in the Twentieth Century* (Cambridge: Cambridge University Press, 2005).

8. Perloff, *Indeterminacy*, 76.

9. Jayne L. Walker, *The Making of a Modernist: Gertrude Stein from "Three Lives" to "Tender Buttons"* (Amherst: University of Massachusetts Press, 1984), 148. In Charles Altieri's account, the "freedom of linguistic play" in the poem enables the expression of basic, nearly infantile desires, without transforming her poetry into prelinguistic indeterminacy. *Painterly Abstraction in Modernist American Poetry: The Contemporaneity of Modernism* (Cambridge: Cambridge University Press, 1989), 248.

10. Melanie Taylor, "A Poetics of Difference: The Making of Americans and Unreadable Subjects," *National Women's Studies Association Journal* 15, no. 3 (2003), 26–42; Juliana Spahr, *Everybody's Autonomy: Connective Reading and Collective Identity* (Tuscaloosa: University of Alabama Press, 2001), 45.

11. Spahr, *Autonomy*, 44.

12. For a different reading of the same passage, see Marjorie Perloff, who focuses on the implied question in the next sentence, "is it disappointing" (which is answered negatively), to claim that Stein produces a "deconstruction of *boxness*" (*21st-Century Modernism: The "New" Poetics* [Oxford: Blackwell, 2002], 78–79). However, just as plausibly, Stein focuses instead on the way a category or set might not obviously resemble the items it contains: "So then the order is that a white way of being round is something suggesting a pin and is it disappointing, it is not" (*GS1* 314).

13. Contemporary poet W. S Merwin promotes a similar view. In an interview, he explains that he gave up punctuating his poetry to see "if I could use the movement of the verse itself and the movement of the line . . . to do the punctuation. . . . A poem then had a sense of integrity and liberation that it did not have before." "Fact has Two Faces": interview, in *W. S. Merwin, Regions of Memory:*

Uncollected Prose, 1949–82, ed. Ed Folsom and Cary Nelson (Urbana: University of Illinois Press, 1987), 357.

14. Gertrude Stein, "Answers to the *Partisan Review*," in *How Writing Is Written: Volume II of the Previously Uncollected Writings of Gertrude Stein*, ed. Robert Bartlett Haas (Los Angeles: Black Sparrow Press, 1974), 55.

15. At first glance, it seems easier to justify the reader's "business" of absorption than the writer's absorption in her own words. Stein, though interested in both, is more committed to the writer's. In another essay, "What Is English Literature," she characterizes this pleasure in concentrating not in terms of the reader's engrossment but in terms of the writer's "choice between serving god and mammon . . . [which] has nothing to do with religion, it has nothing to with success. It has to do with completion" (*GS2* 202). The New Testament reference ("No one can serve two masters . . . You cannot serve God and wealth," Matthew 6:24) suggests that if a writer uses words "indirectly," then he or she is serving material success and, by extension, the reader. Thus, in choosing to write to a particular audience, the writer chooses particularity and materialism ("mammon") over God, losing her "direct" relationship to words.

16. Stein's relationship to success was complicated and has been discussed by numerous critics; see, especially, Kirk Curnutt, "Inside and Outside: Gertrude Stein on Identity, Celebrity, and Authenticity," *Journal of Modern Literature* 23, no. 2 (1999–2000), 291–308, and Lénart-Cheng, "Autobiography as Advertisement." In *The Autobiography of Alice B. Toklas,* Stein reports being hurt by readers' failure to understand her meaning, but later in the same text, she cites this initial confusion and rejection as a validation of her poetic genius and her poetry's semiconscious staying power. Rejection becomes indirect validation: "They always say . . . that my writing is appalling but they always quote it and what is more, they quote it correctly. . . . My sentences do get under their skin, only they do not know that they do" (*GS1* 730).

17. Jeremy Bentham, *The Principles of Morals and Legislation* (Amherst, N.Y.: Prometheus Books, 1988), 3.

18. Wanda Van Dusen and Michael Davidson, "Portrait of a National Fetish: Gertrude Stein's 'Introduction to the Speeches of Maréchal Pétain' (1942)," *Modernism/Modernity* 3, no. 3 (1996), 69–96; Janet Malcolm, "Gertrude Stein's War," *New Yorker* (June 2, 2003), 57–81. For a more nuanced account of Stein's Vichy-era writing, see Barbara Will, "Lost in Translation: Stein's Vichy Collaboration," *Modernism/Modernity* 11, no. 4 (2004), 651–68.

19. Kathryn Kent's fascinating reading of *Tender Buttons*, for example, argues that the poem challenges conventional heterosexism by subversively reframing the domestic sphere to empower a lesbian identity; Kathryn Kent, *Making Girls into Women: American Women's Writing and the Rise of Lesbian Identity* (Durham, N.C.: Duke University Press, 2003), 139–65. Kent argues that *Tender Buttons* should be read as a handbook instructing "the reader in various forms of lesbian textual/sexual gratification," and thus also "rewrites the nineteenth-century stereotype of the sterile spinster" (151, 165). Although Stein's opposition to identitarianism in art creation problematizes the claim for lesbian identification, Kent's account of Stein's interest in individual freedom accords with my claims about breath. More often, interpretations of Stein's political stance attempt a middle ground. In Madelyn Detloff's view, contemporary critical interpreters of Stein struggle because she "does not provide a cohesive politicized identity," whereas Susan Schultz sees Stein paradoxically masking her aims to control her audience;

Madelyn Detloff, *The Persistence of Modernism: Loss and Mourning in the Twentieth Century* (Cambridge: Cambridge University Press, 2009), 15; Susan Schultz, "Gertrude Stein's Self-Advertisement," *Raritan* 12, no. 2 (1992), 71–87. See also Carolyn Burke, "Gertrude Stein, the Cone Sisters, and the Puzzle of Female Friendship," *Critical Inquiry* 8, no. 3 (1982), 543–64; Marianne DeKoven, *A Different Language: Gertrude Stein's Experimental Writing* (Madison: University of Wisconsin Press, 1983); Harriet Scott Chessman, *The Public Is Invited to Dance: Representation, the Body, and Dialogue in Gertrude Stein* (Stanford, Calif.: Stanford University Press, 1989); and Amie Elizabeth Parry, *Interventions into Modernist Cultures: Poetry from beyond the Empty Screen* (Durham, N.C.: Duke University Press, 2007).

20. Gertrude Stein, "A Political Series" in *Painted Lace and Other Pieces 1914–1937, The Yale Edition of the Unpublished Writings of Gertrude Stein*, vol. 5 (New Haven, Conn.: Yale University Press, 1955), 77. See also Stein's "Answer to Eugene Jolas" in response to a question about the future of individualism: "I don't envision collectivism. There is no such animal, it is always individualism, sometimes the rest vote and sometimes they do not, and if they do they do and if they do not they do not"; in *How Writing Is Written*, 53.

21. This view of the reader and reading opposes more common feminist and post-structuralist accounts of Stein's "model of reading as conversation" (Chessman, *Representation*, 150) and Barbara Will's related version of Stein's dialogic engagement between reader and writer in *Gertrude Stein, Modernism, and the Problem of "Genius"* (Edinburgh: Edinburgh University Press, 2000), 87. In Chessman's view, Stein provides the reader a space to question the text, although "our" voice is prompted by Stein's words (Chessman, *Representation*, 142). In the version I present, Stein's egalitarianism does not give us just our voice but our breath and bodies as well.

22. Stein, "A Transatlantic Interview—1946," in *Gertrude Stein: A Primer for the Gradual Understanding of Gertrude Stein*, ed. Robert Bartlett Haas (Los Angeles: Black Sparrow Press, 1971), 16.

23. Ibid., 16–17.

24. Linking commas and suffrage raises doubts for various reasons, not least because suffrage was already old news: women in the United States, England, and France had won the right to vote years earlier (although, of course, for various reasons millions of men and women still could not vote). Imagining that commas impact voting implies a grandiose view of grammar's role in the world. But this perspective becomes more plausible when we consider how certain conventions, like excessive commas, impinge on the deeply private relationship between a person and his or her reading. One need only reread an earlier, ponderously comma-filled text, like *The History of the Decline and Fall of the Roman Empire*, to see Stein's point: "Their aversion, confirmed by years, and fomented by the acts of their interested favourites, broke out in childish, and gradually in more serious, competitions; and, at length divided the theatre, the circus, and the court, into two factions; actuated by the hopes and fears of their respective leaders" (Edward Gibbon, *The History of the Decline and Fall of the Roman Empire*, vol. 1, 2nd ed. [London: W. Strahan and T. Cadell, 1776], 131).

25. For a discussion of her opposition to New Deal policies, see Michael Szalay, *New Deal Modernism: American Literature and the Invention of the Welfare State* (Durham, N.C.: Duke University Press, 2000), 87–93.

26. Stein, *Making of Americans*, 471–72. A similar example appears in *Everybody's Autobiography* (New York: Random House, 1937), 218. Whether via a narrative framework or via a theoretical and grammatical one, Stein consistently employs the example of putting on her own coat (all by herself) to indicate, and perhaps gently self-mock, her American commitment to self-reliance and personal privacy.

27. For the connection to Rand, see Szalay, *New Deal Modernism*, 88. For discussions of the Warren Court's privacy arguments see Robert Wiebe, *Self-Rule: A Cultural History of American Democracy* (Chicago: University of Chicago Press, 1995), 226–27; Michael Kammen, *Sovereignty and Liberty: Constitutional Discourse in American Culture* (Madison: University of Wisconsin Press, 1988), 92–93; William O. Douglas, *The Right of the People* (New York: Doubleday, 1958), 85–94. See also the famous early privacy argument, Samuel Warren and Louis D. Brandeis, "The Right to Privacy [the implicit made explicit]" *Harvard Law Review* 4 (December 1890), reprinted in *Philosophical Dimensions of Privacy: An Anthology*, ed. Ferdinand David Schoeman (Cambridge: Cambridge University Press, 1984), 75–103.

28. Szalay, *New Deal Modernism*, 83–84.

29. "Gertrude Stein," in *The Norton Anthology of American Literature,* 7th ed., vol. D, 1914–1945, ed. Nina Baym et al. (New York: Norton, 2007), 1358.

30. Timothy Galow, "Gertrude Stein's Everybody's Autobiography and the Art of Contradictions," *Journal of Modern Literature* 32, no. 1 (2008), 111–28.

31. Curnutt, "Inside and Outside," 293.

32. Perloff, *Indeterminacy*, 76–77.

33. Ibid., 76; Ellen Berry, *Curved Thought and Textual Wandering: Gertrude Stein's Postmodernism* (Ann Arbor: University of Michigan Press, 1992), 9. See also Barbara Will, who argues that Stein's transformed, feminist notion of "genius" points toward (if not ultimately attains) the postmodern and poststructuralist rewriting of the autonomous artist (Will, *Stein*, 9–10). Relying on Stein's claim that a true genius (such as herself) can listen and talk simultaneously, Will provides an interesting reading (albeit antithetical to my own) to suggest that Stein's texts are "radically open" to readers' interpretations (Will, *Stein*, 84). According to Will, Stein's version of "genius" is a dialogic capacity shared by reader and writer "commensurate with a post-structuralist and feminist agenda" (Will, *Stein*, 87). By splitting up and assigning the listening and talking roles to different people, Will reads against the grain of Stein's *Lectures*, challenging the singularity and uniqueness implied in the category of genius. But Stein is making a simpler, more practical point, trying to defend her writing's odd appearance by explaining its creation: she stays attuned (listening) to someone's active being while writing (talking) about that person.

34. See Nicola Pitchford, "Unlikely Modernism, Unlikely Postmodernism: Stein's *Tender Buttons*," *American Literary History* 11, no. 4 (1999), 642–67; Steven Meyer, *Irresistible Dictation: Gertrude Stein and the Correlations of Writing and Science* (Palo Alto, Calif.: Stanford University Press, 2001); and Ashton, *From Modernism to Postmodernism*.

35. Susan McCabe suggests that Stein's discussion of framing points toward the cinema's embodiment of the continuous present as an art form that more clearly "transcend[s] the limits of the frame" (McCabe, *Cinematic Modernism: Modernist Poetry and Film* [Cambridge: Cambridge University Press, 2005], 56). In contrast, I claim that Stein's engagement with framing obviously implies collage and that she carefully theorizes her own conception of collage and its impact on framing.

36. Robert Rogers, "*Tender Buttons*, Curious Experiment of Gertrude Stein in Literary Anarchy," in *Critical Essays on Gertrude Stein*, ed. Michael Hoffman (Boston: Hall, 1986), 33.

37. Ibid.

38. I am paraphrasing Clement Greenberg's complaint in both "The Pasted-Paper Revolution" (1958) from *Collected Essays and Criticism*, vol. 4 (Chicago: University of Chicago Press, 1993), 61–66, and a later version of that essay, "Collage." Greenberg rejects the notion that synthetic Cubism involves "the need for renewed contact with 'reality' in face of the growing abstractness of Analytical Cubism"; Greenberg, "Collage," in *Art and Culture: Critical Essays* [Boston: Beacon Press, 1961], 70. As he explains, incorporating fake wood-grain wallpaper in a painting is not any more real than painting it.

39. Gris's letter to Kahnweiler, September 17, 1913, quoted in Daniel-Henry Kahnweiler, *Juan Gris: His Life and Work*, rev. ed., trans. Douglass Cooper (New York: Abrams, 1969), n. 2, 86.

40. Greenberg, "Collage," 71.

41. Ibid.

42. Greenberg, "The Pasted-Paper Revolution," 64. Stein, in both the *Autobiography* and the late *Picasso* essay (1938), had a Greenbergian notion of the development of collage: "the reason for putting real objects in the pictures, the real newspaper, the real pipe," writes Stein, was because the Cubists "wanted to see if, by the force of the intensity with which they painted some of these [real] objects, a pipe, a newspaper, in a picture, they could not replace the real by the painted objects which would by their realism require the rest of the picture to oppose itself to them" ("Picasso" [1938], *GS2* 513). The opposition she describes is akin to Greenberg's point: the Cubists were struggling with a basic problem of representation in their attempt to assert the flatness of the picture plane.

43. Greenberg, "The Paste-Paper Revolution," 64–65. For an alternative reading, see Yve-Alain Bois's challenge to Greenberg's interpretation of collage in relation to the *Guitar* construction; *Painting as Model* (Cambridge, Mass.: MIT Press, 1995), 77–79.

44. Anne Baldassari, *Picasso and Photography: The Dark Mirror*, trans. Deke Dusinberre (Houston: Flammarion, 1997), 7.

45. I do not mean to suggest that Stein's notion of the implied frame is equivalent to Jacques Derrida's *parergon*, that which is "neither inside nor outside . . . it disconcerts any opposition but does not remain indeterminate and it *gives rise* to the work" (Derrida, *The Truth in Painting*, trans. Geoff Bennington and Ian McLeod [Chicago: University of Chicago Press, 1987], 9). Derrida's *parergon* is a trait that "lets the frame work," but because it is not part of a binarism (purportedly), it fulfills his project's requisite: "Deconstruction must neither reframe nor dream of the pure and simple absence of the frame" (Derrida, *Truth*, 73). Unlike Derrida's *parergon*, which has materiality, Stein's intrinsic frame lacks a material component. As Frances Ferguson observes, Derrida's discussion of the *parergon* reveals his elision of the distinction between form and matter; *Solitude and the Sublime: Romanticism and the Aesthetics of Individuation* (New York: Routledge, 1992), 78.

46. William Gass, "Gertrude Stein and the Geography of the Sentence," in *The World within the Word* (New York: Knopf, 1978), 92.

47. For an additional discussion of Stein and naming, see Ashton, *From Modernism to Postmodernism*, 67–94.

48. Merrie Bergmann, James Moor, and Jack Nelson, *The Logic Book* (New York: Random House, 1980), 54.

49. John Searle, *Speech Acts: An Essay in The Philosophy of Language* (Cambridge: Cambridge University Press, 1970), 73–74. The use/mention distinction was already well known by the time Stein wrote her *Lectures*. Similar examples can be found in a number of canonical philosophy of language texts, beginning at least with Rudolf Carnap in the 1930s, who emphasizes that in the mention case, it is the "designation of this expression . . . and not the expression itself, [which] occupies the place of the subject in the sentence" (Carnap, *The Logical Syntax of Language* [London: Routledge and Kegan Paul, 1937; reprint 1971], 154). See also Willard V. O. Quine, *Methods of Logic* (New York: Henry Holt, 1950), 91.

50. Searle, *Speech Acts*, 76, 75.

51. Ibid., 75.

52. Will, *Stein*, 82.

53. W. K. Wimsatt Jr. and Monroe Beardsley, *The Verbal Icon: Studies in the Meaning of Poetry* (New York: Noonday Press, 1954), 21. Their account of landscape painting resembles Stein's childhood reaction to painting: "The painting looks like a landscape but we rest in the looks and need not be moved to go outdoors" (273).

54. Walter Benjamin, "The Work of Art in the Age of its Technological Reproducibility [Second Version]," in *Selected Writings, Volume 3, 1935–1939*, trans. Edmund Jephcott et al., ed. Howard Eiland and Michael W. Jennings (Cambridge, Mass.: Belknap Press of Harvard University Press, 1996), 106.

55. As is well known, Adorno recognizes the importance of this point early on, and attempts, *contra* Benjamin, to rescue aesthetic autonomy from *aura*. See Robert Kaufman, "Aura Still," in *Walter Benjamin and Art*, ed. Andrew Benjamin (London: Continuum, 2005), 122.

56. Miriam Bratu Hansen, "Benjamin's Aura," *Critical Inquiry* 34, no. 2 (2008), 336–75.

57. Miriam Bratu Hansen, "Room-for-Play: Benjamin's Gamble with Cinema," *October* 109 (Summer 2004), 4.

58. Benjamin, "Work of Art," 104–5. Benjamin defines aura differently in the subsequent versions of the essay and in the very similar passage in "Little History of Photography." The earliest version is the most expansive and the third version is tighter, but the phrasing is similar in each.

59. Hansen, "Benjamin's Aura," 352–53.

60. Benjamin, "Work of Art," 119.

61. Walter Benjamin, *The Arcades Project*, trans. Howard Eiland and Kevin McLaughlin (Cambridge, Mass.: Belknap Press of Harvard University Press, 1999), 560.

62. Ibid.

63. "Balbec" is in fact Proust's renaming of the Normandy coastal town Cabourg. He presumably is referring to Baalbek, ancient Phoenician ruins in Lebanon, a displacement that contributes to the sense of traveling not just between different places but between altogether different periods and cultures. For helpful discussions of the name swapping, see David Ellison, *Ethics and Aesthetics in European Modernist Literature* (Cambridge: Cambridge University Press, 2001), 143; and Andre Benhaim, "From Baalbek to Baghdad and Beyond: Marcel Proust's Foreign Memories of France," *Journal of European Studies* 35, no. 1 (2005), 87–101.

64. The more familiar version of this distinction in Benjamin's work is the alignment of aura and the "cult value" of a work of art (i.e., its ritualistic, magical, or religious value). Cult value not only marks a ceremonial aspect but differentiates the art work from ordinary life. Thus, according to Benjamin, "Cult value as such even tends to keep the artwork out of sight," out of our ordinary lives (Benjamin,

"Work of Art," 106). Or we might say that the space the cult or auratic object occupies is not the same space we typically occupy.

65. Ibid., 104.
66. Ibid., 103.
67. Ibid., 119.
68. Hansen, "Benjamin's Aura," 351.
69. Walter Benjamin, "Little History of Photography," *Selected Writings, Volume 2, 1927–1934*, trans. Rodney Livingstone et al., ed. Michael Jennings, Howard Eiland, and Gary Smith (Cambridge, Mass.: Belknap Press of Harvard University Press, 1999), 517.
70. Adorno, letter to Benjamin, March 18, 1936, in Theodor W. Adorno, *The Complete Correspondence, 1928–1940*, ed. Henri Lonitz, trans. Nicholas Walker (Cambridge, Mass.: Harvard University Press, 1999), 127–34.
71. Theodor Adorno, *Aesthetic Theory: Newly Translated*. Ed. and trans. Robert Hullot-Kentor (Minneapolis: University of Minnesota Press, 1997), 177.
72. Ibid.
73. More damningly, Stein herself, at least at times, dismisses the political involvement of authors. "Writers only think they are interested in politics," she claims in a response to a *Partisan Review* questionnaire in the 1930s: "they are not really" (Stein, "Answers to the *Partisan Review*" in *How Writing Is Written*, 55).
74. See Alissa Karl, "Modernism's Risky Business: Gertrude Stein, Sylvia Beach, and American Consumer Capitalism," *American Literature* 80, no. 1 (2008), 83–109.
75. Perloff, *Indeterminacy*, 76.

CHAPTER 2

1. Andrew Causey, "The Hero and the Crowd: The Art of Wyndham Lewis in the Twenties," in *Volcanic Heaven: Essays on Wyndham Lewis's Painting and Writing*, ed. Paul Edwards (Santa Rosa: Black Sparrow Press, 1996), 87.
2. See C. J. Fox and Robert Edward Murray, "The War Fiction," in *Volcanic Heaven: Essays on Wyndham Lewis's Painting and Writing*, ed. Paul Edwards (Santa Rosa: Black Sparrow Press, 1996), 67.
3. Literary critics tend not to focus on the lengthy scene of Pulley and Satters walking into a painting, or interpret it in terms of Lewis's critique of cinema (see Paul Tiessen, "Wyndham Lewis's *The Childermass* [1928]: The Slaughter of the Innocents in the Age of Cinema," in *Apocalyptic Visions Past and Present*, ed. JoAnn James and William J. Cloonan [Tallahassee: Florida State University Press, 1984], 25–35; and Anthony Parsekeva, "Wyndham Lewis vs Charlie Chaplin," *Forum for Modern Language Studies* 43:3 [July 2007]: 223–34). The novel's best critics—Hugh Kenner, Fredric Jameson, Peter Caracciolo, Daniel Schenker, and Nicholas Brown—provide valuable insights into its stylistic and formal logics but nonetheless neglect the scene of the painting as such. See Hugh Kenner, *Wyndham Lewis* (Norfolk, Conn.: New Directions, 1954); Fredric Jameson, *Fables of Aggression*: Wyndham Lewis, the Modernist as Fascist (Berkeley: University of California Press, 1979); Peter L. Caracciolo, "'Carnivals of Mass-Murder': The Frazerian Origins of Wyndham Lewis's *The Childermass*," in *Sir James Frazer and the Literary Imagination*, ed. Robert Fraser (London: Macmillan, 1990), 207–31; Daniel Schenker, *Wyndham Lewis: Religion and Modernism* (Tuscaloosa: University of Alabama Press, 1992); Nicholas Brown, *Utopian Generations: The Political Horizon of Twentieth-Century Literature* (Princeton, N.J.: Princeton University Press, 2005), 127–49.

4. Of course, this point is complicated by the fact that Satters and Pulley are already dead and their experience in the afterlife is as close to life as they can get. But instead of problematizing my argument, this point, in fact, supports it. Lewis is suggesting that air-filled painting is nearly indistinguishable not just from real life but from an attenuated afterlife in purgatory.

5. "Critical Realists," Typescript, B1/F11, p. 37, PCMS-0008, Wyndham Lewis Collection, 1917–1942, Poetry Collection of the University Libraries, University at Buffalo, State University of New York (collection hereafter cited as Buffalo). Lewis makes a similar point in *Blast* 1 (June 1914) (rpt. Santa Barbara: Black Sparrow Press, 1981), 135.

6. W. H. Auden, *The English Auden: Poems, Essays, and Dramatic Writings 1927–1939* (London: Faber, 1977), 198. For similar characterizations, see Jeffrey Meyers, *The Enemy: A Biography of Wyndham Lewis* (Boston: Routledge and Kegan Paul, 1980), and Juliana Hanna, "Blasting after *Blast*: Wyndham Lewis's Late Manifestos," *Journal of Modern Literature* 31, no. 1 (2007): 124–35.

7. Important exceptions include Paul Edwards, *Wyndham Lewis: Painter and Writer* (New Haven, Conn.: Yale University Press, 2000), and David A. Wragg, *Wyndham Lewis and the Philosophy of Art in Early Modernist Britain: Creating A Political Aesthetic* (Lewiston, N.Y.: Edwin Mellen Press, 2005).

8. Pericles Lewis, *Modernism, Nationalism, and the Novel* (Cambridge: Cambridge University Press, 2000).

9. Brown, *Utopian Generations*, 129; Douglas Mao, "A Shaman in Common: Lewis, Auden, and the Queerness of Liberalism," in *Bad Modernisms*, ed. Douglas Mao and Rebecca Walkowitz (Durham, N.C.: Duke University Press, 2006): 206–37, 207, 214.

10. The corrected galleys of *The Childermass* show the insertion (in Lewis's handwriting) of additional lines parodying Stein's style (B6/F8, Buffalo).

11. David Ayers, *Wyndham Lewis and Western Man* (New York: St. Martin's, 1992), 30–53.

12. Wyndham Lewis, *Men without Art*, 1934, rpt. ed. Seamus Cooney (Santa Rosa: Black Sparrow Press, 1987), 26.

13. Wyndham Lewis, *The Diabolical Principle and the Dithyrambic Spectator* (London: Chatto and Windus, 1931), vi.

14. Lewis, *Men without Art*, 26.

15. This aesthetic-political-philosophical treatise was published a year before *The Childermass*, but Lewis imagines both as part of a broader cultural critique. Paul Edwards recounts Lewis's writing process of cannibalizing *The Childermass* manuscripts for chapters eventually published elsewhere (*TWM* 455–508).

16. Vorticism emerged from Lewis's Vorticist "Manifesto" in *Blast* 1, the magazine he edited in 1914, as "determinedly anti-Victorian and anti-picturesque," in Charles Harrison's words. "The mechanical and the geometric were upheld against the organic and the naturalistic, energy against sensibility, will against morality"; Charles Harrison, *English Art and Modernism: 1900–1939* (New Haven, Conn.: Yale University Press, 1981), 111. See also Miranda Hickman, *The Geometry of Modernism: The Vorticist Idiom in Lewis, Pound, H.D., and Yeats* (Austin: University of Texas Press, 2005), 27–88.

17. Lewis, *Blast* 1, 130.

18. Wyndham Lewis, *Tarr: The 1918 Version*, ed. Paul O'Keeffe (Santa Rosa: Black Sparrow Press, 1990), 298.

19. Ibid., 298–99.

20. Ibid., 300.
21. For example, Rebecca Beasley sees Tarr as discussing the subject matter of art—as "against the primacy of the self as the ground for art"—instead of the ontology of art. Rebecca Beasley, "Wyndham Lewis and Modernist Satire," in *The Cambridge Companion to the Modernist Novel*, ed. Morag Shiach (Cambridge: Cambridge University Press 2007), 126–36, 130.
22. Geoff Gilbert, "Shellshock, Anti-Semitism, and the Agency of the Avant-Garde," in *Wyndham Lewis and the Art of Modern War*, ed. David Peters Corbett (Cambridge: Cambridge University Press, 1998), 82.
23. In Tom Normand's view, for example, Lewis's belief that art must oppose life paradoxically leads to an insistence on the role of politics in art; Tom Normand, *Wyndham Lewis the Artist: Holding the Mirror up to Politics* (Cambridge: Cambridge University Press, 1992), 2. David Wragg, meanwhile, sees Lewis's refusal "to retreat into the shell of aesthetic autonomy" as his attempt to heal the art/life split (Wragg, *Philosophy*, 104).
24. *Time and Western Man* contains similar condemnations of the temporality of modern literature in the works of James Joyce, Ezra Pound, and Gertrude Stein.
25. Lewis's term "Automobilism" comes from *Blast*: "Futurism, as preached by Marinetti, is largely Impressionism up=to=date. To this is added his Automobilism and Nietzsche stunt" (Lewis, *Blast* 1, 143). Lewis complains that the Futurists' relationship to machinery is more like emotional, thoughtless, worship: "not a deliberate and reasoned enthusiasm for the possibilities that lie in this new spectacle of machinery; of the *use* it can be put to in art"; Wyndham Lewis, *Caliph's Design: Architects! Where Is Your Vortex?*, 1919, rpt. ed. Paul Edwards (Santa Barbara: Black Sparrow Press, 1986), 57. But the larger problem with Futurism is its source (and endpoint) in Impressionism.
26. Lewis, *Diabolical Principle*, 67.
27. Ibid., 69, 68. A deleted quote from "The Revolution Simpleton" makes a similar point: "It is rather as though where art is concerned, a shadow that did not belong to it had invaded its creative fastness and breeding ground, and mixing itself with it, corrupted all its creations," corrected page proofs of *Enemy* I, 57, B14/F12 (Buffalo).
28. Lewis, "Super-Nature versus Super-Real," in *Wyndham Lewis on Art: Collected Writings 1913–1956*, ed. Walter Michel and C. J. Fox (New York: Funk and Wagnalls, 1969), 331–32.
29. Lewis, *Blast* 1, 139.
30. Ibid. For discussions of Lewis's relation to Cubism, see Harrison, *English Art*, 75–113, and Edwards, *Wyndham Lewis*, 53–94.
31. Lewis's theory of representation is often portrayed as divided. Edwards, for example, sees Lewis as fundamentally conflicted between versions of Romanticism and postmodernism (Edwards, *Wyndham Lewis*, 4–5). More positively, both Wragg and António M. Feijó celebrate Lewis's texts for their instability and refusal to cohere; António M. Feijó, *Near Miss: A Study of Wyndham Lewis (1909–1930)* (New York: Peter Lang, 1998), 4; Wragg, *Philosophy*, 7. For a contrast, see Scott Klein, who presents a notable exception to the now conventional reading of the "unstable" Lewis. Klein makes a strong case for the serious, dialogic engagement between Joyce and Lewis as helping form the basis of Lewis's "theory of proclaimed unity . . . that finds its strength in the artist's ontological posture towards the world"; Klein, *The Fictions of James Joyce and Wyndham Lewis: Monsters of Nature and Design* (Cambridge: Cambridge University Press, 1994), 2.

32. David Peters Corbett, for example, interprets Lewis's work as "radically ambiguous—at once essential to all human experience and claustrophobically private." Corbett, "History, Art and Theory in *Time and Western Man*," in *Volcanic Heaven: Essays on Wyndham Lewis's Painting and Writing*, ed. Paul Edwards (Santa Rosa: Black Sparrow Press, 1996), 120. Jessica Burstein provides a provocative account of Lewis's "cold modernism" (characterized by prosthetic devices and beetle shells), also taking its cue from postmodernism in "Waspish Segments: Lewis, Prosthesis, Fascism," *Modernism/Modernity* 4, no. 2 (1997), 139–64. In addition to critical works already mentioned, critics who propose significant theoretical interconnections between Lewis's art and writing—as do Paul Peppis and Reed Way Dasenbrock—tend to focus on the early Vorticist manifestos in relation to Lewis's politics, philosophy, and painting, instead of on *The Childermass*; Peppis, *Literature, Politics, and the English Avant-Garde: Nation and Empire, 1901–1918* (Cambridge: Cambridge University Press, 2000), and Dasenbrock, *The Literary Vorticism of Ezra Pound and Wyndham Lewis: Towards the Condition of Painting* (Baltimore, Md.: Johns Hopkins University Press, 1985).

33. I am paraphrasing Tyrus Miller's view in *Late Modernism: Politics, Fiction, and the Arts between the World Wars* (Berkeley: University of California Press, 1999), 114. He sees Lewis's creation as a "deauthenticated world" in which figure cannot be distinguished from ground, or subject from object (62). He precisely pinpoints some of Lewis's most unique features without revealing why Lewis would be invested in producing such a representation of reality. Yet as we have seen, Lewis's representations aim to be entirely satiric.

34. Jameson, *Fables*, 19–20.

35. Michael Fried argues that unlike the modern painting and sculpture of Frank Stella and Anthony Caro, Minimalist art "was preoccupied with experiences that persist in time; the 'presentment' of duration, of 'time itself as though it were some sort of literalist object'" (*Art and Objecthood: Essays and Reviews* [Chicago: University of Chicago Press, 1998], 41). Moreover, Fried claims that art cannot simply disregard literality (or temporality); it must defeat the theatrical presence of the literal object. Pamela Lee sees Fried's inclusion of temporality in the discourse of literality in relation to the rise of systems theory, but the concern about time in art clearly has earlier sources. Pamela M. Lee, *Chronophobia: On Time in the Art of the 1960s* (Cambridge, Mass.: MIT Press, 2004), 36–83.

36. Part of the confusion here is that Lewis's term of attack—"Modernist"—is the same word Fried uses to defend art. Of course, Lewis could not have known the Minimalist art of the 1960s to which Fried was responding, nor did Lewis ever formulate his theory in Fried's condensed terms. Moreover, the Minimalist "new esthetic" Fried discredits was, for Lewis, already rearing its head in early twentieth-century modernism, whereas the particular objects of Lewis's polemic do not concern Fried.

37. Patricia Novell, interview with Dennis Oppenheim, March 29, 1969, in *Recording Conceptual Art, Early Interviews with Barry, Huebler, Kaltenbach, LeWitt, Morris, Oppenheim, Siegelaub, Weiner* (Berkeley: University of California Press, 2001), 29.

38. Robert Smithson, another major artist of the period, writes that "art not only communicates through space, but also through time," in *Robert Smithson: The Collected Writings*, ed. Jack Flam (Berkeley: University of California Press, 1996), 342. Smithson's glue pours (vats of bright orange glue poured down a slope) and mirror displacements (mirrors cantilevered in the dirt) focus on the issue of art's duration.

39. Roxana Marcoci and Miriam Basilio, "Tempo" Brochure (June 29–September 9, 2002, MOMA/QNS).

40. Erwin Wurm, *One Minute Sculptures, 1988–1998: Index of Works* (Bregenz: Kunsthaus Bregenz, 1999), 139.

41. Lewis, *Diabolical Principle*, 68–69.

42. This half-life/half-death is alluded to in *The Childermass* via frequent references to H. G. Wells's *When the Sleeper Wakes*. The sleeper's trance is described as "a sort of complete absence" by Isbister: "Here's the body, empty. Not dead a bit, and yet not alive. It's like a seat vacant and marked 'engaged.'"; H. G. Wells, *When the Sleeper Wakes* (New York: Harper and Brothers, 1899), 15. But while asleep, a corporation with an active Board of Trustees acted for the sleeper and speculated on his wealth (125–26). Lewis imagines that something similar is happening to billions of people; they are asleep in time-philosophy and someone else is acting for them.

43. Lewis, *Blast* 1, 141.

44. Thomas Paine, *The Rights of Man* (New York: Penguin, 1984), 174–77.

45. Ibid., 173.

46. See Toby Foshay: "Lewis is just as anti-democratic as he is anti-socialist"; *Wyndham Lewis and the Avant-Garde: The Politics of the Intellect* (Montreal: McGill-Queen's University Press, 1992), 19. Tyrus Miller observes that Lewis's key aim is "not to oppose the inexorably advancing destruction of democratic consensus but to negotiate the blighted period of transition and to survive" (Miller, *Late Modernism*, 119). Paul Edwards historicizes Lewis's liberalism by explaining it as a result of his move to North America during World War II, and suggests that Paine is included in *The Childermass* "to expose what [Lewis] considers the sham of British democracy," whereas Douglas Mao shows how "the genuine highbrow's claim to authority" resembles "the classical liberal subject, or the ideal citizen as framed by democratic liberalism." Paul Edwards, "Afterword" in Wyndham Lewis, *The Vulgar Streak* (Santa Barbara: Black Sparrow Press, 1985), 241; Edwards, *Wyndham Lewis*, 330. Mao, "A Shaman in Common," 214.

47. Lewis, *Men without Art*, 15, 191.

48. Ibid., 216.

49. Lewis, "De Tocqueville's *Democracy in America*," in *Creatures of Habit and Creatures of Change: Essays on Art, Literature and Society 1914–1956*, ed. Paul Edwards (Santa Rosa: Black Sparrow Press, 1989), 323–24.

50. An examination of Lewis's corrected galleys of *The Childermass* reveals many sentence-level changes at the page-proof stage, when most of the other page-proof changes throughout the book are minor punctuation changes. Apparently, he was still tweaking the scene of Paine at a late moment in the publication process. *The Childermass*, Corrected Galleys (1928), 45–50 (Buffalo).

51. Lewis, *The Enemy* 2 ([September] 1927), rpt. ed. David Peters Corbett (Santa Rosa: Black Sparrow Press, 1994), 51. Daniel Schenker points out that Lewis adds the crucial detail that this little figure has a "slight American accent"—permitting the Paine identification. However, Schenker also argues that "from Lewis' standpoint, Thomas Paine's demise beneath the foot of Satters carries out the sentence of poetic justice: Paine dies beneath the heel of a creature who embodies the instinctive side of human nature first valorized by romanticism" (Schenker, *Religion and Modernism*, 143). While Lewis indubitably spilled a lot of ink railing against Romanticism, Schenker omits the connection between this scene and Lewis's argument against time-philosophy (which *The Childermass* is almost entirely devoted to): namely, time-philosophy alters the relationship between humans and their representations.

52. Although Lewis is particularly damning of Satters (who has not even heard of Paine or *The Rights of Man*), he points out that feeling threatened by a representation is common: "No sitter for bust or portrait but experiences, probably, an instinctive sense that some *alter ego* is coming into existence beneath the painter's or sculptor's hand" (Lewis, *Diabolical Principle*, 193). The difference is that by understanding representation as separate from life, this threat might be a deeply felt experience, but not necessarily one that must be acted on.

53. My reading here presents another angle with which to consider Nicholas Brown's discussion of "the embodied cliché" throughout *The Childermass* (as when Satters turns into a baby and Pulley into his nurse) as that which "defamiliarizes the social totality itself" (Brown, *Utopian Generations*, 139). The destruction of Paine and representation means that the only way "representation" can occur in this time-philosophy world is through performative embodiment. Thus, Satters cannot represent childishness; instead, he literally turns into a baby.

54. *Paleface* first appeared in *The Enemy*, 1927 (shortly before *The Childermass*), and then was revised for a book version published in 1929, which incorporates a new conclusion to part I underscoring the problem with the concept of democracy as currently employed.

55. Lewis, *Paleface: The Philosophy of the "Melting Pot"* (London: Chatto and Windus, 1929), 72.

56. Ibid., 78.

57. Ibid., 81–82.

58. Ibid., 72.

59. See also Peppis's excellent discussion of *Tarr* as a response to Joyce's nationalism in *Literature*, 133–61.

60. Jameson, *Fables*, 18.

61. Lewis, "America and Cosmic Man," in *Wyndham Lewis: An Anthology of His Prose*, ed. E. W. F. Tomlin (London: Methuen, 1969), 385.

62. Jameson, *Fables*, 17–18.

63. Mao critiques Jameson's monograph for related reasons, suggesting that Jameson's avoidance of *The Art of Being Ruled* contributes to these misreadings (Mao, "A Shaman in Common," 235).

64. Edwards, *Wyndham Lewis*, 6. See Andrew Hewitt, *Fascist Modernism: Aesthetics, Politics, and the Avant Garde* (Stanford, Calif.: Stanford University Press, 1993); Reed Way Dasenbrock, "Wyndham Lewis's Fascist Imagination and the Fiction of Paranoia," in *Fascism, Aesthetics, and Culture*, ed. Richard J. Goslan (Hanover: University Press of New England, 1992), 81–97; Brett Neilson, "History's Stamp: Wyndham Lewis's *The Revenge for Love* and the Heidegger Controversy," *Comparative Literature* 51, no. 1 (1999): 24–41; Merry M. Pawlowski, "Toward a Feminist Theory of the State: Virginia Woolf and Wyndham Lewis on Art, Gender, and Politics," in *Virginia Woolf and Fascism: Resisting the Dictators' Seduction*, ed. Pawlowski (Basingstoke: Palgrave; 2001), 39–55.

65. Lewis, *Paleface*, 82.

66. For example, in "America and Cosmic Man" Lewis worries about the ease with which we might do away with democratic liberty (just as Satters can thoughtlessly mangle Paine in an instant); Lewis, "America and Cosmic Man" in *Wyndham Lewis: Anthology*, 376, 382.

67. Jameson, *Fables*, 15.

68. For these identifications and political affiliations, see Lewis, "Roger Fry's Role as Continental Mediator" in *Wyndham Lewis on Art*, 197–98, "Super-Nature versus

Super-Real," 304–5, and *Rude Assignment: An Intellectual Autobiography,* 1950, rpt. ed. Toby Foshay (Santa Barbara: Black Sparrow Press, 1984), 72, 98–99.

69. Lewis, *Blast* 1, 135.
70. Lewis, *Caliph's Design*, 37.
71. W. K. Rose, ed. *The Letters of Wyndham* Lewis (London: Methuen, 1963), 243.
72. Lewis, *Caliph's Design*, 66.
73. Ibid.
74. From "Essay on the Objective of Plastic Art in Our Time," in Lewis, *Wyndham Lewis on Art*, 210.
75. In contrast to David Peters Corbett, who contends that Lewis's art "is radically ambiguous," I suggest that Lewis's artistic signature might be dual-functioning (both object and nonobject), but it is not ambiguous (Corbett, "History, Art, and Theory," 120).
76. Lewis, *Rude Assignment*, 213.
77. Ibid., 12.
78. Ibid., 144.
79. See Edwards, *Wyndham Lewis*, 303; Lewis, *Rude Assignment*, 212. Lewis describes himself in this way throughout *Rude Assignment*, often conflating type and group in descriptions.
80. The Arthur Press was a fiction concocted by Lewis (as he had to explain to England's Internal Revenue Service when he was audited), "in order to have some address from which to publish ["The Enemy"]." Quoted in Corbett's notes to *The Enemy* 3, in *The Enemy: A Review of Art and Literature, Number 2 (1927)* and *Number 3 (1929),* ed. David Peters Corbett (Santa Rosa: Black Sparrow Press, 1994), 3:133.

CHAPTER 3

Epigraph: William Carlos Williams, "America, Whitman, and the Art of Poetry," *Poetry Journal* (Boston) 8, no. 1 (November 1917), 27–36; reprinted in *The William Carlos Williams Review* 13, no. 1 (spring 1987), 2.

1. Cristanne Miller, *Cultures of Modernism: Marianne Moore, Mina Loy, and Else Lasker-Schuler: Gender and Literary Community in New York and Berlin* (Ann Arbor: University of Michigan Press, 2005), 111. Although Loy was living in Paris during this period, she had become friends with Williams during her sojourn in New York throughout and just after the war. See Carolyn Burke, *Becoming Modern: The Life of Mina Loy* (New York: Farrar, Straus and Giroux, 1996), 282–94.
2. Mina Loy, "Gertrude," *transatlantic review* 2, no. 4 (November 1924), 429–30.
3. Filippo Tommaso Marinetti, "The Founding and Manifesto of Futurism," in *Manifesto: A Century of Isms,* ed. Mary Ann Caws (Lincoln: University of Nebraska Press, 2001), 188.
4. Henry Sayre rightly associates Loy's appreciation of the sublimely concave wash bowl with her friend Marcel Duchamp's aesthetic defense of his readymades, particularly the urinal titled *Fountain* (1917). Sayre, "Ready-mades and Other Measures: The Poetics of Marcel Duchamp and William Carlos Williams," *Journal of Modern Literature* 8 (1980), 11.
5. Catherine Paul, *Poetry in the Museums of Modernism: Yeats, Pound, Moore, Stein* (Ann Arbor: University of Michigan Press, 2002), 116.
6. Pound, "The Curse," *Apple (of Beauty and Discord)* 1, no. 1 (January 1920), 22, 24; reprinted in *Ezra Pound's Poetry and Prose: Contributions to Periodicals, Volume IV*

1920–1927, prefaced and arranged by Lea Baechler, A. Walton Litz, and James Longenbach (New York: Garland, 1991), 1.

7. For Pound, cordoning off aesthetic experience in the museum destroyed the possibility of a viable public art because individuals followed the museum's method and aspired to be collectors rather than creators (Paul, *Museums of Modernism*, 117–18).

8. Pound imagined that museums could be strengthened to become better "institutions of modern culture," teaching good taste to the masses inundated and desiring cheap commodities in the city's many art shops (Paul, *Museums of Modernism*, 119–21). Despite his criticism of those dreaded "plate-glass cabinet[s]," Pound imagines an improved museum that eliminates the glass frame but does not eliminate the frame separating high culture from its dreaded life-bound mass cultural opposite.

9. Discussing Williams's position in modernism, Alan Golding describes the diverging reception history of Williams as the golden child of creative writing programs on the one hand and of Language poetics on the other ("What about all this writing: Williams and Alternative Poetics," *Textual Practice* 18, no. 2 [2004], 265–66), while Seth Moglen sees Williams as "a troubling figure for those who framed the cold war version of modernism . . . a belated and uneasy presence within the established tradition" (*Mourning Modernity: Literary Modernism and the Injuries of American Capitalism* [Palo Alto, Calif.: Stanford University Press, 2007], 81).

10. Dickran Tashjian, *Skyscraper Primitives: Dada and the American Avant-Garde, 1910–1925* (Middletown, Conn.: Wesleyan University Press, 1975), and Irene Gammel, *Baroness Elsa: Gender, Dada, and Everyday Modernity: A Cultural Biography* (Cambridge, Mass.: MIT Press, 2003), 262–85.

11. Williams, "America, Whitman," 2.

12. Leon Battista Alberti, *On Painting*, trans. John R. Spencer (New Haven, Conn.: Yale University Press, 1956), 55. Leonardo da Vinci, *The Notebooks of Leonardo da Vinci*, vol 2, ed. Edward MacCurdy (New York: Reynal and Hitchcock, 1938), 369.

13. Steven Levine, "The Window Metaphor and Monet's Windows," *Arts Magazine* 54, no. 3 (1979), 98–104; 98.

14. Ibid., 100.

15. The much later installation piece *Étant Donnés* (1946–66), designed specifically for the Philadelphia Museum of Art and only viewable through a carved-out "peek hole" in a manufactured wooden barn door, should also be considered a late "window" work.

16. Allan Kaprow, "Doctor MD," in *Marcel Duchamp*, ed. Anne d'Harnoncourt and Kynaston McShine (Greenwich, Conn.: New York Museum of Modern Art, 1973), 205.

17. According to Naomi Sawelson-Gorse, Duchamp was very involved in the presentation of the Arensberg collection of his work in 1954 at the Philadelphia Museum of Art: "He personally selected the site [of the *Large Glass*] and supervised the object's installation." Naomi Sawelson-Gorse, "Hollywood Conversations: Duchamp and the Arensbergs," in *West Coast Duchamp*, ed. Bonnie Clearwater (Miami Beach, Fla.: Grassfield Press, 1991), 25–45; 39.

18. Marcel Duchamp, *The Writings of Marcel Duchamp*, ed. Michel Sanouillet and Elmer Peterson (New York: Da Capo Press, 1973). Originally published as *Salt Seller: The Writings of Marcel Duchamp* (New York: Oxford University Press, 1973), 26.

19. Ibid.

20. Ibid., 42.

21. Ibid., 39. These ratios are approximations based on the *Large Glass*'s dimensions, 109.25 × 69.25 inches. Duchamp was familiar with the Golden Mean: in "The Bride's Veil" he diagrams a slight variation on the Golden Mean mathematical formula by using an ellipsis instead of a circle (41).

22. In an interview with Pierre Cabanne, Duchamp clarifies that his decision to focus on transparency via the medium of glass in the *Large Glass* was the natural extension of his repudiation of canvas and support (Pierre Cabanne, *Dialogues with Marcel Duchamp*, trans. Ron Padgett [1967; rpt., New York: Viking Press, 1971], 18).

23. Williams writes: "Duchamp was working then on his glass screen. It was in the studio as yet unfinished and was said to be a miracle of leaded-glass workmanship. I bumped through these periods like a yokel, narrow-eyed, feeling my own inadequacies, but burning with the lust to write." Williams, *The Autobiography of Williams Carlos Williams* (New York: New Directions, 1948), 137.

24. Discussions of this anecdote include Christopher MacGowen, *Williams Carlos Williams's Early Poetry: The Visual Arts Background* (Ann Arbor: University of Michigan Press, 1984), 61–62; William Marling, *William Carlos Williams and the Painters, 1909–1923* (Athens: Ohio University Press, 1982), 56; Peter Schmidt, *William Carlos Williams, The Arts and Literary Tradition* (Baton Rouge: Louisiana State University Press, 1988), 94; and Tashjian, *Skyscraper Primitives*, 96–97, 111–12.

25. Duchamp, *Writings*, 125.

26. See MacGowan, *Williams's Early Poetry*, 61–62.

27. Samuel Taylor Coleridge, "The Eolian Harp," in *Complete Works of Samuel Taylor Coleridge*, vol. 1, ed. Ernest Hartley Coleridge (Oxford: Clarendon Press, 1912), 100–101.

28. Loy ends her 1925 essay "Modern Poetry" with a general discussion of Williams, but only makes one comment about a specific poem. She does not name the poem, but none other prior to 1925 fits this description. "Modern Poetry," in *Lost Lunar Baedeker: Poems*, ed. Roger L. Conover (New York: Noonday Press, 1996), 157–61; 160–61.

29. Duchamp, "Green Box," in *Writings*, 32.

30. James Breslin, *William Carlos Williams: An American Artist* (New York: Oxford University Press, 1970), 15–17; Ezra Pound, *Selected Poems*, ed. T. S. Eliot (London: Faber and Faber, 1928), 94.

31. For a more comprehensive examination of organicism in Williams's poetry and poetic theory, see Donald W. Markos, *Ideas in Things: The Poems of William Carlos Williams* (Cranbury, N.J.: Associated University Press, 1994).

32. In various letters from 1921 and 1922, Williams laments that he is "still prone to fall inside the piano," *Pound/Williams: Selected Letters of Ezra Pound and William Carlos Williams*, ed. Hugh Witemeyer (New York: New Directions, 1996), 52, 67. A late interview (from 1950) uses the same metaphor for the division between art and life: "You have to objectify your life, as I've said over and over again. The pianist sits in front of the piano and plays it. He doesn't fall into the strings. He sits there apart and makes a melody of it." "An Interview with William Carlos Williams by John W. Gerber and Emily M. Wallace," in *Interviews with William Carlos Williams: "Speaking Straight Ahead,"* ed. Linda Welshimer Wagner (New York: New Directions, 1976), 25.

33. Williams, *Selected Letters of William Carlos Williams* (New York: New Directions, 1957), 97.

34. Ibid.
35. Williams, "Beginning," in *Selected Essays of Williams Carlos Williams* (New York: New Directions, 1954), 299.
36. Williams, "America, Whitman," 3.
37. J. Hillis Miller, *Poets of Reality: Six Twentieth-Century Writers* (Cambridge, Mass.: Harvard University Press, 1966), 289; Joseph Riddel, *The Inverted Bell: Modernism and the Counterpoetics of William Carlos Williams* (Baton Rouge: Louisiana State University Press, 1974), xiii.
38. Henry Sayre, *The Visual Text of William Carlos Williams* (Urbana: University of Illinois Press, 1983), 5.
39. Ibid., 4; Peter Halter, *The Revolution in the Visual Arts and the Poetry of William Carlos Williams* (Cambridge: Cambridge University Press, 1994), 4–5.
40. Williams, *Autobiography,* 137.
41. See Walter Benn Michaels, *The Shape of the Signifier: 1967 to the End of History* (Princeton, N.J.: Princeton University Press, 2004), 118–28, for a brilliantly original articulation of the problems with and consequences of an account of meaning that confuses shape and form.
42. Williams reports and publishes the stained glass window anecdote nearly ten years before the *Large Glass* is actually cracked in transit. However, the resonance between the two incidents is remarkable. Duchamp preferred the *Large Glass* with the cracks to his original creation, underscoring his interest in the role of chance in the production of art, while also clarifying that the essential form of the *Large Glass* remains intact despite the cracks: "The more I look at it the more I like the cracks: they are not like shattered glass. They have a shape" (Duchamp, *Writings,* 127).
43. Marjorie Perloff discusses Williams's familiarity with Apollinaire's Cubism essays in *Poetics of Indeterminacy: Rimbaud to Cage* (Princeton, N.J.: Princeton University Press, 1981), 109–10. According to Apollinaire, Picasso's collage alters the notion of the frame by allowing more things (collage, papier collé) to count as frame: "The real or *trompe-l'oeil* object is doubtless destined to play an increasingly important role. It is the interior frame of the picture, marking its deep, inner limits, just as the frame marks its exterior limits" (Guillaume Apollinaire, *The Cubist Painters*, trans. Peter Read [Berkeley: University of California Press, 2004], 36). He suggests that collage and illusion extend the frame inside the picture frame, marking a new kind of limit, one of flatness and depth instead of interior and exterior. However, Apollinaire's understanding of this idea differs from Williams's. Peter Schmidt explains that some art critics understood Apollinaire to be suggesting that the Cubist frame was in fact uniting art and reality (Schmidt, *Arts and Literary Tradition*, 55–56). Following this logic, instead of simply painting illusionistic details to make a painting look like wallpaper had been glued to it, Picasso and Braque affixed collage pieces (wallpaper, nails, etc.) to the canvas itself to erase the frame, merging art and life. I am arguing, in contrast, that Williams pointedly rejects Apollinaire's "interior frame" as a way to expand and extend the literal frame inside the painting, because Williams's implied frame aims to undermine or eliminate the literal frame.
44. Apollinaire, *Cubist Painters*, 61–62.
45. Ibid.
46. Williams, "An Approach to the Poem," in *English Institute Essays, 1947*, ed. David Allan Robertson Jr. (New York: AMS Press, 1948), 57.

47. Ibid., 53.
48. Later poets have interpreted this question in other ways, such as taking poetry out of books and publishing it in unexpected locations, or as in the Happenings when poetry is blended into more varied aesthetic experience incorporating other media.
49. Frederick Wilse Bateson, *Essays in Critical Dissent* (London: Longman, 1972), 9–10.
50. Ibid., 10, 12. Bateson is taking issue with Wellek and Warren's idea that "the real poem must be conceived as a structure of norms, realized only partially in the actual experience of its many readers" (René Wellek and Austin Warren, *Theory of Literature* [New York: Penguin, 1942], 151).
51. Bateson, *Critical Dissent*, 9.
52. James McLaverty, "The Mode of Existence of Literary Works of Art: The Case of the *Dunciad Variorum*," *Studies in Bibliography* 37 (1984), 82–105.
53. Ibid., 94.
54. Ibid., 105.
55. One technique I do not discuss at length is Williams's poetic version of collage. In a poem such as "Rapid Transit," Williams selects overheard conversations and found pieces of writing from the train, a real-world context. He thus pulls phrases from their in situ place (on the train) and transforms them into ex situ art. This poem also implicitly acknowledges the conceptual continuity between Cubist experiments with collage and Duchamp's rose window anecdote: in both cases, a thing from the world is removed from its context and transformed into something else. Because other critics have discussed this collage strategy ably and at length, I do not focus on it here. It is nonetheless worth noting that poems incorporating overheard conversations and quotations are not the predominant model in *Spring and All*: the only other serious candidates are "Young Love" and "Shoot it Jimmy." Although quotation is a strategy that Williams borrows from Apollinaire, as Peter Schmidt explains, it does not appear to be the dominant strategy of *Spring and All* (Schmidt, *Williams and Literary Tradition*, 52–54).
56. Breslin, *American Artist*, 72. According to Litz and MacGowan, a 1923 *Chapbook* version of the poem is titled "Cornucopia" (*CP1* 500), whereas in *Collected Poems, 1921–1931* (1934), the same poem is titled "Flight to the City." In *The Complete Collected Poems* (1938) the poem is simply labeled "IV," and *The Collected Earlier Poems* (1951) once again inserts the "Flight to the City" title.
57. Breslin, *American Artist*, 72–73.
58. Katherine Dreier, who with Duchamp and Man Ray created the Société Anonyme in 1920, befriended Stefi Kiesler shortly after she arrived in New York in 1926. Dreier proceeded to collect Kiesler's work, which Williams might well have seen in the late 1920s; Jennifer R. Gross, ed., *The Société Anonyme: Modernism for America* (New Haven, Conn.: Yale University Press, 2006), 177.
59. Suzanne Churchill, *The Little Magazine Others and the Renovation of Modern American Poetry* (Aldershot: Ashgate, 2006), 104.
60. Williams, *Selected Letters*, 263.
61. Williams to Pound, July 13, 1922, August 15, 1922, and October 19, 1929, *Pound/Williams*, 61, 65, 97.
62. Williams, *I Wanted to Write a Poem: The Autobiography of the Works of a Poet*, reported and edited by Edith Heal (New York: New Directions, 1958), 37.
63. Paul Mariani, *William Carlos Williams: A New World Naked* (New York: McGraw-Hill, 1981), 205–6.

64. Ibid., 206.
65. Williams hints at the power of authorial will and the necessary limitations of that will in *Spring and All* poems such as "To Have Done Nothing" and "Right of Way."
66. Williams, "America, Whitman," 2.
67. Ibid.
68. Ibid.
69. Eric Foner, *The Story of American Freedom* (New York: Norton, 1998), 178.
70. Ibid. Although at its peak before the war, the Progressive movement lost many of these gains in the 1920s; activist Jane Addams called the decade "a period of political and social sag." Quoted in Michael McGerr, *A Fierce Discontent: The Rise and Fall of the Progressive Movement in America, 1870–1920* (New York: Free Press, 2003), 315.
71. Foner, *American Freedom*, 169–83.
72. Ibid., 183.
73. Williams's political poetics are sometimes treated in two quite different phases: the avant-garde, formalist phase of the 1920s versus the increasingly politically aware poetics of the 1930s and beyond, culminating in that "democratic epic" *Paterson*, as John Beck puts it in *Writing the Radical Center: William Carlos Williams, John Dewey, and American Cultural Politics* (Albany: State University Press of New York, 2001), 8. Bob Johnson sums up this view when he writes that "More than anything else, the Depression shifted the emphasis of [Williams's] work from primarily formal matters to socio-political concerns, infusing what were becoming stale modernist innovations with a new-found vitality in everyday life" (Bob Johnson, "'A Whole Synthesis of his Time': Political Ideology and Cultural Politics in the Writing of William Carlos Williams, 1929–1939," *American Quarterly* 54, no. 2 [June 2002], 188). But Williams's playfulness with the notion of progress troubles Johnson's division between Williams's early formal concerns on the one hand and his seemingly evolved political ones on the other. These political concerns are not a new-fangled exploration of the 1930s but mix with his formal and poetical claims as early as 1921, part of his so-called aesthetic period. My reading accords with those of various critics, including John Lowney, Beck, and Churchill, who show how Williams explores sociopolitical concerns earlier in his career. In particular, Churchill's goal of reclaiming modernism's formal experimentation in relation to the period's political-cultural movements (specifically regarding changing conceptions of sexuality and gender), broadly accords with my own aims here to bring Williams's formal innovations in conversation with his political notions of progress (Churchill, *Others*, 3–5). For discussions of Williams's engagement with leftist politics in the 1930s, see also Michael Denning, *The Culture Front: The Laboring of American Culture in the Twentieth Century* (London: Verso, 1996), 211–14, and Milton Cohen, "Stumbling into Crossfire: William Carlos Williams, *Partisan Review*, and the Left in the 1930s," *Journal of Modern Literature* 32, no. 2 (winter 2009), 143–58.
74. April Boone discusses the incorporation of these different materials in "William Carlos Williams's *The Great American Novel*: Flamboyance and the Beginning of Art," *William Carlos Williams Review* 26, no. 1 (spring 2006), 6–7.
75. As Boone notes, critics such as Hugh Kenner and Dickran Tashjian see *The Great American Novel* as a drafty precursor to later, more successful works (such as *Paterson* and *In the American Grain*) that also employ such textual incorporation and historical revision. She argues that the text ought to be understood instead as a metafictional

novel whose Dadaist experiments with found texts look forward to the postmodern experimental fiction of Joseph Heller and John Barth (ibid., 2–6).

76. The mother's ability to progress, albeit painfully (by pushing out a baby) aurally challenges—and drowns out—the technological progress of modernity. The doctor, in contrast, observes passively by watching the drama unfold, unable to relieve her suffering or challenge the dynamo. Presumably, he wants to borrow or appropriate the women's power.

77. J. Stanley Lemons, *The Woman Citizen: Social Feminism in the 1920s* (Urbana: University of Illinois Press, 1973), 153.

78. Ibid., 155–57. For good overviews of the act in its context see also E. R. Schlesinger, "The Sheppard-Towner Era: A Prototype Case Study in Federal-State Relationships" *American Journal of Public Health and the Nation's Health* 57, no. 6 (June 1967), 1034–40; Robyn Muncy, *Creating a Female Dominion in American Reform: 1890–1935* (New York: Oxford University Press, 1991), 93–123; and Molly Ladd-Taylor, *Mother-Work: Women, Child Welfare, and the State, 1890–1930* (Urbana: University of Illinois Press, 1994), 167–96.

79. Lemons, *Woman Citizen*, 154.

80. Ibid., 170.

81. Ibid., 162–66.

82. Muncy, *Female Dominion*, 112; Jacqueline H. Wolf, *Don't Kill Your Baby: Public Health and the Decline of Breastfeeding in the Nineteenth and Twentieth Centuries* (Columbus: Ohio University Press, 2001), 187–88. Before consistent and well-regulated pasteurization and refrigeration of cow's milk in the late 1920s, these formulas were easily contaminated and very dangerous for infants. In response, nurses and physicians urged breastfeeding through the 1920s. As the quality of formula improved and lobbying by formula companies increased, doctors' insistence on breastfeeding declined.

83. As he writes to Kenneth Burke on December 24, 1921: "The book is, as usual, delayed. With me it seems always the same: obstetrics one way or the other and always difficult deliveries" (*Humane Particulars: The Collected Letters of William Carlos Williams and Kenneth Burke*, ed. James H. East [Columbia: University of South Carolina Press, 2003], 20).

84. Mariani, *New World Naked*, 139.

85. Denning, *Culture Front*, 212–13.

86. Williams to Kenneth Burke (June 10, 1921), *Human Particulars*, 15.

87. See Lynn Dumenil, *The Modern Temper: American Culture and Society in the 1920s* (New York: Hill and Wang, 1995), 26–31.

88. See, for example, Dumenil's discussion of Prohibition as anti-immigrant (ibid., 19–20) and Muncy's discussion of Sheppard-Towner's white, middle-class standards of childrearing (i.e., feeding infants on a set time schedule, discouraging rocking babies or sleeping with them) (Muncy, *Female Dominion*, 113–14).

89. Pound, "Credit and the Fine Arts . . . A Practical Application," *New Age* 30, no. 22 (March 30, 1922), 284–85, reprinted in Pound, *Contributions to Periodicals*, 223–24.

90. Pound to Williams, March 18, 1922, *Pound/Williams*, 54.

91. Pound, "Paris Letter; October, 1922," *Dial* 73, no. 5 (November 1922), 549–54, reprinted in Pound, *Contributions to Periodicals*, 259–63; 261.

92. Williams to Pound, March 29, 1922, and July 13, 1922, *Pound/Williams*, 58, 61.

93. Williams to Pound, November 22, 1922–1923, ibid., 68.

94. Wagner, *Interviews*, 26.

CHAPTER 4

Epigraph: Abraham Moles, *Le Kitsch: l'art du Bonheur* (Paris: Mame, 1971), 74.

1. *An American in Paris*, dir. Vincente Minnelli (Metro Goldwyn Mayer, 1951).
2. Whether the film succeeds in producing good art is another story. For some the film's "cross cultural style . . . was refined—and for others was no more than kitsch," Emanuel Levy, *Vincente Minnelli: Hollywood's Dark Dreamer* (New York: St. Martin's Press, 2009), 210.
3. Angela Dalle Vacche, in contrast, interprets this scene as reflecting Jerry's impending identity crisis, a Pollock-like "rebellious search for origins" on the one hand and "Disneyland's return to the happy days of childhood" on the other (Vacche, *Cinema and Painting: How Art Is Used in Film* [Austin: University of Texas Press, 1996], 20, 42).
4. As should be clear with this description, Minnelli precisely dramatizes Michael Fried's distinction between absorption and theatricality in painting; *Absorption and Theatricality: Painting and Beholder in the Age of Diderot* (Chicago: University of Chicago Press, 1980).
5. In one sense, this Baltimore reference, along with the revelation that her father made his money not from oil wells but suntan oil, tames her: she, too, is just an ordinary American. But the reference also suggests that Milo, like Stein and the Cones, supports her avant-garde lifestyle with American capitalism. Similar to the masculine-named Milo, whose sexual aggressiveness and purchasing power alternatively threatens, disgusts, and entices Jerry, Stein was frequently lampooned for her strong influence over artists, her sexuality, and her feminism (one need only recall Lewis's hysterical parodies of Stein).
6. For a discussion of Minnelli's knowledge of painting, see Levy, *Minnelli*, 21–22, 396–98.
7. Dwight MacDonald, "A Theory of Mass Culture," *Diogenes* 3 (summer 1953), 1–17, reprinted in Bernard Rosenberg and David Manning, *Mass Culture: the Popular Arts in America* (Glencoe, Ill.: Free Press, 1958), 62. The essay later appeared in MacDonald's *Mass Cult and Mid Cult* (New York: Random House, 1961), a copy of which Gaddis owned ("William Gaddis Working Library" list, William Gaddis Papers, Washington University Libraries).
8. Jack Kerouac, *The Subterraneans* (New York: Grove Press, 1958), 90. Kerouac wrote this novel while Gaddis was writing *The Recognitions*.
9. The "modernism heresy" alludes both to the Catholic Reformation but also to the shock of modernist ugliness Picasso discussed.
10. On Gaddis's use of the van Meegeren case, see Christopher Knight, *Hints and Guesses: William Gaddis's Fiction of Longing* (Madison: University of Wisconsin Press, 1997), 70–79.
11. Matei Calinescu, *Five Face of Modernity: Modernism, Avant-Garde, Decadence, Kitsch, Postmodernism* (Durham, N.C.: Duke University Press, 1987), 229. Gillo Dorfles, in his edited volume *Kitsch, the World of Bad Taste* (New York: Universe Books, 1969), promotes a view perhaps closer to Gaddis's, suggesting that all kitsch reproductions are ontologically equivalent to actual forgeries (31).
12. Clement Greenberg, "Avant-Garde and Kitsch," in *The Collected Essays and Criticism, vol. 1, Perceptions and Judgments, 1939–1944*, ed. John O'Brian (Chicago: University of Chicago Press, 1986), 11.
13. *An American in Paris* fulfills this definition of kitsch threefold, with its portrayal of contemporary Americans painting in Paris, its depiction of their kitschy art, and the example of movie star Gene Kelly as a tap-dancing modern painter. From

Greenberg's perspective, Minnelli's early commercial background as a window decorator for the department store Marshall Field would support his argument against kitsch. See James Naremore, *The Films of Vincente Minnelli* (Cambridge: Cambridge University Press, 1993), 9–10.

14. Greenberg, "Avant-Garde and Kitsch," 13. *The New Yorker* allegedly modifies avant-garde poetry and fiction to produce an accessible and consumable product, one that endows readers with bourgeois social status. Here we might think of Donald Barthelme, long published in that magazine and, some have argued, hindered by its conventionality. Whether or not we agree with Greenberg's assessment of *The New Yorker*, his example of that magazine is apt. In the 1930s, Bishop aspired to publish in *The New Yorker* specifically. In 1946 she succeeded, entering into a long-standing first-refusal agreement and publishing dozens of poems with them over her lifetime: Bishop, *One Art: Letters*, ed. Robert Giroux (New York: Farrar, Straus and Giroux, 1994), 15, 142. *The New Yorker* satisfied her ambitions for popular success and literary prestige. Gaddis also had a personal connection to the magazine: from 1944 to 1946 he worked there as a fact checker, and in 1946 he submitted an early draft of his history of the player piano (it was rejected, although years later he successfully placed a short story in the magazine); Steven Moore, "The Secret History of *Agapē Agape*," in *Paper Empire: William Gaddis and the World System*, ed. Joseph Tabbi and Rone Shavers (Tuscaloosa: University of Alabama Press, 2007), 257. I bring up these biographical details not to support or to challenge *The New Yorker* or its social standing, but to suggest that its contested status—and the problematic role of high-class kitsch more generally—might have intrigued two well-regarded writers who aimed to publish in it.
15. MacDonald, "A Theory," 63–64.
16. Calinescu, *Five Faces*, 254.
17. William Marx, "The 20th Century: Century of the Arrière-Gardes?," in *Europa! Europa? The Avant-Garde, Modernism, and the Fate of a Continent*, ed. Sascha Bru, Jan Baetens, et al. (Berlin: Walter de Gruyter, 2009), 59–71.
18. Ibid., 63–65.
19. Ibid., 68.
20. Ibid., 70.
21. Serge Guilbaut, *How New York Stole the Idea of Modern Art: Abstract Expressionism, Freedom, and the Cold War* (Chicago: University of Chicago Press, 1983).
22. Ibid., 91–94.
23. See Janis Mink, *Marcel Duchamp, 1887–1968, Art as Anti-Art* (Köln: Taschen, 2000), 80, and Guilbaut, *New York*, 93–95.
24. Wyatt's critique of post-Impressionism and Abstract Expressionism seems to resemble a conservative attack on all modern and contemporary art. But surprisingly, Wyatt genuinely respects modernism's most well-known mode: abstraction. He visits the Museum of Modern Art even after he begins to paint as a Flemish forger and, while there, Picasso's newest Cubist work, *Night Fishing in Antibes*, moves him deeply (R 91). Therefore, Wyatt seems to critique contemporary art for another reason. Gaddis made this point explicitly in a recently published interview with Tom LeClair. When LeClair points out that "Critics often read *The Recognitions* as an attack on modernism in art," Gaddis demurs, "That was not my purpose," although Abstract Expressionism in particular "seem[ed] part of the disorder"; Tom LeClair, "An Interview with William Gaddis, circa 1980," in *Paper Empire: William Gaddis and the World System*, ed. Joseph Tabbi and Rone Shavers (Tuscaloosa: University of Alabama Press, 2007), 20.

25. Similarly, in Wilde's novel, Gray's portrait changes to reflect the disturbing alteration of his escalating immorality, a "visible symbol of the degradation of sin"; Oscar Wilde, *The Picture of Dorian Gray*, ed. Michael Patrick Gillespie, 2nd ed. (New York: Norton, 2007), 81.

26. According to Steven Moore, Gaddis revealed the Walker Evans connection in a private letter: *A Reader's Guide to William Gaddis's The Recognitions*, http://www.williamgaddis.org/recognitions/I1anno1.shtml.

27. Gilles Mora and John T. Hill, *Walker Evans: The Hungry Eye*, trans. Jacqueline Taylor (New York: Abrams, 1993), 218.

28. The comparison is not without its problems. Evans allegedly refused to fiddle with scenes before photographing them, not wishing to alter them aesthetically. Because his photography elevates the role of spectatorship by focusing on the photographer's visual selections, Evans seems an odd model for Wyatt, an artist bent on undermining the relevance of spectatorship.

29. Wyatt's anxiety could be reframed in Walter Benjamin's terms as that of the artist grappling with the problem of producing art in a world in which aura has decayed, where the traditional cult value of a work has been superseded by its exhibition value in the spectator's world. *Agapē Agape*, Gaddis's final work, focuses particularly on these concerns about the relationship between art, technology, and automation. When Gaddis reported that he had finally read Benjamin—in 1992—he recognized his close affinity to the earlier theorist's work.

30. Often described as a series of simultaneous, differential views collapsed into a single picture plane, Cubism complicates Wyatt's critique of contemporary painting presented here. Gaddis seems aware of this contradiction but does not resolve it: Wyatt loves Picasso's Cubism but hates all other forms of contemporary art.

31. In this instance, Gaddis's account varies from Benjamin's. Wyatt's definition of degenerating *modern* art looking back at us contrasts with Benjamin's interpretation of the same gesture as the experience of aura and thus the hallmark of *premodern* art: "To experience the aura of an object we look at means to invest it with the ability to look back at us"; Benjamin, "On Some Motifs in Baudelaire," *Selected Writings*, vol. 4 (Cambridge, Mass.: Belknap Press of Harvard University Press, 1996), 338.

32. Mark Sagoff suggests that forgeries, irrespective of their success or beauty, cannot be compared to authentic works of art because they are a radically different class of objects, whereas Margolis believes that intention, and not authenticity, is the more fundamental category distinction, a position Gaddis also holds: Mark Sagoff, "The Aesthetic Status of Forgeries," *Journal of Aesthetics and Art Criticism* 35, no. 2 (winter 1976), 169; and Joseph Margolis, "Art, Forgery, and Authenticity," in *The Forger's Art*, ed. Denis Dutton (Berkeley: University of California Press, 1983), 131. See also Nelson Goodman, *Languages of Art*, 2nd ed. (Indianapolis: Hackett, 1976), and Sandor Radnoti, *The Fake: Forgery and Its Place in Art* (Lanham, Md.: Rowman and Littlefield, 1999).

33. Though I do not focus on the novel's innumerable Christian allusions and allegories, *The Recognitions* also probes counterfeiting's moral dimensions in relation to its philosophical aspects, beginning with Aunt May's condemnation of the young Wyatt for drawing because it imitates the Lord's work: Wyatt aims to "steal Our Lord's authority" (*R* 34).

34. The dangerous, pretentious site-specific *Cyclone Seven* sculptures first appear in *J R* (New York: Penguin, 1975) and play a larger and more critical, legalistic role in

A Frolic of His Own (New York: Poseidon, 1994). They seem to refer, deliberately or not, to Richard Serra's *Tilted Arc*, a large, controversial, site-specific sculpture located on the Federal Plaza at Foley Square in Manhattan. See Larry Wertheim, "Symposium: Proposed Restatement (Third) of Torts: Products Liability: Book Review: Law as Frolic: Law and Literature in *A Frolic of His Own*," *William Mitchell Law Review* 421 (winter 1995), and Richard Posner, *Law and Literature*, rev. and enl. ed. (Cambridge, Mass.: Harvard University Press, 1998), 32–37.

35. Joseph Tabbi predicts that "when the literary biography of Gaddis is written, it will be as much about [the postwar Greenwich Village art scene] as about Gaddis himself" ("Introduction," in *Paper Empire: William Gaddis and the World System*, ed. Joseph Tabbi and Rone Shavers [Tuscaloosa: University of Alabama Press, 2007], 13). The crucial point, of course, is that Gaddis's "literary biography" remains unwritten. While some of the fascinating essays in *Paper Empire* relate 1960s culture to texts such as *J R* and *Agapē Agape*, *The Recognitions*'s historical contextualization is a work in progress.

36. Joseph Salemi, "To Soar in Atonement: Art as Expiation in Gaddis's *The Recognitions*," in *In Recognition of William Gaddis*, ed. John Kuehl and Steven Moore (Syracuse, N.Y.: Syracuse University Press, 1984), 46–57.

37. John Johnston, *Carnival of Repetition: Gaddis's "The Recognitions" and Postmodern Theory* (Philadelphia: University of Pennsylvania Press, 1990), 12. See also Mark Taylor's related account of the novel as "an extended meditation on the problem of forgery and counterfeiting in a world where everything has become a copy of a copy or a sign of a sign"; Taylor, *Confidence Games: Money and Markets in a World without Redemption* (Chicago: University of Chicago Press, 2004), 2.

38. In "The Aesthetic Revolution and Its Outcomes," Jacques Rancière describes the Arts and Crafts movement as avant garde, specifically, their attempt to tie "a sense of eternal beauty, and a mediaeval dream of handicrafts and artisan guilds, to concern with the exploitation of the working class and the tenor of everyday life, and to issues of functionality"; in *Dissensus: On Politics and Aesthetics*, ed. and trans. Steven Corcoran (London: Continuum, 2010), 120. Wyatt seems uninterested in the political component Rancière describes, but very interested in a different view of the relationship of the artist to the world.

39. Greenberg, "Avant Garde and Kitsch," 10.

40. Arthur C. Danto, *After the End of Art: Contemporary Art and the Pale of History* (Princeton, N.J.: Princeton University Press, 1997), 15.

41. As Nicholas Brown suggests about *Carpenter's Gothic*, Gaddis tends to advance radical political positions before pulling back from them, letting his heroes drive themselves insane by the contradictions of their positions instead of taking a stand. Nicholas Brown, "Cognitive Map, Aesthetic Object, or National Allegory? *Carpenter's Gothic*," in *Paper Empire: William Gaddis and the World System*, ed. Joseph Tabbi and Rone Shavers, 151–60 (Tuscaloosa: University of Alabama Press, 2007).

42. Edward Dolnick, *The Forger's Spell: A True Story of Vermeer, Nazis, and the Greatest Art Hoax of the Twentieth Century* (New York: Harper, 2008), 265–66.

43. Ibid., 288. The quotation is from Irving Wallace, "The Man Who Swindled Goering," *Saturday Evening Post*, January 11, 1947. Jonathan Lopez challenges this characterization of van Meegeren by documenting his active Nazi sympathies (van Meegeren inscribed a book especially for Hitler); Jonathan Lopez, *The Man Who Made Vermeers: Unvarnishing the Legend of Master Forger Han van Meegeren* (Orlando: Harcourt: 2008), 145–56.

44. Bishop, *The Collected Prose*, ed. Robert Giroux (New York: Farrar, Straus, Giroux, 1984), 59. Betsy Erkkila views this essay as "an attempt to define a popular, communal, working-class art"; "Elizabeth Bishop, Modernism, and the Left," *America Literary History* 9, no. 2 (1996), 291.
45. Bishop, *Collected Prose*, 58.
46. Ibid., 52.
47. Ibid., 59.
48. Ibid., 58.
49. Ibid., 53.
50. Ibid., 58.
51. Calinescu, *Five Faces*, 236.
52. Bishop's letter to Anne Stevenson (January 8, 1964) in Elizabeth Bishop, *Poems, Prose, and Letters*, ed. Robert Giroux and Lloyd Schwartz (New York: Library of America, 2008), 861.
53. Jonathan Lowney rightly calls this strategy a "salvage art of reviving and recycling"; Lowney, *History, Memory, and the Literary Left: Modern American Poetry, 1935–1968* (Iowa City: University of Iowa Press, 2006), 81.
54. Marcel Duchamp, "Apropos of 'Readymades,'" in *The Writings of Marcel Duchamp*, ed. Michel Sanouillet and Elmer Peterson (New York: Da Capo Press, 1973), 141–42.
55. Bishop, *Collected Prose*, 181.
56. Ibid.
57. Ibid., 186.
58. Ibid.,186, 188.
59. Bishop to Marianne Moore, May 5, 1938, *One Art*, 73.
60. Bishop, *Collected Prose*, 187–88.
61. Ibid., 188; Edgar Allan Poe, "The Philosophy of Composition," in *The Fall of the House of Usher and Other Writings: Poems, Tales, Essays and Reviews*, ed. David Galloway (New York: Penguin, 1986), 480–92.
62. Bishop, *Collected Prose*, 188.
63. T. S. Eliot, "Tradition and Individual Talent" in *Selected Prose of T. S. Eliot*, ed. Frank Kermode (New York: Farrar, Straus and Giroux, 1965), 39.
64. John Ashbery, "The Invisible Avant Garde," in *Reported Sightings: Art Chronicles, 1957–1987*, ed. David Bergman (Cambridge, Mass.: Harvard University Press, 1991).
65. Gilbert Sorrentino, "2 Books," *Yugen* 7 (1961): 5–7.
66. See, for example, Guy Rotella: "A look at Bishop's most overtly 'monumental' poem, 'The Monument,' will show that she not only disparaged monuments but also considered how they might be revised, revalued, and used"; Guy Rotella, *Castings: Monuments and Monumentality in Poems by Elizabeth Bishop, Robert Lowell, James Merrill, Derek Walcott and Seamus Heaney* (Nashville, Tenn.: Vanderbilt University Press, 2004), 26.
67. Adrienne Rich, "The Eye of the Outsider: The Poetry of Elizabeth Bishop," in *Blood, Bread and Poetry: Selected Prose 1979–1985* (New York: Norton, 1986), 127; originally published in *Boston Review* (June 1984). However, as early as Randall Jarrell's review of *North & South* (in 1946), in which he identifies "The Fish" and "Roosters" as "two of the most calmly beautiful, deeply sympathetic poems of our time," Bishop's apparent feminine sympathy for marginal artists, castoff fish, and dreadful birds dominated discussions of her work (Randall Jarrell, "On North & South," in *Elizabeth Bishop and Her Art*, ed. Lloyd Schwartz and

Sybil P. Estess [Ann Arbor: University of Michigan Press, 1983], 180). This situation is complicated by Bishop's own feminization of her work, as in her self-description in a letter to Robert Lowell as "a minor female Wordsworth" (Bishop letter to Lowell, July 11, 1951, in Bishop, *One Art*, 221–22).

68. Elizabeth Bishop, *Exchanging Hats: Paintings*, ed. William Benton (New York: Farrar, Straus and Giroux, 1996), xviii. Likewise, Bishop's private interview of T. S. Eliot (at Vassar in 1933) is often left out of accounts of her marginality, no doubt because it registers a young poet aligning herself with *the* modernist father figure. Another difficulty here is that Bishop's conflicted notion of the primitive implies a categorical distinction between primitive writers and primitive painters; she dismissed the former and maintained a certain qualified fascination for the latter.

69. According to these readings, she not only sympathizes with marginal artists but reveals how the binary separating good art from bad deconstructs. Such arguments make a broader claim that Bishop privileges experience over representation, or, in muddling the two, undermines aesthetic representation. Sometimes these claims are given a feminist slant (as in the work of McCabe and Victoria Harrison), or a postmodernist and postcolonialist one (as in the work of Guy Rotella or Jeffrey Gray), but the premises supporting them are similar: Susan McCabe, *Elizabeth Bishop: Her Poetics of Loss* (University Park: Pennsylvania State University Press, 1994); Victoria Harrison, *Elizabeth Bishop's Poetics of Intimacy* (Cambridge: Cambridge University Press, 1993); Jeffrey Gray, *Mastery's End: Travel and Postwar American Poetry* (Athens: University of Georgia Press, 2005). Bishop emerges as the supplemental, feminine counterforce to the prevailing, masculine poetic-presence: while the masculine modernist trumps representative mastery, the feminine poetess supposedly supports naive writing and experience.

70. Max Friedlander, *Art and Connoisseurship* (Oxford: Bruno Cassierer, 1942), 157.

71. Fried makes a related point in his discussion of Minimalism: "the apparent hollowness of most literalist work—the quality of having an *inside*—is almost blatantly anthropomorphic" (*Art and Objecthood: Essays and Reviews* [Chicago: University of Chicago Press, 1998] [*AO*], 156).

72. Brett Millier sees Bishop recasting her attitude toward her uncle's painting in the later poem; Millier, *Elizabeth Bishop; Life and the Memory of It* (Berkeley: University of California Press, 1993), 474–77.

73. Ibid., 474.

74. Ibid., 188. Bishop broke her first-read contract with *The New Yorker* in the early 1960s, and then in 1967, she requested that it be reinstated (ibid., 322, 390).

75. We might contrast this division to what Lowney rightly identifies as Bishop's more synthetic, "socioaesthetic vision" of the 1930s and 1940s (Lowney, *Literary Left*, 94).

76. Bishop's poems "In the Waiting Room," "Crusoe in England," and "12 o'clock News" provide additional examples of the aesthetic gaze framing the anthropological (*CP* 159–66, 174–75).

CHAPTER 5

1. George F. Butterick, *A Guide to The Maximus Poems of Charles Olson* (Berkeley: University of California Press, 1978), l. Little is known about this window frame writing, only photographed after Olson died in 1970; Butterick took interior photographs of the Gloucester house Olson was renting at the time and deposited

them as part of the Charles Olson Papers: George Butterick, *Photograph of 28 Fort Square, Gloucester* (Interior of Charles Olson's house, writing on window frame, March 1970), F148, Archives and Special Collections at the Thomas J. Dodd Research Center, University of Connecticut Libraries. Hereafter this archival collection is referred to as "Dodd." For more photographs of Olson's window writing, see http://charlesolson.uconn.edu/Photographs/selectphotos.cfm?SeriesID=6.

2. Photographs by Butterick, 1970, 329, F148a, Dodd.

3. Ibid.

4. Jones changed his name to Imamu ("spiritual leader") Ameer (later Amiri, "Prince") Baraka ("blessed") in 1967. The name Imamu was subsequently dropped; *The LeRoi Jones/Amiri Baraka Reader,* 2nd ed, ed. William J. Harris (New York: Thunder's Mouth Press, 1991), xxxii. Unless otherwise noted, I use "Baraka" to refer to the poet and his work.

5. Amiri Baraka, "LeRoi Jones: An Interview on *Yūgen,*" interviewed by David Ossman in 1960, collected in *Conversations with Amiri Baraka,* ed. Charlie Reilly (Jackson: University Press of Mississippi, 1994), 6.

6. As editor of *Yūgen* from 1958 to 1962, and coeditor (with Diana di Prima) of the New York poetry journal *Floating Bear; a newsletter,* from 1961 to 1963, Baraka solicited writing from Olson, as well as poetry from other writers in Donald Allen's edited anthology, *The New American Poetry: 1945–1960* (New York: Grove Press, 1960). Four issues of *Yūgen* and seven issues of *Floating Bear* contained Olson's poetry and prose, largely due to Baraka's requests and because Olson appreciated the speed and ease of publishing in Baraka's magazines. Henry Blackwell's study of their correspondence reveals that their letters to one another not only involve the logistical details of magazine publishing but also record Baraka's attempts to "interest Olson in his own work;" Henry Blackwell, "Amiri Baraka's Letters to Charles Olson," *Resources for American Literary Study* 10, no. 1 (spring 1980): 60. See also Aldon Lynn Nielsen's nuanced account of Olson/Baraka's poetical-political relationship in *Integral Music: Languages of African American Innovation* (Tuscaloosa: University of Alabama Press, 2004), 121–36.

7. For a discussion of the relation between Olson's poetics and those of other twentieth-century poets, see Marjorie Perloff, "Charles Olson and the 'Inferior Predecessors': 'Projective Verse' Revisited," *ELH* 40, no. 2 (summer 1973), 285–306, and John Lowney, *The American Avant-Garde Tradition: William Carlos Williams, Postmodern Poetry, and the Politics of Cultural Memory* (Lewisburg: Bucknell University Press, 1997), 79.

8. For example, he remains silent on Roosevelt's internment of Japanese Americans during World War II, and his discussions of gender and minority perspectives frequently follow conventional stereotyping. Less has been written on Olson's racial stereotypes than on his gender ones. His use of his own 6'8" body as a new standard of scale sustains what Daniel Kane calls the (heterosexist, antifeminist) "cowboy aesthetic" of New York in the 1960s; Daniel Kane, *All Poets Welcome: The Lower East Side Poetry Scene in the 1960s* (Berkeley: University of California Press, 2003), 19. See also Susan Howe, *The Birth-Mark: Unsettling the Wilderness in American Literary History* (Hanover: Wesleyan University Press, 1993), 155–81; Lynn Keller, *Forms of Expansion: Recent Long Poems by Women* (Chicago: University of Chicago Press, 1997), 23–58; and Rachel Blau duPlessis, *Blue Studios: Poetry and its Cultural Work* (Tuscaloosa: University of Alabama Press, 2006), 84–87.

9. As Baraka explains, "when politics did emerge . . . in Olson's work, I didn't agree with it;" Kimberly Benston, "Amiri Baraka: An Interview," *boundary 2* 6, no. 2 (winter 1978), 306.

10. Amiri Baraka, *Transbluency: The Selected Poems of Amiri Baraka/LeRoi Jones*, ed. Paul Vangelisti (New York: Marsilio Press, 1995), 136.

11. His ideological incompatibility with the Beats was already assumed in Harold Cruse's critique of him and other members of his generation in *The Crisis of the Negro Intellectual* (New York: Morrow, 1967), 358.

12. Charles Olson, *Muthologos: The Collected Lectures and Interviews*, vol. 2, ed. George F. Butterick (Bolinas: Four Seasons Foundation, 1979), 102. Baraka, "How You Sound??" in *The New American Poetry: 1945–1960*, 425.

13. David Simpson examines the rhetoric of self-positioning in *Situatedness, or, Why We Keep Saying Where We're Coming From* (Durham, N.C.: Duke University Press, 2002). Although beyond the scope of this book, one of the broader questions this chapter poses is the complications and limits of linking political claims of identity or diaspora to one's particular angle of vision.

14. When the OWI was abolished in 1945, its functions were absorbed by the U.S. Department of State and other governmental agencies.

15. Typescript, Application for Federal Employment by Charles Olson, Box 263, Dodd; and Tom Clark, *Charles Olson: The Allegory of a Poet's Life* (Berkeley: North Atlantic Books, 2000), 76–89.

16. Typescript, "Culture and Revolution" by Charles Olson, 1952, Box 29, 1522, Dodd.

17. Olson's work is most often interpreted through the lens of World War II as a postwar poetics of social, cultural, and political resistance. See Don Byrd, who describes Olson as "the first writer to produce a major body of work in full consciousness of the implications of modern totalitarianism." Don Byrd, *Charles Olson's "Maximus"* (Urbana: University of Illinois Press, 1980), xiii; and Stephen Fredman, *Grounding of American Poetry* (Cambridge: Cambridge University Press, 1993), 34.

18. Robert von Hallberg, *Charles Olson: The Scholar's Art* (Cambridge, Mass.: Harvard University Press, 1978), 3. Clark's biography of Olson portrays the poet breaking sharply with his earlier political life while remaining preoccupied with similar concerns, whereas Susan Vanderborg reads Olson's use of open parenthesis as a non-governmental alternative to the dehumanizing, "statistical style of documentation" of institutional bureaucracy. Clark, *Allegory*; Susan Vanderborg, *Paratextual Communities: American Avant Garde Poetry since 1950* (Carbondale: Southern Illinois University Press, 2001), 24–25. Critics not focused on Olson's political biography also interpret Olson in terms of related postwar concerns, as when Ann Day Dewey suggests that "Olson comes to perceive subject and object as subordinate to social forces he cannot identify." Ann Day Dewey, *Beyond Maximus: The Construction of Public Voice in Black Mountain Poetry* (Stanford, Calif.: Stanford University Press, 2007), 55.

19. According to one story, in a backroom scene Democratic Party officials informally offered Olson the job of assistant secretary of the Treasury and the Post Office generalship in 1945—the latter a job he desired to avenge his postman father (Butterick, *Guide*, lxii). Although Olson believed he was a serious contender for these jobs, Senator Alan Cranston challenged this assumption (Clark, *Olson*, 93).

20. From a slightly different perspective, Libbie Rifkin suggests that we examine Olson in relation to nongovernmental cultural institution formations such as his

collaboration with Robert Creeley on *Origin* magazine and the *Black Mountain Review*. Libbie Rifkin, *Career Moves: Olson, Creeley, Zukofsky, Berrigan, and the American Avant-Garde* (Madison: University of Wisconsin Press, 2000), 9.

21. Harvard began offering various graduate courses in government and administration by well-known scholars such as Carl Friedrich, who coauthored *Responsible Bureaucracy* (1932), Arthur Holcomb, Rupert Emerson, and Christian Herter. Indeed, we might think of the American Civilization Program, which combined literature, history, and sociology, as a research-and-development arm of Harvard's program in U.S. government and administration. The huge federal government build-up in the mid-1930s led to a period of rapid "expansion of training for public administration," particularly through the development of more rigorous and intellectual programs of study in administration; Frederick Mosher, ed., *American Public Administration: Past, Present, Future* (Tuscaloosa: University of Alabama Press, 1975), 33, 64. In contrast, when Olson attended college at Wesleyan University (1928–32), no well-defined track existed for potential civil servants, although as a champion debater and accomplished U.S. history scholar, this choice would have been a reasonable career option, as it later became for an increasing number of students training to be teachers. For an excellent discussion of the connection between American studies and Olson's political views, see James Ziegler, "Charles Olson's American Studies: *Call Me Ishmael* and the Cold War," *Arizona Quarterly: A Journal of American Literature, Culture, and Theory* 63, no. 2 (2007), 51–80.

22. Mosher, *Public Administration*, 73.

23. Lucius Wilmerding, *Government by Merit* (New York: McGraw-Hill, 1935), 33.

24. Clark, *Olson*, 73–74.

25. Clayton Laurie, *The Propaganda Warriors: America's Crusade Against Nazi Germany* (Lawrence: University Press of Kansas, 1996), 110–13.

26. Charles A. H. Thomson, *The Overseas Information Service of the US Government* (Washington, D.C.: Brookings Institute, 1948), 47.

27. Laurie, *Propaganda Warriors*, 123.

28. Typescript, Foreign Language Division, News Bureau by Charles Olson, 1941–43, Box 263, Dodd. For a critical analysis of the Foreign Language Division's work, see Gerd Horten, *Radio Goes to War: The Cultural Politics of Propaganda during World War II* (Berkeley: University of California Press, 2003), 66–87.

29. Horten, *Radio Goes to War*, 76.

30. Typescript, Memo, "To: Al From 'me'" by Charles Olson, n.d., Box 263, Dodd.

31. Laurie, *Propaganda Warriors*, 124.

32. Ian Scott, "From Toscanini to Tennessee: Robert Riskin, the OWI and the Construction of American Propaganda in World War II," *Journal of American Studies* 40 (2006), 350–52.

33. Ibid.

34. Ibid., 353–57.

35. "Two documentary films," by Charles Olson, 1946–48, Box 85, Dodd.

36. Clark, *Olson*, 75–83. Horten suggests that a key transformation between the late 1930 and postwar years involving the "reaffirmation of corporate dominance over the civic sphere" was due in large part to the organization of wartime radio propaganda (Horten, *Radio Goes to War*, 3, 83–85).

37. Clark Foreman, "Statement of the NCPAC," *Antioch Review* 4, no. 3 (autumn 1944), 474. Concerns about the majority's complete body remained intensely interesting to Olson throughout his lifetime. His Maximus persona might also be described as a majority body of palpable integrity.

38. For a discussion of the New Deal's transformation into a more corporate-friendly liberalism throughout the 1940s, see Alan Binkley, *The End of Reform: New Deal Liberalism in Recession and War* (New York: Knopf, 1995), 137–74.
39. Typescript, "Religious, Racial and National Origin Factors," by Charles Olson, 1946 ca. May, Box 35, 9, Dodd.
40. Olson to Oscar Lange, September 14, 1945, in *Selected Letters of Charles Olson*, ed. Ralph Maud (Berkeley: University of California Press, 2000), 43.
41. Olson, "Religious, Racial and National Origin Factors."
42. Clark, *Olson*, 93–95; typescript, "Mouths Biting Empty Air," by Charles Olson, October 27, 1946, Box 32, 1630, Dodd. Compare to "Projective Verse," *OPr* 241.
43. Letter to F. O. Matthiessen by Charles Olson, February 2, 1946, Box 193, Dodd.
44. The *Collected Prose*'s topical, nonchronological divisions inadvertently camouflage Olson's gradual transition from party politics to avant-garde poetics in part by omitting unpolished political texts such as the aforementioned "Culture and Revolution" (1952) and his NCPAC political lecture (1946), both unpublished to this day.
45. Typescript, "Projective Verse, early draft," by Charles Olson, 1950, Box 34, Dodd.
46. Olson, "Two documentary films."
47. "Gli Amanti" ["The Lovers"], in *Charles Olson and Frances Boldereff: A Modern Correspondence*, ed. Ralph Maud and Sharon Thesen (Hanover: Wesleyan University Press, 1999), 384–85.
48. Ibid., 384.
49. Ibid., 385.
50. Ibid., 384.
51. Because "Gli Amanti" was never intended for publication, it might have been meant as a private love poem—Olson searching for a way to convey his particular "I love you" to Frances Boldereff. Yet on the same day he sent the poem to Boldereff, he also sent off the original to Robert Creeley (his friend and fellow scholar-poet) for suggestions—while Boldereff received the carbons (ibid., 384 n. 24).
52. Olson, "Religious, Racial and National Origin Factors."
53. Olson, *Muthologos 2*, 74.
54. Olson, "Projective Verse, early draft."
55. Olson's poetry clearly owes much to Whitman's multitudes, a comparison Olson himself makes. But Olson's poetics differ from Whitman's both in the emphasis on the literal embodiment of the reader—where words are deemphasized in contrast to their visual play on the page—and in Olson's modernist concern with impersonality.
56. See also Robert Creeley, "Some Notes on Olson's Maximus," *Yūgen* 8 (1962): 51–55, who argues that Olson's careful substituting of "eye" for "I" shows that his interest in perspective is not the same as an interest in subjectivism. Robert Creeley, *The Collected Essays of Robert Creeley* (Berkeley: University of California Press, 1989), 111.
57. Here we also see how keenly receptive Olson was to Carl Sauer's revamping of modern geography by incorporating the cultural landscape and by emphasizing the skill and judgment of the individual geographer in selecting a place's distinguishing features. For discussions of Olson and mapping, see O. J. Ford, "Charles Olson and Carl Sauer: Towards a Methodology of Knowing," *boundary 2* 2, no. 1–2 (1973 fall/1974 winter), 145–50; Penny Tselentis-Apostolidis, "On Olson's Geographic Methodology: Quoting, Naming, Pacing and Mapping," *Sagtrieb* 12, no. 2 (fall 1993), 119–36; and Christian Moraru, "'Topos/Typos/Tropos': Visual

Strategies and the Mapping of Space in Charles Olson's Poetry," *Word & Image* 14, no. 3 (July–September 1998), 253–66.

58. Ezra Pound, Canto LXXIV, in *The Cantos of Ezra Pound* (New York: New Directions, 1970), 439. For a discussion of Pound's periplum and the sailor's perspective, see Hugh Kenner, *The Pound Era* (Berkeley: University of California Press, 1971), 349–381.

59. Carroll F. Terrell, *A Companion to The Cantos of Ezra Pound* (Berkeley: University of California Press, 1980), 362–63, n. 12.

60. By titling this section, "On first Looking out through Juan de la Cosa's Eyes," an explicit reference to John Keats's sonnet, Olson models his relationship to the ancient mapmaker on Keats's relationship to the new version of Homer.

61. Daniel Dorling and David Fairbairn suggest that the early mappemunde (pre-1450) aimed not to show location but to tell a story; *Mapping: Ways of Representing the World* (Essex: Addison Wesley Longman, 1997), 13–14. De la Cosa's maps were a transition from these older narrative maps to navigational maps. For other discussions of de la Cosa and mapping see Daniel G. Hise, "Noticing Juan De La Cosa", *boundary 2* 2, no. 1/2 (fall 1973/winter 1974), 323–32; and Dewey, *Beyond Maximus*, 37. My reading particularly contrasts with Dewey's reading of the same passage as revealing Olson's social constructivist leanings. In contrast, I argue that Olson's montage of first impressions of the New World highlights the role of particular individual's physical perspectives in the creation of a new form of map.

62. Typescript, "Let's You and me be Chinese," by Charles Olson [ca. 1950], Box 21, 908, Dodd.

63. Ibid.

64. Ibid.

65. Ibid.

66. Olson, *Muthulogos 2*, 72. Olson's renewed interest in three-dimensional geometry (around the time he wrote "Projective Verse") might also have been related to the presence of Buckminster Fuller, who directed the 1949 Summer Institute at Black Mountain. See Clark, *Olson*, 226, and Mary Emma Harris, *The Arts at Black Mountain College* (Cambridge, Mass.: MIT Press, 1987), 158–63.

67. H. S. M. Coxeter, *Projective Geometry*, 2nd ed. (Toronto [Buffalo]: University of Toronto Press, 1974), 236.

68. The major difference between these two methods of representation is not mathematically substantial but aesthetically useful (Coxeter, *Projective Geometry*, 236). For Olson, this aesthetic value contributes to geometry's theoretical development because it impacts our perception and understanding of an abstract figure.

69. Olson, *Muthulogos 2*, 73.

70. Because Olson believed that culture is nothing more than the particularity of one person at one place in time, culture could be essentialized as an immigrant's perspective and literally captured by air: Paul Donchian breathing at his rug store in Hartford. See Charles Olson, *Muthologos: The Collected Lectures and Interviews*, vol. 1, ed. George F. Butterick (Bolinas: Four Seasons Foundation, 1978), 94. In fact, Coxeter and Olson were incorrect: Donchian graduated from Yale University.

71. Vladimir Wertsman, ed., *The Armenians in America, 1618–1976: A Chronology and Fact Book* (Ethnic Chronology Series no. 27) (Dobbs Ferry, N.Y.: Oceana Publications, 1978), 4.

72. Quoted in Butterick, *Guide*, 8–9.

73. Byrd suggests that it is only the third and last volume of *Maximus* that is "genu-inely political," with Olson advocating a view of citizenship that is nonideological and inclusive (Byrd, *Olson's Maximus*, 168, 198). In contrast, I suggest that Olson's understanding of politically preserved particularisms is a hallmark of his long career.
74. Creeley, "Some Notes."
75. Ibid., 52.
76. Ibid., 51.
77. Baraka, "The Largest Ocean in the World," *Yūgen* 8 (1962), 59.
78. Olson, "Place; & Names," *Yūgen* 8 (1962), 60.
79. Cohen is not discussed at length here, although her autobiography, Hettie Jones, *How I Became Hettie Jones* (New York: Grove Press, 1990), makes clear that she belongs in the broader story, as future studies might more amply show. For his-torical recovery of 1960s women poets, see also *Girls Who Wore Black: Women Writing the Beat Generation*, ed. Ronna C. Johnson and Nancy M. Grace (New Brunswick, N.J.: Rutgers University Press, 2002) and Nancy Grace and Ronna Johnson, *Breaking the Rule of Cool: Interviewing and Reading Women Beat Writers* (Jackson: University Press of Mississippi, 2004).
80. Nathaniel Mackey, *Discrepant Engagement: Dissonance, Cross-Culturality, and Ex-perimental Writing* (Cambridge: Cambridge University Press, 1993), 25. Or as Baraka put it, "I liked [Olson's poetry] a great deal, and I like the fact that he did take a stance in the real world, that the things he said had to do with some stuff that was happening outside of the poem as well as within the poem"; quoted in William Harris, *The Poetry and Poetics of Amiri Baraka: The Jazz Aesthetic* (Colum-bia: University of Missouri Press, 1985), 144.
81. From Harris's chronology in *The Baraka Reader*, xxxi.
82. By the late 1960s, Baraka was known for his racial and ideological militancy; more recently, he has become known for fomenting political controversy. His 9/11 poem was decried as anti-Semitic and after the succeeding debate, he refused to resign as poet laureate of New Jersey. See Piotr Gwiazda, "The Aes-thetics of Politics/The Politics of Aesthetics: Amiri Baraka's 'Somebody Blew Up America,'" *Contemporary Literature* 45, no. 3 (fall 2004), 460–85. On the relation-ship between Baraka's writing, black nationalism, and the Black Arts movement, see Philip Brian Harper, "Nationalism and Social Division in Black Arts Poetry of the 1960s," *Critical Inquiry* 19, no. 2 (winter 1993), 234–55; Komozi Woodard, *A Nation within a Nation: Amiri Baraka (LeRoi Jones) & Black Power Politics* (Chapel Hill: University of North Carolina Press, 1999), and James Smethurst, *The Black Art Movement: Literary Nationalism in the 1960s and 1970s* (Chapel Hill: Univer-sity of North Carolina Press, 2005). Responding to the controversy over the 9/11 poem, a special issue on Baraka in *African American Review* (2003) gathered to-gether twenty different perspectives on his long career, seeking to "move beyond his perpetual controversy" to explore his true poetic accomplishments (William J. Harris and Aldon Lynn Nielsen, "Somebody Blew off Baraka," *African American Review* 37, no. 2/3 [Summer-Autumn, 2003], 186). The essays complicate reduc-tive accounts of Baraka's work by illuminating little-known or unpublished work, disputing accounts of his political dogmatism, or linking his work and politics more clearly with the longer cultural history of the avant-garde.
83. "An Interview with Amiri Baraka," interviewed by Debra L. Edwards in 1979, collected in *Conversations*, ed. Reilly, 156. Baraka makes a similar point about *The System of Dante's Hell* in an interview with Kimberly Benston: "I was trying to get

away from the influence of people like Creeley and Olson. I was living in New York then and the whole Creeley-Olson influence was beginning to beat me up. I was in a very closed, little circle—that was about the time I went to Cuba—and I felt the need to break out of the type of form that I was using then. I guess this was not only because of the form itself but because of the content which that form enclosed, which was not my politics." Benston, "Amiri Baraka: An Interview," 304.

84. Baraka, *The Autobiography of LeRoi Jones* (Chicago: Lawrence Hill, 1984), 174.
85. Baraka, *Transbluency*, 34.
86. Ibid., 144.
87. Ibid.
88. Ibid.
89. Baraka [Jones], "Words," originally published in *Tales*. Reprinted in *The Baraka Reader*, ed. Harris, 178.
90. Ibid., 177.
91. Amiri Baraka and Diane di Prima, eds., *Floating Bear; a newsletter* 5 (1961), 41. Reprint, La Jolla, Calif.: Laurence McGilvery, 1973.
92. Ibid., 41.
93. Baraka [Jones], ed., *The Moderns: An Anthology of New Writing in America* (New York: Corinth, 1963), xii.
94. Baraka, *Transbluency*, 17.
95. Ibid., 19.
96. Baraka, "Brief reflections on two hot shots," originally published in *Kulchur*, 1963. Reprinted in Baraka [Jones], *Home: Social Essays* (New York: William Morrow, 1966), 118.
97. The fuller quotation explicitly mentions Olson: "A Negro writer, if he is to get at that place in his be-ing (a verb/participle) where art lives, must do as any other artist, i.e., find out what part of that be-ing is most valuable, and then transfer that energy (again paraphrasing Olson) from where he got it on over to any reader." Baraka, "Le roi jones talking," originally published in *New York: The Sunday Herald Tribune Magazine* (1964). Reprinted in Baraka [Jones], *Home*, 182.
98. Baraka [Jones], "The Screamers," in *The Moderns*, ed. Baraka [Jones], 290–96.
99. Ibid., 292.
100. Ibid., 295.
101. Ibid.
102. This is not to say that the impact of their real-world interventions were parallel. Putting into practice his *Blues People* argument, Baraka's Black Arts endeavors like the "Jazzmobile" (a truck and banquet stage amalgam that "delivered the new jazz to the people") sought to insert this music more directly into African American culture, while the OWI—if not exactly Olson's poetics—sought to use ethnic language station to spread nationalistic propaganda; see John Gennari, *Blowin' Hot and Cool: Jazz and Its Critics* (Chicago: University of Chicago Press, 2006), 258. Inadvertently, the OWI undermined the popularity of ethnic German and Italian radio stations by flooding them with so much propaganda that many immigrants quickly tuned out and switched off (Horten, *Radio Goes to War*, 76).
103. Baraka, "For Hettie," in *Preface to a Twenty Volume Suicide Note* (New York: Totem Press, 1961), 13.
104. Baraka, *Home*, 164.
105. Baraka, *Transbluency*, 136.

106. Ibid., 137.
107. Ibid., 142.
108. Donna Haraway, *Simians, Cyborgs, and Women: The Reinvention of Nature* (New York: Routledge, 1991), 195.
109. Bruce Robbins, *Feeling Global: Internationalism in Distress* (New York: New York University Press, 1999), 1.

CODA

Epigraph: Brenda Hillman, "Altamont Pass," *Pieces of Air in the Epic* (Middletown: Wesleyan University Press, 2005), 23.

1. Samuel Beckett, "Breath," in *Collected Shorter Plays* (New York: Grove, 1984), 209–12.
2. Damien Hirst, dir., "Breath," *Beckett on Film* [videorecording], Blue Angle Films; Tyrone Productions (London: Clarence Pictures, 2001).
3. Luce Irigaray, *The Forgetting of Air in Martin Heidegger*, trans. Mary Beth Mader (Austin, University of Texas Press, 1999), 5.
4. Charles Olson, *Muthologos, The Collected Lectures and Interviews*, vol. 1, ed. George F. Butterick (Bolinas: Four Seasons Foundation, 1978), 94.
5. Paul Gilroy, *The Black Atlantic: Modernity and Double Consciousness* (Cambridge, Mass.: Harvard University Press, 1993), 43; and *Against Race: Imagining a Political Culture beyond the Color Line* (Cambridge, Mass.: Harvard University Press, 2000), 30.
6. Judith Butler, "Wittig's Material Practice: Universalizing a Minority Point of View," *GLQ* 13, no. 4 (2007), 526.
7. Juliana Spahr, *This Connection of Everyone with Lungs* (Berkeley: University of California Press, 2005), 3.
8. Ibid., 4.
9. Ibid.
10. Spahr does not once use the word *air* in this poem. In fact, her entire book of poems about the post-9/11 political and cultural landscape largely avoids positive or even neutral uses of the word *air*. When the word appears—and begins to echo—in the book's final poem, it is through the technical idiom of contemporary warfare: "Air Force," "JSOW air-to-surface precision bombs," "air-blast bombs," "AIM-120 air-to-air missiles," "landing crafts, air cushioned" (ibid., 67, 72–75). Air is refigured as the medium that fuels air-to-surface bombs and makes modern long-distance aerial war possible.
11. Ibid., 9–10.
12. See World Trade Center Medical Working Group, *2009 Annual Report*, September 2009, http://www.nyc.gov/html/fdny/pdf/2009_wtc_medical_working_group_annual_report.pdf.
13. Spahr, *Connection*, 9.
14. William Safire, "No . . . Left Behind." *New York Times*, February 26, 2006, Magazine.
15. Spahr, *Connection*, 9.
16. Macabre images of merging, disintegrating, and dispersing bodies have appeared as a trope of post-9/11 literature. Don DeLillo's *Falling Man* (New York: Scribner, 2008) relates a similarly ghastly scene.
17. Judith Butler takes a similar argument a step further to claim that we are each and all connected to victims and survivors by our "common human vulnerability." Judith Butler, *Precarious Life: The Powers of Mourning and Violence* (London: Verso, 2004), 30–31.

18. Spahr, *Connection*, 10.
19. Judith Butler, "Restaging the Universal: Hegemony and the Limits of Formalism," in *Contingency, Hegemony, Universality: Contemporary Dialogues on the Left*, ed. Judith Butler, Ernesto Laclau, and Slavoj Žižek (London: Verso, 2000), 37.
20. Hayden Carruth, "Particularity," in *Scrambled Eggs and Whiskey: Poems, 1991– 1995* (Port Townsend: Copper Canyon Press, 1996), 52.
21. Ibid.
22. Ibid.
23. My discussion of this passage is based on Žižek's account in *The Parallax View* (Cambridge, Mass.: MIT Press, 2006), 22.
24. Leslie Marmon Silko, *Yellow Woman and the Beauty of the Spirit: Essays on Native American Life Today* (New York: Simon and Schuster, 1996), 18–19.
25. Ibid., 18.
26. Ibid., 169.
27. Kim Barnes, "A Leslie Marmon Silko Interview," *Journal of Ethnic Studies* 13, no. 4 (1986), 71–72.
28. Leslie Marmon Silko, *Sacred Water: Narratives and Pictures* (Tucson: Flood Plain Press, 1994), 84.
29. Silko, *Yellow*, 19.
30. Dipesh Chakrabarty, *Provincializing Europe: Postcolonial Thought and Historical Difference* (Princeton, N.J.: Princeton University Press, 2000), 18.
31. Gilroy, *Black Atlantic*, 45.
32. Lisa Lowe, *Immigrant Acts: On Asian American Cultural Politics* (Durham, N.C.: Duke University Press, 1996), 2.
33. Ibid., 59.
34. Alain Badiou's *Saint Paul: The Foundation of Universalism* (trans. Ray Brassier; Stanford, Calif.: Stanford University Press, 2003), Slavoj Žižek's *The Ticklish Subject: The Absent Centre of Political Ontology* (London: Verso, 1999) and *Parallax*, Etienne Balibar's *Politics and the Other Scene* (trans. Christine Jones, James Swenson, Chris Turner; London: Verso, 2002), and the extended dialogue between Žižek, Ernesto Laclau, and Judith Butler in *Contingency, Hegemony, Universality* (London: Verso, 2000), variously take up this problem.
35. Slavoj Žižek's discussion of the term is even more adamant in his defense of French critics like himself who "are slandered, by neoconservatives as well as by the newly appointed guardians of universal reason, as those who undermine the very ethical fundaments of our societies . . . this slandered group . . . from Gilles Deleuze to Alain Badiou, are engaged in the same task of *practicing concrete universality*"; "A Plea for a Return to Différance (with a Minor Pro Domo Sua)," *Critical Inquiry* 32, no. 2 (2006), 249.
36. Badiou, *Saint Paul*, 106.
37. Ibid., 14.
38. Ibid., 11.
39. Ibid., 88.
40. Ibid., 63.
41. Ibid., 64.
42. Butler, "Wittig," 527. See also Butler, *Giving an Account of Oneself* (New York: Fordham University Press, 2005), 6–7.
43. Monique Wittig, *The Straight Mind and Other Essays* (Boston: Beacon Press, 1992), 67.

44. Butler, "Wittig," 522.

45. Ibid., 524.

46. Ibid., 526.

47. Butler, "Restaging the Universal," 39. For a critique, see Walter Benn Michaels, *The Shape of the Signifier: 1967 to the End of History* (Princeton, N.J.: Princeton University Press, 2004), 31.

48. Michaels, *Shape*, 31.

49. Žižek, *Parallax*, 29.

50. To take one example: we noted in the first chapter that Spahr's literary critical work, *Everybody's Autonomy: Connective Reading and Collective Identity*, interprets Stein according to a poetics similar to Spahr's own. But one consequence of my argument requires us to situate a text of breathly incorporation such as "Poem Written After September 11, 2001" entirely against Stein's conception of meaning's autonomy.

51. Willa Cather, *Song of the Lark* (1915; New York: Signet, 2007), 212–13.

52. Lynn Dumenil, *The Modern Temper: American Culture and Society in the 1920s* (New York: Hill and Wang, 1995), 31.

53. Christine Macel, "'airs de paris' instructions for use," trans. Simon Pleasance and Fronza Woods. "Airs de Paris" Brochure (Centre Pompidou Exhibition, April 25–August 15, 2007), 1.

BIBLIOGRAPHY

Adorno, Theodor. "On Lyric Poetry and Society." In *Notes to Literature*, vol. 1. Ed. Rolf Tiedemann, trans. Shierry Weber Nicholsen, 37–54. New York: Columbia University Press, 1991.

———. *Aesthetic Theory: Newly Translated*. Ed. and trans. Robert Hullot-Kentor. Minneapolis: University of Minnesota Press, 1997.

———. *The Complete Correspondence, 1928–1940*. Ed. Henri Lonitz, trans. Nicholas Walker. Cambridge, Mass.: Harvard University Press, 1999.

Agee, James and Walker Evans. *Let Us Now Praise Famous Men*. Boston: Houghton Mifflin, 1941.

Aitken, Doug. *Broken Screen: 26 Conversations with Doug Aitken; Expanding the Image, Breaking the Narrative*. Ed. Noel Daniel. New York: Dia Arts Press, 2006.

Alberti, Leon Battista. *On Painting*. Trans. John R. Spencer. New Haven, Conn.: Yale University Press, 1956.

Allen, Donald, M., ed. *The New American Poetry: 1945–1960*. New York: Grove Press, 1960.

Altieri, Charles. *Painterly Abstraction in Modernist American Poetry: The Contemporaneity of Modernism*. Cambridge: Cambridge University Press, 1989.

———. "Why Modernist Claims for Autonomy Matter." *Journal of Modern Literature* 32, no. 3 (spring 2009): 1–21.

Apollinaire, Guillaume. *Les Peintres cubists [The Cubist Painters]*. Trans. Peter Read. Berkeley: University of California Press, 2004.

Ashbery, John. *Reported Sightings: Art Chronicles, 1957–1987*. Ed. David Bergman. Cambridge, Mass.: Harvard University Press, 1991.

Ashton, Jennifer. *From Modernism to Postmodernism: American Poetry and Theory in the Twentieth Century*. Cambridge: Cambridge University Press, 2005.

Auden, W(ystan). H(ugh). *The English Auden: Poems, Essays, and Dramatic Writings 1927–1939*. London: Faber, 1977.

Ayers, David. *Wyndham Lewis and Western Man*. New York: St. Martin's, 1992.

Badiou, Alain. *Saint Paul: The Foundation of Universalism*. Trans. Ray Brassier. Stanford, Calif.: Stanford University Press, 2003.

Baldassari, Anne. *Picasso and Photography: The Dark Mirror*. Trans. Deke Dusinberre. Houston: Flammarion, 1997.

Balibar, Étienne. *Politics and the Other Scene*. Trans. Christine Jones, James Swenson, and Chris Turner. London: Verso, 2002.

Baraka, Amiri [LeRoi Jones]. *Preface to a Twenty Volume Suicide Note*. New York: Totem Press, 1961.

———. "The Largest Ocean in the World." *Yūgen* 8 (1962): 59.

————. *Blues People: Negro Music in White America*. New York: William Morrow, 1963. [*BP*]

————. *Home: Social Essays*. New York: William Morrow, 1966.

————. *The Autobiography of LeRoi Jones*. Chicago: Lawrence Hill, 1984.

————. *The LeRoi Jones/Amiri Baraka Reader*, 2nd ed. Ed. William J. Harris. New York: Thunder's Mouth Press, 1991.

————. *Transbluency: The Selected Poems of Amiri Baraka/LeRoi Jones (1961–1995)*. Ed. Paul Vangelisti. New York: Marsilio Press, 1995.

————, ed. *The Moderns: An Anthology of New Writing in America*. New York: Corinth, 1963.

Baraka, Amiri, and Diane di Prima, eds. *Floating Bear; a newsletter*, nos. 1–37 (1961–69). Reprint, La Jolla, Calif.: Laurence McGilvery, 1973.

Barnes, Kim. "A Leslie Marmon Silko Interview." *Journal of Ethnic Studies* 13, no. 4 (1986): 83–105.

Bateson, Frederick Wilse. *Essays in Critical Dissent*. London: Longman, 1972.

Baym, Nina, et al., eds. *The Norton Anthology of American Literature*, 4th ed. New York: Norton, 1994.

Beasley, Rebecca. "Wyndham Lewis and Modernist Satire." In *The Cambridge Companion to the Modernist Novel*, ed. Morag Shiach, 126–36. Cambridge: Cambridge University Press, 2007.

Beck, John. *Writing the Radical Center: William Carlos Williams, John Dewey, and American Cultural Politics*. Albany: State University Press of New York, 2001.

Beckett, Samuel. *Collected Shorter Plays*. New York: Grove Press, 1984.

Benhaim, Andre. "From Baalbek to Baghdad and Beyond: Marcel Proust's Foreign Memories of France." *Journal of European Studies* 35, no. 1 (2005): 87–101.

Benjamin, Walter. *Selected Writings*, 4 vols. Ed. Howard Eiland and Michael W. Jennings, trans. Edmund Jephcott et al. Cambridge, Mass.: Belknap Press of Harvard University Press, 1996.

————. *The Arcades Project*. Trans. Howard Eiland and Kevin McLaughlin. Cambridge, Mass.: Belknap Press of Harvard University Press, 1999.

Benston, Kimberly. "Amiri Baraka: An Interview." *boundary 2* 26, no. 2 (winter 1978): 303–16.

Bentham, Jeremy. *The Principles of Morals and Legislation*. Amherst, N.Y.: Prometheus Books, 1988.

Bergman, Merrie, James Moor, and Jack Nelson. *The Logic Book*. New York: Random House, 1980.

Berry, Ellen. *Curved Thought and Textual Wandering: Gertrude Stein's Postmodernism*. Ann Arbor: University of Michigan Press, 1992.

Binkley, Alan. *The End of Reform: New Deal Liberalism in Recession and War*. New York: Knopf, 1995.

Bishop, Elizabeth. *The Complete Poems, 1927–1979*. New York: Farrar, Straus, Giroux, 1983. [*CP*]

————. *The Collected Prose*. Ed. Robert Giroux. New York: Farrar, Straus, Giroux, 1984.

————. *One Art: Letters*. Ed. Robert Giroux. New York: Farrar, Straus, Giroux, 1994.

————. *Exchanging Hats: Paintings*. Ed. William Benton. New York: Farrar, Straus, Giroux, 1996.

————. *Poems, Prose, and Letters*. Ed. Robert Giroux and Lloyd Schwartz. New York: Library of America, 2008.

Blackwell, Henry. "Amiri Baraka's Letters to Charles Olson." *Resources for American Literary Study* 10, no. 1 (spring 1980): 56–70.

Blau duPlessis, Rachel. *Blue Studios: Poetry and its Cultural Work*. Tuscaloosa: University of Alabama Press, 2006.

Bois, Yve-Alain. "The Semiology of Cubism." In *Picasso and Braque: A Symposium*, ed. Lynn Zelevansky. New York: Abrams, 1992.

———. *Painting as Model*. Cambridge, Mass.: MIT Press, 1995.

Boone, April. "William Carlos Williams's *The Great American Novel*: Flamboyance and the Beginning of Art." *William Carlos Williams Review* 26, no. 1 (spring 2006): 1–25.

Bourdieu, Pierre. *The Rules of Art: Genesis and Structure of the Literary Field*. Trans. Susan Emanuel. Stanford, Calif.: Stanford University Press, 1995.

Breslin, James. *William Carlos Williams: An American Artist*. New York: Oxford University Press, 1970.

Brown, Bill. *A Sense of Things: The Object Matter of American Literature*. Chicago: University of Chicago Press, 2003.

Brown, Nicholas. "Cognitive Map, Aesthetic Object, or National Allegory? *Carpenter's Gothic*." In *Paper Empire: William Gaddis and the World System*, ed. Joseph Tabbi and Rone Shavers, 151–60. Tuscaloosa: University of Alabama Press, 2007.

———. *Utopian Generations: The Political Horizon of Twentieth-Century Literature*. Princeton, N.J.: Princeton University Press, 2006.

Bürger, Peter. *Theory of the Avant-Garde*. Trans. Michael Shaw. Minneapolis: University of Minnesota Press, 1984.

Burke, Carolyn. "Gertrude Stein, the Cone Sisters, and the Puzzle of Female Friendship." *Critical Inquiry* 8, no. 3 (1982): 543–64.

———. *Becoming Modern: The Life of Mina Loy*. New York: Farrar, Straus, Giroux, 1996.

Burstein, Jessica. "Waspish Segments: Lewis, Prosthesis, Fascism." *Modernism/Modernity* 4, no. 2 (1997): 139–64.

Bush, Ann Marie and Louis D. Mitchell. "Jean Toomer: A Cubist Poet." *Black American Literature Forum* 17, no. 3 (fall 1983): 106–8.

Butler, Judith. "Restaging the Universal: Hegemony and the Limits of Formalism" and "Competing Universalities." In *Contingency, Hegemony, Universality*, ed. Judith Butler, Ernesto Laclau, and Slavoj Žižek, 11–43, 136–81. London: Verso, 2000.

———. *Precarious Life: The Powers of Mourning and Violence*. London: Verso, 2004.

———. *Giving an Account of Oneself*. New York: Fordham University Press, 2005.

———. "Wittig's Material Practice: Universalizing a Minority Point of View." *GLQ* 13, no. 4 (2007): 519–33.

Butterick, George, ed. *A Guide to The Maximus Poems of Charles Olson*. Berkeley: University of California Press, 1978.

Byrd, Don. *Charles Olson's "Maximus."* Urbana: University of Illinois Press, 1980.

Cabanne, Pierre. *Dialogues with Marcel Duchamp*. Trans. Ron Padgett. New York: Viking Press, 1971.

Calinescu, Matei. *Five Faces of Modernity: Modernism, Avant-Garde, Decadence, Kitsch, Postmodernism*. Durham, N.C.: Duke University Press, 1987.

Caracciolo, Peter L. "'Carnivals of Mass-Murder': The Frazerian Origins of Wyndham Lewis's *The Childermass*." In *Sir James Frazer and the Literary Imagination*, ed. Robert Fraser, 207–31. London: Macmillan, 1990.

Carnap, Rudolf. *The Logical Syntax of Language*. 1937; rpt. London: Routledge and Kegan Paul, 1971.

Carruth, Hayden. *Scrambled Eggs and Whiskey: Poems, 1991–1995*. Port Townsend: Copper Canyon Press, 1996.

Casetti, Francesco. *Eye of the Century: Film, Experience, Modernity*. New York: Columbia University Press, 2008.

Cather, Willa. *Song of the Lark*. 1915; rpt. New York: Signet, 2007.

Causey, Andrew. "The Hero and the Crowd: The Art of Wyndham Lewis in the Twenties." In *Volcanic Heaven: Essays on Wyndham Lewis's Painting and Writing*, ed. Paul Edwards, 87–102. Santa Rosa: Black Sparrow Press, 1996.

Chakrabarty, Dipesh. *Provincializing Europe: Postcolonial Thought and Historical Difference*. Princeton, N.J.: Princeton University Press, 2000.

Chessman, Harriet Scott. *The Public Is Invited to Dance: Representation, the Body, and Dialogue in Gertrude Stein*. Stanford, Calif.: Stanford University Press, 1989.

Chinitz, David. *T.S. Eliot and the Cultural Divide*. Chicago: University of Chicago Press, 2003.

Chodat, Robert. *Worldly Acts and Sentient Things: The Persistence of Agency from Stein to DeLillo*. Ithaca, N.Y.: Cornell University Press, 2008.

Churchill, Suzanne. *The Little Magazine "Others" and the Renovation of Modern American Poetry*. Aldershot: Ashgate, 2006.

Clark, Tom. *Charles Olson: The Allegory of a Poet's Life*. Berkeley: North Atlantic Books, 2000.

Cohen, Milton. "Stumbling into Crossfire: William Carlos Williams, *Partisan Review*, and the Left in the 1930s." *Journal of Modern Literature* 32, no. 2 (winter 2009): 143–58.

Cohen, Philip. "*The Waste Land*, 1921: Some Developments of the Manuscript's Verse," *Journal of the Midwest Modern Language Association* 19, no. 1 (spring 1986): 12–20.

Coleridge, Samuel Taylor. *Complete Works of Samuel Taylor Coleridge*, vol. 1. Ed. Ernest Hartley Coleridge. Oxford: Clarendon Press, 1912.

Corbett, David Peters. "History, Art and Theory in *Time and Western Man*." In *Volcanic Heaven: Essays on Wyndham Lewis's Painting and Writing*, ed. Paul Edwards, 103–22. Santa Rosa: Black Sparrow Press, 1996.

Coxeter, H. S. M. *Projective Geometry*, 2nd ed. Toronto [Buffalo]: University of Toronto Press, 1974.

Crary, Jonathan. *Suspensions of Perception: Attention, Spectacle, and Modern Culture*. Cambridge, Mass.: MIT Press, 1999.

Creeley, Robert. "Some Notes on Olson's Maximus." *Yūgen* 8 (1962): 51–55.

———. *The Collected Essays of Robert Creeley*. Berkeley: University of California Press, 1989.

Crow, Thomas. *Modern Art in the Common Culture: Essays*. New Haven, Conn.: Yale University Press, 1996.

Cruse, Harold. *The Crisis of the Negro Intellectual*. New York: Morrow, 1967.

Cunningham, Valentine. *Reading after Theory*. Oxford: Blackwell, 2002.

Curnutt, Kirk. "Inside and Outside: Gertrude Stein on Identity, Celebrity, and Authenticity." *Journal of Modern Literature* 23, no. 2 (1999–2000): 291–308.

Danius, Sara. *The Senses of Modernism: Technology, Perception, and Aesthetics*. Ithaca, N.Y.: Cornell University Press, 2002.

Danto, Arthur C. *After the End of Art: Contemporary Art and the Pale of History*. Princeton, N.J.: Princeton University Press, 1997.

Dasenbrock, Reed Way. *The Literary Vorticism of Ezra Pound and Wyndham Lewis: Towards the Condition of Painting*. Baltimore, Md.: Johns Hopkins University Press, 1985.

————. "Wyndham Lewis's Fascist Imagination and the Fiction of Paranoia." In *Fascism, Aesthetics, and Culture*, ed. Richard J. Goslan, 81–97. Hanover: University Press of New England, 1992.

Da Vinci, Leonardo. *The Notebooks of Leonardo da Vinci*, vol. 2. Ed. Edward MacCurdy. New York: Reynal and Hitchcock, 1938.

DeKoven, Marianne. *A Different Language: Gertrude Stein's Experimental Writing*. Madison: University of Wisconsin Press, 1983.

DeLillo, Don. *Falling Man*. New York: Scribner, 2008.

Denning, Michael. *The Culture Front: The Laboring of American Culture in the Twentieth Century*. London: Verso, 1996.

Derrida, Jacques. *The Truth in Painting*. Trans. Geoff Bennington and Ian McLeod. Chicago: University of Chicago Press, 1987.

Detloff, Madelyn. *The Persistence of Modernism: Loss and Mourning in the Twentieth Century*. Cambridge: Cambridge University Press, 2009.

Dewey, Ann Day. *Beyond Maximus: The Construction of Public Voice in Black Mountain Poetry*. Stanford, Calif.: Stanford University Press, 2007.

Dijkstra, Bram. *Cubism, Stieglitz, and the Early Poetry of William Carlos Williams*. Princeton, N.J.: Princeton University Press, 1969.

————, ed. *A Recognizable Image: William Carlos Williams on Art and Artists*. New York: New Directions, 1978.

di Prima, Diane, and Amiri Baraka [LeRoi Jones], eds. *Floating Bear; a newsletter*, numbers 1–37 (1961–1969). Rpt., La Jolla, Calif.: Laurence McGilvery, 1973.

Dolnick, Edward. *The Forger's Spell: A True Story of Vermeer, Nazis, and the Greatest Art Hoax of the Twentieth Century*. New York: Harper, 2008.

Dorfles, Gillo, ed. *Kitsch, the World of Bad Taste*. New York: Universe Books, 1969.

Dorling, Daniel, and David Fairbairn. *Mapping: Ways of Representing the World*. Essex: Addison Wesley Longman, 1997.

Douglas, William O. *The Right of the People*. New York: Doubleday, 1958.

Dubnick, Randa. *The Structure of Obscurity: Gertrude Stein, Language, and Cubism*. Urbana: University of Illinois Press, 1984.

Duchamp, Marcel. *The Writings of Marcel Duchamp*. Ed. Michel Sanouillet and Elmer Peterson. New York: Da Capo Press, 1973. (Originally published as *Salt Seller: The Writings of Marcel Duchamp*. New York: Oxford University Press, 1973.)

Dumenil, Lynn. *The Modern Temper: American Culture and Society in the 1920s*. New York: Hill and Wang, 1995.

Dutton, Denis, ed. *The Forger's Art*. Berkeley: University of California Press, 1983.

Dydo, Ulla E., and William Rice. *Gertrude Stein: The Language That Rises, 1923–1934*. Evanston, Ill.: Northwestern University Press, 2003.

Eagleton, Terry. *The Ideology of the Aesthetic*. Oxford: Basil Blackwell, 1990.

East, James H., ed. *Humane Particulars: The Collected Letters of William Carlos Williams and Kenneth Burke*. Columbia: University of South Carolina Press, 2003.

Edwards, Paul. *Wyndham Lewis: Painter and Writer*. New Haven, Conn.: Yale University Press, 2000.

————. "Afterword." In Wyndham Lewis, *The Vulgar Streak*. 241–53. Santa Barbara: Black Sparrow Press, 1985.

————, ed. *Volcanic Heaven: Essays on Wyndham Lewis's Painting and Writing*. Santa Rosa: Black Sparrow Press, 1996.

Eliot, T(homas). S(tearns). *The Sacred Wood: Essays on Poetry and Criticism*. London: Methuen, 1928.

———. *Selected Prose of T.S. Eliot*. Ed. Frank Kermode. New York: Farrar, Straus, Giroux, 1965.

Ellison, David. *Ethics and Aesthetics in European Modernist Literature*. Cambridge: Cambridge University Press, 2001.

Erkkila, Betsy. "Elizabeth Bishop, Modernism, and the Left." *American Literary History* 9, no. 2 (1996): 284–310.

Eysteinsson, Ástrádur. *The Concept of Modernism*. Ithaca, N.Y.: Cornell University Press, 1990.

Feijó, António M. *Near Miss: A Study of Wyndham Lewis (1909–1930)*. New York: Peter Lang, 1998.

Ferguson, Frances. *Solitude and the Sublime: Romanticism and the Aesthetics of Individuation*. New York: Routledge, 1992.

Filreis, Alan. *Counter-Revolution of the Word: The Conservative Attack on Modern Poetry, 1945–1960*. Chapel Hill: University of North Carolina Press, 2008.

Folsom, Ed, and Cary Nelson, eds. *W.S. Merwin, Regions of Memory: Uncollected Prose, 1949–82*. Urbana: University of Illinois Press, 1987.

Foner, Eric. *The Story of American Freedom*. New York: Norton, 1998.

Ford, O. J. "Charles Olson and Carl Sauer: Towards a Methodology of Knowing." *boundary* 2 2, no. 1–2 (1973 fall/1974 winter): 145–50.

Foreman, Clark. "Statement of the NCPAC." *Antioch Review* 4, no. 3 (autumn 1944): 473–75.

Foshay, Toby. *Wyndham Lewis and the Avant-Garde: The Politics of the Intellect*. Montreal: McGill-Queen's University Press, 1992.

Foster, Hal. "The ABCs of Contemporary Design." *October* 101 (2002): 191–99.

Fox, C. J., and Robert Edward Murray. "The War Fiction." In *Volcanic Heaven: Essays on Wyndham Lewis's Painting and Writing*, ed. Paul Edwards, 65–86. Santa Rosa: Black Sparrow Press, 1996.

Fredman, Stephen. *Grounding of American Poetry*. Cambridge: Cambridge University Press, 1993.

Fried, Michael. *Absorption and Theatricality: Painting and Beholder in the Age of Diderot*. Chicago: University of Chicago Press, 1980.

———. *Art and Objecthood: Essays and Reviews*. Chicago: University of Chicago Press, 1998. [AO]

Friedlander, Max. *Art and Connoisseurship*. Oxford: Bruno Cassierer, 1942.

Gaddis, William. *The Recognitions*. 1955; rpt. New York: Penguin, 1985. [R]

———. *J R*. New York: Penguin, 1975.

———. *A Frolic of His Own*. New York: Poseidon, 1994.

———. William Gaddis Papers, Washington University in St. Louis, Missouri. Special Collections Library.

Galow, Timothy. "Gertrude Stein's *Everybody's Autobiography* and the Art of Contradictions." *Journal of Modern Literature* 32, no. 1 (2008): 111–28.

Gammel, Irene. *Baroness Elsa: Gender, Dada, and Everyday Modernity: A Cultural Biography*. Cambridge, Mass.: MIT Press, 2003.

Gass, William. *The World within the Word*. New York: Knopf, 1978.

Gennari, John. *Blowin' Hot and Cool: Jazz and Its Critics*. Chicago: University of Chicago Press, 2006.

Gibbon, Edward. *The History of the Decline and Fall of the Roman Empire*, vol. 1, 2nd ed. London: W. Strahan and T. Cadell, 1776.

Gilbert, Geoff. "Shellshock, Anti-Semitism, and the Agency of the Avant-Garde." In *Wyndham Lewis and the Art of Modern War*, ed. David Peters Corbett, 78–98. Cambridge: Cambridge University Press, 1998.

Gilroy, Paul. *The Black Atlantic: Modernity and Double Consciousness*. Cambridge, Mass.: Harvard University Press, 1993.

——. *Against Race: Imagining a Political Culture beyond the Color Line*. Cambridge, Mass.: Harvard University Press, 2000.

Golding, Alan. "What about All This Writing: Williams and Alternative Poetics." *Textual Practice* 18, no. 2 (2004): 265–82.

Goodman, Nelson. *Languages of Art*, 2nd ed. Indianapolis: Hackett, 1976.

Grace, Nancy, and Ronna Johnson. *Breaking the Rule of Cool: Interviewing and Reading Women Beat Writers*. Jackson: University Press of Mississippi, 2004.

Graff, Gerald. *Professing Literature: An Institutional History*, 20th anniversary ed. Chicago: University of Chicago Press, 2007.

Gray, Jeffrey. *Mastery's End: Travel and Postwar American Poetry*. Athens: University of Georgia Press, 2005.

Greenberg, Clement. *Art and Culture: Critical Essays*. Boston: Beacon Press, 1961.

——. *Collected Essays and Criticism: Vols. 1–4*. Chicago: University of Chicago Press, 1986–93.

Griffiths, Alison. *Shivers Down Your Spine: Cinema, Museums, and the Immersive View*. New York: Columbia University Press, 2008.

Gross, Jennifer R., ed. *The Société Anonyme: Modernism for America*. New Haven, Conn.: Yale University Press, 2006.

Guilbaut, Serge. *How New York Stole the Idea of Modern Art: Abstract Expressionism, Freedom, and the Cold War*. Trans. Arthur Goldhammer. Chicago: University of Chicago Press, 1983.

Guillory, John. *Cultural Capital: The Problem of Literary Canon Formation*. Chicago: University of Chicago Press, 1993.

Gwiazda, Piotr. "The Aesthetics of Politics/The Politics of Aesthetics: Amiri Baraka's 'Somebody Blew Up America.'" *Contemporary Literature* 45, no. 3 (fall 2004): 460–85.

Halter, Peter. *The Revolution in the Visual Arts and the Poetry of William Carlos Williams*. Cambridge: Cambridge University Press, 1994.

Hanna, Juliana. "Blasting after Blast: Wyndham Lewis's Late Manifestos." *Journal of Modern Literature* 31, no. 1 (2007): 124–35.

Hansen, Miriam Bratu. "Room-for-Play: Benjamin's Gamble with Cinema." *October* 109 (summer 2004): 3–45.

——. "Benjamin's Aura." *Critical Inquiry* 34, no. 2 (2008): 336–75.

Haraway, Donna. *Simians, Cyborgs, and Women: The Reinvention of Nature*. New York: Routledge, 1991.

Harper, Philip Brian. "Nationalism and Social Division in Black Arts Poetry of the 1960s." *Critical Inquiry* 19, no. 2 (winter 1993): 234–55.

Harris, Mary Emma. *The Arts at Black Mountain College*. Cambridge, Mass.: MIT Press, 1987.

Harris, William. *The Poetry and Poetics of Amiri Baraka: The Jazz Aesthetic*. Columbia: University of Missouri Press, 1985.

Harris, William J., and Aldon Lynn Nielsen. "Somebody Blew off Baraka," *African American Review*, 37, no. 2/3 (summer-autumn 2003): 183–88.

Harrison, Charles. *English Art and Modernism: 1900–1939*. New Haven, Conn.: Yale University Press, 1981.

Harrison, Victoria. *Elizabeth Bishop's Poetics of Intimacy*. Cambridge: Cambridge University Press, 1993.

Hewitt, Andrew. *Fascist Modernism: Aesthetics, Politics, and the Avant Garde*. Stanford, Calif.: Stanford University Press, 1993.

Hickman, Miranda. *The Geometry of Modernism: The Vorticist Idiom in Lewis, Pound, H.D., and Yeats.* Austin: University of Texas Press, 2005.

Hillman, Brenda. *Pieces of Air in the Epic.* Middletown, Conn.: Wesleyan University Press, 2005.

Hirst, Damien, dir. "Breath." *Beckett on Film* [videorecording]. Blue Angle Films; Tyrone Productions. London: Clarence Pictures, 2001.

Hise, Daniel G. "Noticing Juan De La Cosa." *boundary* 22, no. 1/2 (fall 1973/winter 1974): 323–32.

Hoffman, Michael J. *Development of Abstractionism in the Writings of Gertrude Stein.* Philadelphia: Pennsylvania University Press, 1965.

Horten, Gerd. *Radio Goes to War: The Cultural Politics of Propaganda during World War II.* Berkeley: University of California Press, 2003.

Howarth, Peter. "Eliot in the Underworld: The Politics of Fragmentary Form." *Textual Practice* 20, no. 3 (2006): 441–62.

Howe, Susan. *The Birth-Mark: Unsettling the Wilderness in American Literary History.* Hanover: Wesleyan University Press, 1993.

Huyssen, Andreas. *After the Great Divide: Modernism, Mass Culture, Postmodernism.* Bloomington: Indiana University Press, 1986.

Irigaray, Luce. *The Forgetting of Air in Martin Heidegger.* Trans. Mary Beth Mader. Austin: University of Texas Press, 1999.

Jacobs, Karen. *The Eye's Mind: Literary Modernism and Visual Culture.* Ithaca, N.Y.: Cornell University Press, 2001.

Jameson, Fredric. *Fables of Aggression: Wyndham Lewis, the Modernist as Fascist.* Berkeley: University of California Press, 1979.

———. *Postmodernism, or, The Cultural Logic of Late Capitalism.* Durham, N.C.: Duke University Press, 1991.

Jarrell, Randall. "On North & South." In *Elizabeth Bishop and Her Art,* ed. Lloyd Schwartz and Sybil P. Estess. Ann Arbor: University of Michigan Press, 1983.

Johnson, Bob. "'A Whole Synthesis of his Time': Political Ideology and Cultural Politics in the Writing of William Carlos Williams, 1929–1939." *American Quarterly* 54, no. 2 (June 2002): 179–215.

Johnson, Ronna C., and Nancy M. Grace, eds. *Girls Who Wore Black: Women Writing the Beat Generation.* New Brunswick, N.J.: Rutgers University Press, 2002.

Johnston, John. *Carnival of Repetition: Gaddis's "The Recognitions" and Postmodern Theory.* Philadelphia: University of Pennsylvania Press, 1990.

Jones, Caroline A. "The Mediated Sensorium." In *Sensorium: Embodied Experience, Technology, and Contemporary Art,* ed. Caroline A. Jones, 5–49. Cambridge, Mass.: MIT Press, 2006.

Jones, Hettie. *How I Became Hettie Jones.* New York: Grove Press, 1990.

Kahnweiler, Daniel-Henry. *Juan Gris: His Life and Work.* Rev. ed. Trans. Douglass Cooper. 1947; rpt. New York: Abrams, 1969.

Kalaidjian, Walter. *American Culture between the Wars: Revisionary Modernism and Postmodern Critique.* New York: Columbia University Press, 1993.

Kammen, Michael. *Sovereignty and Liberty: Constitutional Discourse in American Culture.* Madison: University of Wisconsin Press, 1988.

Kaprow, Allan. "Doctor MD." In *Marcel Duchamp,* ed. Anne d'Harnoncourt and Kynaston McShine. Greenwich, Conn.: New York Museum of Modern Art, New York Graphic Society, 1973.

Kane, Daniel. *All Poets Welcome: The Lower East Side Poetry Scene in the 1960s.* Berkeley: University of California Press, 2003.

Karl, Alissa. "Modernism's Risky Business: Gertrude Stein, Sylvia Beach, and American Consumer Capitalism." *American Literature* 80, no. 1 (2008): 83–109.

Kaufman, Robert. "Adorno's Social Lyric, and Literary Criticism Today: Poetics, Aesthetics, Modernity." In *The Cambridge Companion to Adorno*, ed. Tom Huhn, 354–75. Cambridge: Cambridge University Press, 2004.

———. "Aura Still." In *Walter Benjamin and Art*, ed. Andrew Benjamin, 121–47. London: Continuum, 2005.

Keller, Lynn. *Forms of Expansion: Recent Long Poems by Women*. Chicago: University of Chicago Press, 1997.

Kenner, Hugh. *Wyndham Lewis*. Norfolk, Conn.: New Directions, 1954.

———. *The Pound Era*. Berkeley: University of California Press, 1971.

Kent, Kathryn. *Making Girls into Women: American Women's Writing and the Rise of Lesbian Identity*. Durham, N.C.: Duke University Press, 2003.

Kerouac, Jack. *The Subterraneans*. New York: Grove Press, 1958.

Klein, Scott. *The Fictions of James Joyce and Wyndham Lewis: Monsters of Nature and Design*. Cambridge: Cambridge University Press, 1994.

Knight, Christopher. *Hints and Guesses: William Gaddis's Fiction of Longing*. Madison: University of Wisconsin Press, 1997.

Krauss, Rosalind. *The Originality of the Avant-Garde and Other Modernist Myths*. Cambridge, Mass.: MIT Press, 1985.

———. *The Optical Unconscious*. Cambridge. Mass.: MIT Press, 1993.

Ladd-Taylor, Molly. *Mother-Work: Women, Child Welfare, and the State, 1890–1930*. Urbana: University of Illinois Press, 1994.

Laurie, Clayton. *The Propaganda Warriors: America's Crusade against Nazi Germany*. Lawrence: University Press of Kansas, 1996.

LeClair, Tom. "An Interview with William Gaddis, circa 1980." In *Paper Empire: William Gaddis and the World System*, ed. Joseph Tabbi and Rone Shavers, 17–27. Tuscaloosa: University of Alabama Press, 2007.

Lee, Pamela M. *Chronophobia: On Time in the Art of the 1960s*. Cambridge, Mass.: MIT Press, 2004.

Lemons, J. Stanley. *The Woman Citizen: Social Feminism in the 1920s*. Urbana: University of Illinois Press, 1973.

Lénart-Cheng, Helga. "Autobiography as Advertisement: Why Do Gertrude Stein's Sentences Get under Our Skin?" *New Literary History* 34 (winter 2003): 119–31.

Levine, Steven Z. "The Window Metaphor and Monet's Windows." *Arts Magazine* 54, no. 3 (November 1979): 98–104.

Levy, Emanuel. *Vincente Minnelli: Hollywood's Dark Dreamer*. New York: St. Martin's, 2009.

Lewis, Pericles. *Modernism, Nationalism, and the Novel*. Cambridge: Cambridge University Press, 2000.

Lewis, Wyndham. *Paleface: The Philosophy of the "Melting Pot."* London: Chatto and Windus, 1929.

———. *The Diabolical Principle and the Dithyrambic Spectator*. London: Chatto and Windus, 1931.

———. *Childermass*. 1929; rpt. London: Methuen, 1956. [*Ch*]

———. *Wyndham Lewis on Art: Collected Writings 1913–1956*. Ed. Walter Michel and C. J. Fox. New York: Funk and Wagnalls, 1969.

———. *Wyndham Lewis: An Anthology of His Prose*. Ed. E. W. F. Tomlin. London: Methuen, 1969.

———. *Rude Assignment: An Intellectual Autobiography*. 1950. Rpt. ed. Toby Foshay. Santa Barbara: Black Sparrow Press, 1984.

———. *The Vulgar Streak*. Santa Barbara: Black Sparrow Press, 1985.

———. *Caliph's Design: Architects! Where Is Your Vortex?* Ed. Paul Edwards. Santa Barbara: Black Sparrow Press, 1986.

———. *Men without Art*. Ed. Seamus Cooney. Santa Rosa: Black Sparrow Press, 1987.

———. *Creatures of Habit and Creatures of Change: Essays on Art, Literature and Society 1914–1956*. Ed. Paul Edwards. Santa Rosa: Black Sparrow Press, 1989.

———. *Tarr: The 1918 Version*. Ed. Paul O'Keeffe. Santa Rosa: Black Sparrow Press, 1990.

———. *The Revenge for Love*. Ed. Reed Way Dasenbrock. Santa Rosa: Black Sparrow Press, 1991. [*RL*]

———. *Time and Western Man*. Ed. Paul Edwards. Santa Rosa: Black Sparrow Press, 1993. [*TWM*]

———. *Blast 1*. Ed. Wyndham Lewis. Santa Rosa: Black Sparrow Press, 1992.

———. *The Enemy: A Review of Art and Literature, Number 2 (1927) and Number 3 (1929)*. Ed. Wyndham Lewis; additional editing, David Peters Corbett. Santa Rosa: Black Sparrow Press, 1994.

———. Wyndham Lewis Collection. University at Buffalo, State University of New York.

Loesberg, Jonathan. *A Return to Aesthetics: Autonomy, Indifference, and Postmodernism*. Stanford, Calif.: Stanford University Press, 2005.

Loizeaux, Elizabeth Bergmann. *Twentieth-Century Poetry and the Visual Arts*. Cambridge: Cambridge University Press, 2008.

Lopez, Jonathan. *The Man Who Made Vermeers: Unvarnishing the Legend of Master Forger Han van Meegeren*. Orlando: Harcourt, 2008.

Lowe, Lisa. *Immigrant Acts: On Asian American Cultural Politics*. Durham, N.C.: Duke University Press, 1996.

Lowney, John. *The American Avant-Garde Tradition: William Carlos Williams, Postmodern Poetry, and the Politics of Cultural Memory*. Lewisburg: Bucknell University Press, 1997.

———. *History, Memory, and the Literary Left: Modern American Poetry, 1935–1968*. Iowa City: University of Iowa Press, 2006.

Loy, Mina. "Gertrude," *transatlantic review* 2, no. 4 (November 1924): 429–30.

———. *Lost Lunar Baedeker: Poems*. Ed. Roger L. Conover. New York: Noonday Press, 1996.

Macel, Christine. "'airs de paris' instructions for use." Trans. Simon Pleasance and Fronza Woods. "Airs de Paris" Brochure. Centre Pompidou Exhibition. April 25–August 15, 2007. Available online at http://www.centrepompidou.fr/PDF/Airs-deParis_ChristineMacel_en.pdf.

MacDonald, Dwight. "A Theory of Mass Culture." *Diogenes* 3 (summer 1953): 1–17. Rpt. in Bernard Rosenberg and David Manning, *Mass Culture: The Popular Arts in America*. Glencoe, Ill.: Free Press, 1958.

———. *Mass Cult and Mid Cult*. New York: Random House, 1961.

MacGowen, Christopher. *Williams Carlos Williams's Early Poetry: The Visual Arts Background*. Ann Arbor: University of Michigan Press, 1984.

Mackey, Nathaniel. *Discrepant Engagement: Dissonance, Cross-Culturality, and Experimental Writing*. Cambridge: Cambridge University Press, 1993.

Malcolm, Janet. "Gertrude Stein's War." *New Yorker*. June 2, 2003: 57–81.

Mao, Douglas. "A Shaman in Common: Lewis, Auden, and the Queerness of Liberalism." In *Bad Modernisms*, ed. Douglas Mao and Rebecca Walkowitz. 206–37. Durham, N.C.: Duke University Press, 2006.

Marcoci, Roxana, and Miriam Basilio. "Tempo" Brochure. June 29–September 9, 2002, MOMA/QNS. Available online at http://www.moma.org/exhibitions/2002/tempo/flash_content/Tempo.pdf.

Margolis, Joseph. "Art, Forgery, and Authenticity." In *The Forger's Art*, ed. Denis Dutton, 153–71. Berkeley: University of California Press, 1983.

Mariani, Paul. *William Carlos Williams: A New World Naked*. New York: McGraw-Hill, 1981.

Marinetti, Filippo Tommaso. "The Founding and Manifesto of Futurism." In *Manifesto: A Century of Isms*, ed. Mary Ann Caws, 185–89. Lincoln: University of Nebraska Press, 2001.

Markos, Donald W. *Ideas in Things: The Poems of William Carlos Williams*. Cranbury, N.J.: Associated University Press, 1994.

Marling, William. *William Carlos Williams and the Painters, 1909–1923*. Athens: Ohio University Press, 1982.

Marx, William. "The 20th Century: Century of Arrière-Gardes?" In *Europa! Europa? The Avant-Garde, Modernism, and the Fate of a Continent*, ed. Sascha Bru, Jan Baetens, et al., 59–71. Berlin: Walter de Gruyter, 2009.

Maud, Ralph, ed. *Selected Letters of Charles Olson*. Berkeley: University of California Press, 2000.

Maud, Ralph, and Sharon Thesen, eds. *Charles Olson and Frances Boldereff: A Modern Correspondence*. Hanover: Wesleyan University Press, 1999.

McCabe, Susan. *Elizabeth Bishop: Her Poetics of Loss*. University Park: Pennsylvania State University Press, 1994.

———. *Cinematic Modernism: Modernist Poetry and Film*. Cambridge: Cambridge University Press, 2005.

McCann, Sean. *Gumshoe America: Hard-Boiled Crime Fiction and the Rise and Fall of New Deal Liberalism*. Durham, N.C.: Duke University Press, 2000.

McGerr, Michael. *A Fierce Discontent: The Rise and Fall of the Progressive Movement in America, 1870–1920*. New York: Free Press, 2003.

McLaverty, James. "The Mode of Existence of Literary Works of Art: The Case of the *Dunciad Variorum*." *Studies in Bibliography* 37 (1984): 82–105.

Merwin, W[illiam]. S[tanley]. *W.S. Merwin, Regions of Memory: Uncollected Prose, 1949–82*. Ed. Ed Folsom and Cary Nelson. Urbana: University of Illinois Press, 1987.

Meyer, Steven. *Irresistible Dictation: Gertrude Stein and the Correlations of Writing and Science*. Palo Alto, Calif.: Stanford University Press, 2001.

Meyers, Jeffrey. *The Enemy: A Biography of Wyndham Lewis*. Boston: Routledge and Kegan Paul, 1980.

Michaels, Walter Benn. *The Shape of the Signifier: 1967 to the End of History*. Princeton, N.J.: Princeton University Press, 2004.

Miller, Cristanne. *Cultures of Modernism: Marianne Moore, Mina Loy, and Else Lasker-Schuler: Gender and Literary Community in New York and Berlin*. Ann Arbor: University of Michigan Press, 2005.

Miller, J. Hillis. *Poets of Reality: Six Twentieth-Century Writers*. Cambridge, Mass.: Harvard University Press, 1965.

Miller, Tyrus. *Late Modernism: Politics, Fiction, and the Arts between the World Wars*. Berkeley: University of California Press, 1999.

Millier, Brett. *Elizabeth Bishop; Life and the Memory of It*. Berkeley: University of California Press, 1993.

Mink, Janis. *Marcel Duchamp, 1887–1968, Art as Anti-Art*. Köln: Taschen, 2000.

Minnelli, Vincente, dir. *An American in Paris*. Metro Goldwyn Mayer, 1951.

Moglen, Seth. *Mourning Modernity: Literary Modernism and the Injuries of American Capitalism*. Palo Alto, Calif.: Stanford University Press, 2007.

Moles, Abraham. *Le Kitsch: l'art du Bonheur*. Paris: Mame, 1971.

Moore, Marianne. *The Poems of Marianne Moore*. Ed. Grace Schulman. New York: Penguin, 2003.

Moore, Steven. *A Reader's Guide to William Gaddis's The Recognitions*. Available online at http://www.williamgaddis.org/recognitions/I1anno1.shtml.

———. "The Secret History of *Agapē Agape*." In *Paper Empire: William Gaddis and the World System*, ed. Joseph Tabbi and Rone Shavers, 256–66. Tuscaloosa: University of Alabama Press, 2007.

Mora, Gilles, and John T. Hill. *Walker Evans: The Hungry Eye*. Trans. Jacqueline Taylor. New York: Abrams, 1993.

Moraru, Christian. "'Topos/Typos/Tropos': Visual Strategies and the Mapping of Space in Charles Olson's Poetry." *Word and Image* 14, no. 3 (July–September 1998): 253–66.

Mosher, Frederick, ed. *American Public Administration: Past, Present, Future*. Tuscaloosa: University of Alabama Press, 1975.

Muncy, Robyn. *Creating a Female Dominion in American Reform: 1890–1935*. New York: Oxford University Press, 1991.

Naremore, James. *The Films of Vincente Minnelli*. Cambridge: Cambridge University Press, 1993.

Neilson, Brett. "History's Stamp: Wyndham Lewis's *The Revenge for Love* and the Heidegger Controversy." *Comparative Literature* 51, no. 1 (1999): 24–41.

Nelson, Cary. *Repression and Recovery: Modern American Poetry and the Politics of Cultural Memory, 1910–1945*. Madison: University of Wisconsin Press, 1989.

Nielsen, Aldon Lynn. *Integral Music: Languages of African American Innovation*. Tuscaloosa: University of Alabama Press, 2004.

Normand, Tom. *Wyndham Lewis the Artist: Holding the Mirror up to Politics*. Cambridge: Cambridge University Press, 1992.

North, Michael. *The Political Aesthetic of Yeats, Eliot, and Pound*. Cambridge: Cambridge University Press, 1991.

———. "Eliot, Lukács, and the Politics of Moderns." In *T.S. Eliot: The Modernist in History*, ed. Ronald Bush, 169–90. Cambridge: Cambridge University Press, 1991.

Novell, Patricia. *Recording Conceptual Art, Early Interviews with Barry, Huebler, Kaltenbach, LeWitt, Morris, Oppenheim, Siegelaub, Weiner*. Berkeley: University of California Press, 2001.

Olson, Charles. "Place; & Names." *Yūgen* 8 (1962): 60.

———. *Muthologos: The Collected Lectures and Interviews*, 2 vols. Ed. George F. Butterick. Bolinas: Four Seasons Foundation, 1978 and 1979.

———. *The Maximus Poems*. Ed. George F. Butterick. Berkeley: University of California Press, 1983. [*M*]

———. *The Collected Poems of Charles Olson*. Ed. George F. Butterick. Berkeley: University of California Press, 1987. [*OPo*]

———. *Collected Prose/Charles Olson*. Ed. Donald Allen and Benjamin Friedlander. Berkeley: University of California Press, 1997. [*OPr*]

———. Archives and Special Collections at the Thomas J. Dodd Research Center, University of Connecticut Libraries.

Paine, Thomas. *The Rights of Man*. New York: Penguin, 1984.

Parry, Amie Elizabeth. *Interventions into Modernist Cultures: Poetry from beyond the Empty Screen*. Durham, N.C.: Duke University Press, 2007.

Parsekeva, Anthony. "Wyndham Lewis vs Charlie Chaplin." *Forum for Modern Language Studies* 43, no. 3 (July 2007): 223–34.

Paul, Catherine. *Poetry in the Museums of Modernism: Yeats, Pound, Moore, Stein.* Ann Arbor: University of Michigan Press, 2002.

Pawlowski, Merry M. "Toward a Feminist Theory of the State: Virginia Woolf and Wyndham Lewis on Art, Gender, and Politics." In *Virginia Woolf and Fascism: Resisting the Dictators' Seduction*, ed. Merry Pawlowski, 39–55. Basingstoke: Palgrave, 2001.

Pecorino, Jessica Prinz. "Resurgent Icons: Pound's First Pisan Canto and the Visual Arts." *Journal of Modern Literature* 9, no. 2 (May 1982): 159–74.

Peppis, Paul. *Literature, Politics, and the English Avant-Garde: Nation and Empire, 1901–1918.* Cambridge: Cambridge University Press, 2000.

Perloff, Marjorie. "Charles Olson and the 'Inferior Predecessors': 'Projective Verse' Revisited." *English Literary History* 40, no. 2 (summer 1973): 285–306.

———. *Poetics of Indeterminacy: Rimbaud to Cage.* Princeton, N.J.: Princeton University Press, 1981.

———. "The Invention of Collage." *New York Literary Forum* 10–11 (1983): 5–47.

———. "Collage and Poetry." In *The Encyclopedia of Aesthetics*, vol. 1, ed. Michael Kelly, 384–87. Oxford: Oxford University Press, 1998.

———. *21st-Century Modernism: The "New" Poetics.* Oxford: Blackwell, 2002.

Pitchford, Nicola. "Unlikely Modernism, Unlikely Postmodernism: Stein's *Tender Buttons*." *American Literary History* 11, no. 4 (1999): 642–67.

Poe, Edgar Allan. *The Fall of the House of Usher and Other Writings: Poems, Tales, Essays and Reviews.* Ed. David Galloway. New York: Penguin, 1986.

Poggi, Christine. *In Defiance of Painting: Cubism, Futurism, and the Invention of Collage.* New Haven, Conn.: Yale University Press, 1992.

Posner, Richard. *Law and Literature*, rev. and enl. ed. Cambridge, Mass.: Harvard University Press, 1998.

Pound, Ezra. *Selected Poems.* Ed. T. S. Eliot. London: Faber and Faber, 1928.

———. *The Cantos of Ezra Pound.* New York: New Directions, 1970.

———. *Ezra Pound's Poetry and Prose: Contributions to Periodicals, Volume IV 1920–1927.* Pref. and arr. Lea Baechler, A. Walton Litz, and James Longenbach. New York: Garland, 1991.

Quine, Willard V. O. *Methods of Logic.* New York: Henry Holt, 1950.

Radnoti, Sandor. *The Fake: Forgery and Its Place in Art.* Lanham, Md.: Rowman and Littlefield, 1999.

Rancière, Jacques. *The Politics of Aesthetics: The Distribution of the Sensible.* Trans. Gabriel Rockhill. London: Continuum, 2004.

———. *Aesthetics and Its Discontents.* Trans. Steven Corcoran. Cambridge: Polity, 2009.

———. *Dissensus: On Politics and Aesthetics.* Ed and trans. Steven Corcoran. London: Continuum, 2010.

Reilly, Charlie, ed. *Conversations with Amiri Baraka.* Jackson: University Press of Mississippi, 1994.

Rich, Adrienne. *Blood, Bread and Poetry: Selected Prose 1979–1985.* New York: Norton, 1986.

Riddel, Joseph. *The Inverted Bell: Modernism and the Counterpoetics of William Carlos Williams.* Baton Rouge: Louisiana State University Press, 1974.

Rifkin, Libbie. *Career Moves: Olson, Creeley, Zukofsky, Berrigan, and the American Avant-Garde.* Madison: University of Wisconsin Press, 2000.

Robbins, Bruce. *Feeling Global: Internationalism in Distress*. New York: New York University Press, 1999.

Rogers, Robert. "*Tender Buttons*, Curious Experiment of Gertrude Stein in Literary Anarchy." In *Critical Essays on Gertrude Stein*, ed. Michael Hoffman, 31–33. Boston: Hall, 1986.

Rose, W. K., ed. *The Letters of Wyndham Lewis*. London: Methuen, 1963.

Rotella, Guy. *Castings: Monuments and Monumentality in Poems by Elizabeth Bishop, Robert Lowell, James Merrill, Derek Walcott and Seamus Heaney*. Nashville, Tenn.: Vanderbilt University Press, 2004.

Safire, Williams. "No . . . Left Behind." *New York Times*, February 26, 2006, Magazine. Available online at http://www.nytimes.com/2006/02/26/magazine/26wwln_safire.html.

Sagoff, Mark. "The Aesthetic Status of Forgeries." *Journal of Aesthetics and Art Criticism* 35, no. 2 (winter 1976): 169–80.

Salemi, Joseph. "To Soar in Atonement: Art as Expiation in Gaddis's *The Recognitions*." In *In Recognition of William Gaddis*, ed. John Kuehl and Steven Moore, 46–57. Syracuse, N.Y.: Syracuse University Press, 1984.

Sandel, Michael. *Liberalism and the Limits of Justice*, 2nd ed. Cambridge: Cambridge University Press, 1998.

Sawelson-Gorse, Naomi. "Hollywood Conversations: Duchamp and the Arensbergs." In *West Coast Duchamp*, ed. Bonnie Clearwater, 25–45. Miami Beach, Fla.: Grassfield Press, 1991.

Sayre, Henry. "Ready-mades and Other Measures: The Poetics of Marcel Duchamp and William Carlos Williams." *Journal of Modern Literature* 8 (1980): 3–22.

———. *The Visual Text of William Carlos Williams*. Urbana: University of Illinois Press, 1983.

Schenker, Daniel. *Wyndham Lewis: Religion and Modernism*. Tuscaloosa: University of Alabama Press, 1992.

Schlesinger, E. R. "The Sheppard-Towner Era: A Prototype Case Study in Federal-State Relationships." *American Journal of Public Health and the Nation's Health* 57, no. 6 (June 1967): 1034–40.

Schmidt, Peter. *William Carlos Williams, The Arts and Literary Tradition*. Baton Rouge: Louisiana State University Press, 1988.

Schultz, Susan. "Gertrude Stein's Self-Advertisement." *Raritan* 12, no. 2 (1992): 71–87.

Scott, Ian. "From Toscanini to Tennessee: Robert Riskin, the OWI and the Construction of American Propaganda in World War II." *Journal of American Studies* 40, no. 2 (2006): 347–66.

Searle, John. *Speech Acts: An Essay in The Philosophy of Language*. Cambridge: Cambridge University Press, 1970.

Silko, Leslie Marmon. *Sacred Water: Narratives and Pictures*. 1993; rpt. Tucson: Flood Plain Press, 1994.

———. *Yellow Woman and the Beauty of the Spirit: Essays on Native American Life Today*. New York: Simon and Schuster, 1996.

Silliman, Ron. Interview with Manuel Brito. In *A Suite of Poetic Voices: Interviews with Contemporary American Poets*, ed. Manuel Brito, 145–66. Santa Brigda: Kadel Books, 1992.

Simpson, David. *Situatedness, or, Why We Keep Saying Where We're Coming From*. Durham, N.C.: Duke University Press, 2002.

Siraganian, Lisa. "Wallace Stevens's Fascist Dilemmas and Free Market Resolutions." *American Literary History* 23, no. 2 (2011): 337-61.

Smethurst, James. *The Black Art Movement: Literary Nationalism in the 1960s and 1970s.* Chapel Hill: University of North Carolina Press, 2005.

Smithson, Robert. *Robert Smithson: The Collected Writings.* Ed. Jack Flam. Berkeley: University of California Press, 1996.

Sorrentino, Gilbert. "2 Books." *Yūgen* 7 (1961): 5–7.

Spahr, Juliana. *Everybody's Autonomy: Connective Reading and Collective Identity.* Tuscaloosa: University of Alabama Press, 2001.

———. *This Connection of Everyone with Lungs.* Berkeley: University of California Press, 2005.

Spengler, Oswald. *The Decline of the West.* Trans. Charles Francis Atkinson. New York: Knopf, 1926.

Stein, Gertrude. *Everybody's Autobiography.* New York: Random House, 1937.

———. *Painted Lace and Other Pieces 1914–1937, The Yale Edition of the Unpublished Writings of Gertrude Stein,* vol. 5. New Haven, Conn.: Yale University Press, 1955.

———. *Gertrude Stein: A Primer for the Gradual Understand of Gertrude Stein.* Ed. Robert Bartlett Haas. Los Angeles: Black Sparrow Press, 1971.

———. *How Writing Is Written: Volume II of the Previously Uncollected Writings of Gertrude Stein.* Ed. Robert Bartlett Haas. Los Angeles: Black Sparrow Press, 1974.

———. *The Making of Americans: Being a History of a Family's Progress.* Normal, Ill.: Dalkey Archive Press, 1995. (Originally published, France: Contact Editions, 1925.)

———. *Writings 1903–1932* (vol. 1) and *Writings 1932–1946* (vol. 2). New York: Library of America, 1998. [*GS1* and *GS2*]

Steiner, Wendy. *Exact Resemblance to Exact Resemblance: The Literary Portraiture of Gertrude Stein.* New Haven, Conn.: Yale University Press, 1978.

Stevens, Wallace. *The Collected Poems.* New York: Knopf, 1954.

———. *Opus Posthumous: Poems, Plays, Prose.* Rev., enl., and corr. ed. Ed. Milton J. Bates. New York: Knopf, 1989.

Szalay, Michael. *New Deal Modernism: American Literature and the Invention of the Welfare State.* Durham, N.C.: Duke University Press, 2000.

Tabbi, Joseph, and Rone Shavers, eds. *Paper Empire: William Gaddis and the World System.* Tuscaloosa: University of Alabama Press, 2007.

Tashjian, Dickran. *Skyscraper Primitives: Dada and the American Avant-Garde, 1910–1925.* Middletown, Conn.: Wesleyan University Press, 1975.

Taylor, Charles. *Multiculturalism and "The Politics of Recognition": An Essay.* Princeton, N.J.: Princeton University Press, 1992.

Taylor, Mark. *Confidence Games: Money and Markets in a World without Redemption.* Chicago: University of Chicago Press, 2004.

Taylor, Melanie. "A Poetics of Difference: The Making of Americans and Unreadable Subjects." *National Women's Studies Association Journal* 15, no. 3 (2003): 26–42.

Terrell, Carroll F. *A Companion to "The Cantos" of Ezra Pound.* Berkeley: University of California Press, 1980.

Thomson, Charles A. H. *The Overseas Information Service of the US Government.* Washington, D.C.: Brookings Institute, 1948.

Tiessen, Paul. "Wyndham Lewis's *The Childermass* (1928): The Slaughter of the Innocents in the Age of Cinema." In *Apocalyptic Visions Past and Present,* ed. JoAnn James and William J. Cloonan, 25–35. Tallahasee: Florida State University Press, 1984.

Tselentis-Apostolidis, Penny. "On Olson's Geographic Methodology: Quoting, Naming, Pacing and Mapping." *Sagtrieb* 12, no. 2 (fall 1993): 119–36.

Vacche, Angela Dalle. *Cinema and Painting: How Art Is Used in Film*. Austin: University of Texas Press, 1996.

Vanderborg, Susan. *Paratextual Communities: American Avant Garde Poetry since 1950*. Carbondale: Southern Illinois University Press, 2001.

Van Dusen, Wanda, and Michael Davidson. "Portrait of a National Fetish: Gertrude Stein's 'Introduction to the Speeches of Maréchal Pétain' (1942)." *Modernism/Modernity* 3, no. 3 (1996): 69–96.

von Hallberg, Robert. *Charles Olson: The Scholar's Art*. Cambridge, Mass.: Harvard University Press, 1978.

Walker, Jayne L. *The Making of a Modernist: Gertrude Stein from "Three Lives" to "Tender Buttons."* Amherst: University of Massachusetts Press, 1984.

Warren, Samuel, and Louis D. Brandeis. "The Right to Privacy [the implicit made explicit]." *Harvard Law Review* 4 (December 1890). (Reprinted in *Philosophical Dimensions of Privacy: An Anthology*, ed. Ferdinand David Schoeman, 75–103. Cambridge: Cambridge University Press, 1984.)

Wellek, René, and Austin Warren. *Theory of Literature*. New York: Penguin, 1942.

Wells, H. G. *When the Sleeper Wakes*. New York: Harper and Brothers, 1899.

Wertheim, Larry. "Symposium: Proposed Restatement (Third) of Torts: Products Liability: Book Review: Law as Frolic: Law and Literature in *A Frolic of His Own*." *William Mitchell Law Review* 421 (winter 1995).

Wertsman, Vladimir, ed. *The Armenians in America 1618–1976: A Chronology and Fact Book*. Ethnic Chronology Series no. 27. Dobbs Ferry, N.Y.: Oceana Publications, 1978.

Wiebe, Robert. *Self-Rule: A Cultural History of American Democracy*. Chicago: University of Chicago Press, 1995.

Wilde, Oscar. *The Picture of Dorian Gray*, 2nd ed. Ed. Michael Patrick Gillespie. New York: Norton, 2007.

Will, Barbara. *Gertrude Stein, Modernism, and the Problem of "Genius."* Edinburgh: Edinburgh University Press, 2000.

———. "Lost in Translation: Stein's Vichy Collaboration." *Modernism/Modernity* 11, no. 4 (2004): 651–68.

Williams, William Carlos. "America, Whitman, and the Art of Poetry." *The Poetry Journal* (Boston) 8, no. 1 (November, 1917): 27–36. (Reprinted in *The William Carlos Williams Review* 13, no. 1 [spring 1987]: 1–4.)

———. "An Approach to the Poem." In *English Institute Essays, 1947*, ed. David Allan Robertson Jr., 50–75. New York: AMS Press, 1948.

———. *The Autobiography of William Carlos Williams*. New York: New Directions, 1951.

———. *Selected Essays of William Carlos Williams*. New York: New Directions, 1954.

———. *Selected Letters of William Carlos Williams*. New York: New Directions, 1957.

———. *I Wanted to Write a Poem: The Autobiography of the Works of a Poet*. Ed. Edith Heal. New York: New Directions, 1958.

———. *Imaginations*. Ed. Webster Shott. New York: New Directions, 1970. [*I*]

———. *Interviews with William Carlos Williams: "Speaking Straight Ahead."* Ed. Linda Welshimer Wagner. New York: New Directions, 1976.

———. "(Revolutions Revalued:) The Attack on Credit Monopoly from a Cultural Viewpoint." In *A Recognizable Image: William Carlos Williams on Art and Artists*, ed. Bram Dijkstra, 97–118. New York: New Directions, 1978.

———. *The Collected Poems*, vol. 1. Ed. A. Walton Litz and Christopher MacGowan. New York: New Directions, 1986. [*CP1*]

———. *The Collected Poems*, vol. 2. Ed. Christopher MacGowan. New York: New Directions, 1988. [*CP2*]

Wilmerding, Lucius. *Government by Merit*. New York: McGraw-Hill, 1935.

Wimsatt, William K. Jr., and Monroe Beardsley. *The Verbal Icon: Studies in the Meaning of Poetry*. New York: Noonday Press, 1954.

Wimsatt, William K. Jr., and Cleanth Brooks. *Literary Criticism: A Short History*. New York: Knopf, 1957.

Witemeyer, Hugh, ed. *Pound/Williams: Selected Letters of Ezra Pound and William Carlos Williams*. New York: New Directions, 1996.

Wittig, Monique. *The Straight Mind and Other Essays*. Boston: Beacon Press, 1992.

Wolf, Jacqueline H. *Don't Kill Your Baby: Public Health and the Decline of Breastfeeding in the Nineteenth and Twentieth Centuries*. Columbus: Ohio University Press, 2001.

Woodard, Komozi. *A Nation within a Nation: Amiri Baraka (LeRoi Jones) and Black Power Politics*. Chapel Hill: University of North Carolina Press, 1999.

World Trade Center Medical Working Group. *2009 Annual Report*. September 2009. Available online at http://www.nyc.gov/html/fdny/pdf/2009_wtc_medical_working_group_annual_report.pdf.

Wragg, David A. *Wyndham Lewis and the Philosophy of Art in Early Modernist Britain: Creating A Political Aesthetic*. Lewiston, N.Y.: Edwin Mellen Press, 2005.

Wurm, Erwin. *One Minute Sculptures, 1988–1998: Index of Works*. Bregenz: Kunsthaus Bregenz, 1999.

Ziegler, James. "Charles Olson's American Studies: *Call Me Ishmael* and the Cold War." *Arizona Quarterly: A Journal of American Literature, Culture, and Theory* 63, no. 2 (2007): 51–80.

Žižek, Slavoj. *The Ticklish Subject: The Absent Centre of Political Ontology*. London: Verso, 1999.

———. "A Plea for a Return to Différance (with a Minor Pro Domo Sua)." *Critical Inquiry* 32, no. 2 (2006): 226–49.

———. *The Parallax View*. Cambridge, Mass.: MIT Press, 2006.

INDEX

Abstract Expressionism, 118–19,
213n24
Adorno, Theodor, 3
on aesthetic autonomy, 16–17, 49–50
"On Lyric Poetry and Society," 16–17,
190n44
aesthetic autonomy. *See also* meaning's
autonomy
Adorno on, 16–17, 49–50
Benjamin on, 16, 25, 45–49
Bürger on, 6, 19–20, 192n55
definitions of, 4, 6, 16–17, 19
Gaddis on, 3
Lewis, W., on, 3, 6
meaning's autonomy compared to, 6,
11–12, 15–17, 191n47
New Critics on, 15–17, 25, 45,
189n33, 190n35
politics and, 3, 6, 9, 18–19
Stein on, 3, 6, 44–50
aesthetic gaze, 137–38, 217n76
aesthetic of criticism, 22, 114, 125
affective fallacy, 45
*Against Race: Imagining a Political Culture
Beyond the Color Line* (Gilroy), 170
Agee, James, 122
air. *See also* breath
in art, 7–9, 12–14, 52–55, 57, 60–61,
168–69, 200n4
art without, 24–28, 48–49
body and, 140, 170–73
breath and, 7–11, 14, 32, 48, 52–54,
168–69, 181, 187n23
as collaged element, 14
Hillman on, 12, 14, 168–69
window frame and, 53, 81, 85
Alberti, Leon Battista, 83
"America, Whitman, and the Art of
Poetry" (Williams), 79, 102

An American in Paris (film), 21, 110–11,
111*f*–112*f*, 113–14, 212n13,
212nn2–4
"American Anyman" film (Olson), 147,
148
American Medical Association, 104
"Anecdote of the Jar" (Stevens), 4
antiparticularism, 35, 50
Apollinaire, Guillaume, 92, 208n43
Apple (of Beauty and Discord) (magazine),
80
The Arcades Project (Benjamin), 46–47
Arensberg, Walter, 86, 91
art. *See also* aesthetic autonomy;
forgeries
without air, 24–28, 48–49
air in, 7–9, 12–14, 52–55, 57, 60–61,
168–69, 200n4
autonomy of, 3–6, 15–20
bad, 130–34, 181, 217n69
beetle shell, 69–76, 74*f*, 77*f*, 78
cult value of, 198n64
durational, 62, 202n38
high, 21–22
life and, 58–60, 62, 76, 113, 134–35,
201n23, 207n32
minimalist, 12, 202nn35–36, 217n71
objecthood and, 12, 26–27, 61–62
primitive, 115, 134, 137, 217n68
senses and, 12, 14
space of beholder and space of,
27–28, 56
"Art and Objecthood" (Fried), 12, 14,
26–27, 61–62
art-for-art's-sake movement, 190n38,
191n47. *See also* l'art pour l'art
movement
art history, 188n31
Arthur Press, 205n80